CAMERA WORK°°
A CRITICAL ANTHOLOGY

CAMERA WORK°°

A
Critical
Anthology

Edited
With an
Introduction
by
Jonathan
Green

Aperture, Inc. publishes a quarterly of photography, portfolios, and books to communicate with serious photographers and creative people everywhere. A complete catalogue will be mailed upon request. Address: Elm Street, Millerton, New York 12546

This project is supported by a grant from the National Endowment for the Arts in Washington, D. C., a Federal agency and by a grant from the Florence V. Burden Foundation.

Contents

Plates

Preface

ALFRED STIEGLITZ conceived of the portrait as a "photographic journal," a visual daybook which would record the day-by-day growth and change of its subject. In this sense, CAMERA WORK is a portrait. It is a portrait of Stieglitz, for it documents each step in his transition from a youthful experimenter preoccupied with a range of subject matter and technique to a mature artist able to express the intimate and the spiritual through an extraordinarily refined perception of the people and places closest to him. More than this, CAMERA WORK is a portrait of an age. To read through its fifty issues is to experience the growth by which the artistic sensibility of the nineteenth century was transformed into the artistic awareness of the present day.

CAMERA WORK: A CRITICAL ANTHOLOGY illustrates this evolution. In the selection of plates and texts and in the introduction and indices, emphasis has been placed on the historical development of the quarterly. Because this development is mirrored in the style as well as in the content of the prose, nearly all the selections are presented in full. In the few instances where a selection is cut, omissions are indicated by a long dash (————), or by extra spacing between paragraphs. All footnotes and point ellipses (. . .) in the text appear in the original edition. An English translation of *Vers l'Amorphisme* has been added.

The indices simultaneously index this Anthology and the complete fifty issues and three special issues of CAMERA WORK. A bibliography and biographies are included.

Minor White and Michael Hoffman first suggested this book and gave me invaluable aid throughout its preparation. My father, Rabbi Alan S. Green, and William E. Parker helped to clarify content, presentation, and expression. Lisalee Anne Wells prepared the alphabetical index to CAMERA WORK. My wife, Louise, has been an active intellectual partner in every aspect of my work.

I wish to acknowledge my debt—especially in the historical aspect of my introduction—to the published work of Robert Doty and Beaumont Newhall. Their essays on the Photo-Secession have paved the way for all further inquiry into the period.

I am indebted to other friends and colleagues who have helped in many ways: to Bill Johnson for directing me to important bibliographical material; to Jane Gilbert and Judith Wechsler for their valuable criticism of my manuscript; to Magda Buka, Susan Devins, and Whitney Chadwick for advice in translations; to Henry Millon for helpful suggestions on the indices; to Jane Tarlow and Laura Schlesinger for their help in the preparation of early drafts; and again to Susan Devins who prepared the manuscript for press.

I have been greatly helped in the preparation of the biographies by Meridel Rubenstein and the following people who kindly shared their knowledge of CAMERA WORK's authors and artists: Thomas Barrow of the University of New Mexico, Suzanne Boorsch of the Metropolitan Museum of Art, Mary Steichen Calderone, Rodrigo De Zayas, Robert Doty, Frederick Haviland, Jack Haviland, William I. Homer, Dennis Longwell and Grace Mayer of The Museum of Modern Art, Tom Norton of the Parke-Bernet Gallery, Mrs. Harold G. Pierce, Jr. of the Stockbridge Library Association, and Mrs. Florence King Weichsel.

I am especially grateful to Miss Florence Connolly and the staff of the Fine Arts Department of the Boston Public Library for allowing me extensive use of their copy of CAMERA WORK.

"CAMERA WORK," Paul Rosenfeld wrote, "is perhaps the handsomest, most esthetically presented of all periodicals." An attempt has been made here to translate the spirit of the original format into contemporary terms. The design is by Stephen Korbet. The typesetting was supervised by Sam Halpert. The plates have been printed by Rapoport Printing Corporation and the text has been set in Linofilm Baskerville and printed by Halliday Lithograph Corp. The dust-jacket has been designed by Herb Lubalin.

The reproductions have been made in large part from plates provided by the Alfred Stieglitz Center of the Philadelphia Museum of Art which is indebted to Dorothy Norman and Carl Zigrosser for their gifts of the original editions of CAMERA WORK. *The Lotus Screen* by Edward Steichen, owned by Mrs. Edward Steichen, and *Mountains and Clouds* by John Marin, owned by Harry Spiro, have been reproduced from transparencies made from the original works of art by Malcolm Varon with the kind permission of the owners.

J.G.

*Alfred Stieglitz
and Pictorial Photography*

When Alfred Stieglitz published the first issue of CAMERA WORK in January, 1903, he was taking only the latest in a series of major steps in his fight to establish photography as a legitimate and recognized medium of artistic expression.

Stieglitz had become fascinated with the camera during the 1880's, while he was an American engineering student in Berlin. Already imbued with the vitality of European music, theater, art, and craftsmanship, he began to pursue photography with a vigorous concern for its expressive potential. Studies under H. W. Vogel, the inventor of orthochromatic plates, gave him the basis for a thorough knowledge of optics and photochemistry; and he soon abandoned engineering entirely to spend his last student years traveling and photographing in Germany and Italy. Constantly experimenting with the new medium, he felt very much a part of the growing expressionistic movements in art which were to blossom into the German Secession. He began at this time to enter his work in competitions and to write occasionally for photographic journals. In 1887 he was awarded his first silver medal by the English photographer Peter H. Emerson, the most articulate spokesman of the day for photography as a fine art and future author of the seminal *Naturalistic Photography*.

Photography had been practiced as an expressive medium since the 1840's, but it had not been accepted as an equal to painting or the other visual arts. It was considered by the institutionalized art world as a curiosity, a painter's aid, a craft, or at best a mechanical art. As late as 1890, photography had never been shown on a level with painting at the salons, nor had it been acquired for museum collections. During the 1880's, in England and on the Continent, the introduction of ready-sensitized platinum printing paper, together with continuing technical advances in equipment and film materials, encouraged serious amateurs to re-explore the esthetic possibilities of the camera. They banded together in clubs and societies and demanded that photography be accepted as an art. Their active campaigning resulted in the first international photography salon in Vienna in 1891 and exhibitions in London and Hamburg in 1893.

Caught up in the beginnings of this esthetic movement in European photography, Stieglitz soon came to regard photography with a seriousness and dedication unknown in America. On his return to New York in 1890, he found amateur photography thriving. Nearly a dozen photographic journals were being distributed nationally, and almost every town had its camera club or society. Yet, nowhere did Stieglitz find the passionate concern with photographic expression he had known in Europe. The editor of the *American Amateur Photographer* wrote in 1890 that photography "is largely a matter of an hour now and then, a brief vacation, snatched from the cares of a busy life."[1]

With characteristic intensity, Stieglitz determined to put aside his initial feelings of dismay at American provincialism to demonstrate, at least through his own work and writings, his belief in the medium. He became an active participant in the New York Society of Amateur Photographers, and he soon gained international attention through his articles and photographs shown at the salons in Vienna. Hamburg, and London. During the early 1890's, Stieglitz produced a series of remarkable images of everyday New York metropolitan scenes. Such photographs as "The Terminal" and "Winter, Fifth Avenue" were not only technical revelations—the first successful images made during driving snowstorms—they were also esthetically revolutionary; for they were unretouched, hand-held "detective camera" snapshots of real, precisely observed moments.

Most of Stieglitz's fellow photographers identified esthetic expression with a painterly effect. Indeed, at the turn of the century, they had few other examples. Since 1850, photographic production had been divided into two distinct categories: the scientific and the artistic. Artistic photography was considered to be an extension of the painted image, demonstrating its legitimacy by a formal and conceptual congruence with painting. Thus, the aspiring artistic photographer imitated not only the style but also the subject matter of high art. Since photography was generally practiced as a popular art form, it reflected public expectations of art and popular taste. In the popular mind art was defined by the current academic standards. The majority of photographers, even those who were painters, followed these standards. Their esthetic taste and comprehension were frequently decades behind the avant-garde of their day.

For example, Oscar Gustave Rejlander's

ambitious allegorical photograph, "The Two Ways of Life", which created a sensation at the Manchester Art Treasures Exhibition of 1857, was based on the neo-classical allegorical style of the 1780's. The chief contemporary exponent of this style was the French academic painter, Thomas Couture. In England, Lake Price's illustrations of Cervantes and his genre photographs, as well as H. P. Robinson's sentimental anecdotes and pastorals, were similar to hundreds of paintings that lined the academy walls.

Under the delayed influence of Constable, Corot, and the Barbizon School of painting, allegorical and picturesque concerns began to give way in the 1880's to a more naturalistic style. Peter H. Emerson championed this new direction by word and example. His finest photographs sensitively record the quiet mood and atmosphere of peasant life and watery landscape along the Norfolk Broads in East Anglia. While his work was free of the sentimentality and artificiality of the earlier pictorialists, his theory of focusing introduced a new rigor to photography. Emerson believed that the principal subject should be separated from the secondary elements by differential focusing. The slightly, diffused quality which resulted was pushed to an extreme in the 1890's by some of Emerson's followers who, under the influence of Impressionism, used out-of-focus, uncorrected, or pinhole lenses to destroy detail and outline. The introduction of the gum process gave these photographers a printing technique by which they could further suppress detail, accentuate the tonal massing of light and shade, and even simulate the surface texture of brush, charcoal, or pastel.

When Stieglitz returned to New York, there were three major forces in artistic photography: the allegorical and genre tradition inherited from the earliest days of the camera; the slightly soft focused naturalism advocated by Emerson; and photographic impressionism. These were not mutually exclusive; many photographers not only worked in more than one area, but developed hybrid personal styles. Since these directions were deeply tied to the esthetics of painting, they became known collectively as "pictorial photography."

In 1893, Stieglitz became an editor of the *American Amateur Photographer*, where for three years he pursued his campaign to encourage American photographers to do expressive work and to promote the establishment of a dignified, European type of photographic salon. Though Stieglitz's own approach to photography was closest to Emerson's naturalism, as editor he favored no single style. Rather, he published the freshest and most dynamic work he could find in all three of the major styles. He constantly demanded excellence and exploration, harshly criticizing mediocrity and the cliché. Stieglitz resigned the editorship in 1896 because of business obligations, ill health, and his realization of the limited possibility of developing a new photographic spirit through an established magazine whose ownership and subscribers were more concerned with technique than with expression.

CAMERA NOTES AND THE ESTABLISHMENT OF THE PHOTO-SECESSION. In 1897 the Society for Amateur Photographers merged with the New York Camera Club. Stieglitz, sensing a chance to inaugurate a publication which would deal seriously with the issues of expression and give vigorous direction to the esthetic movement in photography, became chairman of the Club's publication committee.

He then presented the Club with a plan to establish an illustrated quarterly to replace their leaflet *Journal*. Hoping to set the publication above the petty disputes and provincial concerns of the organization, he asked for and obtained "unhampered and absolute control of all matters, direct and remote, relating to the conduct" of his quarterly.[2] Ostensibly the new publication, *Camera Notes*, was "the official organ of the Camera Club;" nevertheless, Stieglitz used it as a vehicle to "reach a class outside of the membership, and to stimulate them to artistic effort . . . to take cognizance also of what is going on in the photographic world at large . . . in short to keep . . . in touch with everything connected with the progress and elevation of photography."[3]

It was in *Camera Notes* that the basic format and attitudes which would later mature into CAMERA WORK were evolved and tested. While the letterpress of the first issue of *Camera Notes* had much the same tenor as the *American Amateur Photographer*, the quality and choice of the illustrations immediately distinguished it. Each issue contained two hand-pulled photogravures chosen by Stieglitz to illustrate

"the development of an organic idea, the evolution of an inward principle; a picture rather than a photograph."⁴ The plates were the foremost examples of pictorial expression selected from both European and American photographers. "Landscapes breathing atmosphere and light, mysterious allegorical figure studies . . . picturesque genre studies, and true portraits, which put life and character into the subject, were presented to the readers."⁵

Stieglitz demanded that the plates serve as more than a record of what was being produced in the photographic world; they had to interpret fully the spirit and quality of the original print. As a method of reproduction, the photogravure process was uniquely suited to reproduce the subtle platinum prints of the day. Considered by many a direct photographic printing technique, photogravure was able to capture in printer's ink a subtle tonal gradation and a delicate luminosity that is unknown in any contemporary, mechanical, reproduction process. Many of the gravures in *Camera Notes* and later in CAMERA WORK were made directly from the original negatives. Frequently supervised, sometimes actually etched and printed by the photographers themselves, these reproductions are vital equivalents of the original prints.

Because he wanted to expand the critical basis of the magazine, Stieglitz began to look outside of the Club for sources of articles and illustrations. He soon gathered a dedicated group of editors and contributors—drawn both from photography and from the worlds of art and literature—who shared his strong belief in the power and legitimacy of the medium. Included were the noted art critics Charles Caffin and Sadakichi Hartmann, who had published in such widely read periodicals as *Forum, Century, Harpers Weekly* and the *International Studio;* the humorist and literary critic, J. B. Kerfoot; and the lawyer and photographer, Joseph Keiley. The excellence of *Camera Notes* acted as a magnet on many serious photographers throughout the country, bringing Stieglitz in touch with Clarence White, then a grocery clerk in Newark, Ohio, and Edward Steichen, a young lithographer from Milwaukee. Many prominent Eastern pictorialists such as Gertrude Käsebier and Eva Watson—Schütze also became part of the *Camera Notes* group. By 1902, Stieglitz had published all the major photographers and critics whom he would later bring together to form the Photo-Secession.

Since 1890, Stieglitz actively campaigned for an American photographic exhibition in which the superficialities of classes and medals would be elimated, in which only the finest works would be shown. This campaign was partially realized in 1898 and 1899, when the Pennsylvania Academy of Fine Arts hosted exhibition salons sponsored by the Photographic Society of Philadelphia. But the egalitarian spirit of the camera clubs would not permit the forming of a photographic elite. The Philadelphia salons soon succumbed to popular pressure to liberalize the esthetic standards and to make the salons more representative of the total membership of the sponsoring clubs. *Camera Notes* had been under increasing attack from members of the Camera Club who complained about Stieglitz's "tyranny" and the publication's "artiness." These discontented members felt that *Camera Notes*, rather than emphasizing the range of pictorial photography and the esthetics of the medium, should be devoted exclusively to their own work.

As a result of these pressures, Stieglitz readily accepted late in 1901 an unsolicited request from the National Arts Club of New York to organize an exhibit of pictorial photographs. He now had the opportunity to take photography out of the hands of the clubs and present it to the public as an independent art. Stieglitz turned to the photographers whom he had encouraged and published, assembling their finest prints for exhibition at the National Arts Club in March, 1902, under the title, "The Photo-Secession." By choosing this name, Stieglitz signaled his spiritual alliance with European groups in photography and art which had recently revolted from the established viewpoint: the photographers of the Linked Ring Brotherhood in England, who in 1892 had broken away from the Royal Photographic Society; and the painters of the Munich, Berlin, and Vienna *Sezession* who had reacted against official German and Austrian Salon art. In less than a year, the Photo-Secession developed into an affiliation with elected members, a Council, and Stieglitz as Director.

Shortly after the Arts Club exhibition, Stieglitz resigned from *Camera Notes* and made plans for a new publication which would "owe allegiance to no organization or clique," but, paradoxically, would be the "mouthpiece of the Photo-Secession."⁶ To insure its independence, Stieglitz took upon himself the total responsibility for its editing and publishing. He soon had received

647 subscriptions—sight unseen—for the new periodical. Consequently, in January, 1903, there appeared the first issue of CAMERA WORK, the "illustrated quarterly magazine devoted to Photography."[7]

Camera Work

Freed from allegiance to formal clubs and established publications, Stieglitz was now able to produce a publication radically different from anything that had gone before—a magazine as integrated and diverse as his own maturing sensibility. CAMERA WORK, wrote Paul Rosenfeld, "is a constantly progressive, steadily cumulative work of art."[8]

In order to follow this growth, we may conveniently divide the fifty issues of CAMERA WORK into four major periods. While these periods are not sharply delineated, the essential tendencies of each may be emphasized by referring to them as *Consolidation*, 1903–1907, the time of transition from *Camera Notes; Expansion*, 1907–1910, the development of the Little Galleries of the Photo-Secession, CAMERA WORK's initial contact with modern art, and the last major exhibitions of the Photo-Secession; *Exploration*, 1910–1915, when CAMERA WORK and the Little Galleries were vitally concerned with the radical new art movements of Fauvism, Cubism and Futurism; and the final period, 1915–1917, when CAMERA WORK offered an effective *Summation* of the interests and activities of the preceding twelve years by publishing photographic tributes to Stieglitz and Paul Strand.

THE FIRST PERIOD: CONSOLIDATION, 1903–1907. In its earliest years, CAMERA WORK represented a deepening and broadening of the concerns inherited from *Camera Notes*. Charles Caffin, Sadakichi Hartmann, Joseph Keiley, Dallett Fuguet, and J. B. Kerfoot—who had come with Stieglitz to CAMERA WORK—took advantage of the scope and freedom of the new publication. They began to publish more extensive analyses of photographers and their work, and more sensitive explorations of photography's relationship to the other arts. These articles, as well as essays on photography by George Bernard Shaw (a keen amateur photographer and supporter of photography as an art) and by Maurice Maeterlinck (introduced to photography by Steichen, then an art student in Paris) more

than fulfilled Stieglitz's pledge in the first issue that CAMERA WORK's literary contributions would be the best of their kind.

Sadakichi Hartmann's record of his visit to Steichen's studio—published in issue 2 under the pen name Sidney Allan—exemplifies the early emotional and critical concerns. One's first impression of this article is of its style rather than its content. Like the photographs reproduced at first, Hartmann's prose projects a distinctly *fin de siécle* atmosphere. There is a romantic brooding, a sensitivity beyond passion, the transcendental melancholy of Maeterlinck's German forests. Like the European Symbolist and Decadent writers and artists of the time, Hartmann was profoundly nostalgic for a lost elegance. Underlying his writing was a weary yet continual search for essential emotional expression, for the beautiful and the visionary. This sensibility was echoed in Stieglitz's home, which in 1903 contained reproductions of the paintings of Franz von Stuck, founder of the Munich Secession, and Arnold Böcklin, the Swiss painter. For these painters, as for a great many of the photographic pictorialists, esthetic profundity was associated with darkness and sensual melancholy. Stuck's main themes were sin and death, portrayed through erotic personifications of evil and sphinx-like nudes. Böcklin found meaning and drama in grotesque figures drawn from classical myth and in images of the foreboding quiet of melancholy ruins. This mood reappears during the first two periods of CAMERA WORK, both in the plates and in the text, and especially in Joseph Keiley's Visions and Dallett Fuguet's poems and articles.

Although it would be superseded in later issues by the bright, hard, direct concerns of modernism, this kind of romantic sensibility was significant in elevating the photograph from a mechanically produced object to a work of art. The very style of Hartmann's prose certified the worth of the object, providing the dignified response formerly reserved for the other arts. Moreover, the *fin de siècle* concern with "beauty" forced the critic to perceive the photograph with a fresh eye, permitting a response from the expression rather than the technique. "In art the method of expression matters naught," Hartmann wrote, after comparing Steichen's paintings to his photographs. "I believe that every effort, no matter in what medium, may become a work of art provided it manifests with utmost sincerity

and intensity the emotions of a man face to face with nature and life." And again, "Biographical data do not interest me. What is the difference where a man is born, how old he is, where he studied, and where he was medaled? His art must speak—that is all I care for."⁹ Steichen's photographs did, indeed, speak to Hartmann; and he followed his prose article with two poems inspired by Stiechen's prints.

While Hartmann's article and poems reveal the intensely serious concerns of the early CAMERA WORK, another aspect is evident in the humorous pieces that dot the early text. These function as comic relief, allowing the camera workers to pause and look at themselves with detachment and objectivity. The comic perspective, in fact, helped forge the unity and spirit of the Secessionists. Centered around the prominent members of the Secession, and frequently focused on Stieglitz, the humor, born of conviviality and mutual respect, reinforced the exclusiveness of the group. In J. B. Kerfoot's good-humored "Black Art," Stieglitz, Steichen, Coburn, and Käsebier are elevated to the photographic round table with Stieglitz as Alfred the Great. Stieglitz's expulsion from the Camera Club in 1908 provided the background for Charles Caffin's fable, "Rumpus in a Hen House," in which the comic effectively differentiates the Secessionists from the philistines. It allows Caffin an opportunity to question established values and summarily dispose of them.

The comic imagination is an integral facet of the critical, skeptical intelligence that animates CAMERA WORK. Expressed in the early issues through fable, aphorism, and jest, it will mature in the later numbers into sophisticated irony and caricature. It will be transformed in the writing of Benjamin De Casseres and the caricatures of Marius De Zayas into a scathing Dadaistic attack on American civilization.

THE PRINTING AND FORMAT. Stieglitz's demand for excellence, apparent in the text, becomes manifest in the plates. Throughout the fifteen years of publication, all but one of the regular issues—which were consistently printed in editions of 1000 copies—contained a hand-tipped gravure portfolio by a single camera worker or artist, as well as several additional plates. In the early issues, the photogravures were printed on Japan tissue and placed on colored mounts.

Steichen went to the extent in issue 19 of hand-toning copies of his photogravure, "Pastoral-Moonlight." Stieglitz, who had been briefly involved in the photoengraving business, always took great pains to equate the reproduction with the qualities of the original. As a result, CAMERA WORK is a small encyclopedia of the mechanical printing processes available during the first seventeen years of this century. Along with straight photogravure, there are mezzotint photogravures, duogravures, one-color halftone, duplex halftones, four-color halftones, and collotypes. It has been frequently remarked that the reproductions in CAMERA WORK are often finer than the original prints.

While the photogravures were made from grained, intaglio plates, inked and printed by hand, the mezzotint photogravures and duogravures were screened intaglio plates printed by machine. These processes offered a full-bodied impression and where eminently suitable for the reproduction of the heavy, dense gum prints, particularly if the originals were produced on highly textured papers. The double printing of the duogravure, as with the duplex halftone, offered the possibility of introducing an overlay tint that could approximate the color of the original. CAMERA WORK's reproduction of Steichen's Lumière Autochromes was one of the first published examples of the four-color, half-tone process applied to color transparencies. Because of their random color structure, the Lumière plates were not considered reproducible; yet, the famous Bruckmann printing firm of Munich made such miraculous halftones from them that they retain unequalled color saturation and intensity. The Bruckmann Verlag did a great deal of the engraving for CAMERA WORK. It was their modified version of the almost grainless collotype process that was responsible for the reproductions of Rodin's wash drawings. These plates were made with such sensitivity to line, tint, and density of shading that it is impossible to tell them from the originals without the closest inspection.

The format of CAMERA WORK displayed the same concern for quality. The cover, marque, and typography were designed by Steichen in a refined, rectilinear version of the Art Nouveau style. Paul Rosenfeld has written that CAMERA WORK "is itself a work of art: the lover's touch having been lavished on every aspect of its form and content. Spacing, printing, and quality of the paper, the format of the pages, the format of the

advertisements, even, are simple and magnificent."[10]

THE SECOND PERIOD: EXPANSION, 1907–1910. After the plates, it is the articles about its own history that best capture the spirit of CAMERA WORK and the Photo-Secession. During the first two periods, 1903–1910, the Photo-Secession's chief activity centered around exhibitions of photographs. Under Stieglitz's direction, collections of selected American prints were shown here and abroad with the avowed and slowly realized intention of raising the standards of pictorial photography and gaining respect for the medium. The three principal exhibitions of this time occurred at the Carnegie Institute, Pittsburgh, in 1904; the Pennsylvania Academy of Fine Arts in 1906; and the Albright Gallery, Buffalo, in 1910. CAMERA WORK, as spokesman for the Photo-Secession, diligently reviewed these exhibitions. The factual richness of its extended commentaries on these shows and on other Photo-Secession activities has provided the main source for all subsequent inquiries into the period.

In 1905, to further the exhibition work and to give the Secession a headquarters, Stieglitz, encouraged by Steichen, leased three rooms at 291 Fifth Avenue. With Steichen as decorator and designer, the space became The Little Galleries of the Photo-Secession. The first exhibitions held there were of European as well as American photography and attracted widespread attention from photographers and the press.

But however successful CAMERA WORK and the Photo-Secession exhibitions, Stieglitz and Steichen realized that the position of photography could be most firmly established by direct comparison with other visual media. In January, 1907, therefore, Pamela Colman Smith exhibited the first nonphotographic work at The Little Galleries—a group of wash drawings. Stieglitz's brief comment on this exhibition published in issue 18 inaugurated CAMERA WORK's formal entry into the world of modern art. "The Secession Idea is neither the servant nor the product of a medium," Stieglitz wrote. "It is a spirit."[11]

This comment marks the beginning of the second period of CAMERA WORK, that of its *Expansion*. During the next two years the Little Galleries at 291 Fifth Avenue were transformed into "291": "Mr. Stieglitz's Gallery for the

newest in art."[12] Before returning to Paris in 1906, Steichen, who was already close to the sculptor Rodin, promised to send some of the master's drawings back to Stieglitz. Consequently, in January, 1908, the Little Galleries exhibited wash drawings by Rodin. This show was followed in April by a group of drawings, lithographs, watercolors, and etchings by Henri Matisse. Fascinated by the bold new art of Paris, Steichen began to seek out additional work. A year later he obtained oil sketches by Alfred Maurer, watercolors by John Marin, and lithographs by Toulouse-Lautrec. Except for Rodin, these were the first exhibitions of these artists in the United States.

The New York press looked on the new art at "291" with suspicion and hostility, the art columns frequently dismissing modernism as immoral, unintelligible, and technically incompetent. Matisse's female figures "are of an ugliness that is most appalling and haunting, and that seem to condemn this man's brain to the limbo of artistic degeneration."[13] And Rodin's sketches were "not the sort of thing to offer to public view even in a gallery devoted to preciosity in artistic things."[14] Stieglitz remained sure of his direction. "The New York 'art world' was sorely in need of an irritant," he noted, "and Matisse certainly proved a timely one."[15] To indicate the extent of the irritation, he began to reprint the criticism that appeared in the daily press. Thus CAMERA WORK preserves a great many of the textual documents that relate to the introduction of modern art into America.

The reprinted articles helped to encourage a spirit of debate which made CAMERA WORK an open forum where painters, photographers, and critics could explore the issues surrounding the emerging esthetic sensibility. Since its inception, CAMERA WORK had contained essays based on broader critical grounds than those of the popular esthetics of the day. Such articles as "Photography and Natural Selection," "The Unmechanicalness of Photography," and "Unphotographic Paint: The Texture of Impressionism," brought together a wide range of scientific, philosophical, and ideological concerns, and centered them on the theory and practice of painting and photography.

Other articles, such as Caffin's "Is Herzog Also Among the Prophets?" and Hartmann's "Puritanism: Its Grandeur and Shame," attempted to articulate an esthetic uniquely suited to the American artist. Caffin analyzed

Herzog's composite, academic photographs in terms of their painterly tradition, the characteristics of American society, and the particularities of photography. He concluded that photography could be a powerful tool in the hands of the modern artist who wished to "body forth the forms and ideals and emotions of actual present life," for the photograph can both "capture" and "transmit" sight. Herzog looked to the past rather than to the future for he ignored the "complexity of sensations in himself and . . . in the world about him."[16]

Hartmann pushed the analysis of American society even further. Seeing Puritanism as a monster octopus which had entangled its tentacles in America's customs and manners, he concluded that "there can be no vital art of any sort until there has grown up an appreciation of the Rubens-Goya spirit; until we dare face our passions, until we are unashamed to be what we are, until we are frank enough to let wholesome egotism have its sway."[17]

THE THIRD PERIOD: EXPLORATION, 1910–1915. In January, 1910, CAMERA WORK abandoned its policy of limiting reproductions to photography and, in issue 29, published four caricatures by the Mexican artist, Marius De Zayas. This change marks the beginning of the third period, characterized by a dynamic exploration of all that was new and vital in artistic expression. CAMERA WORK expanded its inquiries into the esthetics and spirit of photography and Post-Impressionism, becoming the voice and catalyst of the American avant-garde.

It was natural that CAMERA WORK's concern with the new art should significantly alter its treatment of all media. At the end of the second period, articles dealing with photography had become increasingly sophisticated and abstract, and many subscribers, unable to comprehend CAMERA WORK's growth, withdrew their support.

Ironically, even the triumphant 1910 retrospective exhibition of the Photo-Secession at the Albright Gallery in Buffalo contributed to a radical change in the audience. "The aim of the exhibition," the catalogue stated unequivocally, "is to sum up the development and progress of photography as a means of pictorial expression."[18] Stieglitz, with Secessionists Paul Haviland, Clarence White, and the young painter Max Weber, made the Albright exhibition the most comprehensive ever held in the States. Five hundred and eighty-four prints were shown,

representing four national groups and sixty-five photographers. These included photographs by all of the Secessionists, as well as work of historical interest made in 1843 by the Scotch painter David Octavius Hill. More than fifteen thousand people visited the galleries during the four weeks of the exhibition. At its conclusion, the Albright Gallery purchased twelve prints and reserved one room for a permanent display of pictorial work. The scope and strength of the images and the prestige of the gallery finally brought the Secession the endorsement it had long sought from established institutions. The exhibition was immediately acknowledged as a summation and demonstration of photography's place in the fine arts.

With this decisive recognition, the Photo-Secession lost some of the sense of purpose that had held it together. Moreover, the exhibition contained new work that went beyond the pictorial techniques of soft focus and hand manipulation and demonstrated a more straightforward style. The introduction of other visual art at "291" had begun to shatter the old pictorial esthetic. A year before the Buffalo Exhibition, CAMERA WORK had sensed this change: "photography in order to assert its esthetic possibilities strenuously strove to become 'pictorial'; and this endeavor produced in recent years the singular coincidence that, while men of the lens busied themselves with endowing their new and most pliable medium with the beauties of former art expressions, those of the brush were seeking but for accuracy of the camera plus a technique that was novel and — unphotographic."[19]

Stieglitz was working more frequently with pure photography. After the Buffalo Exhibition, he could no longer support Secessionists who continued in the pictorial tradition. The organization soon disbanded. "The Photo-Secession," Paul Haviland wrote, "can be said now to stand for those artists who seceded from the photographic attitude toward representation of form."[20]

In 1911, a double issue of CAMERA WORK, 34/35, was devoted to reproductions of Rodin's drawings and analyses of his, Paul Cezanne's and Pablo Picasso's work. Half the remaining subscribers, bewildered by Rodin's breezy wash sketches of the nude and annoyed that the issue lacked even a single article on photography, cancelled their subscriptions. CAMERA WORK now became the quarterly publication of "291" written

by and addressed to an extremely small group consisting mainly of the artists whom Stieglitz supported, the writers who frequented the back room at "291," and the few remaining subscribers.

Beginning with its first entry into modern art with the Rodin exhibition in 1908, "291" had slowly developed into the center for avant-garde activity in New York. In addition to the revolutionary Fauves and Cubists, Stieglitz showed the work of the young Americans Alfred Maurer, John Marin, Marsden Hartley, Arthur Dove, Max Weber, Abraham Walkowitz and, by 1916, Georgia O'Keeffe. It was not only artists in every visual medium who gravitated toward Stieglitz; many writers were attracted by his experimentation. Alfred Kreymborg, William Carlos Williams, Mina Loy, Paul Rosenfeld, Djuna Barnes, Waldo Frank, Sherwood Anderson, and Carl Sandburg became frequent callers at "291." Their intense discussions about the theories of the new art soon made their way into CAMERA WORK.

This was the period of the publication's radical maturity. The letter-press contained articles by Max Weber, Gertrude Stein, Benjamin De Casseres, Mabel Dodge, Gabrielle and Frances Picabia, Oscar Bluemner, Paul Haviland, John Weichel and Marius De Zayas, as well as by the mainstays of the magazine, Caffin, Hartmann, and Kerfoot. The subjects discussed ranged from photography to primitivism to the new theories of expression — Amorphism, Futurism, and Cubism. The explorative atmosphere of "291" became so intense that Maurice Aisen could announce in the special issue of 1913 that "the dominant note of the present epoch is revolutionary, not only in the plastic arts and in music, but in everything that exists."[21]

The plates of this period are reproductions — many for the first time in any publication — of drawings and etchings of Rodin, De Zayas, Matisse, Picasso, Craig, Manolo, and Walkowitz; watercolors of Marin; paintings of Steichen, Cezanne, Picabia, Van Gogh, and Picasso; and sculpture of Matisse, Picasso, Brancusi, and Nadelman. While these artists had little impact outside of CAMERA WORK and "291," CAMERA WORK's constant search "for the deeper meaning of Photography" nourished the avant-garde attitude and initiated the formal modernist revolution in America which exploded in 1913 at the famous Armory Show. This International Exhibition of Modern Art at the 69th Regiment Armory in New York introduced Post-Impressionism to a shocked and outraged American public. Though he played but a minor role in the actual organization of the show, Stieglitz was aware of his responsibility for its revolutionary character. "The Big International Exhibition was held at the Armory," he wrote a friend, "and was really the outcome of the work going on at '291' for many years, was a sensational success, possibly primarily a success of sensation. One thing is sure, the people at large and for that matter also the artists, etc., have been made to realize the importance of the work that has been going on at '291' and in CAMERA WORK. This much the Exhibition accomplished for us."[22]

THE FOURTH PERIOD: SUMMATION, 1915–1917. The disruptive forces of the war, the rising expense of publication and the lack of support — the last issue had a total of thirty-seven subscribers — forced CAMERA WORK to suspend publication in June, 1917. Though there is a sense of finality in the last three numbers, Stieglitz had no notion that the periodical would end with issue 49/50. Indeed, this issue describes future articles and reproductions.

Three years earlier Stieglitz had asked "twenty or thirty people, men and women, of different ages, of different temperaments, of different walks of life . . . to put down in as few words as possible" what "291" meant to them.[23] In issue 47 he published these statements along with over twenty others he had received in order to summarize the inquiring spirit that CAMERA WORK and "291" had nurtured. It was a demonstration of the freedom and openness of CAMERA WORK, for it contained not only many positive replies but also statements by Steichen and others that were sharply critical of Steiglitz and "291." Steichen believed that the aims of "291" had already been accomplished in terms of photography and art. While he acknowledged Stieglitz's importance in his personal development, he saw the gallery as merely marking time, with issue 47 as Stieglitz's egoistic "project in self-adulation." Deeply affected by the German invasion of Belgium and France, Steichen urged "291" to broaden its work into something that could become a civilizing "vast force instead of a local one."[24]

Issue 47, CAMERA WORK's last regular number, was published in January, 1915. Issue 48 was not to appear until twenty-one months later. During

Herzog's composite, academic photographs in terms of their painterly tradition, the characteristics of American society, and the particularities of photography. He concluded that photography could be a powerful tool in the hands of the modern artist who wished to "body forth the forms and ideals and emotions of actual present life," for the photograph can both "capture" and "transmit" sight. Herzog looked to the past rather than to the future for he ignored the "complexity of sensations in himself and . . . in the world about him."[16]

Hartmann pushed the analysis of American society even further. Seeing Puritanism as a monster octopus which had entangled its tentacles in America's customs and manners, he concluded that "there can be no vital art of any sort until there has grown up an appreciation of the Rubens-Goya spirit; until we dare face our passions, until we are unashamed to be what we are, until we are frank enough to let wholesome egotism have its sway."[17]

THE THIRD PERIOD: EXPLORATION, 1910–1915. In January, 1910, CAMERA WORK abandoned its policy of limiting reproductions to photography and, in issue 29, published four caricatures by the Mexican artist, Marius De Zayas. This change marks the beginning of the third period, characterized by a dynamic exploration of all that was new and vital in artistic expression. CAMERA WORK expanded its inquiries into the esthetics and spirit of photography and Post-Impressionism, becoming the voice and catalyst of the American avant-garde.

It was natural that CAMERA WORK's concern with the new art should significantly alter its treatment of all media. At the end of the second period, articles dealing with photography had become increasingly sophisticated and abstract, and many subscribers, unable to comprehend CAMERA WORK's growth, withdrew their support.

Ironically, even the triumphant 1910 retrospective exhibition of the Photo-Secession at the Albright Gallery in Buffalo contributed to a radical change in the audience. "The aim of the exhibition," the catalogue stated unequivocally, "is to sum up the development and progress of photography as a means of pictorial expression."[18] Stieglitz, with Secessionists Paul Haviland, Clarence White, and the young painter Max Weber, made the Albright exhibition the most comprehensive ever held in the States. Five hundred and eighty-four prints were shown,

representing four national groups and sixty-five photographers. These included photographs by all of the Secessionists, as well as work of historical interest made in 1843 by the Scotch painter David Octavius Hill. More than fifteen thousand people visited the galleries during the four weeks of the exhibition. At its conclusion, the Albright Gallery purchased twelve prints and reserved one room for a permanent display of pictorial work. The scope and strength of the images and the prestige of the gallery finally brought the Secession the endorsement it had long sought from established institutions. The exhibition was immediately acknowledged as a summation and demonstration of photography's place in the fine arts.

With this decisive recognition, the Photo-Secession lost some of the sense of purpose that had held it together. Moreover, the exhibition contained new work that went beyond the pictorial techniques of soft focus and hand manipulation and demonstrated a more straightforward style. The introduction of other visual art at "291" had begun to shatter the old pictorial esthetic. A year before the Buffalo Exhibition, CAMERA WORK had sensed this change: "photography in order to assert its esthetic possibilities strenuously strove to become 'pictorial'; and this endeavor produced in recent years the singular coincidence that, while men of the lens busied themselves with endowing their new and most pliable medium with the beauties of former art expressions, those of the brush were seeking but for accuracy of the camera plus a technique that was novel and — unphotographic."[19]

Stieglitz was working more frequently with pure photography. After the Buffalo Exhibition, he could no longer support Secessionists who continued in the pictorial tradition. The organization soon disbanded. "The Photo-Secession," Paul Haviland wrote, "can be said now to stand for those artists who seceded from the photographic attitude toward representation of form."[20]

In 1911, a double issue of CAMERA WORK, 34/35, was devoted to reproductions of Rodin's drawings and analyses of his, Paul Cezanne's and Pablo Picasso's work. Half the remaining subscribers, bewildered by Rodin's breezy wash sketches of the nude and annoyed that the issue lacked even a single article on photography, cancelled their subscriptions. CAMERA WORK now became the quarterly publication of "291" written

by and addressed to an extremely small group consisting mainly of the artists whom Stieglitz supported, the writers who frequented the back room at "291," and the few remaining subscribers.

Beginning with its first entry into modern art with the Rodin exhibition in 1908, "291" had slowly developed into the center for avant-garde activity in New York. In addition to the revolutionary Fauves and Cubists, Stieglitz showed the work of the young Americans Alfred Maurer, John Marin, Marsden Hartley, Arthur Dove, Max Weber, Abraham Walkowitz and, by 1916, Georgia O'Keeffe. It was not only artists in every visual medium who gravitated toward Stieglitz; many writers were attracted by his experimentation. Alfred Kreymborg, William Carlos Williams, Mina Loy, Paul Rosenfeld, Djuna Barnes, Waldo Frank, Sherwood Anderson, and Carl Sandburg became frequent callers at "291." Their intense discussions about the theories of the new art soon made their way into CAMERA WORK.

This was the period of the publication's radical maturity. The letter-press contained articles by Max Weber, Gertrude Stein, Benjamin De Casseres, Mabel Dodge, Gabrielle and Frances Picabia, Oscar Bluemner, Paul Haviland, John Weichel and Marius De Zayas, as well as by the mainstays of the magazine, Caffin, Hartmann, and Kerfoot. The subjects discussed ranged from photography to primitivism to the new theories of expression—Amorphism, Futurism, and Cubism. The explorative atmosphere of "291" became so intense that Maurice Aisen could announce in the special issue of 1913 that "the dominant note of the present epoch is revolutionary, not only in the plastic arts and in music, but in everything that exists."[21]

The plates of this period are reproductions—many for the first time in any publication—of drawings and etchings of Rodin, De Zayas, Matisse, Picasso, Craig, Manolo, and Walkowitz; watercolors of Marin; paintings of Steichen, Cezanne, Picabia, Van Gogh, and Picasso; and sculpture of Matisse, Picasso, Brancusi, and Nadelman. While these artists had little impact outside of CAMERA WORK and "291," CAMERA WORK's constant search "for the deeper meaning of Photography" nourished the avant-garde attitude and initiated the formal modernist revolution in America which exploded in 1913 at the famous Armory Show. This International Exhibition of Modern Art at the 69th Regiment Armory in New York introduced Post-Impressionism to a shocked and outraged American public. Though he played but a minor role in the actual organization of the show, Stieglitz was aware of his responsibility for its revolutionary character. "The Big International Exhibition was held at the Armory," he wrote a friend, "and was really the outcome of the work going on at '291' for many years, was a sensational success, possibly primarily a success of sensation. One thing is sure, the people at large and for that matter also the artists, etc., have been made to realize the importance of the work that has been going on at '291' and in CAMERA WORK. This much the Exhibition accomplished for us."[22]

THE FOURTH PERIOD: SUMMATION, 1915–1917. The disruptive forces of the war, the rising expense of publication and the lack of support—the last issue had a total of thirty-seven subscribers—forced CAMERA WORK to suspend publication in June, 1917. Though there is a sense of finality in the last three numbers, Stieglitz had no notion that the periodical would end with issue 49/50. Indeed, this issue describes future articles and reproductions.

Three years earlier Stieglitz had asked "twenty or thirty people, men and women, of different ages, of different temperaments, of different walks of life . . . to put down in as few words as possible" what "291" meant to them.[23] In issue 47 he published these statements along with over twenty others he had received in order to summarize the inquiring spirit that CAMERA WORK and "291" had nurtured. It was a demonstration of the freedom and openness of CAMERA WORK, for it contained not only many positive replies but also statements by Steichen and others that were sharply critical of Stieglitz and "291." Steichen believed that the aims of "291" had already been accomplished in terms of photography and art. While he acknowledged Stieglitz's importance in his personal development, he saw the gallery as merely marking time, with issue 47 as Stieglitz's egoistic "project in self-adulation." Deeply affected by the German invasion of Belgium and France, Steichen urged "291" to broaden its work into something that could become a civilizing "vast force instead of a local one."[24]

Issue 47, CAMERA WORK's last regular number, was published in January, 1915. Issue 48 was not to appear until twenty-one months later. During

the interim, the spirit of CAMERA WORK generated several important "little" magazines. *291*, edited by Marius De Zayas, Paul Haviland, and Agnes Ernst Meyer under Stieglitz's sponsorship, appeared in March, 1915. Its twelve issues (1915–1916) had a decidedly proto-Dada nature, containing typographical experiments, such as one of Apollinaire's *ideogrammes*, and thought flashes constructed of interconnected words, drawings, and advertising slogans. The text and illustrations were done by many of the same writers and artists who contributed to CAMERA WORK. Even Steichen, who never resolved his differences on the issue of the war with Stieglitz, contributed two drawings to *291*. Of particular interest are several Freudian dream narratives by Stieglitz and a series of erotic, meticulously executed drawings of machine parts by Picabia.

Another magazine, *The Seven Arts*, appeared in November, 1916. It, too, was short-lived (1916–1917), but it gave the young photographer Paul Strand an outlet for his far-reaching statement on photography which was reprinted in the last issue of CAMERA WORK. These magazines also prepared the way for five other brief but important expressions of the closely integrated New York avant-garde group: *391* (1917–1924), edited by Picabia; *The Blind Man* (1917), *Rongwrong* (1917), and *New York Dada* (1921)—all edited by Marcel Duchamp; and *Manuscripts* (1922–1923), edited by Paul Rosenfeld.

Having summarized the effect of Stieglitz and the spirit of "291," CAMERA WORK seemed to have ceased publication. Yet, Stieglitz revived the magazine for two last issues in order to preserve the photographs of Paul Strand and to summarize CAMERA WORK's concern with photography. In 1913, during the Armory Show, Stieglitz had presented a major selection of his own photographs at "291." Repeating this procedure of contrasting photography with other art, "291" showed the photographs of Paul Strand during the Forum Exhibition of American Art of 1916. No photographs had been shown at "291" in the interim, and for many people Strand's work was a revelation. In his statement on photography, Strand clearly presented the photographic esthetic for which Stieglitz and CAMERA WORK had been groping. This esthetic relied on the actual characteristics of the photographic process and neatly synthesized the expressive concerns of the pictorialists with the abstract and formal concerns

of modern art. The photographs published in the last issues demonstrate Strand's ability to find form and evoke feeling through images of such ordinary objects as kitchen bowls and porch railings. In these photographs, particularly, as the art historian Samuel Green has remarked, in "The White Fence," we find the "*locus classicus* for the subsequent development of the main tradition of American photography."[25]

Camera Work and Photographic Esthetics

CAMERA WORK appeared at exactly that moment in the history of Western art when the conventions of representation were undergoing radical transformations. The pictorial structure and elevated subject matter which had dominated Western art since the early Renaissance were giving way to new forms and concepts. During the nineteenth century, the avant-garde artist, nourished by romantic ideals of sensibility, began to vigorously explore his subjective response to the visible world. The invention of photography contributed to this search. It made the minutia of the physical world poignantly available and provided new equivalents of direct experience. Moreover, the photographic method of reproduction, by summing up in an absolute way the facsimile tradition of representation, emphasized the need for new creative elements. It encouraged experimentation which stressed visual sensation as opposed to optical perception. Photography's detailed scrutiny thus contributed to the literal topographic studies of the early pre-Raphaelites and more significantly, to the analysis of color and atmosphere that was the innovating contribution of the Impressionists.

When CAMERA WORK appeared, advanced painting had effected a major shift in sensibility. The real no longer resided in the external world of nature, institutions, and religion; it was now centered squarely in each individual's unique capacities for experience and perception. Painting was no longer seen as a window opening onto the objective, visible world, but as a record of the infinite variations of subjective experience. In applying this new esthetic to photography, CAMERA WORK was able to synthesize the two paramount photographic traditions of the day— the straight and the pictorial. During its fifteen years of publication, it evolved and articulated the transition from brooding pictorialism to hard-

edged modernism: an esthetic that continues to be the principal approach of creative photographers.

At the turn of the century the aspiring artistic photographer knew nothing of Post-Impressionism or the contributions of Cezanne, Van Gogh, or Gauguin. While these photographers may have been aware of the *fin de siècle* paintings of the Decadents and Symbolists, this art only reinforced the dominant painterly esthetic that demanded diffusion or modulation of observed natural forms. Indeed, in the popular mind, emotion and feeling in art were equated with mood and atmosphere. By the end of the century the search for new content led by the early romantics in literature and the early Impressionists in painting had degenerated in popular art into an acceptance of the shadowy and the beautiful—the inventions of neo-classical pastoralism and pre-Raphaelite medievalism—or had become stylized in the forms of Art Nouveau. Even Peter H. Emerson's attempt in *Naturalistic Photography* to formulate an esthetic based on the pure use of the medium and "truth to subject" was thwarted by his advocacy of differential focusing, a practice which encouraged the diffuse Impressionistic manner. The reality that lay before the camera's lens was not a poetic enough subject. If the camera was to produce art, it must be freed from the tyranny of the visible world. The photographer could become an expressive artist only by reshaping the sharp, optically corrected image, or by consciously arranging in front of the lens the accepted symbols and devices of the world of feeling.

Not all the photographers, however, desired to produce art. The vast majority of the photographs produced from the 1840's to the turn of the century were inherently photographic. Directly seen, composed on the ground-glass, and printed with full attention to detail and tonal values, they showed unquestioning acceptance of the visible world. For the photographers who made them, they were a means of documentation. While many of these men were concerned with craft, few had any pretensions toward self-expression. Photography for them was "The Mirror with a Memory" or "The Faithful Witness," not "Rembrandt Perfected."[26]

The finest of these early straight photographs made by the Americans Hesler, Brady, O'Sullivan, Gardner, Jackson, and by untold numbers of anonymous photographers, retain a psychological impact and strength of vision.[27] These photographers possessed an uncomplicated attitude toward nature. Their straightforward interest in the landscape, architecture, place, or person in front of their lens produced accurate, detailed studies in which the freshness of the composition and viewpoint conveys the presence of an intensely human eye. We have no trouble acknowledging their photographs as products of heightened consciousness and sensibility. Nonetheless, during the last half of the nineteenth century, there was no recognized esthetic that would certify the straight photograph as an expressive object, no sense that a personal point of view of the objective world could reveal "the vital essences of things."[28] That we now acknowledge their work as classic is due in large part to CAMERA WORK.

Those few individuals like Stieglitz, Frederick Evans and J. Craig Annan who were determined to make conscious, expressive statements through the use of straight photography could look only to their own intuition for esthetic justification. Acutely aware that some of his own straight work did not meet the dominant pictorial esthetic, Stieglitz called his prints "snapshots" and "explorations of the familiar." He was more concerned with the spirit and vitality of the photograph than with its style or approach. "There are many schools of painting," he wrote in 1893. "Why should there not be many schools of photographic art? There is hardly a right and a wrong in these matters, but there is truth, and that should form the basis of all works of art."[29]

When CAMERA WORK appeared, the pictorial photographers were divided into two camps: those who favored hand manipulation of the negatives and prints and those who believed in the use of purely photographic methods. While their methods were different, their ends were the same, and Käsebier's and White's "straight" platinum prints are as diaphanous and elaborately posed as Steichen's and Demachy's painterly gum. There was a far greater distance between the classic straight photographer and the pictorialist than between the two pictorial camps. Nevertheless, the distinction between the manipulated and unmanipulated pictorial print reflected a crucial difference in esthetic viewpoint, and the gradual realization of the significance of this difference allowed

photography to develop a new esthetic.

EDWARD STEICHEN. During CAMERA WORK's first seven years of publication, the freshness of its plates were the strongest motivation for change. The impact of these pictures lay not in their style, for they were admittedly painterly, but in the very fact that they were *photographic* restatements of painterly concerns.

Edward Steichen's work received the most extensive publication and examination during these early years. A recognized painter as well as photographer, he provided living proof that a photographer could possess esthetic sensitivity. His individuality, enormous productivity and technical virtuosity, as well as his personal associations with Shaw, Maeterlinck, and Rodin, made him the acknowledged standard-bearer of the Photo-Secession. Steichen's prints, more than those of any other single individual, helped force the acknowledgement of the photograph as an expressive statement.

Though Steichen was one of the first Americans to recognize the importance of the new art of Paris, his own photographic work was deeply tied to the late nineteenth century fondness for mood and reverie. The essence of Steichen's photographs is sensibility itself; the sensual is secondary to atmosphere, mystery, and nostalgia. In his prints the intricacies of the visible world are condensed through the controls of gum printing and soft focus into monumental forces of darkness and light. In such photographs as "Rodin-Le Penseur," "Self Portrait," "In Memoriam," "The Big White Cloud," "Moonrise," and "Nocturne, Orangerie Staircase," and even in the more photographic prints like "Steeplechase Day," Steichen is primarily concerned with light as an emotional force. The graphic fluency in these prints emerges from the bold juxtaposition of shadow and source, from the tense interplay of black and white.

Steichen's portraits are conceived in the same spirit as his other work; yet, the necessity of concentrating on a real human face gives his finest portraits a subtlety and sensuality that his other works lack. While Steichen's anonymous nudes are, as Hartmann keenly observed, "non-moral, almost sexless," his portraits of real women like Eleanor Duse and Mrs. Philip Lydig are profoundly ambivalent.[30] One feels in them both the spiritual and the sensual, the sacred and the profane. A similar dichotomy is embodied in his portraits of J. P. Morgan and Gordon Craig, each an amalgam of innocence and malevolence; and the "Portraits—Evening," though overtly innocent, is one of the most sensuous photographs of the period.

While Steichen's range was far broader than that of most of the Photo-Secessionists, his prints reflect the quintessence of the Secessionist's esthetic. Like Keiley, Käsebier, Seeley, and White, Steichen found truth and being in suggestiveness and reverberation. His prints exist in the transitory worlds of dawn and dusk; they search out the mystery and the dream—the reality beyond the edge of actual visible experience.

Marius De Zayas attested to the continuing power of Steichen's work in issue 42/43, long after the manipulated print had fallen in disfavor. "Up to the present, the highest point . . . of Photography has been reached by Steichen as an artist and by Stieglitz as an experimentalist. The work of Steichen brought to its highest expression the aim of the realistic painting of Form. In his photographs he has succeeded in expressing the perfect fusion of the subject and the object."[31]

GEORGE SEELEY AND THE BLESSED DAMOZEL. While Steichen's work constitutes the major achievement of the pictorial school, it was George Seeley who took the single most pervasive motif of pictorial photography—the Blessed Damozel—and pushed it to its limit. This image was not unique to photography. She appears as a psychic symbol of the revolt against neo-classicism—an image derived from the rebellion against the conventional sources of energy and creativity in religion and morality. A synthesis of the inaccessible woman of secular romance and the major female figures of the sacred world—the Virgin Mother and the temptress Eve—her languid, sensual beauty continually reappears in all nineteenth century art forms. Her inaccessibility suggests modern man's inability to escape from the materialistic present, and her latent sensuality may be seen as a libidinous manifestation of the yearning for the supposed sexual and psychic energy of the medieval and mystical past. We find her early as "la belle Dame sans merci" of Keat's literary ballad, and as the maidens of Poe's dream land. Later she is seen in the poetry of Baudelaire, Mallarmé and Yeats,

the plays of Maeterlinck, the paintings and poems of Rossetti, the elaborate orchestral coloring of Debussy, and in the countless *femme fatale* and sphinx-like images of the Symbolists and Decadents.

She first appears in photography in the 1860's in H. P. Robinson's photomontage, "The Lady of Shalott," and in Julia Margaret Cameron's illustrations of Tennyson's romances. In the first issue of CAMERA WORK, she emerges in the guise of Gertrude Käsebier's "Miss N." Continually modulating through such photographs as Steichen's "Poster Lady" and Keiley's "Leonore," she reaches her pictorial perfection in the work of Clarence White and George Seeley. She did not die with CAMERA WORK, and her most spectacular apotheosis occurred in Stieglitz's early photographs of Georgia O'Keeffe. While Stieglitz approached the O'Keeffe portraits through a more radically photographic style, their essential spirit can be traced back to CAMERA WORK. From Clarence White's "Lady in Black" and "Morning," Stieglitz drew a meditative calm and an air of aesthetic timelessness; from Seeley's "Firefly" and "The Burning of Rome," he inherited an underlying eroticism and an incredible lushness and luminosity.

The Seeley prints in issue 20 are perhaps the richest and subtlest photogravures contained in CAMERA WORK. While these plates are not radically photographic in vision, they are intensely photographic in medium, for they have an exquisite sense of value, tone, and chiaroscuro. They achieve a vitality and sensuality that is matched only by the Rodin reproductions. In his review of Seeley's work, Caffin was unable to comprehend their power; yet Stieglitz, with his uncanny sense of rightness, exhibited Seeley's prints in 1908 as the sequel to the extraordinary Rodin show at "291."

PORTRAITS OF THE SECESSIONISTS AND THE WORK OF FRANK EUGENE. If Seeley's variations on the Blessed Damozel point toward truth to feeling — the visual embodiment of pure emotion and sentiment — then the Secessionists' portraits of each other exemplify truth to subject. In Steichen's portrait of White, White's portrait of Coburn and his mother, and Coburn's and Eugene's portraits of Stieglitz, we have the most genuine statements of the pictorial school. These portraits were created out of mutual sympathy and understanding. In spite of their soft focus they evince a psychological penetration that is distinctly photographic; they are both authentic records of physical appearance and acute revelations of character.

That the camera can accurately reveal both physiognomy and psychology was perhaps most clearly apprehended by Frank Eugene, whose work was unique among the Secessionists. First, he took optically sharp rather than soft focused negatives. Second, he modified them, not by manipulating the print, but by using an etching needle on the negative itself.

It has been exceedingly difficult during the last fifty years to look at Eugene's work — as at a great many of the plates in CAMERA WORK — with any degree of sympathy or objectivity. The publication itself helped foster this attitude, for the later issues implicitly denounced the modified print. After 1917, the straight esthetic was slowly dogmatized; and it became impossible to speak of the early mixed media work except as historical curiosity.

Today, we are not so sure that we know what a photograph should look like. The work presented during the last few years in the Museum of Modern Art's exhibition, *Photography As Printmaking* (1968), and in an exhibition at George Eastman House, *The Persistence of Vision* (1967), has demonstrated that photographers are again vitally concerned with the interpenetration of various art forms. Like the Photo-Secessionists, though perhaps with less innocence, contemporary photographers are concerned with the final image as a new experience.[32] They well realize that its power depends on the strength and persistence of the artist's vision, not on the purity of his means.

Eugene demonstrated this strength and persistence: his finest work deserves to be much better known. At least six of his plates — "Sir Henry Irving," "The Horse," "Adam and Eve," "Frau Ludwig von Hohlwein," "Prof. Adolph Hengeler," and "Alfred Stieglitz" — must be ranked among the most powerful reproductions in CAMERA WORK. These images are constructed out of a union of eye and hand, vision and feeling. Their spontaneity of expression grows out of the tension set up between photography and etched lines. Eugene reveals a certain clairvoyance of the relationship that exists between substance and shadow, between the object and the image it projects, not in the real world of things, but in the psychic world of sight. His scratchings have a profound rightness: they provide both halo and ground, surrounding the

directly seen person or object with indirect and subtle modulations of memory and insight.

THE IMPACT OF MODERN ART. The variety and excellence of the plates in CAMERA WORK encouraged the critics to establish new means of evaluation and scrutiny. They began to sort out the painterly and the photographic. Having become consciously aware of the mannerisms and style of the Secessionsists, they made first attempts at defining photography's unique capacities for personal expression. By 1910 Hartmann could write: "The photographer interprets by spontaneity of judgment. He practices *composition by the eye*."[33]

In spite of such insights, the style and concerns of the Secessionists did not significantly grow during the last half of the second period; even Stieglitz, who had rejected genre subjects for an exploration of the city, still saw the city veiled in romantic mists. For him it was still hieratic rather than actual: New York was "The City of Ambition" and the railroad was "The Hand of Man." Only in a few of his reproductions, such as "Going to the Start," and in Rubicam's "In the Circus," and in some of Coburn's and Annan's work do we get a hint of what will come.

After the 1910 Buffalo Exhibition, it became quite clear that new expressive methods and critical perspectives had to be discovered if photography were to retain its spirit and vitality. And it was from art rather than from photography that this new blood and energy came. The art Stieglitz showed at "291" was dramatically different in style and intent from the work of the Photo-Secessionists. While the Photo-Secession prints looked backward in time to "the beauties of former art expressions," the new art seemed unequivocally modern.[34] It demonstrated a new way of seeing and a new attitude toward life and toward nature.

The early Rodin and Matisse exhibitions emphasized the spontaneity of line and the relationship of shape and tone, substance and weight. In their renditions of the human form these men disregarded external appearances and traditional chiaroscuro for the sake of the internal logic of shading and design.

The design element became even more apparent in the work of Picasso, Braque and Marsden Hartley. The first two, the founders of Cubism, used geometric forms and many-faceted planes to build up highly structured correlatives

of sight and sensation. Hartley used pattern and rhythmic decorative notation in his search for expressive form. These concerns were further mirrored in Gertrude Stein's prose, which was published for the first time anywhere in CAMERA WORK's two special 1912 and 1913 numbers on modern art.

It was not the art museums but the museums of natural history that stimulated these new artists. Matisse and Picasso turned to African sculpture. Max Weber and Hartley looked closely at American Indian quilts and blankets, Coptic textiles, and Chinese dolls in order to intensify their sense of form, abstraction, and color. Influenced by these new directions and by a growing realization of the significance of non-Western conceptions of form, Stieglitz exhibited African sculputre and children's drawings at "291."

These exhibitions, as well as the work of the three artists who were to remain closest to Stieglitz—O'Keeffe, Marin, and Dove—offered alternatives to traditional expression and form. Dove's art, as well as O'Keeffe's, was built up from abstract simplifications of natural forms like the wave, the cloud, and the flower. Marin's lyrical watercolors derived their power from the spatial tension implicit in natural and man-made forms. The work of these artists was fundamentally optimistic, nourished by a joy that came from the rediscovery of the basic elements of natural form and of the graphic medium. Stress on shape, line, color, texture, and pattern revealed the expressiveness of form in its own right.

The contrast between pictorial photography and the new art was striking. While the Secessionists had softened reality in the interests of sentiment and mood, the new artists radically distorted the visible world. Where the Secessionists had conceived of space in terms of atmosphere, the new artists depicted it in terms of form. Where the Secessionists had sought contentment and serenity, the new artists—more truly and radically romantic—sought essence.

Most significantly, where the Secessionists had avoided and rejected the particular and the immediate in the belief that feeling could be embodied only in generalized form and sterotyped motifs, the new artists demonstrated that formal coherence by itself could generate emotional meaning. For the new artists, the visible world no longer existed as the model of reality. What the inner eye conceived rather than

what the external eye perceived defined the subject and the technique of their art.

This new vision forced Stieglitz and his friends to reevaluate their medium and their relationship to the world around them. It brought into sharp perspective their continually growing awareness of both the basic characteristics of the photographic process and the strength of the photographer's eye. It forced them to develop an esthetic that was both unique to photography and congruent with modern art. They slowly realized that a photograph could express inner significance through outer form, and that a straight photograph could be charged with the same emotional intensity as the finest pictorial print.

This new esthetic was forcefully though somewhat obscurely expressed by Marius De Zayas's articles "Photography" and "Photography and Artistic Photography." Looking at such photographs as "Steerage," De Zayas wrote that Stieglitz was "trying to do synthetically, with the means of a mechanical process, what some of the most advanced artists of the modern movement are trying to do analytically with the means of Art." De Zayas realized that the camera could be used as a "means to penetrate the objective reality of facts, to acquire a truth . . . it is the means by which the man of instinct, reason and experience approaches nature in order to attain the evidence of reality."[35]

While pictorial prints continued to be shown in CAMERA WORK during the period 1910–1915, this new esthetic can nevertheless be sensed. In issue 36—which also included a Picasso drawing—Stieglitz published "The Steerage" and three striking, straight prints of New York: "The Ferry Boat," "The Mauretania," and "Old and New New York." Issue 38 was devoted to a newcomer, Karl Struss, whose work hinted at an apprehension of a photographic as opposed to painterly design. In issue 39, Paul Haviland published "Passing Steamer," a photograph whose formal tension is very similar to Stieglitz's "Going to the Start." In Haviland's image, the momentary visual intersection of two passing ocean liners is emphasized by an unbalanced yet vigorous network of lines and spaces. Together with J. Craig Annan's "The White House," published in issue 32, and Stieglitz's "The Steerage" and "Going to the Start," Haviland's print stands out as one of the seminal examples of the instantaneous snapshot wedded by vision to the formal concerns of modern art. In issue

40, Baron De Meyer's directly apprehended street scenes defined a course that Strand would soon follow. Issue 45 was given over to J. Craig Annan, who with Stieglitz and Evans remained throughout the period one of the major exponents of the straight approach.

PAUL STRAND. The mature manifestation of the new photography was reached in the last two issues when Stieglitz published seventeen gravures of Paul Strand's photographs. Relating Strand's work to the art he had been showing at "291," Stieglitz wrote: "For ten years Strand quietly has been studying, constantly experimenting, keeping in close touch with all that is related to life in its fullest aspect; intimately related to the spirit of '291.' His work is rooted in the best traditions of photography. His vision is potential. His work is pure. It is direct. It does not rely upon tricks of process. . . . [These] photogravures . . . represent the real Strand. The man who has actually done something from within. The photographer who has added something to what has gone before. The work is brutally direct. Devoid of flimflam; devoid of trickery and any 'ism;' devoid of any attempt to mystify an ignorant public, including the photographers themselves. These photographs are the direct expression of today."[36]

While Strand's photographs deal with the immediate, they reveal in their design and formal organization an acute comprehension of modern art. His work achieves a memorable union of the abstract and the concrete. Stimulated by the formalistic painting, drawing, and sculpture shown at "291," Strand experimented with the camera's ability to create abstraction and design. In "Kitchen Bowls" and "Porch Shadows," the rhythmic repetition of light and shadow construct lyrical compositions that attest to his delight in the object and the mind's ability to perceive form. In "Wall Street," wide angle convergence and the extreme modeling power of low sunlight registers a Cubistic composition of white light bands and cleancut geometric shapes. Bird's-eye distortion and the checkerboard surfaces of signs and rooftops are used to organize the picture surface in "From the Viaduct." Formal concern sustains even the detailed candid closeups of New York street characters. In the "Sandwich Man," the rectilinear sign board cuts boldly into the frame. In the "Blind Woman," the juxtaposition of the circular shapes of the eye, the face, the peddler's

badge, and the starkly lettered neck tag are the formal foundation for an unforgettable portrait.

Perhaps the most powerful example of Strand's ability to wed abstraction to personal expression is "The White Fence." The linear tenseness and energy of the picket fence is emphasized by the geometric solidity of the organization and by the abrupt tonal transition between fence and pasture. The subject is rendered with unequivocal objectivity, yet, the image is more than a neutral recording—the intensity of Strand's vision has charged the balance of shapes, tones, and point of view with unique and personal meaning.

Strand's sharply focused work represented the rebirth of the classic style and the rediscovery of the American scene. Stieglitz had photographed the city; White had captured the mood of the small town. With a few significant exceptions, each began by seeing his subject through the impressionistic mists of the pictorial style. Then Strand began to search out indigenous America, and to deal directly with the people, the land they inhabit, and the objects they create. He turned to the city, not so much to explore urban injustice as to reveal character; and he turned to the rural to explore the vitality of the landscape and native architectural forms.

Strand's photographs demonstrate his belief—articulated so clearly in the final issue of CAMERA WORK—that "it is in the organization . . . that the photographer's point of view toward Life enters in, and where a formal conception born of the emotions, the intellect, or of both, is as inevitably necessary for him, before an exposure is made, as for the painter, before he puts brush to canvas."

"Photography," Strand affirmed, "finds its raison d'être, like all media, in a complete uniqueness of means. This is an absolute unqualified objectivity. Unlike the other arts which are really anti-photographic, this objectivity is of the very essence of photography, its contribution and at the same time its limitation. . . . The photographer's problem therefore, is to see clearly the limitations and at the same time the potential qualities of his medium. . . . This means a real respect for the thing in front of him. . . . The objects may be organized to express the causes of which they are the effects, or they may be used as abstract forms, to create an emotion unrelated to the objectivity as such. This organization is evolved either by movement of the camera in relation to the objects themselves or through their actual arrangement, but here, as in everything, the expression is simply the measure of a vision, shallow or profound as the case may be. Photography is only a new road from a different direction but moving toward the common goal, which is Life."[37]

Strand's photographs defined the direction that modern photography would take. The force of his words and images may be traced through Stieglitz's later work and that of Charles Sheeler, Edward Weston, Ansel Adams, and Minor White to many young contemporary photographers, Paul Caponigro and Bruce Davidson among them. Strand's photographs not only point to the present but also define the past. For the difference between Käsebier's portrait of Miss N. published in the first issue, and Strand's portrait of the blind peddler woman is precisely the difference between 1903 and 1917. Romance has given way to reality; idealization to documentation. Miss N's soft, velvet background has been transformed into a hard-edged wall, her classic cup into a street peddler's badge, her subdued sensual eyes into the terrifying eyes of blindness.

Few publications are at once as diverse and as unified as CAMERA WORK. Animated for fifteen years by Stieglitz's deeply creative spirit, it ranged from photography through modern art and modern literature to the larger concerns of freedom and vision. Profoundly sensitive to its time and place, CAMERA WORK represents the crystallization, in written and visual form, of the most vital intellectual, emotional, and artistic currents of its day. It will endure as an affirmation of the possibilities of growth and as a tribute to Stieglitz's belief in significant expression.

"I have not received CAMERA WORK for a very long time, probably due to the war, censorship," Frank Eugene wrote Stieglitz from Leipzig in 1916. "The older I grow the more I appreciate what you have accomplished with your very wonderful publication. When I see you I shall be delighted to tell you, how largely the possession of CAMERA WORK has helped me in my work as a teacher, and what an incentive it has always been to my pupils toward a higher standard. It does that for the man with a camera, what the Bible has, more or less vainly, for centuries, tried to do for the man with a conscience."[38]

CAMERA WORK: AN illustrated quarterly magazine devoted to Photography. Published and edited by Alfred Stieglitz. Associate Editors: Joseph T. Keiley, Dallett Fuguet, John Francis Strauss. Subscription price for one year, Four Dollars. Single copy-price of this number at present, Two Dollars. The right to increase the price of subscription without notice is reserved. All copies are mailed at the risk of the subscriber; positively no duplicates. Registering and cardboard packing, Fifty Cents extra. The management binds itself to no stated size or fixed number of illustrations, though subscribers may feel assured of receiving the full equivalent of their subscription. While inviting contributions upon any topic related to Photography, unavailable manuscript or photographs will not be returned unless requested and accompanied by required return postage. Address all communications or remittances to Alfred Stieglitz, 162 Leonard Street, New York, U. S. A. The cover and marque designed by Eduard J. Steichen. Gravures in this number by the Photochrome Engraving Company, New York. Arranged and printed on the presses of Fleming & Carnrick, New York. This issue, Number 1, is dated January, 1903.

An Apology

THE time appearing ripe for the publication of an independent American photographic magazine devoted largely to the interests of pictorial photography, CAMERA WORK makes its appearance as the logical outcome of the evolution of the photographic art.

It is proposed to issue quarterly an illustrated publication which will appeal to the everincreasing ranks of those who have faith in photography as a medium of individual expression, and, in addition, to make converts of many at present ignorant of its possibilities.

Photography being in the main a process in monochrome, it is on subtle gradations in tone and value that its artistic beauty so frequently depends. It is, therefore, highly necessary that reproductions of photographic work must be made with exceptional care and discretion if the spirit of the originals is to be retained, though no reproductions can do full justice to the subtleties of some photographs. Such supervision will be given to all the illustrations which will appear in each number of CAMERA WORK. Only examples of such work as gives evidence of individuality and artistic worth, regardless of school, or contains some exceptional feature of technical merit, or such as exemplifies some treatment worthy of consideration, will find recognition in these pages. Nevertheless the pictorial will be the dominating feature of the magazine.

CAMERA WORK is already assured of the support of photographers, writers and art critics, such as Charles H. Caffin, art editor of the American section of The International Studio and art critic of the New York Sun; A. Horsley Hinton, editor of The Amateur Photographer, London; Ernst Juhl, editor of the Jahrbuch der Kunstphotographie, Germany; Sydney Allan (Sadakichi Hartmann), the well-known writer on art matters; Otto W. Beck, painter and art instructor at the Pratt Institute, Brooklyn; J. B. Kerfoot, literary critic; A. Radclyffe Dugmore, painter and naturalist; Robert Demachy, W.B. Cadby, Eduard J. Steichen, Gertrude Käsebier, Frank Eugene, J. Craig Annan, Clarence H. White, Wm. B. Dyer, Eva Watson-Schütze, Frances B. Johnston, R. Child Bayley, editor of Photography, and many others of prominence.

Though the literary contributions will be the best of their kind procurable, it is not intended to make this a photographic primer, but rather a magazine for the more advanced photographer.

CAMERA WORK owes allegiance to no organization or clique, and though it is the mouthpiece of the Photo-Secession that fact will not be allowed to hamper its independence in the slightest degree.

An undertaking of this kind, begun with the sole purpose of furthering the "Cause" and with the intention of devoting all profits to the enlargement of the magazine's beauty and scope is dependent for its success upon the sympathy and coöperation, moral and financial, of its friends. And it is mainly upon you that the life of this magazine hangs. The many subscribers who have responded to our advance notice have encouraged us to believe that the future of the publication is assured beyond question; but we can not express too strongly the

hope that you will continue your good offices in our behalf.

Without making further pledges we present the first number of CAMERA WORK, allowing it to speak for itself.

ALFRED STIEGLITZ *Editor*
JOSEPH T. KEILEY *Associate Editor*
DALLETT FUGUET *Associate Editor*
JOHN FRANCIS STRAUSS *Associate Editor*

From a Photograph

All shadows once were free;
But wingless now are we,
And doomed henceforth to be
In Light's Captivity. JOHN B. TABB

Ye Fakers

IT is rather amusing, this tendency of the wise to regard a print which has been locally manipulated as irrational photography—this tendency which finds an esthetic tone of expression in the word faked.

A manipulated print may not be a photograph. The personal intervention between the action of the light and the print itself may be a blemish on the purity of photography. But, whether this intervention consists merely of marking, shading and tinting in a direct print, or of stippling, painting and scratching on the negative, or of using glycerine, brush and mop on a print, faking has set in, and the results must always depend upon the photographer, upon his personality, his technical ability and his feeling.

But long before this stage of conscious manipulation has been begun, faking has already set in. In the very beginning, when the operator controls and regulates his time of exposure, when in the dark-room the developer is mixed for detail, breadth, flatness or contrast, faking has been resorted to. In fact, every photograph is a fake from start to finish, a purely impersonal, unmanipulated photograph being practically impossible. When all is said, it still remains entirely a matter of degree and ability.

Someday there may be invented a machine that needs but to be wound up and sent roaming o'er hill and dale, through fields and meadows, by babbling brooks and shady woods—in short, a machine that will discriminatingly select its subject and by means of a skillful arrangement of springs and screws, compose its motif, expose the plate, develop, print, and even mount and frame the result of its excursion, so that there will remain nothing for us to do but to send it to the Royal Photographic Society's exhibition and gratefully to receive the "Royal Medal."

Then, ye wise men; ye jabbering button-pushers! Then shall ye indeed

make merry, offering incense and sacrifice upon the only original altar of true photography. Then shall the fakers slink off in dismay into the "inky blackness" of their prints.

EDUARD J. STEICHEN

It is an error common to many artists, strive merely to avoid mistakes; when all our efforts should be to create positive and important work. Better the positive and important with mistakes and failures than perfect mediocrity.

Followers manage to make of the footpaths of a great man a wide road.

A Visit to Steichen's Studio

A DARK, chilly December afternoon. The rain falls in thin, straight lines on the streets of New York, and the lighted shop windows are reflected like some blurred and golden dream, on the slushy pavement. You mount the slippery iron stairs of a humble and reticent office building on Fifth Avenue. To the Negro, who comes to your ring, you say: "Mr. Steichen." He takes you up to the top floor, and carelessly, indifferently, as one points to a door, he points to the right. "Right in there, sir," he says.

You knock at the door. It is Mr. Steichen who admits you. It is a plain little room, without skylight, but with an artistic atmosphere of its own. The first impression is one of cool grays and pale terra-cotta, a studio void of furniture, but full of artistic accessories—a vagrom place, where a sort of orderly disorder, a sort of gypsy fashion prevails. The light of the waning day seems to rest in the center of the walls, while the corners are filled with twilight shadows, whose monotony is only here and there relieved by the color-notes of a Japanese lantern, a large brass vessel, or some other quaint accessory. A little plaster fragment of one of Rodin's statues hangs in proud isolation over the mantelpiece.

Mr. Steichen looms tall among his canvases, his arms crossed. With his square shoulders, his pallid, angular face, his dark, disheveled hair, his steady eyes, he reminds one of some old statue carved of wood, a quaint personality which has at times the air of some classical visionary, "a modern citizen of Calais," and at other times the deportment of some gallant figure of Sir Reynolds's time.

He showed me his paintings, sketches, and photographs in rapid succession, which is one of those ordeals the art critic has to go through if he wants to become acquainted with a new man. I have probably passed through this severe experience oftener than any other man. I remember of having visited at least four hundred and fifty American studios for a similar purpose—as I have convinced myself that it is the only way to get at a man's individuality. And art criticism is to me nothing but a peculiar mania for searching in every expression of art, and life as well, for its most individual perhaps innermost, essence.

Biographical data do not interest me. What is the difference where a man is

born, how old he is, where he studied, and where he was medaled? His art must speak — that is all I care for.

The first picture that attracted my attention in Steichen's studio was his Beethoven. It is all black and gray, huge and grim (though no canvas of colossal size) almost Doric in its severity. Everything is sacrificed to the idea, a study in the somber supremacy of genius and the martyrdom of the artist. It is the Beethoven of the Fifth, not of the Ninth, Symphony. It contains more strength and power than beauty. The simplicity of its composition is remarkable. The dark pyramidal shape of a seated figure, harsh and angular as if cast in iron, crowned by a pale, apocalyptic face, is seen against a slab of grayish stone, whose monotony is scarcely broken by a vista of dark, twisted tree trunks in the upper corners. The face, haggard as a ghost of Dante's Inferno, makes one think of stormy tortuous nights, of sinister shadows trailing obstinately along the ground. It is a picture barbaric as the clangor of iron chains against each other, the only attempt of the young painter in the epic field. It presents Steichen at the height of his amibition; but being a solitary effort, it is difficult to judge the artist's individuality solely from this exalted point of view. One can not fully grasp his intentions, and it is very likely that he is not conscious of them himself.

In his landscapes he reveals himself much more clearly. He has created a world of his own, but one based on actual things, translated into dreams.

The rain still falls in thin, straight lines upon the blurred symphony of black and gold that glistens and glimmers on the wet pavements of Fifth Avenue, and there seems to be something analogous in the vertical lines of Steichen's landscapes and the gray lines of the rain outside. Nobody has carried the composition of lines further than Mr. Steichen. All his pictures are composed in vertical, diagonal, and outer-twisting line-work, but the lines are not as distinct and scientific as in Chavannes's or Tryon's pictures. They are not outlines, they only serve as accentuation. He endows each line with a mystic quality, and they run like some strange rune through his tonal composition. French critics have compared his pictures with muscial compositions, but I beg to differ. To me all his tree trunks, whether ethereally thin, repeating their wavering lines in some moon-hazed water, or crudely massive, towering into some dismal twilight atmosphere, are purely decorative. In order to be musical, the line-composition has to serve as outlines for the color-patches which should in turn repeat or accentuate the motive of the spacing. In Steichen's pictures color is always subordinate to one tonal value, and the dominating idea is rather the expression of a single sentiment than the varying subtleties of a musical theme. To me Steichen is a poet of rare depth and significance, who expresses his dreams, as does Maeterlinck, by surface decoration, and with the simplest of images — for instance, a vague vista of some nocturnal landscape seen through various clusters of branches, or a group of beech and birch trees, whose bark forms a quaint mosaic of horizontal color suggestions — can add something to

our consciousness of life. His lines, blurred and indistinct as they generally are, are surprisingly eloquent and rhythmical. They become with him as suggestive as the dividing-line of some sad woman's lips, as fragile as some tremulous flower-branch writing strange hieroglyphics on the pale-blue sky, or as mystic as the visionary forms which rise in our mind's eye, as we peer through the prison bars of modern life into some nocturnal landscape or twilight atmosphere. The only fault that I find with his landscapes, as with the majority of his pictures, is that they are not finished pictures. They are sketches. A mere suggestion suffices him. It is left to the imagination of the spectator to carry them out to their full mental realization.

There are many other pictures of interest, mixtures of fantasy and reality clearly characteristic of the gifts and methods of Steichen. I mention some at random. A violent color-study of a sailor, reclining, with a red bowl in his hand; the heads of four Parisian types; an old man, an artist with his model supposed to be crossing one of the Seine bridges, with the silhouette of another bridge, and a vague suggestion of the Louvre in the background; the sphynx-like profile of some phantom woman; portraits of F. H. Day and Mrs. Käsebier, and color-schemes of various types of womanhood, one of a young girl and another of a woman of the world. The manner in which he used flowers to tell the characters of his sitters (in the two latter portraits) shows how deeply he can read in the human soul. The young girl folds her hands listlessly around a large, round flower with a straight stem, the other flowers resting in a long and narrow vase; while the woman of fashion throws a weary glance at the few pink blossoms which loom from some large, round vase and which repeat the color-note of her face.

To look immediately at monotypes after you have looked at a lot of paintings would prove in most cases very disastrous to the former. But, strange to say, Steichen's photographs hold their own. It proved to me once more that in art the method of expression matters naught; that every effort, no matter in what medium, may become a work of art provided it manifests with utmost sincerity and intensity the emotions of a man face to face with nature and life.

The "artistic photograph" answers better than any other graphic art to the special necessities of a democratic and leveling age like ours. I believe this, besides some technical charms like the solidity of dark tones and the facility with which forms can be lost in shadows, is the principal reason why Steichen has chosen it as one of his mediums of expression.

He never relies upon accidents; he employs in his photographic portraits the same creative faculty which he employs in his paintings. That is the secret of his success. Look at his portraits of Lenbach, Stuck, Watts, Maeterlinck, Besnard, Bartholomé, and Rodin. In each, with the exception of Maeterlinck—and Maeterlinck's face seems to be one of those which do not lend themselves to pictorial representation, being too subtle, perhaps—he has fully grasped the sitter's personality. Lenbach he has treated like a "Lenbach," with the light-effects

of an old master and with copious detail bristling with intellectuality, such as the Munich master is apt to use in all his important portraits. The Stuck portrait is full of a riotous technique, with a *bravado* touch in the white glare in the corner of the eyes. This is a man often vulgar and crude, but with healthy blood in his veins—an artist personifying the *storm and stress* element in genre art. How calm and dignified in comparison is Steichen's handling of Watts! And then, again, his Besnard, direct and realistic, and yet unforeseen in its effect. The treatment of the big fur mantle, with which the bulky form of the painter is clad, is symbolical of his tumultuous technique, and the burst of light behind the curtains suggestive of Besnard color-orgies in violent yellows, blues, and reds. The Batholomé is deficient in composition, the Greek column against which the sculptor is leaning and the huge caryatid, which he is contemplating and which fills the rest of the picture, are too obstrusive, and yet they intimate the dreams of this poet of form, with their mixed savor of the modern and archaic.

But the masterpiece of this collection is the Rodin. It can not be improved upon. It is a portrait of Rodin, of the man as well as his art, and to me by far more satisfactory than Alexander's portrait of the French sculptor, excellent as it is. It is a whole man's life condensed into a simple silhouette, but a silhouette of somber splendor, powerful and personal, against a vast background, where black and white seem to struggle for supremacy. This print should, once for all, end all dispute whether artistic photography is a process indicative of decadence, an impression under which so many people and most artists still seem to labor. A medium, so rich and so complete, one in which such a masterpiece can be achieved, the world can no longer ignore. The battle is won!

But it is getting late. Only a few more words, about Mr. Steichen's nudes.

"These nudes nobody seems to understand," Mr. Steichen remarks. "Do they mean anything to you?" It has grown dark and the rain is still tapping, curiously and faintly, at the windowpanes.

My answer is a smile. He does not know that my whole life has been a fight for the nude, for liberty of thought in literature and art, and how I silently rejoice when I meet a man with convictions similar to mine.

Steichen's photographic nudes are not as perfect as the majority of his portraits, but they contain perhaps the best and noblest aspirations of his artistic nature. They are absolutely incomprehensible to the crowd.

To him the naked body, as to any true lover of the nude, contains the ideals, both of mysticism and beauty. Their bodies are no pæans of the flesh nor do they proclaim absolutely the purity of nudity. Steichen's nudes are a strange procession of female forms, naïve, non-moral, almost sexless, with shy, furtive movements, groping with their arms mysteriously into the air or assuming attitudes commonplace enough, but imbued with some mystic meaning, with the light concentrated upon their thighs, their arms, or the back, while the rest of the body is drowned in darkness.

What does all this mean? Futile question. Can you explain the melancholy beauty of the falling rain, or tell why the slushy pavements, reflecting the glaring lights of Fifth Avenue stores, remind us of the golden dreams the poets dream?

I seize my umbrella and say "Good night" indifferently, as I might say it to any stranger, and he answers absent-mindedly "Come again!" He is thinking of his soul, and I am thinking of mine. What a foolish occupation is this busy, practical world of ours!

<div align="right">SIDNEY ALLAN</div>

Dawn-Flowers*
(To Maurice Maeterlinck)

WEIRD phantoms rise in the dawn-wind's blow,
In the land of shadows the dawn-flowers grow;
The night-worn moon yields her weary glow
To the morn-rays that over the dream-waste flow.

Oh, to know what the dawn-wind murmurs
 In chapel of pines to the ashen moons;
What the forest-well whispers to dale and dell
 With her singular, reticent runes!
To know the plaint of each falling leaf
 As it whirls across the autumnal plain;
To know the dreams of the desolate shore
 As sails, like ghosts, pass o'er the dawn-lit main!
 To know, oh, to know
 Why all life's strains have the same refrain
 As of rain
 Beating sadly against the windowpane!

We do not know and we cannot know,
And all that is left for us here below
(Since "songs and singers are out of date"
And the muses have met with a similar fate)
Is to flee to the land of shadows and dreams,
 Where the dawn-flowers grow
 In the dawn-wind's blow,
As morn-rays over life's dream-waste flow
To drown the moon in their ambient glow.

*Lines suggested by Mr. Steichen's print "Dawn-Flowers."

ENVOY

Oh, gray dawn-poet of Flanders,
 Though in this life we ne'er may meet,
I'll linger where thy muse meanders
 To strew these dawn-flowers at her feet.

S.H.

Evans—An Appreciation

YES: No doubt Evans is a photographer. But then Evans is such a lot of things that it seems invidious to dwell on this particular facet of him. When a man has keen artistic susceptibility, exceptional manipulative dexterity, and plenty of prosaic business capacity, the world offers him a wide range of activities; and Evans, who is thus triply gifted and has a consuming supply of nervous energy to boot, has exploited the range very variously.

I cannot say exactly where I first met Evans. He broke in upon me from several directions simultaneously; and some time passed before I coördinated all the avatars into one and the same man. He was in many respects an oddity. He imposed on me as a man of fragile health, to whom an exciting performance of a Beethoven Symphony was as disastrous as a railway collision to an ordinary Philistine, until I discovered that his condition never prevented him from doing anything he really wanted to do, and that the things he wanted to do and did would have worn out a navvy in three weeks. Again, he imposed on me as a poor man, struggling in a modest lodging to make a scanty income in a brutal commercial civilization for which his organization was far too delicate. But a personal examination of the modest lodging revealed the fact that this Franciscan devotee of poverty never seemed to deny himself anything he really cared for. It is true that he had neither a yacht, nor a couple of Panhard cars, nor a liveried domestic staff, nor even, as far as I could ascertain, a Sunday hat. But you could spend a couple of hours easily in the modest lodging looking at treasures, and then stop only from exhaustion.

Among the books were Kelmscott Press books and some of them presentation copies from their maker; and everything else was on the same plane. Not that there was anything of the museum about the place. He did not collect anything except, as one guessed, current coin of the realm to buy what he liked with. Being, as aforesaid, a highly susceptible person artistically, he liked nothing but works of art: besides, he accreted lots of those unpurchasable little things which artists give to sympathetic people who appreciate them. After all, in the republic of art, the best way to pick up pearls is not to be a pig.

But where did the anchorite's money come from? Well, the fact is, Evans, like Richardson, kept a shop; and the shop kept him. It was a bookshop. Not a place where you could buy slate pencils, and reporter's notebooks, and string and sealing wax and paper knives, with a garnish of ready reckoners, prayer

books, birthday Shakespeare, and sixpenny editions of the Waverley novels; but a genuine bookshop and nothing else, in the heart of the ancient city of London, halfway between the Mansion House and St. Paul's. It was jam full of books. The window was completely blocked up with them, so that the interior was dark; you could see nothing for the first second or so after you went in, though you could feel the stands of books you were tumbling over. Evans, lurking in the darkest corner at the back, acquired the habits and aspect of an aziola; the enlargement of his eyes is clearly visible in Mrs. Käsebier's fine portrait of him. Everybody who knows Evans sees in those eyes the outward and visible sign of his restless imagination, and says, "You have that in the portraits of William Blake, too"; but I am convinced that he got them by watching for his prey in the darkness of that busy shop.

The shop was an important factor in Evans's artistic career; and I believe it was the artist's instinct of self-preservation that made him keep it. The fact that he gave it up as soon as it had made him independent of it shows that he did not like business for its own sake. But to live by business was only irksome, whilst to live by art would have been to him simply self-murder. The shop was the rampart behind which the artist could do what he liked, and the man (who is as proud as Lucifer) maintain his independence. This must have been what nerved him to succeed in business, just as it has nerved him to do more amazing things still. He has been known to go up to the Dean of an English Cathedral—a dignitary compared to whom the President of the United States is the merest worm, and who is not approached by ordinary men save in their Sunday clothes—Evans, I say, in an outlandish silk collar, blue tie, and crushed soft hat, with a tripod under his arm, has accosted a Dean in his own cathedral and said, pointing to the multitude of chairs that hid the venerable flagged floor of the fane, "I should like all those cleared away." And the Dean has had it done, only to be told then that he must have a certain door kept open during a two hours' exposure for the sake of completing his scale of light.

I took a great interest in the shop, because there was a book of mine which apparently no Englishman wanted, or could ever possibly come to want without being hypnotized; and yet it used to keep selling in an unaccountable manner. The explanation was that Evans liked it. And he stood no nonsense from his customers. He sold them what was good for them, not what they asked for. You would see something in the window that tempted you; and you would go in to buy it, and stand blinking and peering about you until you found a shop assistant. "I want," you would perhaps say, "the Manners and Tone of Good Society, by a member of the Aristocracy." Suddenly the aziola would pounce, and the shop assistant vanish. "Ibsen, sir?" Evans would say. "Certainly; here are Ibsen's works, and, by the way, have you read that amazingly clever and thought-making work by Bernard Shaw, *The Quintessence of Ibsenism*?"—and before you are aware of it you had bought it and were proceeding out of the shop reading a specially remarkable passage pointed out by this ideal bookseller. But

observe, if after a keen observation of you in a short preliminary talk he found you were the wrong sort of man, and asked for *The Quintessence of Ibsenism* without being up to the Shavian level, he would tell you that the title of the book had been changed, and that it was now called *For Love and My Lady*, by Guy de Marmion. In which form you would like it so much that you would come back to Evans and buy all the rest of de Marmion's works.

This method of shopkeeping was so successful that Evans retired from business some years ago in the prime of his vigor; and the sale of *The Quintessence of Ibsenism* instantly stopped forever. It is now out of print. Evans said, as usual, that he had given up the struggle; that his health was ruined and his resources exhausted. He then got married; took a small country cottage on the borders of Epping Forest, and is now doing just what he likes on a larger scale than ever. Altogether an amazing chap is Evans! Who am I that I should "appreciate" him?

I first found out about his photography in one of the modest lodgings of the pre-Epping days (he was always changing them because of the coarse design of the fireplace, or some other crumple in the rose leaf). He had a heap of very interesting drawings, especially by Beardsley, whom he had discovered long before the rest of the world did; and when I went to look at them I was struck by the beauty of several photographic portraits he had. I asked who did them; and he said he did them himself—another facet suddenly turned on me. At that time the impression produced was much greater than it could be at present; for the question whether photography was a fine art had then hardly been seriously posed; and when Evans suddenly settled it at one blow for me by simply handing me one of his prints in platinotype, he achieved a *coup de théâtre* which would be impossible now that the position of the artist-photographer has been conquered by the victorious rush of the last few years. But nothing that has been done since has put his work in the least out of countenance. In studying it from reproductions a very large allowance must be made for even the very best photogravures. Compared to the originals they are harsh and dry: the tone he produces on rough platinotype paper by skillful printing and carefully aged mercury baths and by delicately chosen mounts, can not be reproduced by any mechanical process. You occasionally hear people say of him that he is "simply" and extraordinarily skillful printer in platinotype. This, considering that printing is the most difficult process in photography, is a high compliment; but the implication that he excels in printing only will not hold water for a moment. He can not get good prints from bad negatives, nor good negatives from ill-judged exposures and he does not try to. His decisive gift is, of course, the gift of seeing: his picture-making is done on the screen; and if the negative does not reproduce that picture, it is a failure, because the delicacies he delights in cannot be faked: he relies on pure photography, not as a doctrinaire, but as an artist working on that extreme margin of photographic subtlety at which attempts to doctor the negative are worse than useless. He does not re-

duce, and only occasionally and slightly intensifies; and platinotype leaves him but little of his "control" which enables the gummist so often to make a virtue of a blemish and a merit of a failure. If the negative does not give him what he saw when he set up his camera, he smashes it. Indeed, a moment's examination of the way his finest portraits are modeled by light alone and not by such contour markings or impressionist touches as a retoucher can imitate, or of his cathedral interiors, in which the obscurest detail in the corners seems as delicately penciled by the darkness as the flood of sunshine through window or open door is penciled by the light, without a trace of halation or overexposure, will convince any expert that he is consummate at all points, as artist and negative-maker no less than as printer. And he has the "luck" which attends the born photographer. He is also an enthusiastic user of the Dallmeyer-Bergheim lens; but you have only to turn over a few of the portraits he has taken with a landscape-lens to see that if he were limited to an eighteenpenny spectacle-glass and a camera improvised from a soapbox, he would get better results than less apt photographers could achieve with a whole optical laboratory at their disposal.

Evans is, or pretends to be, utterly ignorant of architecture, of optics, of chemistry, of everything except the right thing to photograph and the right moment at which to photograph it. These professions are probably more for edification than for information; but they are excellent doctrine. His latest feat concerns another facet of him: the musical one. He used to play the piano with his fingers. Then came the photographic boom. The English critics, scandalized by the pretensions of the American photographers, and terrified by their performances, began to expatiate on the mechanicalness of camera work, etc. Even the ablest of the English critics, Mr. D. S. McCall, driven into a corner as much by his own superiority to the follies of his colleagues as by the onslaught of the champions of photography, desperately declared that all artistic drawing was symbolic, a proposition which either exalts the prison tailor who daubs a broad arrow on a convict's jacket above Rembrandt and Velasquez, or else, if steered clear of that crudity, will be found to include ninety-nine-hundredths of the painting and sculpture of all the ages in the clean sweep it makes of photography. Evans abstained from controversy, but promptly gave up using his fingers on the piano and bought a Pianola, with which he presently acquired an extraordinary virtuosity in playing Bach and Beethoven, to the confusion of those who had transferred to that device all the arguments they had hurled in vain at the camera. And that was Evans all over. Heaven knows what he will take to next!

GEORGE BERNARD SHAW

On the Vanity of Appreciation

NEARLY every art worker has occasion to complain about lack of appreciation. "Genuine appreciation—*i. e.*, the capacity for poetic insight into another man's work—amounts almost to genius." And that is the reason why it is so rarely met with. It is almost nonexistent, and not merely because we live in a mercenary age in the most mercenary country of the world. The evil roots deeper.

Of whom can the artist expect appreciation? Of the profession? Many artists seem to be of that opinion. They believe that a painting can be appreciated only by painters, and that it is always the profession that puts the first stamp of approval on a man's work. The latter is true, as the artist—even though a feeling of their own possible superiority may at all times be rankling in their breast—can appreciate the technical accomplishments, which always remain a *terra incognita* to the laymen. But the painter, as a rule, is taken up so much by his own work, and narrowed to his own school and line of thought, that he finds it extremely difficult to contemplate another man's work with absolute liberality and impartiality. The more individual he is, the less can he escape his *ego*, as another man's convictions can never mean to him as much as his own.

Equally unreliable is the practice of self-criticism. Of course, we know whether we have really put our very best into a work or not. But strange, our latest work always seems the most important to us. And often years have to elapse before the mist of self-delusion, obscuring our mental vision even to the beauties of our own creations, is finally dissolved. No, we cannot rely on ourselves, no matter how anxious we may be to gain the just valuation of our merits we all are craving for. It is, after all, the public whose approbation we most care for, although we realize at the very start that it recognizes only the value of precedent, that it is always biased and absolutely incapable of accurate perception and of the independent estimation of a work of art. It is the everlasting tragedy of the artist that, in order to keep his genius from starvation, he is forced to beg for every mite of praise, with doglike servility, from the very public which he despises beyond expression.

The public finds gratification only in the workmanship as a whole, apart from any consciousness of the actual skill displayed. And therefore only the art and poetry which have become an organic part of our life and thought, the so-called classics, are readily understood. Innovations of any kind are generally condemned, simply because people are not used to them. The general public objects to artists who do not conform to the usual and customary forms. It lacks absolutely the gift of discernment, and will take no pains to enter into the significance of works which treat new themes, or old themes in a new and startling manner. It finds unusual action of the mind painful, and far from ever blaming itself, the public simply declares that there is nothing in such artists, and either abuses them or treats them with indifference.

There are, overmore, in every branch of art men and women who, because

they are utterly devoid of genius, avenge themselves by making a practice of their mediocrity at the public expense. This clan of parasites, composed of the average critics, teachers, connoisseurs, of the vulgar middlemen and boastful art promoters, makes it its trade to submit from generation to generation, theoretically or mechanically, certain fixed laws of the beautiful, to convert nature into a theme of scholastic babble, and to lay down accurate rules, as one might set rules for measuring pieces of silk or mending shoes. In this way the chain of masters and disciples extends back into the remotest centuries; and this interminable series of people, repeating and imitating one another through ages, we term tradition. It is infinitely respected, this tradition. It has its schools, its organs, its regular administration, and the entire social organization does duty in its service, watching sharply over its continuance, recompensing it, and guarding it from any possible accident that might break the remarkable chain.

It is the tyranny of conventional and prescribed estimates in artistic matters which stands father to so many of the shams, confusing and injuring honest and healthy appreciation. Honesty is the beginning of all pleasure in art and literature as in life, and the only fruitful method of studying masterpieces is to judge them by what they do for us. Art is no exact science, and there is always room for a robust personal opinion. If it should happen that some lover of art had no use for Whistler's nocturnes, Monet's fragments of nature, or Rodin's melodies in marble or bronze, while it isn't at all necessary for him to cry the fact from the housetop, it is necessary for his own salvation to remain firm and not to feign admiration for something he does not appreciate. It implies no idiocy to take that attitude, but only a different idiosyncrasy, education, environment, taste from that of the lovers of the above-named masters. He should be broad-minded enough to allow that they may be right, but not weak-minded enough to make an effort to agree with them. As Stendhal said, all that the layman in the enjoyment of art requires is to *dare* to feel for himself.

The critics could do much to create what is called a public opinion. They should possess "the leisure to be wise." But as it is, the majority of critics write from hurried glances and in the abundance of their ignorance, and should not be honored with any consideration at all. Such criticism reveals nothing so much as the incapacity of the writer and judges him more than the subject of his criticism. Even great men often miss the mark. The unfavorable comments of Voltaire and Goethe on the *Divine Comedy* of Dante showed that neither the philosopher of Ferney nor the sage of Weimar was able to bring his mind into sympathy with the grand epic of smoke and flames and human suffering. Heine and Börne in turn were incompetent to appreciate Goethe's *Faust.* Criticism nearly always consists of blaming the artist because his idea is not clearly expressed. It forgets that clearness is always relative and dependent on certain conditions. When the subject is profound and demands close reasoning subtlety of sentiment, and delicacy of expression, it is impertinent for the critic to say it is not clear. If the artist has failed to express his idea in the best possi-

ble way, he may do well to heed the judgment of competent critics. But the lack of clearness need not be entirely his fault. His creation may be luminous and only the critic opaque. The artist has a right to demand some labor of mind and heart from his admirers. He does not profess to work for those to whom it is painful to "gird up the loins of their minds."

The condemnation of critics and the indifference of the public should not disturb the art worker in the least. So long as he feels sure that they merely misapprehend his efforts, his attitude should be one of perfect indifference. No artist has a right to work with the standard of even his best critics in his conscious view, for the essence of art must ever lie in its spontaneity. The true artist far removed from the noise, the coteries, the sham estheticism and hideous jealousies of the profession knows that the eternal spirit of art is of more significance than any customary or momentary form. He must calmly abide his time, till he finds his audience "fit though few," till the masses learn the secret of his aim and purpose, and the sneering amateurs of yesterday are honored by the possession of one of his pictures and willing to lay down gold for it instead of coppers. Millet and our George Inness received recognition only "at the eleventh hour," but calmly and successfully bore silence, neglect, blame, misunderstanding and the frequent laughter of fools.

Yet as "the time to wait is long," it is not astonishing that some artists, who cannot bring their life into harmony with such frugality and martyrdom, should try to force the appreciation of the public by indulging in the art of self-advertisement and assuming a pose. Whistler probably owes his worldwide reputation more to "The Gentle Art of Making Enemies" than to his Leyland House and Luxembourg triumphs. He had the personality to back his eccentricities and his methods were pardonable, perhaps even recommendable from a practical point of view.

We all are human, and praise and appreciation are welcome to all of us, but this weakness does not hinder us from realizing that Browning's *Pictor Ignotus* is, after all, a more ideal type of artist than that represented by the cynic of the rue de Bac. The true artist—should wealth and fame not come his way—has ever preferred to worship his lofty and often narrow ideals in poverty and obscurity, rather than to waste his genius on the vain world, which has but little in common with his dreams and aspirations.

SADAKICHI HARTMANN

Photography and Natural Selection

THE doctrine of evolution, held by some thinkers even before the time of Charles Darwin, was by him given a status which it did not till then possess. By discovering two of the processes by which new forms are evolved, namely by variation and by natural or artificial selection, he gave a logical explanation of what before was merely speculation.

At the present day, whether they be prepared to admit their descent from a common stock with the ape or not, few thinking persons will be found to deny that evolution is at work in many fields other than the domain of natural history.

It will be my endeavor in this article to trace its action, and the actions of variation and of selection in photography.

In using the word evolution in this connection, it must be remembered that, though analogous to its meaning in natural history, it is not synonymous with it. In nature a new species is derived, on the Darwinian theory, by lineal descent from preceding species — that is to say, all existing beings are the progeny of some of those that existed before them. To say that the dry plate is the progeny of the wet plate would be farfetched; but it is its successor and became so through being a variation of the photographic plate, which, in the struggle for existence, beat its rival and predecessor.

In the beginning, photography was claimed by art, chemistry, and optics; though doubtless to chemistry and manipulative skill fell the major portion of the credit. The object of everybody was to *record*. That many pictures, and good pictures, were produced by those possessing artistic faculties was necessarily the case. The work of Hill in 1843 – 1845, for instance, is of high artistic value.

There was, in those days, one species of photograph with a number of slight varieties, in the same way that in the prime of Greece, painting and sculpture were but varieties of one art, differing in their materials (as daguerreotype and calotype did from one another), but essentially one art insofar as ideals and objects were concerned. Scuplture and painting are nowadays widely differing arts, not different varieties, not different species, but different orders of art. Painting itself is split up into many *genera* — oil- and watercolor, not to speak of pastel or tempera, while whole families of kindred arts have risen and worked themselves into the position of separate arts with separate aims and methods; I speak of pencil-drawing and crayon; etching, mezzotint, and engraving; woodcut; lithography, etc., etc.

In the same way photography, from being a single art-science, has ramified into a growth of many kindred branches. Already the aims and methods of "process" itself is subdivided into intaglio, typographic, and collographic methods; each, however, as a rule, with the same *mental** objective in view, namely, the production of a more or less exact facsimile, though by different *mechanical* methods. Leaving out of our purview color-photography, which is

*I wish to differentiate here the *mental* objective — *i. e.*, the purpose of the author, from the *mechanical* method employed in carrying it out.

still in a rather primitive state (though also a well-marked species), we come to photography proper. Here we have a large number of different processes (*mechanical* methods) used for many different (*mental*) purposes.

Whereas in the "process" group the mechanical methods are the chief difference, in the other group the mental differences are perhaps the more important.

These differences of object (which I have called mental differences) class themselves naturally into two groups with a third intermediate between them: I. Educational and scientific; such as astronomical, archaeological, and natural-history photographs. II. Personal and topographical; a subgroup, in which we may include all that photography primitively meant—that is, the recording of a portrait or place which is of personal interest, for the purpose of possessing a memento or likeness when the original is not before us. III. Pictorial or artistic; in which the object is to obtain a result of intrinsic beauty without reference to its scientific value or to our knowing or not knowing the place or person represented.

These three groups (and especially the first and third), as a whole, are very distinct in their aims and objects, though many photographs will partake of the nature of more than one group. Roughly speaking, the objects of photography of the first group are the highest attainable accuracy and *truth to fact*; in many cases the minutest details, whether seen by the eye in the original subject or not, are invaluable, and the influence of the personal equation on the result must be reduced to a minimum.

In the third group the ideal is totally different, if not contrary, to that of the first. Here we wish to stimulate the esthetic sensations of the beholder. *Truth to fact* is not wanted, though to a certain extent *truth to appearance* is.* The influence of the personal equation is given as full play as possible.

The second group lies midway between the other two; generally partaking of the nature of a record, with the first group, and of something pleasing to the eye with the third.

It is in photographs of the third group that readers of CAMERA WORK are chiefly interested, and in such of the second as overlap the third. I will, therefore, dismiss the first group briefly by saying that in general its objects and methods are dictated pretty rigidly by the particular science which calls photography to its aid, and that the more the operations approximate those of a machine the better, as a rule: *e. g.*, star-mapping, sunshine-recording, spectrography, etc.

With the third group the contrary is the case; although, because of the com-

*For an example I may suggest a photograph of a ship for educational purposes, in which it is important that the lighting and technical treatment shall show, to the greatest extent, the details of hull and rigging; and a similar photograph, taken for artistic purposes, in which a broad mass of shade and a technical treatment merging details into one another may best subserve the artistic requirements.

mon genesis of all the groups, this fact is hardly realized, with the result that artistic photography is sometimes criticized because it does not fulfill the conditions of scientific photography. It need not and should not be. The latter appeals to the intellect, the former to the imagination; the latter asks for exact facts, the former for pleasing suggestions.

What I particularly wish to point out in this article is that these differences between the various "species" of photography will tend in the natural course of evolution to become ever more marked, and that a photograph which attempts to combine at the same time the scientific accuracy of group I with the esthetic beauty of group III will lead—as in nature—to a sterile hybrid partaking of some of the qualities of both. For instance, in treating a natural-history subject, although we may (and should) make it as pleasing to the eye as possible, we must not thereby sacrifice any of the educational value; to do so would be to produce neither fish, flesh, fowl, nor good red herring.

The same line of reasoning will show that, in the natural course of events, each variety of method will work itself out separately, and that the technique and the effects aimed at and produced will vary with the *genius* of the methods. This separation of ideals and treatment is seen clearly in, say, etching and engraving or woodcut. In photography we have come to the parting lines, but we are only at the initial stage. Already the effects sought after in bromide, platinum, and gum-bichromate are different, and with the specialization of each medium they will become more so.

In a bromide (as at present worked) a brush-mark would look out of place; in a gum, brush-marks are quite allowable. In the former they are an alien element, in the latter they are part of the process. As photography expands these differences will become more and more marked, and both mental ideal and mechanical methods more and more differentiated, for that is the universal law of evolution as we see it all around us. That some of the branches will lead nowhere—that is, will not survive the struggle for life—is also a foregone conclusion; but as long as photography does not limit itself to one line of progress, this will not affect its advance, for the fittest will survive. It is for this reason that it seems unwise to lay down canons as to the lines on which photography *ought* to advance. We are in the early days of photographic art-evolution as yet, and though artificial selection *may* be useful, its use depends entirely on the wisdom of those who select, and they cannot, in the nature of things, see very far into the future.* It is safer to let natural selection do its work, perhaps a little more slowly but more surely in the end, than to meddle in problems whose ultimate outcome we cannot grasp; in seeking to root out the bad, we stunt and destroy what might, if left alone, be the beginning of a useful and valuable departure.

J. C. WARBURG

*As an instance of such injurious, but luckily unsuccessful, interference, I would recall the attempt to ridicule the gum-bichromate process out of existence some years ago.

The Photo-Secession Exhibition at the
Carnegie Art Galleries, Pittsburgh, Pa.

W HEN two years ago—it is hard to believe that it is only two years—a few artistic photographers founded the Secession, the outsiders, largely the profession, a few artists and that small part of the public interested in photographic matters, smiled rather incredulously at the attempt and wisely shook their heads and offered all sorts of cheap advice. Love's labor lost, they thought; that might do for painters, etchers, wood-engravers, but for photographers—ridiculous!

But the Secessionists were not to be discouraged; they listened to no advice; they had convictions and persevered. Then came their first exhibition at the National Arts Club, at New York, which taught such a practical lesson to many a publisher, painter, and art-student. "It has met with success simply because of its novelty," the wiseacres remarked; "but wait awhile! It is just like a new play; everybody wants to see it merely to talk about it; then the interest will cease."

What have all these now to say after the triumph of the Secession ideas at the Corcoran Art Gallery in Washington and at the Carnegie Art Galleries in Pittsburgh? Will they still be able to find excuses, or will they suddenly, as is usually the case in such matters, come over to the enemy's camp, proudly asseverating that they have fully believed, from the very start, in the principles of this movement.

Fortunately the Secessionists care little for popular approval, insisting upon works, not faith, and believing that their share having been done in producing the work, the public must now do the rest. A few friends, and these of understanding mind, a few true appreciators, this is all they expect and all they desire.

The Photo-Secession Exhibition at Pittsburgh is indisputably the most important and complete pictorial photographic exhibition ever held in this country. I must confess to no special fondness for the ordinary run of photographic exhibitions, but the Pittsburgh show is so far superior to anything of its kind I have ever seen before, that I consider it a privilege to have viewed it and to have found real pleasure in my task of studying it. With exception of the background, which was red in color and dilapidated in appearance—a state of affairs over which the Secession had, unfortunately, no control—the arrangement, the lighting of the galleries, which concentrated the light upon the pictures and left all else in semidarkness, was particularly effective and seemed incapable of improvement. The hanging, at best a thankless task, was done with untiring energy and exquisite taste by Mr. Joseph T. Keiley. The exhibit is exceedingly well grouped; the framing of the pictures up to the usual high standard; and the catalogues arranged by Stieglitz himself, especially the illustrated edition de luxe with cover design by Steichen, which contained seven gravures, may all be regarded as models of good taste.

Thanks to those who selected the collection fully two-thirds of the exhibit of three hundred frames is of a superior kind, masterpieces, of course, being as scarce here as everywhere.

Nearly all of the pictures contained some artistic note that lifted them above the commonplace. The exhibition was national in its character, fifty-four photographers being represented. Only Day, Lee, Maurer, and Genthe, for some reason or another, could or would not participate. The large bulk of the exhibit was by the members of the Secession.

Photo-Secession! The outsider is generally startled at the name; he does not know the exact meaning of the word nor in what way it is applied to this class of energetic and enthusiastic workers. People wonder what the Secessionists really want, and yet their aim is such a simple one. They want to be artistic, that is all. They want to see their work classed as an art; but this is only a secondary consideration, as recognition can not be forced; it must come by itself. Their first and last aim is to do artistic work.

Why, then, all this mockery, noise, and opposition? Because it is a fight, after all. It is a fight of modern ideas against tradition, or, more modestly expressed, a fight for a new technique. I am convinced that the better class of photographers also want to be artistic, not quite as much as the Secessionists, but to their best understanding. The whole trouble is that the two parties can't agree on the mediums of expression. It is a fight about conception, theory, and temperament. And the Secessionists, even if they accomplish nothing but the improvement of the average standard of photographic work, will remain victors, because they are more sincere and are willing to sacrifice everything to reach their end.

It sometimes seems to me as if this fight were not at all about esthetics, as the Secessionists seem willing to accept almost anything, so long as it contains a spark of artistic merit. They object only to such commercial work as is produced for no other purpose than to suit a sitter or a publisher. They wish to be independent artists and not time-pleasing speculators. That was really the cause of their revolt. And the Secession was created for no other purpose than to foster and cultivate this genuine art feeling, which must be found at the root of every work of art.

The best which the exhibition had to offer, and so far as my personal feelings are concerned the best which the Secession has produced, are the prints of Steichen. None can deny his power. He stands in a class by himself. That which he shows us is not always photography, but it invariably belongs to the domain of art. He sacrifices everything to painter-like qualities and conception as well as treatment, and with astonishing precision he realizes the ideas which he wishes to convey. Like a highwayman he lies in wait for beauty, seizes her and drags her away as she passes. He steps straight into her path and, like an Espada whose reputation would be lost had he to make a second thrust, he settles the whole question with one clever stroke. To him life is a sojourn in darkness, illuminated by innumerable streaks of lightning. These he tries to grasp. Every object he endeavors to imbue with beauty, and even the simplest, a vessel or a branch of flowers, sets him to dreaming about some big artistic problem, and

he at once makes the effort to transform it into a pictorial revelation.

Just his very opposite is Joseph T. Keiley. He, too, sees the beauty of detail, but finds it so beautiful in itself that he forgets all artistic possibilities. He lingers over details so long and lovingly and discovers such a wealth of beauty in them that he grows confused. When he photographs a beautiful woman, he hesitates to show her in the full bloom of her youth, but tries to subdue her charms. And as beauty must be wooed in a more ardent fashion, she often evades so cold a lover; but when he succeeds in holding her she reveals herself in one of the most tender of moods. His work conveys an effect like the ringing of an old church bell. A deep, mysterious sound in the bass and above it a very light ethereal one, so fugitive that it seems to vanish at every moment. His "Spring," Corot-like and evanescent like spring itself, plainly sounds these two notes and is one of the gems of the exhibition.

Stieglitz, as usual, holds his own. His older work seems just as strong and interesting as it did years ago, and nearly every picture he adds comes near to being a masterpiece. In his "Hand of Man" he shows that he is still the same accomplished artist as in "The Net-Mender," "Watching for the Return," and "Winter on Fifth Avenue." In it he betrays a decided step in advance, as he has undertaken to imbue it with a feeling of mystery which his earlier pictures have lacked. We all know how indefatigably he has worked for the Secession, and I know no better word of praise than to apply to him what I have said about St. Gaudens and American sculpture: "It owes the best, if not everything, to him; without him American artistic photography would be a myth."

A very welcome newcomer is Alvin Langdon Coburn. During the last two years he has made wonderful strides. The first exhibition of his pictures that I ever saw rather bored me, though his personality interested me, reminding me of the French symbolist poet Emanuel Signoret (whom he strongly resembles in appearance), who said of himself at the age of twenty: "I am young; I am a poet, for youth is poetry." But now matters have changed. He is on the way toward becoming a full-fledged personality. He has begun to see objects, insignificant in themselves, in a big way. His "Ipswich Bridge" is one of the strongest pictures in the exhibition. He displays a decided feeling for the decorative arrangement of masses, and his composition, strongly influenced by the Japanese, via Dow, is at times exceedingly clever, as shown in "The Dragon."

Clarence H. White, a sincere, straightforward talent of rare refinement and never-tiring student in quest of beauty, has convinced me more than ever that his is a rather limited field, but that he stands absolutely unique as a photographic illustrator. His illustrations for "Eben Holden" and "Beneath the Wrinkle" will not be easily surpassed, the only man at times approaching him, in the power of characterization being Edmund Stirling.

A note, not exactly new, but nevertheless praiseworthy was struck by W. F. James. He is the pictorial reporter *par excellence*. He displays a fine conception of atmosphere and of moving crowds, and his "Christmas Shopping" appeals to

me even more than Stieglitz's well-known "Wet Day on the Boulevard."

A very satisfactory group of pictures is furnished by J. G. Bullock, W. B. Post, whose winter landscapes are perhaps a little too white and barren, and Rose Clark, whose portraits, though not great, possess a refinement and vague pictorial old-masterlike charm that is exquisite.

Eugene has nothing new to show. Strange that a man with so much talent, with such an overabundance of talent—in his application of painterlike qualities he is second only to Steichen—should at times do such slovenly work. And yet one is forced to admire him, and his "Adam and Eve," in spite of its shortcomings, is one of the few great pictures artistic photography has produced. His art is like a flower which, though its leaves are withered and crumpled, still retains its perfume.

Mary Devens, judged by her pictures in this exhibition, impresses me as being the strongest woman photographer we have just at present. Gertrude Käsebier's newer work does not appeal to me in the same way as her older, lacking in spontaneity and virility. Pictures like "The Manger" and "Blessed Art Thou Among Women" hold their own as of old in the best of company. Yarnall Abbott and Rudolf Eickemeyer are rather inadequately represented. By having failed to show their most representative work they have missed a rare opportunity—or is it possible that the very high standard of this exhibition has made their work look less important?

But it is not my intention to criticize all the exhibits in detail—though I should still like to mention Dyer's "Nude" and "Dinah Morris," Willard's "Oenone" and "The Veil," and Herbert G. French who, all by himself, holds up the banner of artistic photography in the large city of Cincinnati—I merely wish to prove that there are quite a number of photographic workers who have succeeded in making camera work "a distinctive medium of individual expression." The best proof of this assertion is in that nearly all the prominent Secessionists have imitators galore. There were decided indications of this in the exhibition. There are two ways of looking at it. One might say, here we have the proof that true reformatory work is never in vain, that genuine invention always produces an effect. But do these imitators really follow in the footsteps of their masters? Do they not merely strive for the form and not for the idea as revealed in Secessionist work? Do they not merely imitate certain lines and certain peculiar effects because others have applied and successfully applied them? And therein lies, to my way of thinking, the great danger of the Photo-Secession movement. Mannerism means the decline of all art. To substitute one mannerism for another surely is not their aim. As soon as beauty is imitated or produced at second hand it ceases to be beautiful, and is at best but pretty, clever, or effective. There is no sincerity in it. It has deteriorated into mere play. It produces its effect not by its own merit but by reminiscences. To copy Hollinger or Histed can surely not lead to the beautiful, no more than you can achieve beauty though you imitate Steichen, Eugene, or White. In its future

exhibitions, the Photo-Secession must guard against routine, imitation, and mannerism. Is this a complaint or a piece of advice? Neither. Complaint were unjust, and advice is not needed. The older Secessionists have long ago realized what I have just said. They can not hinder the influence of their individuality, though at the same time they know that the real fight has only just begun—a fight in their own ranks between the true and the false Secession.

With every human being a new world is born which did not exist before he saw it, which will never exist again when death closes his eyes. To represent the world, which is nothing but life as seen by the individual, is the aim of the artist. They are the storytellers of some foreign land which they alone have seen and which they alone can depict for the benefit of others. To listen to the inner voice, to be true to themselves, to obey nobody, that is their law; and only those who in this fashion work out their own individuality, their own innermost convictions which they share with no one else; those who work it out in a convincing manner, without looking out to please or to succeed; they alone are true Secessionists. And if they produce others of the same caliber, pitilessly ignoring and casting aside all who adhere to time-serving aims, then the Photo-Secession will be the beginning of a great movement that will have a permanent value in the annals of American Art.

<div align="right">SADAKICHI HARTMANN</div>

Black Art
A Lecture on Necromancy and the Photo-Secession

LADIES and Gentlemen: If you will keep your attention sharply focused upon my manipulations you will doubtless be able to see that there is no possibility of faking in the little exhibition of Black Magic which I shall give you for your benefit. You have, I suppose, each of you, experimented with that harmless game of our childhood, which consists of placing a drop of ink upon a sheet of paper, folding the paper over—so—giving it a quick pressure—so—and reading fortunes and soul-fancies in the resultant

You will please notice that I have here a sheet of ordinary white paper and a bottle of ordinary ink. Examine the paper, please—thank you. And the ink?—thank you again. Now, you observe, I put a drop of ink on the page—fold the

sheet over on itself—give it a quick slap—so!—and pronounce the magic word, "Excalibur!" Now we will examine the result

What do you think it is, my little man in the front row? "A dustbrush?" No, no, no! Look again! Is it not Alfred the Great? Not that Alfred who let the cakes burn. No; this is the Alfred who pulled the cakes out of the fire. The Photographic Cakes. Yes, dear; his hair *is* a little rumply, but if you were ringmaster in this show your hair would stand up too. Daniel, the good book tells us, spent some time in the lion's den and came out unscathed; but it leaves us to imagine the condition of his coiffure.

Well, shall we try again? Perhaps we can materialize one of the lions. Watch me sharply—there! I told you so.

See how meek he looks? Would you take him for the king of beasts? Ah, Steichen! With that recumbent mane, that forelock softly drooping, who would guess the fiery eye, the tossing mane, the ROAR—? Don't be uneasy, ladies and gentlemen, it's only a picture!

And now, perhaps I can do something gentle for you for a change. I'll put a drop of sugar in the ink, and we'll try again

Parsifal! Pouting because the Grail eludes him! Cheer up, Alvin Langdon, I'll cast another magic drop and glimpse the future for you—

By the way, ladies and gentlemen, I hope you notice that there is nothing fuzzy about my magic? It may be mysterious, but the mystery has its source in no pussy willow quality of focus. This is only *one* of the differences between Black Art and Modern Art. There are also others.

However, no art, black or otherwise, is complete without a Madonna. I therefore give you [Gertrude Käsebier]

The Madonna of the Lens.

J. B. KERFOOT

Eduard Steichen: Painter and Photographer

Mr. Charles FitzGerald, the art critic of the *Evening Sun*, New York, has in the past strenuously denied the claims of photography as a possible medium of art-expression in the same spirit as has moved him to deny the existence of art in the productions of many modern painting exhibitions in New York. A recent one-man show of Mr. Steichen's paintings at Glaenzer's seemed to us a fitting opportunity to request Mr. FitzGerald to write for CAMERA WORK, and thus to present to our readers the estimate of one not previously connected with photography. In view of Mr. Steichen's position in photography, it seemed proper to us that this exhibition of paintings should be noticed in these pages, and it is interesting to read Mr. Fitz-Gerald's estimate of this young painter-photographer's artistic perceptions. That Mr. FitzGerald's point of view was uninfluenced by any considerations other than his honest judgment is evident from the text. The future alone can determine the validity of the judgment thus rendered. — EDITORS.

Finding myself at times on the brink of argument with some earnest votary of the photographic art, I have hitherto invariably been saved at the critical moment by a friendly warning, a polite reminder of the perils incident to a plunge into depths as yet unsounded by explorers whose lives have been given to their task with a singleness of purpose to which I would by no means pretend. And, although at such moments I have secretly resented this treatment, thinking the photographers too fastidious in their bearing towards the rest of the world (as if the mysteries of their calling were far above the understanding of the vulgar); yet, upon mature consideration it seemed not incredible to me that perfect comprehension of the art they profess might involve the acceptance of a new and strange set of symbols distinct from the common heritage of the black-and-white tradition, and not instantly apparent to the uninitiated. For the rest I must in candor add that this concession was speculative rather than actual, seeing the photographers themselves had given me no reason to suppose that the postulates of their convention differed in essence from those generally accepted in drawing and painting; but, on the contrary, had insisted at all times that in practice they stood upon the same foot with other designers, the only distinction lying in the variety of media employed. Quite recently a singular opportunity has arisen to test the matter in doubt, and to take the measure of photographic mastery without encroachment in the occult domain so jealously guarded by the profession.

I am ignorant whether Mr. Eduard Steichen is more painter or photographer; but, on the evidence of his peers, I judge that his standing among the masters of the camera is undisputed. In the criticism of painting, the term "master" is employed more sparingly, and comments on his recent exhibition at Mr. Glaenzer's showed a general disposition to treat him rather as a newcomer, as a young man "feeling his way." I know that in the critics' cant every painter is young till he has won a prize at the Academy or Society, and I am the more perplexed to decide what allowances are required on the score of youth in this instance by finding Mr. Steichen spoken of in CAMERA WORK as an "old leader"

in photography. If, however, we are to concede any, it cannot surely be in consideration of technical deficiency. I suspect that the critics have been deceived, imagining that he took to painting after having exhausted the resources of the camera; but be that as it may, I was unable to discover convincing evidence of such a process in his work, and have no hesitation in saying that his accomplishment is fully commensurate with his purpose. Satisfied in this particular, I sought in his paintings some confirmation of the great things I had heard, when in the presence of his photographs I stood dumb and listened to the eulogies of the expert.

The cleverness of the work was abundantly apparent, nor had I any trouble in recognizing a complete equivalent for the quality of taste shown in his photographs. Moreover, I perceived a nice ingenuity in the use of color, a definite sense of harmony, though employed generally without reference to the perceptive faculties and making for a sensuous effect habitually premeditated, and adapted, as it were, in each case to the subject in hand. But, of the deep feeling attributed to him by his colleagues I could find no trace in his pictures, nor any sign whatever of a mystic apprehension of nature; in my mind's eye the painter was revealed as a bravely equipped and self-possessed gallant, ready on all occasions to make himself at home, and resolved to achieve a conquest at every encounter. It is true that a mysterious significance is hinted at in many of his inventions, from the turgid, mock-profound "Beethoven" to the "Nocturne of the Black Women," with its symbolistic dressing and portentous air of tragedy. But this meant nothing to me more than a deliberate sentimental assumption: the mystery appeared to come from without, not from within; it implied no strange truth lying beneath the superficies of things, but rather suggested a wrapper for trite facts, the seeming strangeness being part of a very artificial picture-scheme. Throughout the exhibition, embracing work of considerable variety, both in subject and style, this spirit of artifice was predominant. The general atmosphere was oppressive and stuffy as that of a hothouse, and I came away with the impression not of one struggling to express ideas associated with a rare and true vision, but of an accomplished and ingenious painter, approaching nature invariably with a preconceived determination to see a picture.

My space will not allow me to consider the exhibition more at large, but in conclusion I would like to add a few words in a general way. Here is a "master of photography" with the painter's means of expression all at his command. Supposing him to possess the rare qualities with which he is credited by his fellows, there is, I maintain, no technical cause or just impediment why they should not be declared in his paintings. The result of the practical test is discouraging, and considering this as an indirect demonstration of the qualities and conditions that make for mastery with the camera, I, for one, can see no reason for revising my previous estimate of the limitations of photography.

CHARLES FITZGERALD

On Art and Originality Again

EVERY now and then there is a recrudescence of those views based on the popular obsession that mere optical and chemical excellencies and mathematical accuracies make for art in photography, while, as a matter of fact, they are especially misleading to their undiscriminating admirers. Though oft confuted—as much as such persons can be said to be confuted— the exponents of such ideas still urge accuracy and "truth to nature"—by which they mean only apparent truth to the facts, accidentals and all, in their line of vision. They argue that "delicate rendition of planes," "apparent depth," and so on, are reasons for a peculiar claim to artistic value for the products of pure photography when tastefully done. This at best is bald naturalism, but at its usual worst it is as bad as claiming that "all hand-painted" work is art. If the most elementary laws of esthetics be considered with an open mind, any fair student must see that in no form are renderings or representations of natural facts truly art merely because they are good reports, no matter how accurately, how daintily or how deceptively they may be done. But there seems great need for a continual protest against views so mistaken, especially when in any way put forth by advocates of pictorialism, who thus hinder the cause they try to advance—yes, need to save photography from its many ununderstanding friends, above all others. Almost every one means to love beauty and tries to appreciate it—just as they intend to do right—but often their conceptions of beauty, as sometimes of right, are rudimentary, or twisted, or ill-proportioned. The cure for this ill, and the need for all, is ever for greater culture, to broaden the understanding of life and of art. If people will only try to look at art with vision undistorted by primitive prejudices and childish ideas concerning natural phenomena, they will see that artifice is not art, and they will find themselves greatly rewarded and spiritually enriched.

Briefly: graphic art is a means to tell us something by symbolizing, on a flat surface, any of the objects seen by us in space. It is employed to give us some idea that was in the mind of the artist, to communicate the sentiment he had about this thing, or collocation of space objects. He assembles certain things in his picture because he considers them essential to his idea, selecting them thus to make an esthetic unity. If it helps his purpose to have many gradations and many focal planes or abundant detail, well and good; he should have them. But if such optical and chemical technicalities and such florid ornateness hinder his object—as they probably will, if he has an esthetic intent and is not trying for a lens- or plate-maker's prize, he must throw such complications overboard. He will find his skill more highly exercised and taxed when he tries, by every means in his power, to accent the idea, the feeling that he wishes to express; and the more of what is not absolutely essential that he can eliminate in the process the better will the result be—as art. Let us pause to consider this "idea," the theme, or "motif," in art. It is not a thing of fact-communication as in science, but a thing of feeling, in graphic art as in poetry or in music. Its thought is in terms of sentiment, not of logic; its growth and sequence are by emotional

connection, so that its coherence must be one of feeling and not of rhetorical reasoning—of the heart and not merely of the head. And that explains why faking, insincerity, vanity, or even honest but prosaic endeavor, cannot accomplish anything that rings true.

Obviously it is ridiculous, for philosophic and esthetic reasons, to make truth and perfection in "copying nature" the crucial test and gauge of art. It is even absurd on physical grounds. There can be no "perfect copy" upon a flat surface of three-dimensional objects; no, not even a perfect copy of the way we see them. To talk of such a perfect copy is more than paradoxical; it is a mere contradiction in terms. Old-time critics, it is true, said that the artist's ideal was to "hold the mirror up to nature." Well and good; it was—and is. But how? What did they mean? They were not materialists nor scientists. By nature they meant not merely physical matter, but all things, quick as well as dead; and mainly the emotions. And the mirror? Did they mean a Claude Lorraine glass, and then a rectangle of canvas? No, they meant a man's heart. Our esthetic aims and intents today do not differ from those of the ancients or of the Renaissance in these essentials so much as in other ways. We have gone forward (or roundabouts!); we have built on their buildings, and we have perforce continued to differentiate—perhaps spiritualize—certainly to evolve species from species and to specialize the individual. The printing press and other cheapening means of reproduction, the closer association of nations, have made past, and foreign, art achievements so generally known that we cannot merely imitate or repaint and rewrite, to present in the style and fashion of our own day and land the beautiful truths that others have said in their own way before us, though it is ever a great temptation to retell these in the new aspect of our modern feeling. However, captious critics so inflate and wave on high the bogey of plagiarism, even while they cry aloud that there can be nothing more, really new, born under the sun, that we moderns must apparently tremble even when we dare to use the universal ideas in which we live and move and have our being. As a matter of fact, no true artist would or could actually and merely plagiarize. However, print is so cheap and there is so continual a hullabaloo, that all are kept on edge by the watchdogs that smell poachers and thieves everywhere. Discipleship seems at a discount—only temporarily, let us hope; and one might think derivative work to be shouted down effectually, just as if it were a crime to be young and to admire and study a great master, and so show his influence. But though all are chastened by the shouting and though some are thereby infected with the ruinous genius-bug, those who are any good still wholesomely survive and continue to be inspired by their elders and their betters. As an average instance of criticism, we can call to mind how a writer recently told us, in effect, that a certain artist painted well, but with an ingenious "preconceived determination" to see pictures in nature, instead of showing a "struggle to express ideas associated with a rare and true vision." The distinction is a subtle one, and requires something of a transcendentalist to make it. It

is upon a plane where we must be extra careful not to be confused by catch-words, for idealities and spiritualisms add their batteries to the studio critical patter, which is quite misleading enough for rapid writers, as well as readers, without such mystical additions. However, it should in fairness be added that many current formularies of ephemeral criticism are a growth of the endeavor to criticize by indirections, and so to avoid throwing stones that can hurt other glass-house dwellers materially.

To the fakers who look outside for their ideas, it has become a serious question as to what they may take undetected and uncontemned. But to the artist who looks within and holds up the mirror of his heart, there comes no such problem. His serious question is: will what I see, as best I can render it, be understood and valued by others? All that exists, including all that has gone before, is his — if he can make it vitally and truly of himself; for he never was before and what is really his will be a new note struck in art. That is the meaning of the "personality" of today: it is not the eccentricity of effort; it is not the egoism of the prescientific romanticist; though a true individuality, it works by more scientific methods than of old, and is replete with the poise of uncommon common sense. Life "goes in courage"; art "comes out power." For art is the esthetic projection of a trained "organism which is functioning freely" — to adapt further from John J. Chapman's essay, "Education: Froebel," in his volume entitled *Causes and Consequences.* He enlarges, further on, thus: "We find that in the old vocabulary such words as genius, temperament, style, originality, etc., have always been fumblingly used to denote different degrees in which some man's brain was working freely and with full self-consciousness [*i.e.* self-realization]. A deliverance of this kind has always been designated as 'creative,' no matter in what field it was found."

A certain brilliant English writer has said that life imitates art more than art imitates life. Paradox though this be, there is a fruitful germ of truth in it. It is only the crystalization into an epigram of the facts that people are ruled by convention in art as in other things, but that for the expression of beauty they turn to the works of those who have made the study of beauty their especial pursuit; so that the artist sooner or later guides and teaches, as well as do the advanced minds in other fields. But the very artists must also be creatures of conventions and either adopt old or adapt new ones: thus is the paradoxical circle completed. Indeed, the artists do not know half what they stand for in the world. Many good makers consider such theories as those developed in this article to be mainly impractical rainbow-chasing. They have fenced their minds about with working formulae; an instinctive feeling restrains them from expeditions into that domain of philosophy whence they have intuitively derived all in their processes not due to the observation and imitation of others. They smile at philosophical criticism, general theories, and inductive reasoning (except in a few classical authorities). That accomplished artist, John La Farge, gives the attitude of the painters in his suggestive little volume, *Considerations*

on Painting, when he says: "The difficulty for the artist who works in things to put his thoughts into words is a natural difficulty. . . . All efforts made in any direction are made at the expense of our being able equally well to carry out others of a different kind; the artist's nature has warned him of the loss, and his usual willingness to be satisfied without words is not misplaced." How different from the critic's point of view! I never had this more beautifully illustrated than lately. A noted New York critic gave a most instructive address on the growth and construction of music. But a successful musician took issue with him, saying that he was misleading; that he had shown us merely the empty forms, the dead bones of music, and not its living spirit. Then the musician went over part of the same ground; played things that the critic had had played, and explained their ideas in construction and feeling from his utterly different point of view—and the hearers learned from both!

The acme of the critical attitude is well given in an essay by the paradox-lover, the "artist in attitudes," who has been quoted a while back. He argued that pure criticism was in reality creative work, a form of literature in which the art treated of was merely material which the critical essayist used for his own artistic ends. And surely this suggestive essay is more than just a brilliant *tour de force.* Whatever thinker we study, we find that if he be more than a half-cultured or a mechanical reasoner, from whatsoever point of view he has regarded the ways of man in the creation of the beautiful, all conclusions center at the one goal. Art is to him the skill, of every kind, that man uses: (1) to select from nature what pleases his taste, to express his idea; (2) to correct faults in nature, so as to unify his selections; and (3) to embody the results in appropriate form. All these operations he does more or less simultaneously; originality is the result of power to do them well and to do them sincerely. We call it genius when the organism is in all respects "functioning freely," as Chapman put it, or, as La Farge said, when man possesses in high degree "the power of organizing ideas, images, signs, without employing the slow processes of apparently consecutive thought."

DALLETT FUGUET

Of Verities And Illusions

THERE is a Buddhist text: "He alone is wise, who can see things without their individuality." Japanese art and life, at least until lately, have been based on it. We, however, of the Western world live by a different rule; individuality is the keynote of our civilization; the pushing of it to furthest possible extreme the measure of personal success, and success, appraised at a money valuation, almost our sole criterion of worthiness.

An echo of the Buddhist text appears in Winckelmann's dictum: "The highest beauty is that which is proper neither to this nor to that person." He derived it from a study of the sculptures of Phidias and his immediate follow-

ers, whose impersonal types of human form represented a supreme union of physical perfection and mental elevation—the harmonious balance of matter and spirit. A little later the balance was disturbed. Praxiteles and Scopas began to glorify physical perfection at the expense of mental grandeur, and the further trend of Greek art was toward the loss of the spiritual in the material. And all the subsequent story of Western art may be summarized, so far as its motives are concerned, as a perpetual readjustment of the claims of the material and the spiritual; as most often an acquiescence in the superiority of the material, at intervals a restoration of the spiritual to a share in the artist's ideal. Its conspicuous feature has been a reliance upon form, the actual visible appearance of it, such as will scarcely be found in Japanese art. It is with us an inheritance from the great Greek days, a survival, as it were, of the letter of the law of beauty, even while its spirit has been obscured. To Western artists form has presented itself as a reality; those exclusively interested in its appearances we call "realists"; Courbet, who dubbed himself a realist, proclaimed that the appearance of form was *la vérité vraie*.

To the Japanese, however, by reason of Buddhist teaching, the reality is Spirit or Soul; matter an illusion; form, not of itself to be admired, not to be studied for its own sake, but only as the temporary embodiment or habitation of some portion of the universal Spirit, yet necessarily to be studied by artists, indeed not able to be escaped by them, since through form primarily must they make appeal to the imagination. It is in the attitude toward form that the Western and the Oriental artists rudimentally differ. Before considering the Oriental habit of mind, so alien to our own, in order to bridge over, as it were, the great gap between, let us recall the attempt of Whistler to get away from the obsession of form.

Moved by the example of the Japanese, which fitted in with his own rarely sensitive feeling for beauty, he tried for a time to eliminate form from his pictures, and to depend as nearly as possible only upon color. He realized that form, the concrete thing, expressible in words and suggesting them, draws off the mind of the spectator from the more abstract qualities of beauty; moreover, that music, because of its appeal being uninterrupted by the concrete, is capable of deeper and farther reaching expression than painting, and that the nearest analogy to the harmony of sound within the scope of the painter, is the harmony of color. So, for a time, he experimented with Symphonies, Nocturnes, Harmonies. But it was only an experiment, and by the nature of the case incapable of more than temporary and partial success. For this effort to escape from form was like that of the anchorite to escape from the wickedness of the world. That it may not be a trammel to his spirit, he buries himself in a cave, communing with himself of spiritual matters; as if the world did not exist both outside and inside himself. The Japanese artist, on the contrary, admits the necessity of form, but strives to subdue its materialism to an expression of the Spirit.

This conflict of tendency—the Western preoccupation with what is conceived to be the realities of form and the Oriental subordination of form to spiritual expression—is a phase of the wider difference of motives which separates the West and East. A very illuminating statement concerning this difference occurs in Mr. Okakura's *Ideals of the East.* He has been saying that the Himalayas divide only to accentuate two mighty civilizations—the Indian and the Chinese. "But, not even the snowy barriers," he continues, "can interrupt for a moment that broad expanse of love for the Ultimate and the Universal, which is the common thought-inheritance of every Asiatic race, enabling them to produce all the great religions of the world, and distinguishing them from those maritime people of the Mediterranean and the Baltic, who love to dwell on the Particular, and to search out the Means, not the End, of life." And nowhere better than in Japan can the Oriental ideal be studied, since the successive thought-waves of Asia—Confucianism, Taoism, Buddhism—have washed up on her shores, until she has become "the real repository of the truest Asiatic thought and culture, and the history of her art has been the history of Asiatic ideals."

To repeat the antithesis—theirs the love of the Universal and the Ultimate; ours the love of the Particular and the Means. Postponing for a moment the consideration of the Oriental, can we have any doubt as to the substantial truth of this estimate of our own ideals?

Our love of the Particular: Did not the abstract perfection of the art of Phidias become speedily supplanted by the perfection of particular types? Have not all the developing influences of our civilization—Italian Renaissance, Revival of Learning, Reformation, English Civil War, and Revolutions, American and French, trended toward the assertion of that form of the Particular— the Individual? And what is realism, as it has fastened itself down upon literature and painting, but the minute and detailed study of the Individual, the Particular; not mankind's relation to the Universe, but a man's adaptability to his own little backyard.

And our love of the Means: The art for art's sake theory of practice may have dissolved in dry rot, but the dust of it still lies over our art. Only a few days ago, a pupil of Mr. Chase, a very promising one I had thought him until he opened up to me his own emptiness, asserted with every appearance of sincerity and conviction that the sole thing necessary for a painter was to be able to paint. And really, if one searches the annual exhibitions with their array of more or less skillfully handled canvases, barren all but completely of any idea to stir a thrill, much less to lift a man above the level of his ordinary thoughts, one is compelled to the conclusion that a large number of painters remain satisfied to be mere brush-practitioners, to whom the Means are the sole End.

Nor can this be a matter of surprise, since the chief aim of school and college is to make education a means to an end; and to the smallest of ends—the fitting of the Individual to assert himself; not to discover his relation to the

Universe, or to the human brotherhood, but how by superior cunning and endurance he may thrust his brother from his place. The idea of Soul and Spirit is banished from our schools and colleges; confused in our pulpits with ethical and economic considerations; in the world of society and business swallowed up in the madness to succeed. For spiritual ideals we have substituted the ideal of success; for the Golden Rule the consecration of Self to itself; until the brutal lust of Individualism has become so rampant, so defiant of religion, ethics, and law that we are in danger of being devoured by the Minotaur we have bred and petted.

In such an atmosphere, how should works of art attain to higher imagination? Our painting is, with slight exception, and that mostly of style, not of feeling, *bourgeois*. A large share of artistic effort is consumed in portraiture; the same directed chiefly to the representation of mere external appearances, especially of those of clothes and finery; another large share in illustration, about equally divided between clever characterization, shallowness, and vulgarity. Only in landscape are there evidences of the quiet detachment and communion with things larger and better than oneself, out of which good art may grow. But even the landscape painters, since our habit of minds is not toward the Universal, but toward the Particular in relation to ourselves, seldom rise above the expression of a gracious sentiment. It is only when one, like Winslow Homer, cuts himself off from the mad whirl of materialism and communes with the vast life of the Universal and the Impersonal, as typified in the ocean, that a picture is made which stirs one's soul.

On the other hand it is the habit of seeing all things impersonally in relation to the Universal, the result of Taoist and Buddhist influences, which has kept the art of Japan from becoming *bourgeois*, even in the branch that corresponds to ours of illustration—the paintings, drawings, and prints of the Ukiyoe, or Passing Show. Taoism, that spiritual product of the valleys of the Southern River, the Yangtze Kiang or Blue River, early sublimated the practical system of ethics and economics, based on communism of land and labor, which Confucius founded in the valleys of the Yellow River, the Hwang-Ho. Lao-tse, the great rival of the northern sage, wrote of the worthiness of retiring into oneself and of freeing Ego from the trammels of convention. Moreover, in the book of Soshi, one of his followers, is this: "The Wind, Nature's flute, sweeping across trees and waters, sings many melodies. Even so, the Tao, the Great Mood, expresses Itself through different minds and ages, and yet remains ever Itself." Fruit of this teaching, Shakaku in the fifth century, A.D., lays down six canons of pictorial art. The first of these is "The Life-Movement of the Spirit through the Rhythm of Things." "For," says Mr. Okakura, "art was to him the great Mood of the Universe, moving hither and thither amidst those harmonic laws of matter which are Rhythm." The second of these canons is called "The Law of Bones and Brush-work"; the creative spirit descending into pictorial composition must take upon itself organic structure. Line thus

became the foundation of Chinese and Japanese art. Line, as the basis of composition and of expression, was "a sacred thing; each stroke of the brush contained in itself the principle of life and death; outlines and contours, simply as lines, possessed an abstract beauty of their own."* The third of these canons was the depicting of Nature, in the spirit of the first and through the methods of the second.

This Taoism, with its conception of a Universal Mood and its assertion of a spiritual Ego grafted upon the communism of Confucius and his consecration of Man to Man, prepared the way for Buddhism. Now again appeared, but in tenser form, the passion of pity for humanity; in larger form the idea of Universal Spirit, temporarily manifested in matter; the spiritual Ego perfecting itself through successive stages, not as an individual, personal Ego, but as an infinitesimal portion of the Infinite Oneness. It adds to pictorial art the beauty of chiaroscuro, not, however, scientifically, as a means of increasing the likeness of form to life, but artistically, as a source of expressional beauty; and, further, it adds the subtlety and increased expressiveness of color. But through these developments of thought, affecting the life of the people and finding highest expression in their art, it is Spirit that is real, universal, eternal; Form is but its temporary manifestation; Matter is an illusion, impermanent.

This idea of the impermanence of Matter would present no difficulty to the Japanese, because their country, under constant action of seismic forces, is continually undergoing changes of topography. "The land itself," writes Lafcadio Hearn, "is a land of impermanence. Rivers shift their courses, coasts their outlines, plains their level; volcanic peaks heighten or crumble; valleys are blocked by lava floods or landslides; lakes appear and disappear. Even the matchless shape of Fuji, that snowy miracle which has been the inspiration of artists for centuries, is said to have been slightly changed since my advent to the country (about ten years before), and not a few other mountains have in the same short time taken totally new forms."

So, to the Japanese artist, habituated to the idea of the impermanence of Matter, conceiving of it only as a temporary, local manifestation of the Universal, our idea of realism is philosophically false, from an artistic view-point intolerably vulgar. This artistic aspect of the matter I may perhaps be allowed to touch on in another number of CAMERA WORK; the philosophic viewpoint and the practical results which flow therefrom, if it be sound, may be considered now.

"While you knew of us," said the Japanese ambassador to London, "as a people who had produced some fascinating kinds of art, unapproachable by Western artists, you regarded us only as an interesting anomaly; now that we have succeeded in butchering many thousands of Russians we seem to you

*If we need a clue to the meaning of this, we may find it nearer to the spirit of our own times in Botticelli's pictures.

quite civilized." This recent war has almost cloyed our appetite for surprises. Of course, the Japanese have learned of the West its most modern methods; but is that the whole story? It is not alone the value of the methods, but also a superior kind of capacity for receiving them. This the Japanese have exhibited only in directions for which their previous experiences had already prepared them; in such, for example, as war, hygiene, surgery. On the other hand, an acquaintance with Western literature, music, and painting has so far produced among them no development of importance. In these subjects their point of view is so different from ours as to deprive our practices of any value of suggestion. We must conclude, then, that the ability in certain directions to adopt our methods, and in many respects to better them, is not the result of virtue in the methods, but of some capacity previously existing in the brain of the race. Now, the latter has been shaped and nourished for centuries on Idealism, so we are confronted with a proposition that to our educators must seem paradoxical: namely, that Idealism is a soil which may produce the finest growth of practicalness; that out of the habitual belief in the supremacy of Spirit may be derived a most efficient mastery of the material; out of the idea of an impersonal Ego an extraordinarily noble type of Individualism.

The success of the Japanese has already suggested a readjustment of the balance of power in politics; it will, unless we are obtuse, suggest to us also a readjustment of the balance of power within ourselves. Too long has the Intellectual, in our system of education and economics, like the Russians, "been putting up a bluff," and not all in the direction of sweet reasonableness, but of brag and bluster and grab; the Spiritual in us, which for a time, like the Japanese, has "lain low," will "call it," and the bluff will be revealed for what it is. Then, again, we may recover the old consciousness of our race, that Soul as well as Intelligence abides in each one of us; we may readjust in our ideals and in practice the rival claims of the Spiritual and the Material. We may even advance the former to its proper consideration of superiority, if only in desperation over the plight to which our inordinate materialism has brought us.

For we used to live up to our oft-repeated shibboleth: "Honesty is the best policy." Incidentally it shall be observed that the idea of honesty or honorable conduct being desirable because it is the "best policy"—that is to say, because it will pay—is a very materialistic ideal, but still it has some workable relation to the rights of others and to the old-time general convenience of the Golden Rule. Now, however, in private and public affairs it has become discredited; individual greed has proved itself stronger than the interests even of the community; the situation has become desperate. Materialism, rabid, rampant, and insatiable, has about run its course, reached its own *reductio ad absurdum.* Possibly the remedy may lie in the return to a fuller recognition of the Spiritual.

<div align="right">CHARLES H. CAFFIN</div>

Exhibition Notes

The Photo-Secession

It had been planned by the Photo-Secession to hold in New York, early next spring, an exhibition, consisting of the very best that has been accomplished in pictorial photography, from the time of Hill up to date, in the various countries. Many of the prints have been selected for the purpose, but, owing to the impossibility of securing at any price adequate gallery accommodations during the desirable New York season, the exhibition is held in abeyance.

The Photo-Secession, for the present thus unable to hold the proposed big exhibition, has determined to present in detail some of the work which had already been selected and which would have been embraced therein, and for that purpose has leased rooms at 291 Fifth Avenue, New York City, where will be shown continuous fortnightly exhibitions of from thirty to forty prints each. These small but very select shows will consist not only of American pictures never before publicly shown in any city in this country, but also of Austrian, German, British, and French photographs, as well as such other art-productions, other than photographic, as the Council of the Photo-Secession will from time to time secure.

These rooms will be opened to the public generally without charge, and the exhibitions will commence about November first.

Fuller announcements will be made later. It is planned to make these rooms headquarters for all Secessionists.

Maeterlinck on Photography

I BELIEVE that here are observable the first steps, still somewhat hesitating but already significant, toward an important evolution. Art has held itself aloof from the great movement, which for half a century has engrossed all forms of human activity in profitably exploiting the natural forces that fill heaven and earth. Instead of calling to his aid the enormous forces ever ready to serve the wants of the world, as an assistance in those mechanical and unnecessarily fatiguing portions of his labor, the artist has remained true to processes which are primitive, traditional, narrow, small, egotistical, and overscrupulous, and thus has lost the better part of his time and energy. These processes date from the days when man believed himself alone in the universe, confronted by innumerable enemies. Little by little he discovers that these innumerable enemies were but allies and mysterious slaves of man which had not been taught to serve him. Man, today, is on the point of realizing that everything around him begs to be allowed to come to his assistance, and is ever ready to work with him and for him, if he will but make his wishes understood. This glad message is daily spreading more widely through all the domains of human intelligence. The artist alone, moved by a sort of superannuated pride, has refused to listen to the modern voice. He reminds one of one of those unhappy solitary weavers, still to be found in remote parts of the country, who, though weighed down by the misery of poverty and useless fatigue, yet absolutely continues to weave

coarse fabric by an antiquated and obsolete method, and this although but a few steps from his cabin are to be found the power of the torrent, of coal and of wind, which offer to do twenty times in one hour the work which cost him a long month of slavery, and to do it better.

It is already many years since the sun revealed to us its power to portray objects and beings more quickly and more accurately than can pencil or crayon. It seemed to work only its own way and at its own pleasure. At first man was restricted to making permanent that which the impersonal and unsympathetic light had registered. He had not yet been permitted to imbue it with thought. But today it seems that thought has found a fissure through which to penetrate the mystery of this anonymous force, invade it, subjugate it, animate it, and compel it to say such things as have not yet been said in all the realm of chiaroscuro, of grace, of beauty and of truth.

MAURICE MAETERLINCK

The Unmechanicalness of Photography *
An Introduction to the London Photographic Exhibitions

BEFORE I resume the subject of the annual exhibitions of pictorial photography, let me, in mere humanity, beg my fellow-journalists of every degree not to continue the really desolating display of clever ignorance — the most trying sort of ignorance — which has raged ever since certain platitudes of mine last year were extensively quoted, requoted, and quoted yet again, as startling and outrageous paradoxes.

It happens that for the moment we have our minds sufficiently open and active on the subject of photography to be rather aggressively conscious of its limitations, whilst we are at the same time so reconciled by long usage to the very same limitations in painting that we have become unconscious of them. That is why we think nothing of citing a dozen of the most obvious drawbacks to easel-work and throwing them in the teeth of photography as if we had never met with them in any other pictorial method. But this is not the worst. Critics who have never taken a photograph elaborately explain why the camera can not do what every painter can do, the instance chosen being generally of something that the camera can do to perfection and the painter not at all. For example, one writer has taken quite pathetic pains to demonstrate the inferiority of the camera to the hand as an instrument of portraiture. The camera, he explains, can give you only one version of a sitter: the painter can give you a hundred. Here the gentleman hits on the strongest point in photography, and the weakest point in draughtsmanship, under the impression that he is doing just the reverse. It is the draughtsman that can give you only one version of a sitter. Velasquez, with all his skill, had only one Philip; Vandyke had only one Charles; Tenniel has only one Gladstone; Furniss only one Sir William Har-

*Reprinted from *The Amateur Photographer*, October 9, 1902.

court; and none of these are quite the real ones. The camera, with one sitter, will give you authentic portraits of at least six apparently different persons and characters. Even when the photographer aims at reproducing a favorite aspect of a favorite sitter, as all artist-photographers are apt to do, each photograph differs more subtly from the other than Velasquez's Philip in his prime differs from his Philip in his age. The painter sees nothing in the sitter but his opinion of him: the camera has no opinions: it has only a lens and a retina. One reply to this is obvious. It is that if I only knew how stupid a painter can be, I would admit that many painters have no opinions, no mind, nothing but an eye and a hand. Granted; but the camera has an eye without a hand; and that is how it beats even the supidest painter. The hand of the painter is incurably mechanical: his technique is incurably artificial. Just as the historian has a handwriting which remains the same whether he is chronicling Elizabeth or Mary, so the painter has a hand-drawing which remains the same, no matter how widely his subjects vary. And it is because the camera is independent of this hand-drawing and this technique that a photograph is so much less hampered by mechanical considerations, so much more responsive to the artist's feeling, than a design. It gives you a direct picture where the pencil gives you primarily a drawing. It evades the clumsy tyranny of the hand, and so eliminates that curious element of monstrosity which we call the style or mannerism of the painter, a monstrosity which, in some very eminent cases, amounts to quite revolting deformity. It also evades the connoisseurship in these deformities which is the stock-in-trade of many critics. The effect on them is as if the brains of a goose were removed. They lose their bearings completely, and flounder into the countersense that the camera is more mechanical than the painter's hand.

The true relation of the two can be seen by adding a third term to the comparison. There are things still more mechanical than the draughtsman's hand: to wit, the rule and compass. The medieval masons found out that if they drew their decorative patterns with rule and compass they got regularity without life, interest, or beauty. So they made their patterns free-hand; and the result was enchanting. But when a modern builder gets his brother-in-law the Mayor, to humbug the Dean into a panic about "the dangerous condition of the west front," and so puts up a lucrative "restoration" job for himself, and a knighthood for the brother-in-law, at the expense of subscribers whose knowledge of art is represented by the delusion that photographs are mechanical, he tries to imitate the old work by rule and compass, and produces work which is no more enchanting than the figures in Euclid. Now if it could be proved against the camera that its lines were ruled and its curves struck with a compass, there would be some sense in the parrot-cries of mechanicalness. The truth is that it is as much less mechanical than the hand as the hand is less mechanical than the compass. The hand, striking a curve with its fingers from the pivot of the wrist or shoulder, is still a compass, differing from the brass one only in the number of movements of which it is capable. Not even when it is the hand of a

Memling can it strike a curve quite such as flesh or flower reaches by its growth; and the student of pictures who has never felt this incompatibility between the inevitable laws of the motion of a set of levers and the perfectly truthful representation of the forms produced by growth will never be a critic of photography: his eye may be good enough to compare one picture with another, but not good enough to make a lens for a five-shilling camera.

It will be seen that the penalty of talking conventional nonsense about the camera is that its disparagers not only muff the case they bring forward, but miss the case they might bring forward if they had sufficient judgment to measure the enormous artistic importance of the new process. Their attempt to pass off their ignorance as superiority by a display of inconsiderate insolence was not necessary: it was only easy and lazy. There is plenty to be said against any pretension of the camera to supersede the designer altogether. The camera cannot decorate; it cannot dramatize; it cannot allegorize. Just as it cannot do the work of Dürer or Crane, any more than it can design wallpapers, so it cannot do the work of Raphael, or Kaulbach, or Hogarth. Of course you can twist boughs or festoon ribbons and arrange flowers decoratively, and then photograph them. You can pose actors in costume and photograph them. But a born decorative draughtsman like Crane will make you a good design in the fiftieth part of the time a bad photographic makeshift will cost; and as to anecdotic, dramatic, didactic, and historical tableaux vivants, you have only to glance at the attempts in the exhibitions at giving dramatic titles to sentimental-looking portraits to see that the camera's power of representation is so intense that the photographer who attempts little fictions of this kind is at once found out and scorned for playing the fool.

If you take an artist out of the Parisian ateliers, and give him a camera to work with, what happens? He immediately sets to work to produce, not photographs, but the sophisticated works of art which formerly attracted him to the painter's profession. His very first blunder in exposure, especially underexposure, may result in a negative which a skilled tradesman would instantly scrub off the glass. The artist-novice makes a print from it, and finds that he has got something like what he calls an impression. Trained as he is to make merits of makeshifts in the atelier, he is not slow to make a merit of a mistake in the darkroom. He very soon finds out that though his proceedings involve a great deal of what a London shopkeeper described to me the other day as the backbone of his photographic trade: namely, waste of materials by amateurs, yet an encouraging proportion of his plates, especially those which, if turned out by a skilled member of the trade, would lead to instant and precipitous loss of employment, give prints which have many of the qualities of those early makeshifts of Impressionism in which tone was achieved by a frank sacrifice of local color and local drawing. If he is really an artist, the blunders he selects for exhibition will be more interesting than the unselected technical successes of the

photographer who is not an artist. He soon learns how to produce these happy blunders intentionally, at which point, of course, they cease to be blunders and become crimes.

Finally, he discovers that the camera can imitate the most flagrant makeshifts of the draughtsman, and in so doing get all the advantage of that curiosity which mere processes rouse: the same curiosity that makes people with no ear for music crowd eagerly round a pianoforte to *see* Paderewski play. When a photographer prints from his negative through a hatching, and so makes the resultant picture look like an engraving or etching of some kind, his work immediately becomes what bric-à-brac dealers call a curio; and as a photograph had better be curious than merely null, the trick is not so unmeaning as it seems. Then there are the pigment processes, in which the most amusing games can be played with a kettle of hot water. The photographer gains control of his process, and can, if he likes, become a forger of painter's work.

When the photographer takes to forgery, the Press encourages him. The critics, being professional connoisseurs of the shiftiest of the old makeshifts, come to the galleries where the forgeries are exhibited. They find, to their relief, that here, instead of a new business for them to learn, is a row of monochromes which their old jargon fits like a glove. Forthwith they proclaim that photography has become an art; and all the old phrases that were composed when Mr. Whistler was President of the British Artists, and the New English Art Club was perceptibly newer than the New River Water Company, are scissored out of the old articles and pasted into the new ones, with substituted names, as Steichen for Whistler, Käsebier for Wilson Steer, Demachy for Degas or Sickert, and any lucky underexposer for Peppercorn or Muhrman.

Now this is all very well; but who would not rather produce a silver print which could be fitted to an old description of a picture by Van Eyck or Memling, or a platinotype portrait that would rival a good impression of a mezzotint by Raphael Smith, than imitate with gum or pigment plasters the object lessons of the anti-academic propaganda of twenty years ago? I grant that some propaganda is still needed; that the old guard of photography used to tolerate, and even reward by medals, such monstrous faking as no gummist has yet been guilty of; that the plucky negative with microscopic definition, plenty of detail in the shadows (and everywhere else), and a range from complete opacity to clear glass was made just as much an end in itself as the simulation of the makeshifts of painting and draughtsmanship now threatens to become; and that Philistinism was as rampant in the Royal Photographic Society as in the Royal Academy. But none of the Impressionists was so wanting in respect for his art as to pretend that the pictures in which he preached tone and atmosphere, or open-air light, were not paintings but photographs. Besides, he aimed at representing these things as he saw them, sometimes with very defective sight, it is true, but still honestly at first hand. Now some of our photographers who have been corrupted by beginning as draughtsmen and painters *are* wanting in self-

respect; for they openly try to make their photographs simulate drawings, and even engravings; and they aim, not at representing nature to the utmost of the camera's power, but at reproducing the Impressionists' version of nature, with all the characteristic shortcomings and drawbacks of the makeshift methods of Impressionism. This modeling of new works of art on old ones, instead of on nature and the artist's own feeling, is no novelty: it is Academicism pure and simple. Mr. Whistler was not academic; but the photographer who aims at producing a Whistleresque print is as academic as Nicolas Poussin. Every original artist draws into his wake a shoal of academics of his "school," who imitate his infirmities and observe the limitations and conventions imposed on him against his will by the imperfections of his methods and faculty, just as bigotedly as they strive after as much as they understand of his excellencies. Thus in orchestral music we have the barks and stutterings of the defective trumpets written for by Beethoven, still imitated by learned professors, although modern instruments have a complete scale which makes the stuttering as unnecessary as it is absurd. Haydon, who wanted above all things to be an "old master," painted flesh a dirty yellow, because candle soot had reduced the altarpieces of his idols to that complexion. Let nobody suppose, therefore, that the critics who stood for Sargent against Bouguereau, for Monet against Vicat Cole, nearly twenty years ago, are now going to stand for the photographers who imitate Sargent and Monet against the original photographers. Much of the most daring and sincere work of the Impressionists and Naturalists dealt with most elusive and difficult subjects, and had to be painted with grotesquely inadequate colors; so that the desired effect was often suggested only by letting everything else go by the board, and demanding allowances from the spectator which the ordinary hooligan of the shilling-turnstile refused, with loud horselaughter, to make. Even spectators who were by no means hooligan, including John Ruskin himself, lost their tempers under the strain at first. But they soon saw the point of the movement and made the allowances cheerfully, and even enthusiastically.

And now, may I ask, what right has photography to these allowances? None whatever, it seems to me. The difficulties which justified the Impressionist in asking for them do not exist for the camera. The photographer has his own difficulties and receives his own allowances for them; and the minimization of these is quite enough to keep him busy. If he deliberately sets to work to make his photograph imitate the shortcomings and forge the technique of the Impressionists, he must not be surprised if he finds that those who were most tolerant of both when they were the inevitable price of originality will be the most resolute not to stand them for a moment when they are a gratuitous academic affectation.

I prefer not to connect these painful observations with the names of any of the exhibitors of the Dudley and New Galleries. In their fullest force they do not fairly apply to any individual artist; but they are seasonable for all that.

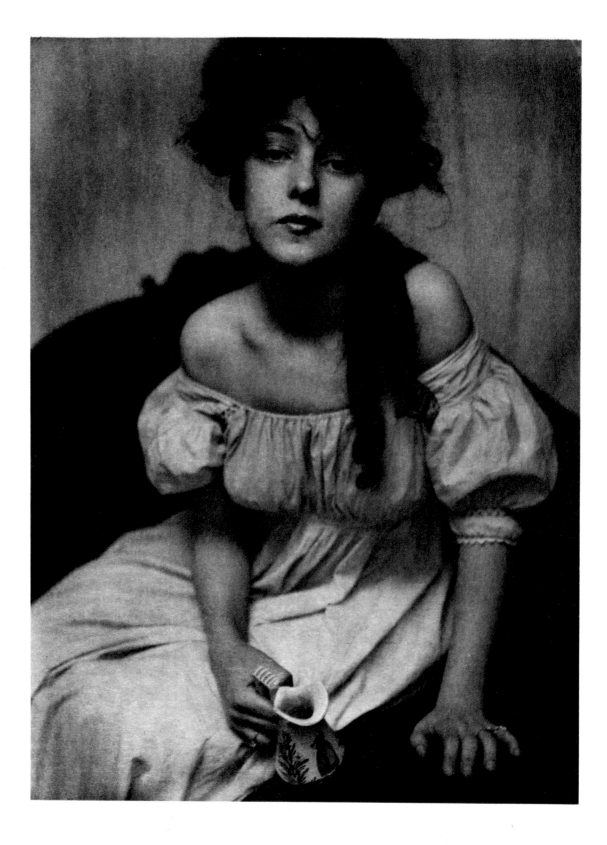

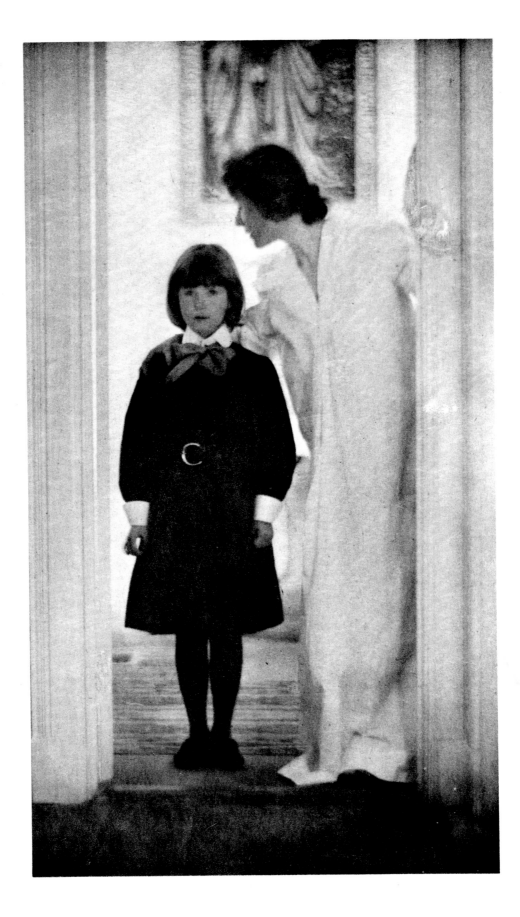

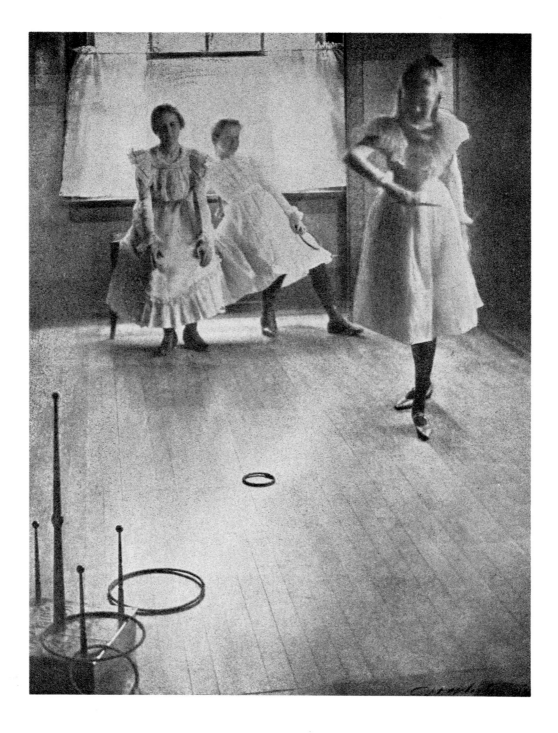

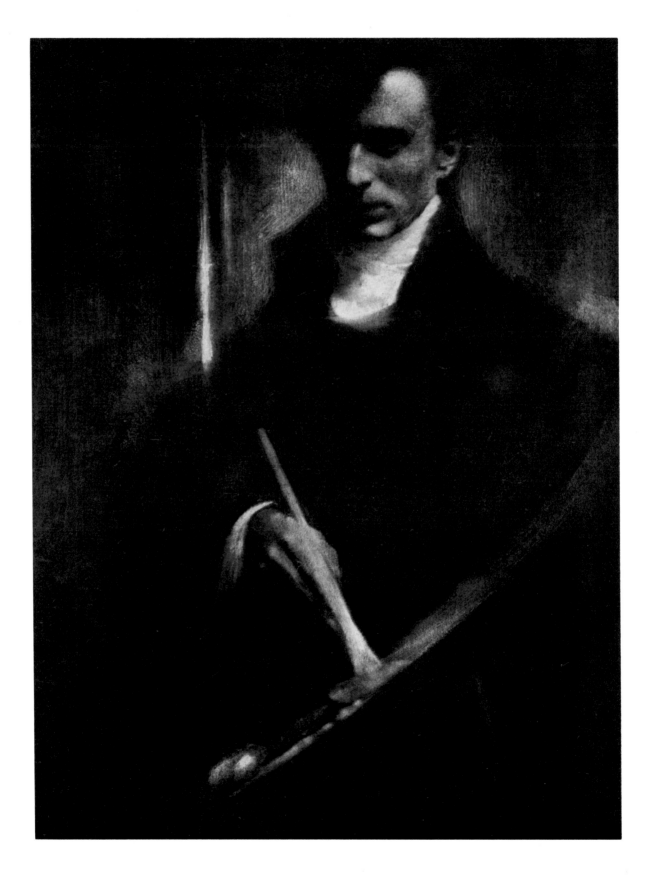

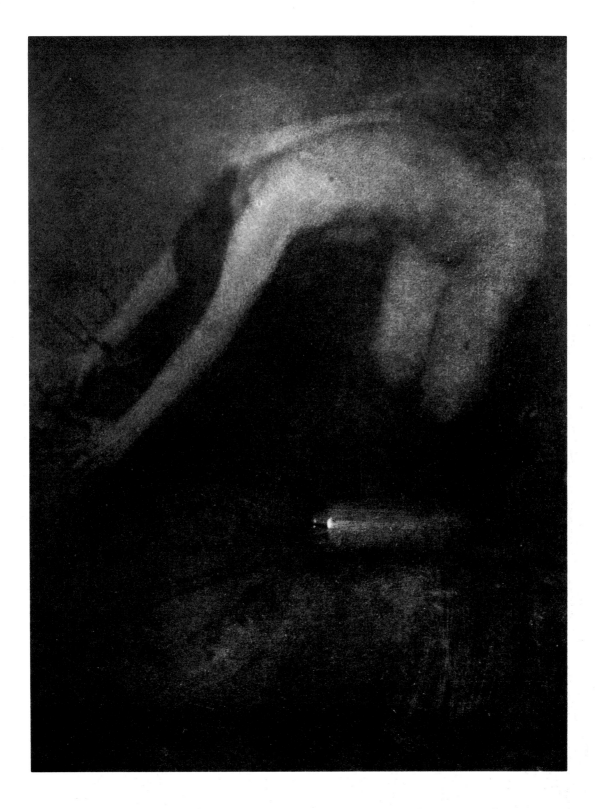

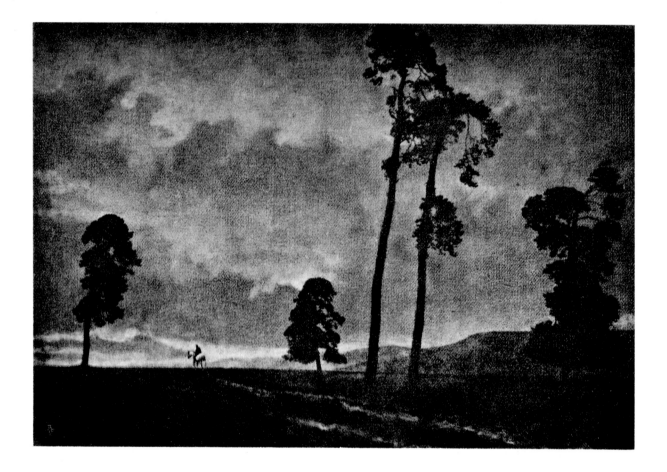

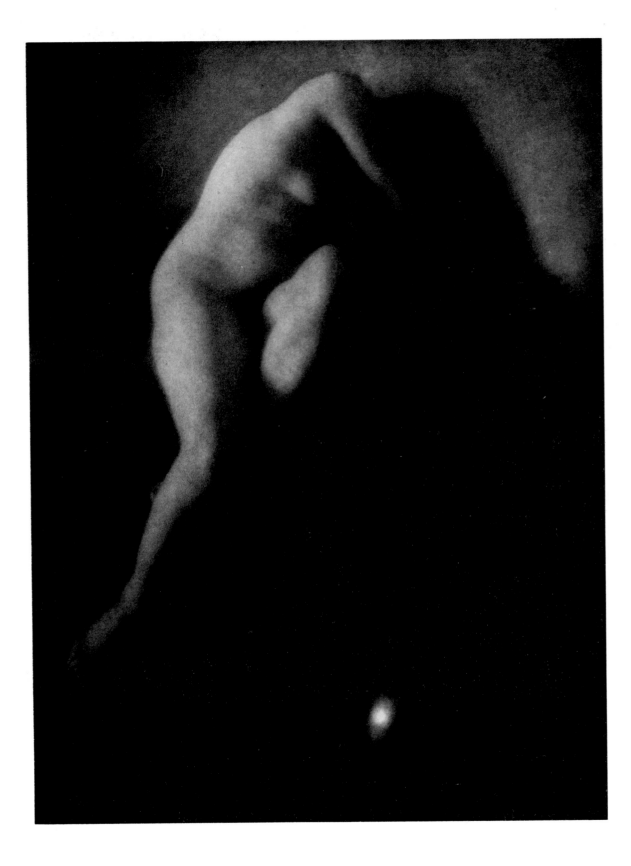

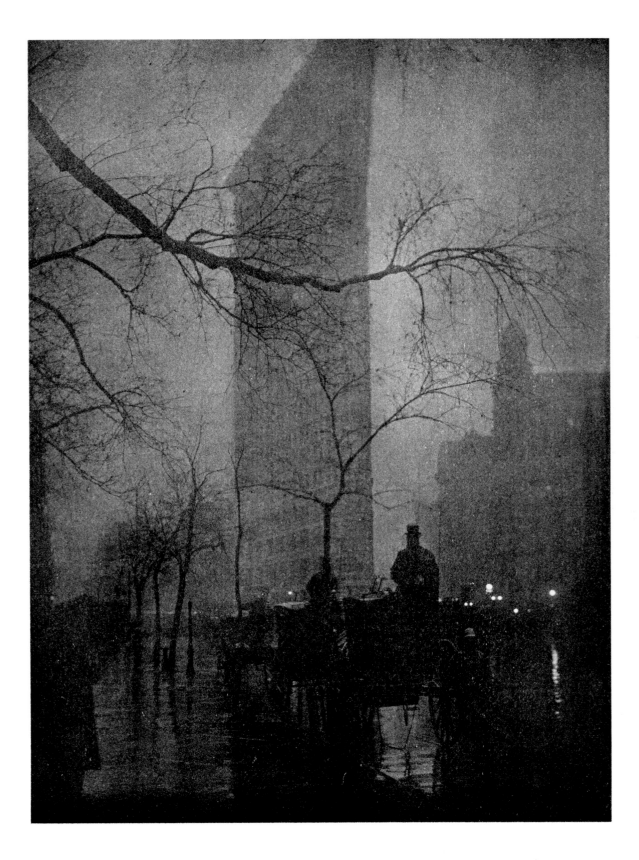

Eduard J. Steichen Rodin—Le Penseur

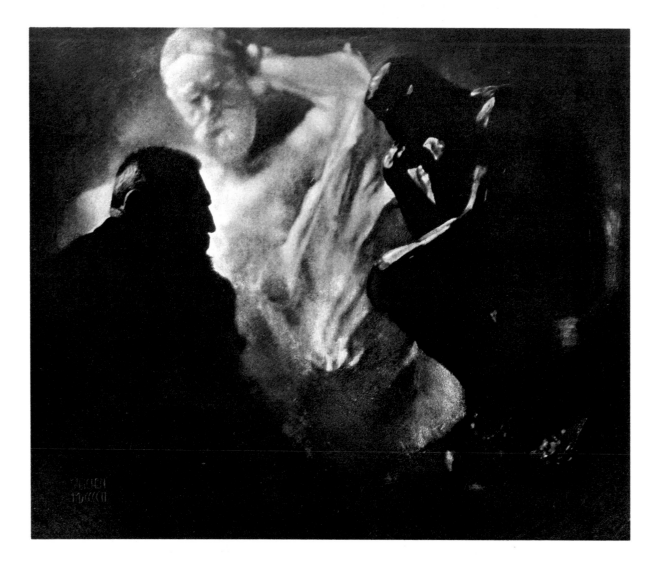

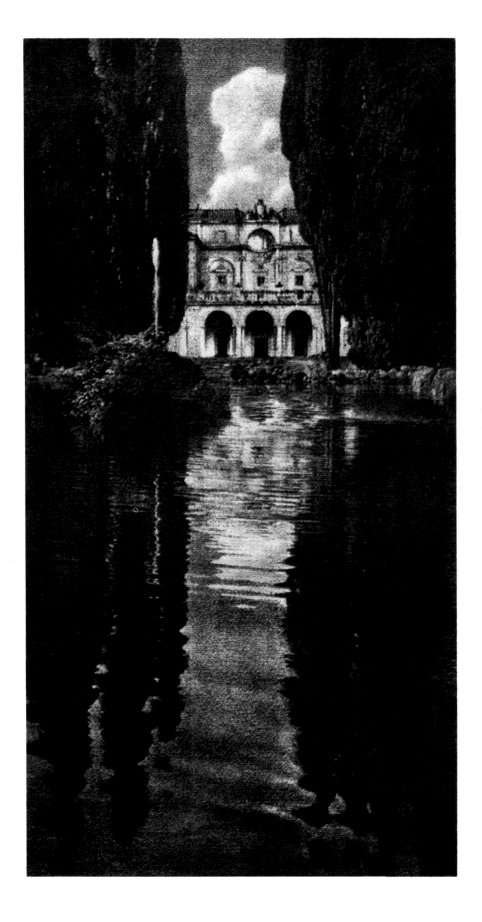

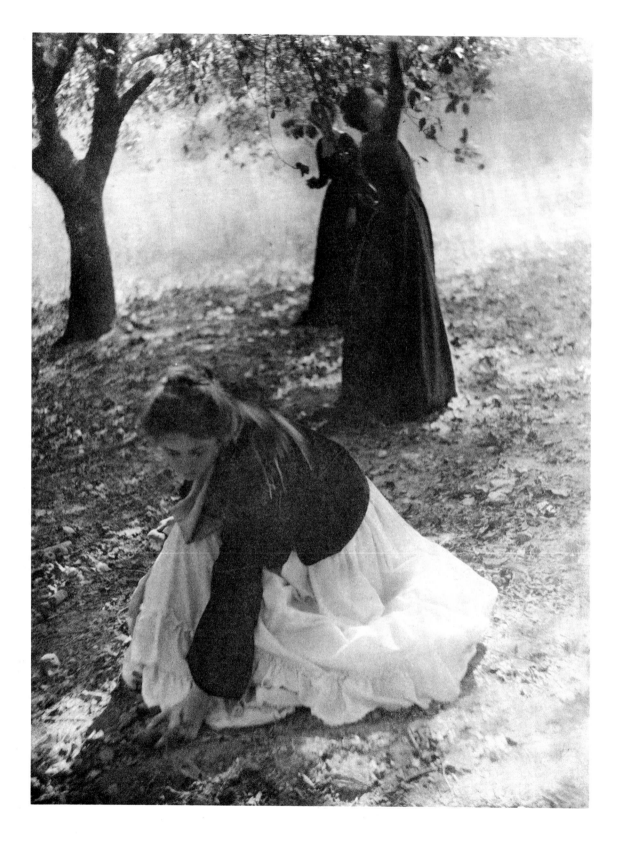

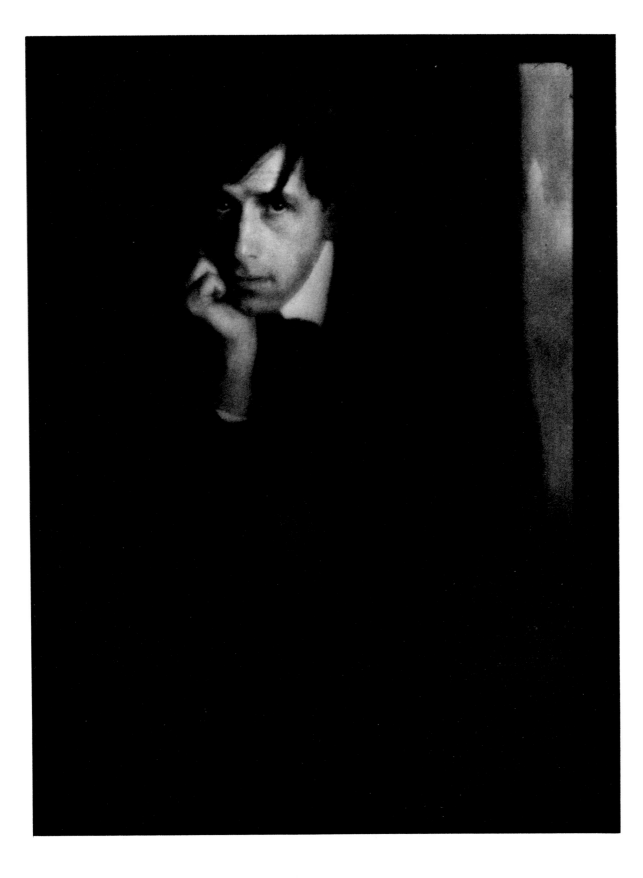

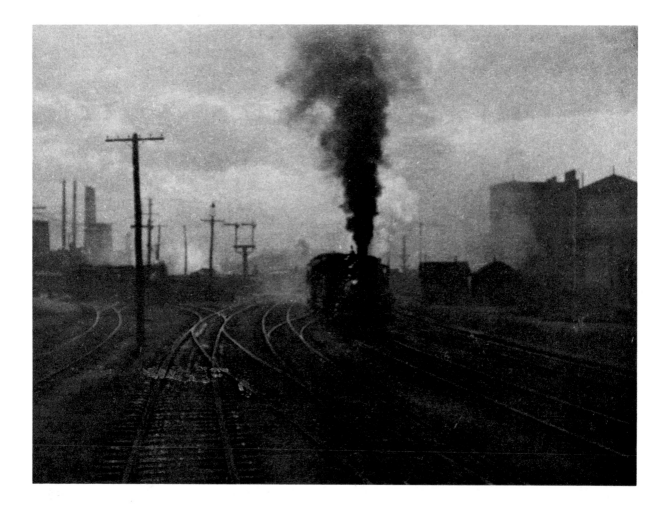

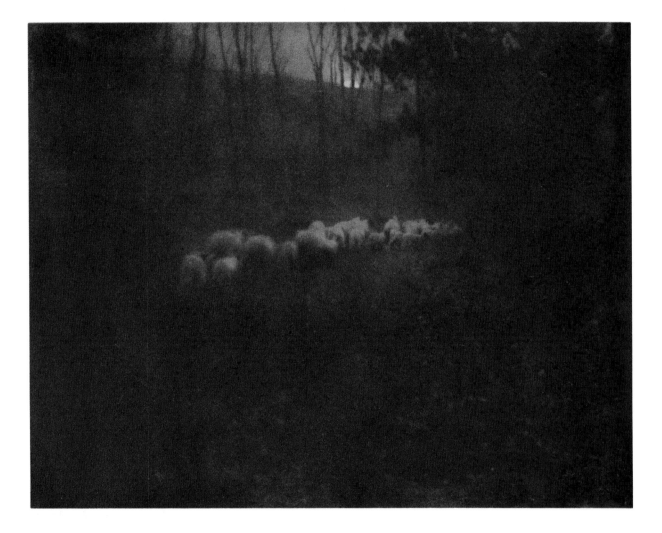

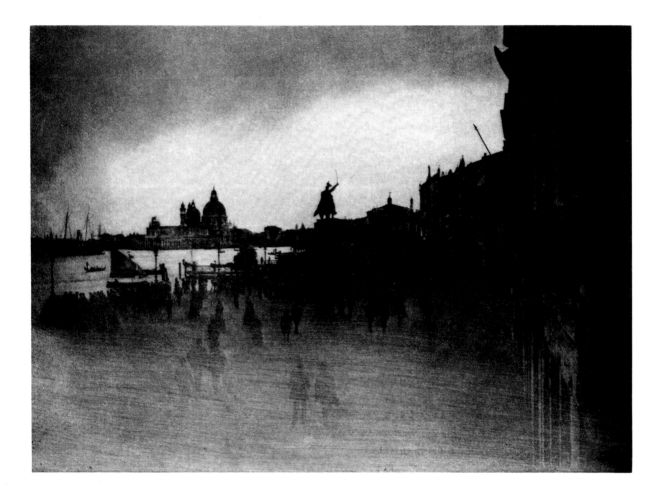

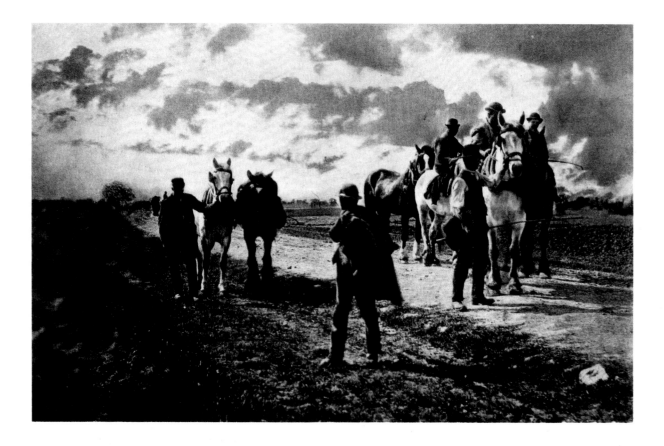

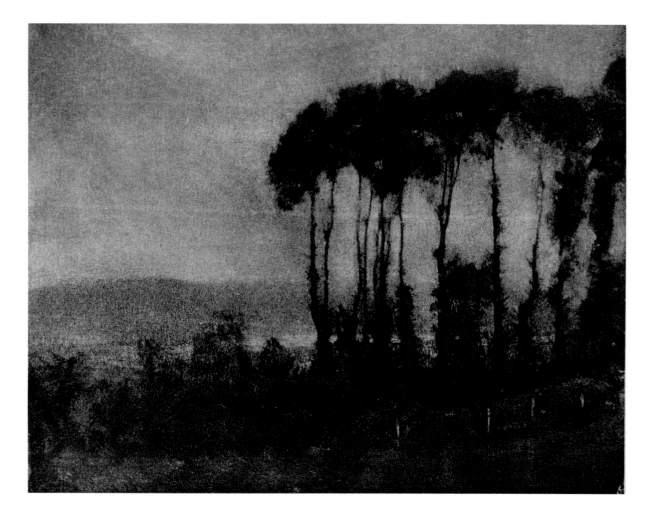

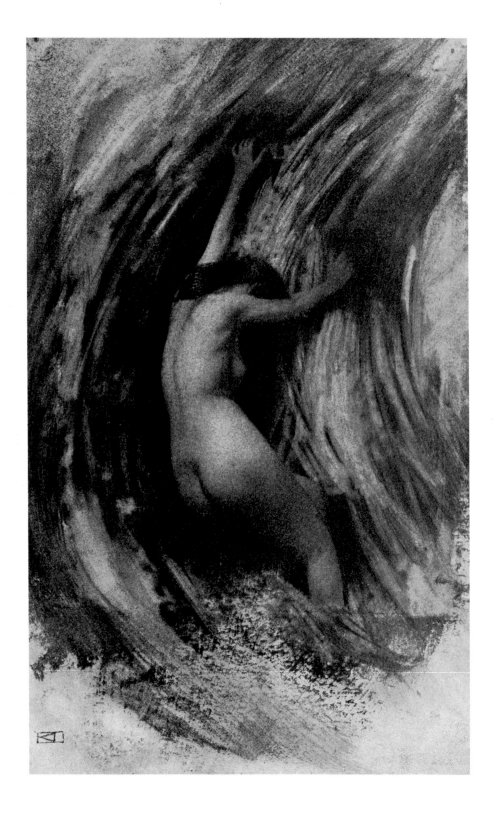

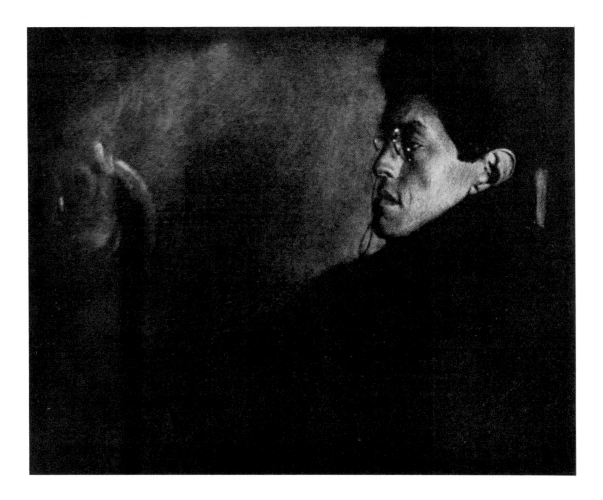

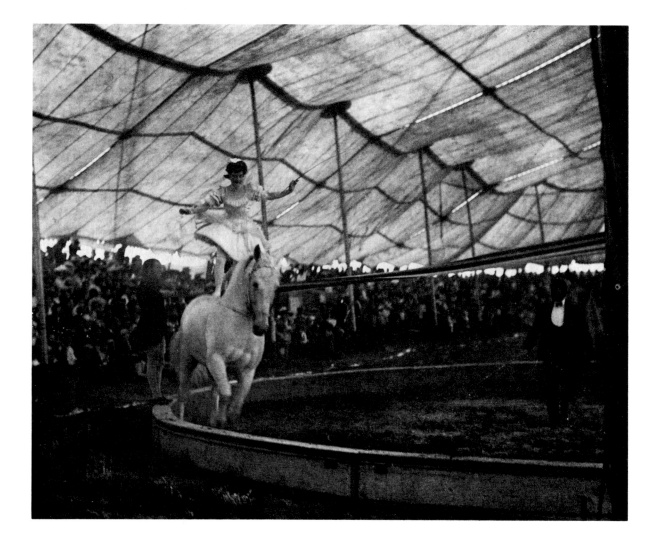

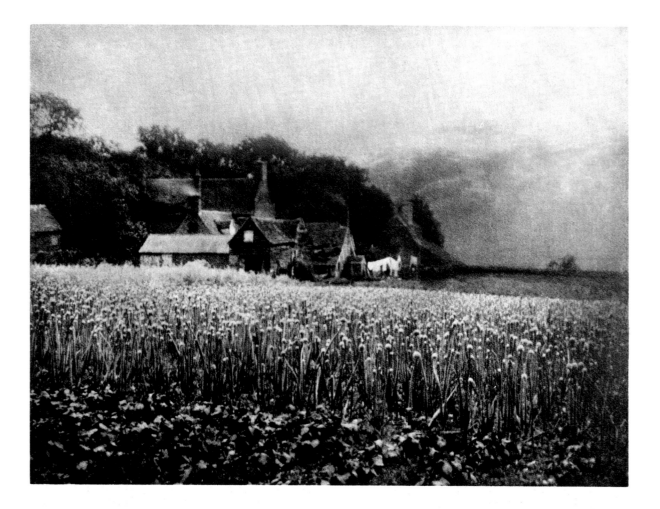

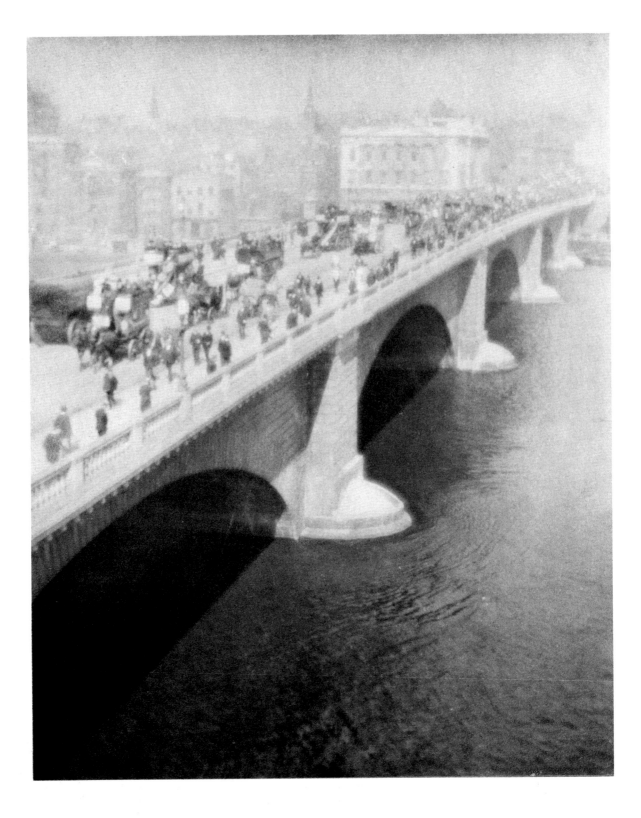

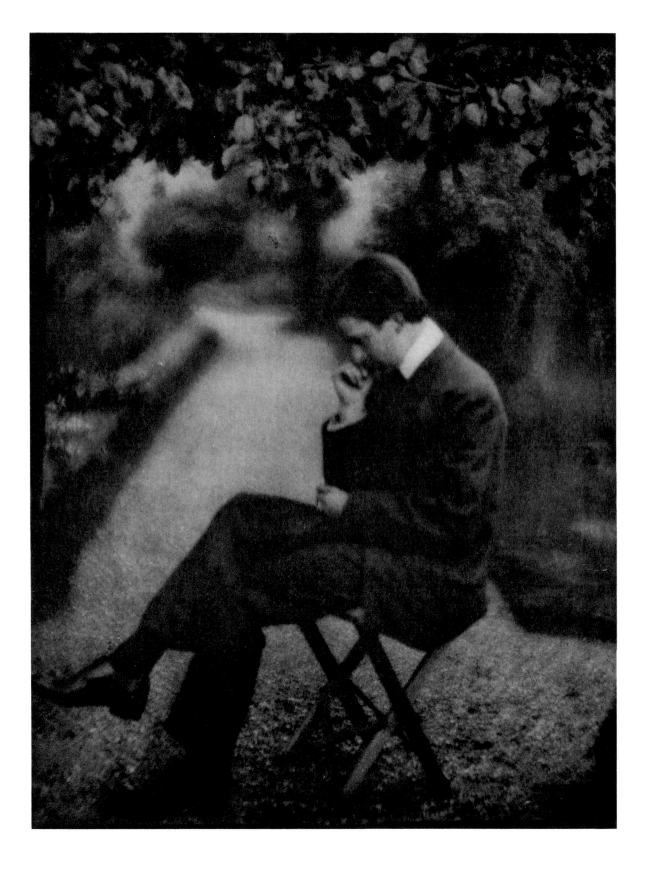

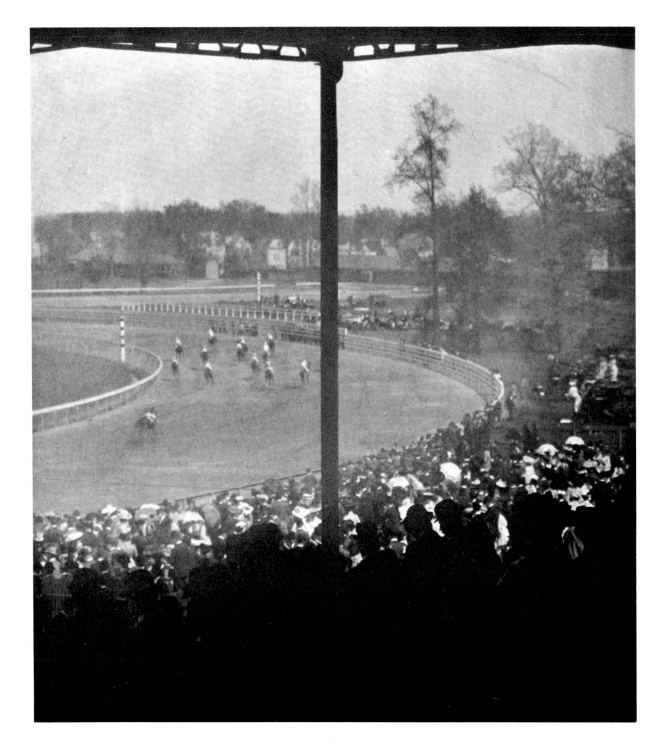

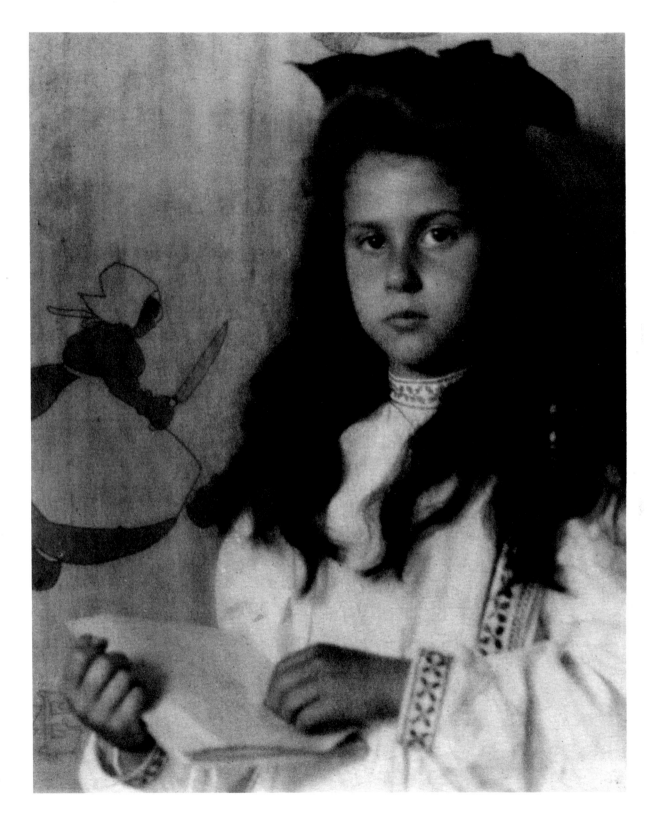

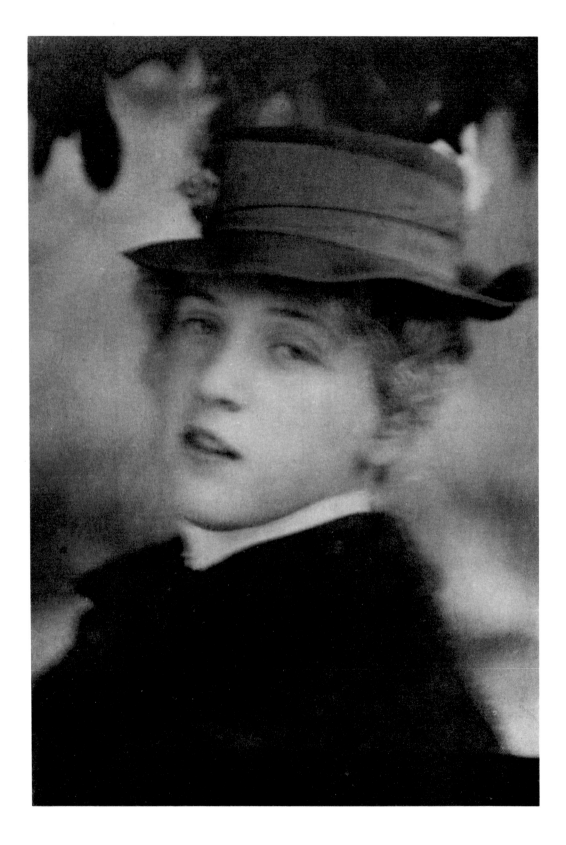

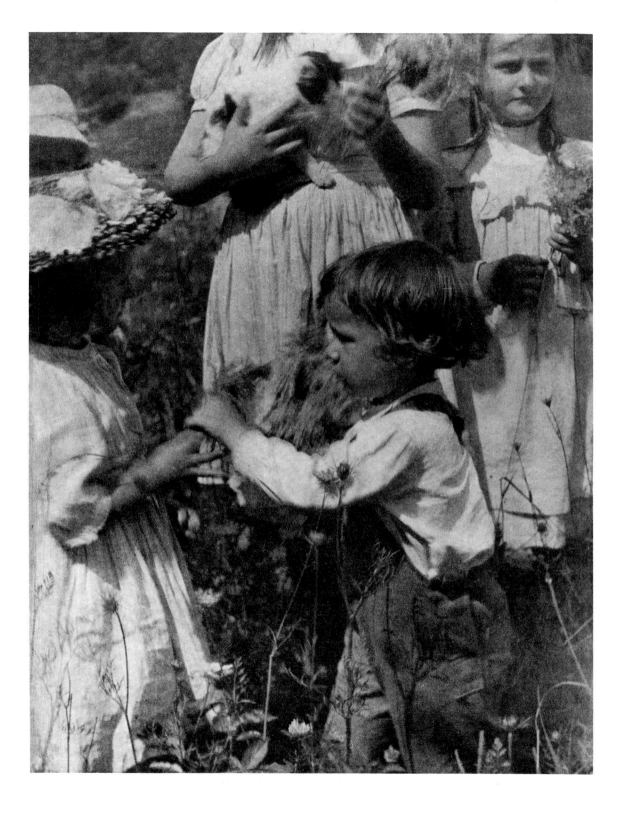

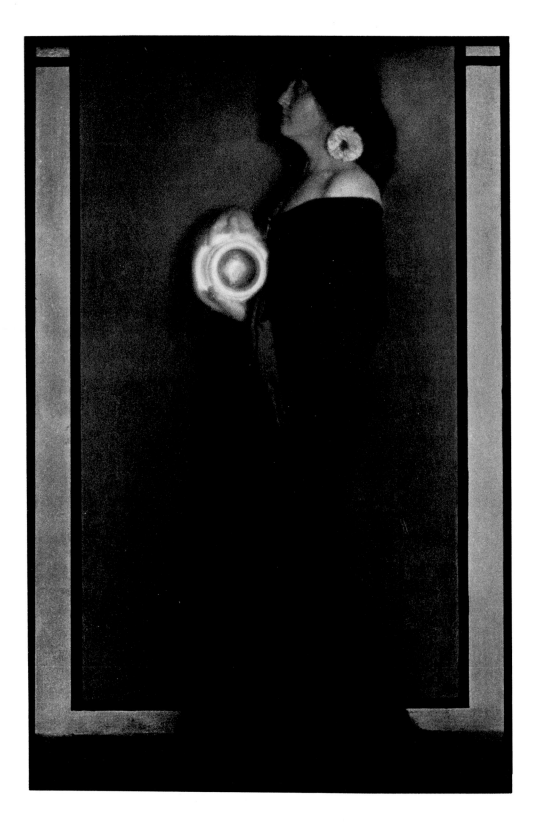

Nobody can look round the Salon without seeing that the remarkable and sometimes exquisite technique for which the French and American exhibitors are specially honored is not always an original photographic technique; and nobody who remembers the first Grosvenor Gallery exhibitions and their off-shoots (to go no further afield than St. James's parish) can possibly mistake these enthusiasts for anything but Academicians. The Academic enthusiasm is a wonderful and beautiful thing when it is young; but it leads to a dull, decrepit age. When Benjamin West first saw the "Apollo Belvedere," he felt unutterable things; but if he had foreseen the curse that now superseded statue was to bring on later generations of Academy students he would have smashed it then and there. And a Whistler nocturne may in course of time become a greater academic nuisance than ten "Apollo Belvederes."

And now enough of sermonizing. Let us have a look at the actual photographs. . . .

<div align="right">G. Bernard Shaw</div>

The Photo-Secession Exhibition at the Pennsylvania Academy of Fine Arts— Its Place and Significance in the Progress of Pictorial Photography

ONLY after the smoke of battle has cleared away and the din and clamor of conflict have trembled into silence can adequate idea be gathered of real results. 'Tis then that forces, readjusting themselves to the requirements of conditions, seek to attain the logic of their purpose, along lines of least resistance.

Chaos evolving into inevitable order and law, often gropes blindly before reaching the right path. Too often through sheer ignorance, it involves itself in unnecessary travail and defeat—like the ant that must climb over rather than go around the obstacles in its path.

Responding to impelling instinct it must go forward—whither, it does not know.

Such, invariably, is the character of popular progress. Instinct compels advance; fear, born of ignorance, holds it back. And, of all retarding forces, fear of ridicule is the most powerful. With the majority, ridicule is more persuasive than the force of logic or canon. And 'tis well so, for, while ridicule has often killed what was of rare but fragile beauty and promise, it has been the Spartan test of the virile, of what is timely, well-balanced, and possessed of the robustness of Life. What it has not killed it has strengthened, developing the latent force, by pruning what sapped the strength. Often those who ridicule most bitterly are at heart in sympathy with those they ridicule, and are eventually to be found in their ranks. They are impelled to ridicule because they honestly fail to understand; or regarding the cause attacked lightly or without thought, be-

cause they would win reputation by ridiculing recognized persons or standards. At conflict with those who hold back are those who strive forward to some definite end, too full of the enthusiasm of conviction and of the correctness and desirability of their purpose to fear the force of ridicule. Them it but tempers, trains, and makes clearer of vision; teaches and corrects their weakness without weakening their strength of purpose; strengthens the lights, and supplies the shadows necessary to show by very contrast the brightness of Light. It is the shades and shadows that go to making the picture. Without them all would be monotony. Lacking the aid of the one, the other could not be made apparent. So, without ridicule and opposition, there would be no contest. Without contest, no progress.

The movement for the recognition of photography as a means of original pictorial expression has been not lacking of conflict, of opposition, of ridicule and misrepresentation, of Lights and Shadows. As so often happens, many of those engaged in the conflict had the same end in view. Others, fearing radical change, that would materially affect their professional standing, with the success of the movement, opposed its progress with the vigor that is born of the instinct of self-preservation. Others again saw in the conflict that was waging opportunity of personal advancement, and so agitated vigorously toward that end. Others again, from pure love of conflict, attached themselves to one party or the other, without possessing any pronounced convictions either way. While others still, sought convictions through conflict. Some, few in number, be it said to the credit of the photographic world, and they, as a rule, not properly of that world, professed and recorded convictions of one sort, till they felt higher pay could be gotten for their MSS., by advocating the opposite. So the course of the conflict was bedimmed—confused—and, to the casual observer, often extremely hard to follow. The really essential facts of progress and accomplishment were, on the one hand, often either not known or but imperfectly so, to those who most loudly discussed the subject; or on the other, being known, not infrequently ignored through indifference or lack of understanding of their real trend and significance; or else deliberately misrepresented or suppressed from motives of idle mischief or sheer malice.

There were in consequence differences of every sort and in all quarters. With its beginnings photography had a few dignified organizations, usually of savants, for the promotion of its progress. When popularized and brought within reach of nearly everyone, through being made comparatively inexpensive, and so simplified that but small knowledge of any sort was required to be able to produce photographs, there sprang into existence, all over the country, little clubs of those who had cameras. The majority of their numbers had neither scientific nor artistic training. With most, it was a mere pastime, that gave birth to the ambition to "make pictures." Soon there were small exhibitions here and there that faithfully reflected the crude beginnings of the movement. As the idea began to take more definite shape, clubs began to have their fac-

tions. Magazines sprang up, a few representative ones of general interest, a whole army of small fry each devoted to the theories, party policy, or exploitation of their particular following. Then began to simmer the question—what really constituted a picture. This led to innumerable quarrels, which, as a consequence, drew together those having the most advanced and definite ideas upon the subject. Their efforts evolved what were known as the Joint Exhibitions, held annually alternately in New York, Philadelphia, and Boston from 1884 to 1894. These began well, but in time, with the majority, their larger purpose was subordinated to the desire for medal and riband, or place-winning. It soon became evident to the few who, understandingly, were striving for the advancement of photography as a picture-making medium, that the Joint Exhibitions had gotten into a rut that made further progress, through their assistance, impossible. The Exhibitions had ceased not alone to forward the movement, but were creating a condition and unsound standards that held back those who urged on, and ignoring their warnings, were rapidly degenerating the whole movement.

In 1894 Alfred Stieglitz, one of the chief prizewinners at these exhibitions, and at the time editor of the *American Amateur Photographer*, wrote:

> We Americans cannot afford to stand still; we have the best of material among us, hidden in many cases; let us bring it out. Let us make up our minds that we are equal to the occasion, and prove to the photographic world at large that we are awake, and interested in the progress of picture photography. Abolish these Joint Exhibitions, which have done their work and served their purpose, and let us start afresh with an Annual Photographic Salon, to be run on the strictest lines. Abolish medals and prizes; the acceptance and hanging of a picture should be the honor. There is no better instructor than public exhibitions.

In 1895 the Joint Exhibitions were discontinued, followed by widespread dissension.

In 1896, the aspirations of those striving for the advancement of the movement were voiced in the following language by the founder of CAMERA WORK:

> Photographic exhibitions in other countries are gradually decreasing in number, and greatly increasing in quality. Medals are being abolished in high-class exhibitions, and only the very best work hung. Let us hope that the United States will soon show the world the finest collection of pictorial photographic work ever seen, if only to make up for its former deficiencies and backwardness.

And in 1897 he established *Camera Notes* in the interest of the pictorial photographic cause, and to forward the movement initiated abroad, and attempted to be carried on here, through the instrumentality of these Joint Exhibitions. Two years later were inaugurated the Philadelphia Salons, national as to their submitted pictures, international by invitation, the warring forces of the past binding themselves by spoken and written pledge to their support. The great

army of amateur and professional photographers who had been reveling in, and winning medals and honors from, their various local exhibitions, failing to understand the real purpose and standards of the Philadelphia Salon, and vastly disappointed at having their elsewhere-successful "masterpieces" turned down at Philadelphia, waxed bitter and abusive. With the termination of the Third Salon, war again broke out with even greater fury. The Philadelphia Society, the oldest and most conservative in the country, was torn to its center by the conflict. The reactionaries, some of them pledged to the policy of the Salons as held, threw over that policy to which the Society was pledged. A fourth exhibition was inaugurated on lines absolutely in conflict with those of the previous years' "broad" lines,* that disestablished all recognized standards, sacrificed all that had been gained, deprived the Philadelphia Society of the confidence and trust of all those who had held faith in its past pledges, and shut out photography from the Pennsylvania Academy of Fine Arts, and threw the American photographic world once more into turmoil and confusion, with the result that the fourth Philadelphia exhibition marked the decline and fall of the Philadelphia Salons.

In reviewing the Third Philadelphia Salon, *Camera Notes* had warned the Philadelphia Photographic Society and the Academy of Fine Arts what would be the result did they violate their pledges to the photo-pictorialists, and abandon established standards. Commenting on the Exhibition of 1901, *Camera Notes* had closed its review of the situation with these words:

> The pictorial photographers of the country will now form their own organization, and hold their own exhibitions where the best interests of pictorial photography will be more faithfully guarded and consistently served.

Following the decline and fall of the Philadelphia Salon, came increased bitter dissension throughout the American photographic world. The Philadelphia Photographic Society was torn by conflict, and lost some of its oldest and most valued members. The New York organization also felt the force of the storm. An adverse administration having been elected, the founder and editors of *Camera Notes*, from sense of justice to that administration and sense of self-respect, refused longer to edit and publish a magazine whose policy was distinctly at variance with the organization of which it was nominally the official organ. They retired with the issuance of Vol. VI, No. 1, of that publication. With No. 4 of the same volume that magazine died. The opposition, ever ready with objection, seemed unwilling or unable to take up the work from which it endeavored to drive others. Out of all this chaos grew the Secession, a body com-

*For history of the Salon movement see *Camera Notes*, Vol. II, No. 3: The Philadelphia Salon—Its Origin and Influence; Vol. III, No. 3: The Salon—Its Purpose, Character, and Lesson; Vol. IV, No. 3: The Salon—Its Place, Pictures, Critics, and Prospects; Vol. V, No. 4: The Decline and Fall of the Philadelphia Salon. See *Photo-Times Almanac*, 1901, Photography and Progress; *Photograms of Year*, 1899 and 1900, The American School.

posed of those who believed in, and had been connected with, the photographic pictorial movement, who had well-defined ideas on the subject. Banded together to carry out those ideas as one man, they were pledged to loyalty to the movement and to each other, and to participate in no quarrel. Petty quarrels had been the bane of photographic progress—had time and again turned victory to defeat, brought earnest labor to sterile results, and engendered harmful ill-feeling and retrogressive discouraging chaos. Only by making such differences and conditions impossible could final attainment of success be hoped. Every person who came into the Secession did so with full understanding of its purpose and tenets, and was pledged to live up to both. Those who did not feel free to do this were not wanted in the organization, where unity of purpose and harmony of action were the governing laws. This did not mean that the work of outsiders, where up to standard, was not wanted. The contrary was the case. One of the Secession's objects was to exploit all representative work, whether by friend or foe, and the catalogues of all its leading exhibitions show names not enrolled with the Secession. It was its policy to put before the picture-loving public compact shows of the very best examples to be had of photography as a picture-making medium, and in such shape and manner as to excite attention and respect.

It was founded February 17, 1902. Its first exhibition was at the National Arts Club, on the invitation of that organization, in March of the same year. In that exhibition were thirty-two exhibitors, at least half of whom were not members of the Secession.

If success be a criterion, the correctness of the policy of the Photo-Secession at once became apparent in the immediate and convincing character of the results.

Collections of selected American prints were sent abroad by invitation on the strength of the showing of the National Arts Club. Not only did the American work win universal attention, but was enthusiastically conceded to be in the front rank of the pictorial photographic work of the world, and at Turin and elsewhere was awarded premier position among the national work shown. And, furthermore, its evident seriousness of purpose and convincing results won in many places serious consideration by the public and by the management of art institutions, of the claims of pictorial photography, a matter of far greater importance to the Secession. In *Die Photographische Kunst* for 1905, Ernst Schul recites what appears to have been the universal impression made by the American work abroad:

> It is a mark of maturity in them that they steer entirely clear of exaggeration, pretension, and modern affectations. They are the most modern of all, yet the most sure and reposeful. They are the most advanced, yet they have prepared their position with circumspection, and they reach a consciously selected goal with the calm of perfect deliberation, like the hunter who, with a cool and deadly aim, reaches his prey.

They do not overstep their limits, but seek the highest possible perfection within their clearly-defined sphere. They do not reach out for the impossible, the forbidden, and avoid every insincere pose. Being of a practical bend, they exploit the possibilities of their technique, thus producing a rare harmony between their aspirations and their attainments. At every step we feel that they have practiced long and hard; their development has passed through a number of stages; and their work is entirely free from the faults of the beginner's impatience.

When the announcement of the formation of the Secession was made public, it was received in many quarters rather derisively. But when successes here and abroad began to crown its earliest labors, the attitude changed to one of expectant interest. Finally, when all was ready, the Little Galleries were opened. The rooms were gotten up in the simplest possible manner, and a series of exhibitions put on the walls displaying numerous original examples of the best work of the world. Before opening the Little Galleries, the Secession, as has been seen, had tested its strength by exhibitions in the United States and abroad. As an organization, it had kept apart from all entanglements with other organizations. Effort was repeatedly made to affiliate it with other organizations, or to draw it into controversy. Experience had taught it the lesson of the safeness of standing alone. Into controversy or politics it always declined to enter. On the other hand, it opposed no organization or individual, and where good work appeared, at once gave it recognition, and sought to secure it for its own exhibitions. The exhibitions displayed in the Little Galleries, covered European as well as American work. All of the exhibitions attracted widespread and serious attention, not alone from the photographers, but from the art-loving public, the editors of some of the leading art magazines, and some of the leading painters of the city. During the last five months of this year's season, the galleries were visited in all by something over 15,000 people. Among those visitors came the manager of the Pennsylvania Academy of Fine Arts, which, having helped to initiate the Salon movement in Philadelphia in 1898, had, after four years, practically closed its doors on the photographers and their claims.

Under his progressive management the Philadelphia Academy has become one of the foremost and up-to-date institutions of art in the United States. One of the policies of the Academy was to place before its patrons examples of all the various media of art expression. During the season there had been international exhibitions of exceptional quality of painting in oil, in watercolor, in pastel, of sculpture, of etching, of engraving, of woodcuts, of lithographs.

Study of the Secession exhibitions convinced the manager of the Philadelphia Academy of the propriety and desirability of adding to the Academy's series of exhibitions one of representative photographic pictures, arranged by the Photo-Secession. The Secession was to make its own selection, to select its own exhibition rooms in the Academy, and to superintend the hanging of its own

pictures. The catalogue of this exhibition, published by the Philadelphia Academy, contained this foreword:

> The pictures in this exhibition have, with very few exceptions, been chosen from those that were hung in a series of exhibitions at the Photo-Secession Galleries in New York during the present season. They summarize in a broad way the trend of that international movement of which the Photo-Secession is the organized American exponent, a protest against the conventional conception of what constitutes pictorial photography.

At St. Louis, with whose Exposition the Secession refused to be associated a few years ago, though invited, because the Exhibition management evaded pledging itself to accord to pictorial photography, the recognition and standing accorded at Turin, and elsewhere, abroad and here, it being a principle of the Secession to surrender no ground gained, the Secession is now scheduled for an exhibition during the coming season in the Art Academy, and on the invitation of Mr. Halsey Ives, the Art Director of that Exposition.

And now the smoke of battle has cleared away, its din reverberates no longer, and it is possible, with calm brain and clear vision, to look over the field even to the horizon. All the serious workers and believers in the cause have turned their faces towards that horizon, and are already speculating as to the possibilities of the future that lies beyond. Some of those who in the beginning claimed to have been with the Secession, are now ranged against it, but they represent only themselves. The soundness of the principles for which the Secession was organized to contend have been more than tested, proven and sustained. Many, who in the past were, through misunderstanding, the bitterest of its opponents, are now ranged with it. Some, indeed, misunderstanding its purpose, have felt that the Secession has not done all that it might in helping individuals along the road to fame, through sympathetic appreciation, and allowance for the drawbacks of personal surroundings; and hence, that some careers have been marred through the Secession's failure to exploit work which, while often of great promise, appealed to the imagination largely through what, designed to convey, it failed to express, or did so but indifferently. Unlike certain critics, who appear to believe of themselves that a word from them could mar or make an artistic reputation, the Secession never suffered from any such delusion. The making or marring is alone the work of the individual. The worth of the work, not the individual, was that to which the Secession, by the very nature of things, was compelled to look; for its purpose was to marshal the best work to be had, in the most convincing manner possible, in the proving of its case; and it would seem from the results that its decisions were safe, and the verdict of the art public with it. Did it ever become possessed of the foolish vanity of believing that by its mere will it could make this one a great photographer, or pull that great one down, then surely would it soon perish, for endeavoring to arrogate to itself the function and powers of

gods and the Individual Self. The Secession does not claim to even begin to represent and encompass within itself all that is best and finest in American pictorial photography. It simply stands for an idea—that idea is faith in the future of photography as a medium of original art expression, faith in the principle that the soundness of an idea will be tested by time, and that the logical, consistent support of a sound idea is bound to win out in the end.

Today in America the real battle for the recognition of pictorial photography is over. The chief purpose for which the Photo-Secession was established has been accomplished—the serious recognition of photography as an additional medium of pictorial expression. But even for this there is now small room. The partisan feeling, that in the past ran high, and in moments of white heat made possible the publication of bitter personal attacks, has burnt itself out for lack of fuel. In that time all have learned salutary lessons; and to-day, in America, there are few photographic publications that are willing to descend to personal attack, or open their columns to vituperative abuse or ridcule of any worker. It has come to be generally understood that the Photo-Secession, because it has set unto itself a definite end, is not of necessity an enemy of all other organizations or movements. Furthermore, it has likewise come to be appreciated that all other photo-organizations seriously interested in the recognition of photography as a new medium of expression, are very materially and deeply interested in the aims and accomplishments of the Secession. So long as the photographers quarreled among themselves, as to standards and exhibitions and salons, it was impossible to carry conviction of their claims to those outside their circle and the public.

In reviewing the First Philadelphia Salon, that of 1898, voicing the convictions of those who were deeply interested in the advancement of the pictorial movement, and who had studied and taken active part in the movement here and abroad for many years practically from its inception, *Camera Notes* addressed the following words to those struggling for the universal recognition of photography as an independent medium of original pictorial expression, which, being equally applicable now as then, I shall quote in closing:

> Progress in the right direction can only be accomplished by the united action of all serious workers in photography, irrespective of race or country; for it is a true art, it knows no country, but claims the best energies of the world.

JOSEPH T. KEILEY

Is Herzog Also Among the Prophets?

I HAD been looking over the prints of F. Benedict Herzog, and listening with interest to his talk. At length he cornered me categorically. "Surely you will not deny that these prints have beauty?" "Certainly not," I said. Then he asked: "Has the like been done before in photography?" I replied that, as far as I knew, it had not. "Well, then," said he, "haven't I advanced the art of photography?" When I demurred that using photography for a purpose to which previously it had been put only by painters, did not seem to me to be carrying the art forward so much as backward he interrupted me: "That is what other people say. Now won't you explain your meaning?" I said I would try, and herewith make the attempt.

As I sit trying to arrange the train of my thoughts there strikes across it a flash of boyish memory, connected with a certain great lady. She was a very great lady. There could be no doubt of that, for she occupied a big, curtained pew in the chancel. When she stood up during the Creed a bit of black feather showed above the curtains, and I, a very small boy, was not the only member of the congregation whose eyes were fixed on that feather with a longing to see the face underneath it. For beside being a great lady she was a very great mystery, even to the villagers whose cottages nestled outside her park fence. Presently, when the service should be concluded, she would pull down her veil, and, escorted by the rector, pass through the churchyard, where the living clustered in groups above the sleeping places of the dead, while hats were doffed and curtsies bobbed, as the tall black figure cleft the sunniness of the footpath and cast a passing shadow over the grassy mounds. And it was not until the postern-gate at the corner of the churchyard had been opened, and the arch for a moment framed the black figure, and the door had closed upon it, that the awe was lifted from the people.

But I was privileged to see her, and much more of her than her face, as you shall hear. For, during her visits to the country, she laid a command upon the rector that he should dine with her every Sunday evening, and because of her wealth and that through him she distributed much of it to the poor, and because also she was a parishioner and ought to have a soul to be saved, he submitted to her whim. And on this occasion she had notified him to bring his little visitor, myself.

So in the hush of a summer evening I passed with him through the mysterious postern. I remember a house that looked as old as the church, but a hundred times bigger, with rows upon rows of windows, all dark except a few upon the ground floor; a stately terrace with peacocks standing on the balustrade, and when we approached they recollected, as the rector said, that it was bedtime, and rose in a mass and floated over to some treetops, where the park began in a broad avenue which stretched away so far that the dark trees seemed already asleep against the pale sky. But the memory of all this is blurred, as, too, is that of the great salon which was full of gold furniture. Presently, however, as we waited, the boy's hand snugly in the rector's, the curtains

107

over a doorway parted, and two tall men, more beautifully dressed than the grandest soldiers I had ever seen, stepped through. Each held a gilded sconce, brilliant with lighted candles; and the one stepped to the right a pace and the other to the left; then they drew apart the curtains, announcing in a deep voice, "Her Ladyship."

Yes, it was the Great Lady herself; a tall figure in a mossy green velvet gown that descended from the waist in volumes of heavy folds. Above her waist were bulging sleeves and a deep-cut bodice, that allowed more to be seen than to be conjectured. And it was all very white, while her cheeks were crimson, and her eyes large and very black, and her hair a mass of reddish gold. And as she stood there beneath the canopy of cloth-of-gold curtains, lighted by the glare of the candles held by the two grand men, she looked like some old pictures that I had seen, very wonderful and very ugly.

And indeed she was a painted lady—this and more about her I have heard since—and very ugly, with that terrible kind of ugliness that comes of an old woman's attempt to look young. She had been a noted beauty; artists had coupled her name with the creations of Paul Veronese, and rumor mixed her honor with somebody else than her husband. She had been a *femme galante*—but that was fifty years ago. Now she was a *devote*, and her mind, fixed on eternity, had lost count of the flight of time. Decrepit as she was, she fancied herself in the full glow of her mature attractions, and that evening, as on other Sunday evenings, she displayed them for the edification of the rector partly, but mostly of herself. It was a dreary meal, despite the gold plate on the table and sideboard. The lights were arranged to set off her person, as she sat with the rector on one side and me on the other, the rest of the long table vanishing into gloom, while the desolation of the huge room was relieved only by the spectral forms of six silent serving men. The rector exhausted his gifts of talk; she was mute, a decked corpse at her own Egyptian feast.

Crazy? Who knows? For my own part I was too young then to analyze causes, and today I only recollect her as a worn, sapless woman, masquerading in the memory of her past.

But why should Herzog's prints have awakened this reminiscence? If you are familar with them, you will recall that his motive is to create compositions of ideal beauty that shall appeal to the imagination through the decorative arrangement of line, masses, and chiaroscuro, and through sentiment of expression in the faces, poses, and gestures. Generally the appeal of these pictures is purely abstract; sometimes, however, it includes an allegorical or literary significance. His method of composition is based upon the principles brought to perfection by the great Italians—a balanced distribution of nicely calculated repetitions and contrasts. They derived it from the study of antique sculpture, influenced also, one may suspect, by the example of architecture. For, as in the case of the latter, it is a composition of geometric arrangement, as florid as the designer chose to make it, yet essentially precise and formal.

The example of Michelangelo, Raphael, and Correggio, was imitated broadcast through the seventeenth and eighteenth centuries, until Winckelmann once more directed the attention of artists to the original source of Greek sculpture. Painting, thus reinspired, produced a David, from whom are lineally descended the modern representatives of the so-called Academic School. Individuals have been variously affected by the naturalistic tendencies that surrounded and assailed the fortress of the Academy, but the latter still remains the exponent of form as opposed to color, of the formal, artificial building-up of "ideal" compositions instead of the representation of life. It stands for art as a thing separate from and superior to nature, in opposition to the modern effort to find the ideal in a union of art and life.

In applying the academic principle to photography, Herzog is without a rival, whether one considers the abundance of his studies or the knowledge and skill they exhibit. Yet the question arises: Is what he is doing worthwhile? I will try to consider it from two viewpoints: that of pictorial art generally, and of photography in particular.

Its relation to the academic department of painting is direct and close. Herzog, the photographer, is using his art as a good many painters use theirs—actuated by similar motives, employing corresponding methods, and producing practically equivalent results.

The *motive* is similar, for all set out to invent an ideal composition, in which the effects of nature shall be superseded by artifice. As to *method*, they start with some kind of preliminary sketch in which, as they would say, they "hunt" the line; decide upon the general direction and character of the lines and the distribution of the masses. Then for each of the figures a model is separately posed. The painter makes a detailed study of it; copying such parts of the figure as satisfy his taste, correcting others to bring them up to his standard of perfection, and changing the features and expression of the face to accord with his ideas of beauty and sentiment. Or, as is frequently the case, he will save a good deal of time and trouble by having the model photographed; after which he has a lantern slide made, and throws the figure onto his canvas, draws it in either with his own hand or his assistant's, and subsequently adds what he can of perfection and sentiment. It is in this particular that the painter, while making a convenience of photography, boasts his superiority to it. He is not, he says, dependent on what the camera sees; he can have an antecedent conception, and work to it freely from start to finish. In this he recognizes, as we all do, the artistic limitations of the camera, but is ignorant of the artist-photographer's ability to reduce them. We will refer to this later; meanwhile it is pertinent to remark that this criticism of photography comes mainly from the academic painter, whose mind is blurred with the academic formula stated so bluntly by Ingres, that "form is everything."

However, even in this method of securing form-effects by the use of the camera, Herzog has gone the painters many times better. He has trained his

eye and feeling, as they have, by study of the old examples; and he can pose a figure, manipulate the draperies, and calculate the niceties of gesture with the best of them, and surpass them in the originality and resourcefulness of his inventions. You may pick out dozens of his studies that are more imaginative in conception and handsomer in the patterning of forms and spaces than the mural paintings which are the product of our academic painters. If "form is everything," he has them beaten; nor in the rivalry of coloring is he at much disadvantage, for the academic painter is not a colorist, and his tinted compositions make a poor showing beside the rich chiaroscuro of Herzog's prints.

He betters his painter-cousins in another way. With the audacity of the neophyte, he summons the conceptions of his imagination into immediate shape by posing a number of models simultaneously in one composite picture. In far less time than the painter bestows on the study of a single figure, he has secured a study of the whole. The results, as a rule, are surprisingly free from imperfections. With a remarkable faculty, simultaneously of comprehending the *ensemble*, and of being keenly sensitive to details, he handles his models with the genius of some great stage manager, evolving an intricate figure out of a bunch of ballet girls. They are responsive to his directions, and inspired by his purposes. On the other hand, if he is not satisfied with any attained result, he attacks his problem again, and, if need be, again and again, his own rapidity reinforced by that of the camera. So while a painter is tiring out his model over one drawing, Herzog can multiply his studies while his model or group of models is still fresh. The benefit of this is very marked. The best of his work has a spontaneity of feeling, a fluency of movement and line, compared with which a good many of our mural paintings seem mechanical and labored. They betray the evidence of having been built up piece by piece, while his would rather seem to have grown together. Therefore it is not surprising that the academic painters applaud Herzog's work as the best thing in photography, while some few even regard it as a menace to their own art.

And now for a consideration of his *results*. I have said they are practically equivalent to those obtained by the academic painter: by which I mean that they make a corresponding appeal to the spectator. How does the work of both affect us?

If we are satisfied with the abstract enjoyment to be derived from the beauty of lines and masses and chiaroscuro, we shall applaud it, not vociferously, perhaps, but sincerely. So, too, if we can still take an interest in allegory, and recognize, for example, in a lady, holding a toy ship, an adequate suggestion of the vastness and complexity of modern commerce; or, when the artist requests her to slip off her clothes, and hold a mirror, discover in this allegory of Truth some incentive to more honorable living in our own day. But I have strayed into an inadvertence; for this style of picture makes little or no pretense of wedding art with life.

What, however, if we happen to be much alive, and to know and to be impressed with the fact that the whole trend of modern science has been toward a better understanding of living, and the direction of modern art to try to body forth the form and ideals and emotions of actual present life? What, if, with no less respectful admiration for the dead Beethoven, we thrill to the modernity of the living Strauss? Will such of us be able to satisfy our sense of structural beauty, our spiritual consciousness, and the eager longing of our physical and mental life, with this comparatively puny effort to revive the spirit of a past that is dead? For the Academician, whether painter or photographer, is only stirring ashes out of which all fire is passed. The fire is dead because the conditions are dead which started it and fed it. For in its recovery of art and knowledge, the world of the Renaissance was a young world, with, at once, a child's sexless attitude toward form, and the natural man's capacity for passion: a world of pageantry, set before all eyes in religious and public ceremonies, familiar to those of high estate in palaces and courts; an age accustomed to mimic allegorical displays in which the stage carpenter, property maker, and costumer carried out the designs of the artist. And when the latter, in easel picture or mural panel, rendered the religious fervor of the masses, or the devotion, scarcely less religious, of cultivated people for the classic legends, or celebrated the pomp and circumstance of a municipality or a noble family, he conceived his subject with a mingling of naïveté and freedom of intention, and represented it in a manner of formal stateliness or of splendid pageantry that was tuned to the emotion and experience of the time.

But today, and in America? Our drama, when it is anything but foolishness, is realistic; our engrossment, not with allegories and old-world myths, but with actualities of the present; our life is a fast and strenuous race, heeding little of ceremonial formalities; the cast of our mind toward seriousness and subtleties; our capacity for pain and pleasure multiform and complex. For all the youth of the nation, we have been born into a late time. Yet these academical artists would interpret the drama of our throbbing life by recourse to costumes, mechanicals, and properties dragged from the lumber room of antiquity. No wonder I was reminded of that painted, costumed anachronism, Her Ladyship, the Countess!

So far we have been considering Herzog in company of his colleagues the academical painters. It remains to discuss him in relation to his own, particular art of photography. We recall that the latter is a new art, as electricity is a new science. Each has captured and harnessed an elemental force: the one to transmit speech, the other, sight. Each is endowed with motive power: electricity to move the body, photography, the spirit. We recall too, that contemporary with the development of photography has been a new development in painting. The new motive of the latter, intent at first upon the actual representation of form, as it is, gradually passed to a study of the *milieu* in which all form appears—the *enveloppe* of lighted atmosphere. The realist and the idealist, alike, discovered

that the means to attain his purpose was to be found in the rendering of light.

The one, by rendering the light upon his figure, gave it increased reality; the other, noting how the variations of lighted atmosphere changed the aspect of the landscape, discovered that the rendering of light was a potent means of emotional expression. For the grand generalization of old-fashioned chiaroscuro, the artist, working in the modern spirit, has substituted a delicate analysis of light. Moreover, in studying the effect of light on the local colors of objects, he has discovered new subtleties of tone. In a word, *quality*, as represented in the "values," or degrees of light, and in "tone," or the relation of lighted surfaces to one another, is now both the motive of his craftsmanship and his medium of expression.

Herzog, however, regards this *quality* as being purely a trick of craftsmanship, attainable in its perfection by anyone with a reasonable knowledge of and skill in photograhic processes. If it is so simple a matter, how surprising that so few attain it! His own failure to secure this *quality* he explains by saying that he does not consider it of sufficient importance!

It is precisely in this respect that he proves himself to be out of touch with his time and with the modern aims of painting and photography. Though he is handling a new medium, which is peculiarly responsive to the new technical motive, he puts it to the service of a motive that is belated. He affects to belittle it, forgetting that it is by the use of this technical "trick," as he styles it, that Whistler expressed the beauty of his conceptions, and that the modern landscape picture has been brought to its present efficiency; that, in a word, it is to the use of this "trick," that the majority of what is best in modern pictorial art is to be ascribed. Meanwhile, he himself locks step with the painters of Her Ancient Ladyship, as she masquerades in the gewgaws of her youth.

But there is another aspect of *quality*. It is not only a matter of technique, but a medium of expression. Of this, however, it would seem that Herzog is completely unconscious. Yet he must admit, I suppose, that even in manipulating the technical "trick," the result is considerably determined by the operator's own personality. He can not prevent the print from becoming an expression of either the depth or the shallowness of his artistic intentions. Herzog's own prints, for example, betray the limitation of his purpose. They show him to be mainly occupied with the abstract beauty of line and mass, with the unindividual expression of form—the academic ideal of expression. Meanwhile, the tendency of the modern world has been toward individuality, and the modern artist has extended his conception of beauty in order to include Rembrandt, for example, as well as Bouguereau.

So far as it can be put into one word, the new ideal is character—both expression of character and character of expression. The modern artist seeks to discover the individuality existing both in himself and in his subject; and, not in the manner of sweeping generalizations, but of searching and exact analysis. He is conscious of a complexity of sensations in himself and of suggestions in

the world about him, and seeks to interpret their subtlety. He has found the means in this new idea of technique. It is to him an instrument of wide range and sensitive possibilities, responsive to the variations of his own moods, and suggestive to the imagination of others; and, as the musician, not satisfied with brilliant finger work, demands *quality* in his instrument, and seeks to express *quality* in his playing, so the painter and photographer, if he is in touch with modern feeling, tries for *quality* in his pictures.

Herzog doesn't. In belittling the technique of quality he proves himself behind the march of the last fifty years; in not caring for its expressiveness, he is out of touch with the modern spirit. While photography, like painting, has been striding toward a new light, he has made a strategic movement to the rear, and set his face backward, to where the sun has long since set. In the dwindling glow of its reflection he conjures up the phantom of Her Ancient Ladyship.

<div align="right">Charles H. Caffin</div>

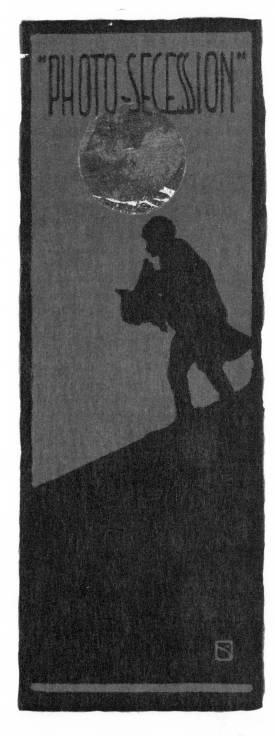

Permanent Exhibitions (November-
April) of Pictorial Photographs—
American, Viennese, German, French,
British—as well as of Modern Art
not necessarily photographic, at the
"Little Galleries," 291 Fifth Avenue,
New York City. Open week days
10-12 a.m. and 2-6 p.m. Visiting-
card admits

CAMERA WORK: AN illustrated quarterly magazine devoted to Photography. Published and edited by Alfred Stieglitz. Associate Editors: Joseph T. Keiley, Dallett Fuguet, John Francis Strauss, J. B. Kerfoot. Subscription price Six Dollars per year. All subscriptions begin with current number. Back numbers sold only at single-copy price and upward. Price for single copy of this number at present, Four Dollars. The right to increase the price of subscription without notice is reserved. All copies are mailed at the risk of the subscriber; positively no duplicates. Registering and special packing, Fifty Cents extra. The management binds itself to no stated size or fixed number of illustrations, though subscribers may feel assured of receiving the full equivalent of their subscription. While inviting contributions upon any topic related to Photography, unavailable manuscript or photographs will not be returned unless so requested and accompanied by required return postage. Address all communications and remittances to Alfred Stieglitz, 1111 Madison Avenue, New York, U. S. A. The Davison photogravures in this number by T. & R. Annan & Sons, Glasgow, Scotland; the others by The Manhattan Photogravure Company, New York. Arranged and printed at the printinghouse of The Fleming Press, New York. Entered as second-class matter December 23, 1902, at the post-office at New York, N. Y., under the act of Congress of March 3, 1879. This issue, No. 18, is dated April, 1907.

The Editors' Page

THE exhibition of drawings in black and color by Miss Pamela Colman Smith, held at the Little Galleries of the Photo-Secession in January, marked, not a departure from the intentions of the Photo-Secession, but a welcome opportunity of their manifesting. The Secession Idea is neither the servant nor the product of a medium. It is a spirit. Let us say it is the Spirit of the Lamp; the old and discolored, the too frequently despised, the too often discarded lamp of honesty; honesty of aim, honesty of self-expression, honesty of revolt against the autocracy of convention. The Photo-Secession is not the keeper of this Lamp, but lights it when it may; and when these pictures of Miss Smith's, conceived in this spirit and no other, came to us, although they came unheralded and unexpectant, we but tended the Lamp in tendering them hospitality.

On the Straight Print

THE old war between straight photography and the other one — call it as you like — has begun over again. It is not, as it ought to be a question of principle. No, it has become a personal question amongst a good many photographers, because most of them, and especially those who take purely documentary photographs, look to being recognized as artists. It follows that any definition of art that does not fit in with their methods will be violently attacked because the recognition of such a definition would limit pictorial photography to a certain number of men instead of throwing open the doors of the temple to the vast horde of camera carriers.

It is not without certain misgivings that I am attempting to give a clear résumé of this ever debated question, for I know that the above paragraph will be used against me and I shall be accused of "pleading for my saint" as we say. As a fact I am doing nothing of the sort, for though I believe firmly that a work of art can only be evolved under certain circumstances, I am equally convinced that these same circumstances will not perforce engender a work of art. Meddling with a gum print may or may not add the vital spark, though without the meddling there will surely be no spark whatever.

My meaning I hope has been made clear. Still there is a second point to be elucidated, and that is the precise signification of a term that we shall be using presently, "straight print." According to the sense that is given to this term the whole structure of our arguments may be radically changed and the subsequent verdict falsified. For here is *"par avance"* my opinion in a few words. A straight print may be beautiful, and it may prove superabundantly that its author is an artist; but it cannot be a work of art. You see now that it is necessary before entering into details to give a clear definition of the nature of the straight print as I understand it, and also a definition of the work of art. A straight print, to be worthy of its name, must first of all be taken from a straight negative. There must be no playing upon words in a serious controver-

sy of this nature. One must not call "straight" a bromide mechanically printed, but from a negative reduced locally and painted on the glass side with all the colors of the rainbow. This leads us to describe the straight negative. It will be a negative produced by normal development, or better still by tank development, during which no control is possible; and of course it will not be submitted to any subsequent retouching either on the film or on the glass. From this negative a print will be taken with a normal exposure without local shading. If the paper used for printing has to be developed, it will not be developed locally nor interfered with in any way during development. It will be mounted or framed without its surface being touched by a finger or a brush.

This is my idea of the sense of the term "straight print." If any readers consider that it is a false idea they had better leave the next pages unread. Now, speaking of graphic methods only, what are the distinctive qualities of a work of art? A work of art must be a transcription, not a copy, of nature. The beauty of the motive in nature has nothing to do with the quality that makes a work of art. This special quality is given by the artist's way of expressing himself. In other words, there is not a particle of art in the most beautiful scene of nature. The art is man's alone, it is subjective not objective. If a man slavishly copies nature, no matter if it is with hand and pencil or through a photographic lens, he may be a supreme artist all the while, but that particular work of his cannot be called a work of art.

I have so often heard the terms "artistic" and "beautiful" employed as if they were synonymous that I believe it is necessary to insist on the radical difference between their meanings. Quite lately I have read in the course of an interesting article on American pictorial photography the following paragraph: "In nature there is the beautiful, the commonplace and the ugly, and he who has the insight to recognize the one from the other and the cunning to separate and transfix only the beautiful, is the artist." This would induce us to believe that when Rembrandt painted the "Lesson in Anatomy" he proved himself no artist. Is there anything uglier in nature than a greenish, half-disemboweled corpse; or anything more commonplace than a score of men dressed in black standing round a table? Nevertheless, the result of this combination of the ugly and the commonplace is one of the greatest masterpieces in painting. Because the artist intervened.

If Rembrandt had painted that scene exactly as he saw it in nature he would have given us exactly the same impression that he would have felt in front of the actual scene, a sensation of disgust—mingled perhaps with a vivid admiration for the manual and visual skill of the copyist, but without a shadow of any art sensation.

Let us change the circumstances and take as example a beautiful motive such as a sunset. Do you think that Turner's sunsets existed in nature such as he painted them? Do you think that if he had painted them as they were, and not as he felt them, he would have left a name as an artist? Why, if the choice

of a beautiful motive was sufficient to make a work of art ninety percent of the graphic works in the world, paintings, drawings, photographs and chromos would be works of art, a few of them only are distinctly ugly and not as many commonplace.

Choose the man whom you consider the very first landscape artist photographer in the world; suppose he has, thanks to his artistic nature and visual training, chosen the hour and spot, of all others. Imagine him shadowed by some atrocious photographic bounder furnished with the same plates and lens as the master. Imagine this plagiarist setting his tripod in the actual dents left by the artist's machine and taking the same picture with the same exposure. Now, suppose that both are straight printers? Who will be able later on to tell which is the artist's and which is the other one's picture? But figure to yourself the artist printing his negative, selectively, by the gum bichromate or the oil process, or developing his platinotype print with glycerine. Even if the other man has used the same printing method one print will have the artist's signature all over it from the sky to the ground, the other will be a meaningless muddle. For *the man* has intervened in both cases. One has made a work of art out of a simply beautiful picture, the other has probably spoiled its beauty and certainly has introduced no art. The moral of this fable is twofold. It shows that a beautiful straight print may be made by a man incapable of producing a work of art, and that a straight print cannot possibly be a work of art even when its author is an artist, since it may be identical to that taken by a man who is no artist.

You will answer that a gum or an oil print from a master can be copied by a patient and painstaking worker, just as the above beautiful motive was stolen from the artist—well, you may try. I know of a man who has been copying Steichen to the extent of having canvas background painted exactly like the brush-developed background of one of his gum portraits. I prefer not to speak of the result. That it was all to the credit of Steichen you may believe.

Not once but many times have I heard it said that the choice of the motive is sufficient to turn an otherwise mechanically produced positive into a work of art. This is not true; what is true is that a carefully chosen motive (beautiful, ugly or commonplace, but well composed and properly lighted) is necessary in the subsequent evolution towards art. It is not the same thing. No, you cannot escape the consequences of the mere copying of nature. A copyist may be an artist but his copy is not a work of art; the more accurate it is, the worse art it will be. Please do not unearth the old story about Zeuxis and Apelles, when the bird and then the painter were taken in. I have no faith in sparrows as art critics and I think the mistake of the painter was an insult to his brother artist.

The result of all this argument will be that I shall be taxed with having said that all unmodified prints are detestable productions, fit for the wastepaper basket, and that before locally developed platinotype, gum bichromate, ozotype and oils, there were no artists to be found amongst photographers. I deny all

this. I have seen many straight prints that were beautiful and that gave evidence of the artistic nature of their authors, without being, in my private opinion, works of art. For a work of art is a big thing. I have also seen so-called straight prints that struck me as works of art, so much so that I immediately asked for some technical details about their genesis, and found to my intimate satisfaction that they were not straight prints at all. I have seen brush-developed, multi-modified gum prints that were worse—immeasurably worse—then the vilest tintype in existence, and I have seen and have in my possession straight prints by Miss Cameron and by Salomon, one of our first professionals, just after Daguerre's time, that are undoubtedly the work of artists. All is not artistically bad in a straight print. Some values are often well rendered; some "passages" from light to shade are excellent, and the drawing can be good if proper lenses are used at a proper distance from the motive; but there is something wanting, something all important, extremely difficult to express in words. If you can see it there is no use trying to describe it; if you do not, it is useless also, for you would not understand. But apart from the absence of this mysterious something, this thumb mark of the living, thinking, and feeling artist, are there not other things wrong in all straight photographs—faults due not only to the inevitable human errors in exposure and development, but to photography itself, photographic faults in the rendering of values (that no orthochromatic plates are capable of correcting without creating other exaggerations just as bad), faults in the equal translation of important and useless detail, in the monotonous registering of different textures, in the exaggeration of brilliant spots, and in other things, too? What will the pure photographer do when he has detected these faults? If he allows them to remain out of respect for the laws of the pure goddess photography, he may prove himself a high priest photographic, but will he still be a true artist, faithful to the gospel of art? I believe that, unless he has had his fingers amputated according to the dictates of Bernard Shaw, he will feel them itching to tone down or to lighten this spot or that, and to do other things also. But he *may not* do these things, the Law of the Straight Print forbids it. The conclusion is simple enough, for there is no middle course between the mechanical copy of nature and the personal transcription of nature. The law is there; but there is no sanction to it, and the button-pressers will continue to extol the purity of their intentions and to make a virtue of their incapacity to correct and modify their mechanical copies. And too many pictorialists will meddle with their prints in the fond belief that any alteration, however bungling, is the touchstone of art. Later on perhaps a sane, moderate school of pictorial photography will evolve. *La verité est en marche, mais elle marche lentement.*

Before ending I cannot but confess my astonishment at the necessity of such a profession of faith as the one I have been making. Pictorial photography owes its birth to the universal dissatisfaction of artist photographers in front of the photographic errors of the straight print. Its false values, its lack of accents,

its equal delineation of things important and useless, were universally recognized and deplored by a host of malcontents. There was a general cry toward liberty of treatment and liberty of correction. Glycerine-developed platinotype and gum bichromate were soon after hailed with enthusiasm as liberators; today the oil process opens outer and inner doors to personal treatment. And yet, after all this outcry against old-fashioned and narrow-minded methods, after this thankful acceptance of new ones, the men who fought for new ideas are now fighting for old errors. That documentary photographers should hold up the straight print as a model is but natural, they will continue doing so *in æternum* for various personal reasons; but that men like A and B should extol the virtues of mechanical photography *as an art process*, I cannot understand.

I consider that, from an art point of view, the straight print of today is not a whit better than the straight print of fifteen years ago. If it was faulty then it is still faulty now. If it was all that can be desired, pictorial photographers, the Links and the various secessionists of the new and the old world have been wasting their time, to say the least, during the last decade.

ROBERT DEMACHY

Pisgah

WHERE it happened, I shall not say. I mean to be the only one to venture there again, some springtide, when I want to forget that I am growing old—some springtide when the first feathery green of the hornbeams is vivid against the enmisted purple of the moist oak and chestnut forest, and when the slender, white stems of the old-field birches each upholds a canopy of yellow catkins. Again I shall go up the old, overgrown road, passing by the half-obliterated cellar-hole, the three graves, and the rude well, at the time when the gnarled old apple tree is trying to open a handful of blossoms as a protest against the general reversion to wilderness. Then I shall strike into the old charcoal-burners' path, that still winds its elusive way upward, and then scramble up through that same cleft in the rocks.

I shall not again drag a camera into these dim woodland aisles, as I did late in the day, that year when I felt young, and for shadows, forsooth! It is the best things of life that we cannot catch; that we may not hold; that we dare not try to keep—lest we be separated from our kind. The thrush knows the mysteries of such sanctified places, but he dwells there apart; and when I enter for a moment, as in a temple too vast for human creeds, I take off my everyday spiritual cap—or lid—but I must be mindful to screw it down again ere I depart, lest the devil-wagons of progress promptly immolate me, while I am beclouded by my own vaporings.

But that year I went there with a camera, through the still bare chestnuts and the tasseling oaks. One soon steps as gently as he may; for the beautiful budding laurels are rugged, and resent and resist other progress. The grouse

whirred up and away from their coverts, not so startled as I who had flushed them. Then I fared on over a silent brown carpet, beneath soughing scrub pines, and down into a dell of dense hemlock, all green and red-brown lights and shades. The fox that turned to look at me, ere he silently disappeared among the low-sweeping boughs, was not redder than the hemlock trunks where the late afternoon sun broke in on them. Peering through the branches, I saw a clear space, closed in by the hemlocks, big and little, in an irregular circle, while near the center stood a goodly maple, with low-hanging sprays thick with the coppery young leaves of May. On a low gray rock in front of the gray maple bole sat a girl clad in warm-toned gray, with hair of old copper, surely warmer even than the tone of the young maple leaves unfolding about her head. I stood still, for she had not seen me. A cloud had passed over the sun, softening the light within these mystic precincts. I braced my box against the hemlock beside me and gave as long an exposure as I dared. She had not moved; but then I dropped a plateholder, with a clatter, and when I looked up again, the cloud had fled from the sun, and the girl from her seat. The screen of boughs behind the maple still swayed, surely. But I felt guilty, and I intruded no further. I bore my plate home and developed eagerly, but found no girl on it, only a faint outline, like her figure, against the trunk of the maple, and over all an obstreperous intrusion of nearby hemlock fronds.

I was puzzled at the time, although I have learned since to be glad that I can see more than a camera. In my more youthful enterprise, I revisited the mystic spot. As I went quietly, I caught a glimpse of the fox as he stole away. There was no girl there, and only faint markings on the tree. I went across to the further fringe of hemlocks, and I circled round them. The laurels and brush closed in closely and uninvitingly; I did not care for a thrash through them. I went back to the rock that had served as a seat for my vision, lighted a cigar, and meditated pleasantly. The thing was charmingly natural. I glanced luxuriously over the mossy ground, which was a harmony of greens and browns. Then my eye paused near my feet—was arrested—fixed. In a bit of smooth mold, velvety with fine moss, was apparently the print of a girl's foot, of a small sandal. But further search was useless, and I turned back to the affairs of men. Now that I am older, and know more—and less—I have learned to be well content with what small hints of lovely things the gods may let fall in my way. Even if this forest nymph were just a tenuous figment of my imagination, she was also a renascent gleam of the wonder of the world. And the dull copper of young silver-maple leaves is doubly lovely for her elusive sake.

DALLETT FUGUET

The New Color Photography—A Bit of History

COLOR photography is an accomplished fact. The seemingly everlasting question whether color would ever be within the reach of the photographer has been definitely answered. The answer the Lumières, of France, have supplied. For fourteen years, it is related, they have been seeking it. Thanks to their science, perseverance, and patience, practical application and unlimited means, these men have finally achieved what many of us had looked upon practically as unachievable. Prof. Lippmann, of the Sorbonne at Paris, had a few years ago actually obtained scientifically correct color photographs, but his methods were so difficult and uncertain as to make each success very costly. In consequence his invention is only of scientific value. But the Autochrome Plate, as the plate invented and made by the Lumières has been named, permits every photographer to obtain color photographs with an ordinary camera and with the greatest ease and quickness. The Lumières evolved their plate from the theories of others, but the practical solution is entirely theirs. They have given the world a process which in history will rank with the startling and wonderful inventions of those two other Frenchmen, Daguerre and Nièpce. We venture to predict that in all likelihood what the Daguerreotype has been to modern monochrome photography, the Autochromotype will be to the future color photography. We believe the capitalist, who has for obvious reasons fought shy of color "fanatics," will now, in view of the beautiful and readily obtained practical results with the Autochrome plate, untie his purse strings and support the color experimenters whose numbers are already legion. The latter will thus receive a fair opportunity to work out their innumerable theories and countless patents. Who can predict what may yet be in store for us from these sources? In the meantime we rejoice in what we have. It will be hard to beat.

The Autochrome Plate photographs color automatically. A transparent support (glass) is covered with an adhesive matter which receives a coating of potato starch grains dyed blue-violet, green, and red-orange. After isolating this with a waterproof varnish (zapon, we believe) it is coated with a panchromatic (collodion) emulsion. The exposure is made in the usual way, but with the glass side of the plate facing the lens, so that the light passes through the colored grains and only then reaches the emulsion. The lens is fitted with a special yellow filter made by the Lumières for the plate. The plate is developed and then, without fixing, is treated in broad daylight with an acid permanganate reducer, rinsed and redeveloped. The result is a positive print in natural colors. If the exposure has been correct—and correct exposure is *the* essential for ultimate success—the results are uncommonly realistic. Thus far only one picture can result from each exposure. It is a transparency which can only be seen properly by transmitted white light or, if small enough to put into the lantern, on the screen. The Lumières, as well as others, are now at work trying to make possible the multiplication of the original, but so far the experimental stage has not been passed. No print on paper will ever present the

colors as brilliantly as those seen on the transparencies. This is due to the difference of reflected and transmitted light. The solution of the problem is but a matter of time.

It was in the beginning of June that the plates in small quantities were put on the market in Paris; a few plates had been sent to Germany to be tested by scientific experts. Elsewhere none were to be had. Fortunately for ourselves, Steichen and I were in Paris when Lumière was to demonstrate his process for the first time. The following letter sent by me to the Editor of *Photography* (London) speaks for itself: It is reprinted with the Editor's comments:

The Color Problem for Practical Work Solved.
The characteristically outspoken letter from Mr. Stieglitz, which we print below, will be read with interest by those who have seen some of the amusing deprecatory statements as to the real meaning of the Autochrome advance.

Sir,—Your enthusiasm about the Lumière Autochrome plates and the results to be obtained with them is well founded. I have read every word *Photography* has published on the subject. Nothing you have written is an exaggeration. No matter what you or anyone else may write on the subject and in praise of the results, the pictures themselves are so startlingly true that they surpass anyone's keenest expectations.

I fear that those of your contemporaries who are decrying and belittling what they have not seen, and seem to know nothing about, will in the near future, have to do some crawling. For upwards of twenty years I have been closely identified with color photography. I paid much good coin before I came to the conclusion that color, so far as practical purposes were concerned, would ever remain the *perpetual motion* problem of photography.

Over eighteen months ago I was informed from inside sources that Lumière's had actually solved the problem; that in a short time everyone could make color pictures as readily as he could snap films. I smiled incredulously, although the name Lumière gave that smile an awkwardness, Lumière and success and science thus far always having been intimately identified. Good fortune willed it that early this June I was in Paris when the first results were to be shown at the Photo-Club. Steichen and I were to go there together. Steichen went; illness kept me at home. Anxiously I awaited Steichen's report. His "pretty good only" satisfied my vanity of knowing it all.

Steichen nevertheless bought some plates that morning, as he wished to see what results he could obtain. Don't we all know that in photography the manufacturer rarely gets all there is in his own invention? Steichen arrived breathlessly at my hotel to show me his first two pictures. Although comparative failures, they convinced me at a glance that the color problem for practical work had been solved, and that even the most fastidious must be satisfied. These experiments were hastily followed up by others, and in less than a week Steichen had a series of pictures which outdid anything that Lumière had had to

show. I wrote to you about that time, and told you what I had seen and thought, and you remember what you replied. His trip to London, his looking you up and showing you his work, how it took you literally off your feet, how a glance (like with myself) was sufficient to show you that the day had come, your enthusiasm, your own experiments, etc., etc. — all that is history, and is for the most part recorded in your weekly. While in London Steichen did Shaw and Lady Hamilton in color; also a group of four on Davison's houseboat. The pictures are artistically far in advance of anything he had to show you.

The possibilities of the process seem to be unlimited. Steichen's pictures are with me here in Munich; he himself is now in Venice working. It is a positive pleasure to watch the faces of the doubting Thomases — the painters and art critics especially — as they listen interestedly about what the process can do. You feel their cynical smile. Then, showing them the transparencies, one and all faces look positively paralyzed, stunned. A color kinematographic record of them would be priceless in many respects. Then enthusiasm, delighted, unbound, breaks loose, like yours and mine and everyone's who sees decent results. All are amazed at the remarkably truthful color rendering; the wonderful luminosity of the shadows, that bugbear of the photographer in monochrome; the endless range of grays; the richness of the deep colors. In short, soon the world will be color-mad, and Lumière will be responsible.

It is perhaps fortunate that temporarily the plates are out of the market. The difference between the results that will be obtained between the artistic fine feeling and the everyday blind will even be greater in color than in monochrome. Heaven have pity on us. But the good will eventually outweigh the evil, as in all things. I for one have learned above all that no problem seems to be beyond the reach of science.

<div style="text-align:right">Yours truly,</div>

Tutzing, Munich, July 31st, 1907. ALFRED STIEGLITZ."

When Steichen visited Mr. Bayley, the editor of *Photography*, he gave him a box of plates to try and judge for himself what could be done with them. It is needless to say that Bayley took the cue. *Photography* came out at once with a blare of trumpets about the wonderful invention. The Steichen interview was printed in full. As no plates could be had in Great Britain until very recently — even France had virtually none in July and part of August owing to some trouble in the factory at Lyons — and as the editors had no opportunity of seeing any pictures, Bayley and his enthusiasm were laughed at with derision. It was then that my letter was written. As a result some of the English dailies which devote space regularly to photography had become keenly interested in color photography, although none had seen any actual results. In the United States also, most of the editors having followed the English press, were having great sport with the claims made about the pictures which they had not seen. Then

followed, therefore, a second letter to Bayley. It is more suggestive than comprehensive:

Mr. Stieglitz on the Personal Factor in Autochrome.

The following extract from a letter to hand from Mr. Stieglitz, which we have had his permission to publish, was written under the impression that the writer in the *Daily Telegraph* referred to had sufficient knowledge of the process and its results to give his opinion weight. We are informed that when the paragraph in question was penned he had seen no representative work on the Autochrome plates whatever. But the value of Mr. Stieglitz's views does not depend on the triviality or otherwise of the occasion that called them forth.

Why does a writer in the *Daily Telegraph* of August 23 rush into print and jump at erroneous conclusions not only about the Autochrome process, but about myself? I have overlooked nothing in considering the Lumière method of producing color photographs, I can assure him.

No one realizes more fully than I do what has been accomplished so far in color photography, what really beautiful results have occasionally been achieved in press color printing, and also in the other color processes thus far invented—Ives' Chromoscope, Lippmann, etc.* It is even my good luck now to be in Munich, where color printing is probably carried to the most perfect degree of the day, and where Dr. Albert—undoubtedly one of the greatest of all color experimenters as far as theory and practical achievement are concerned—has his laboratory and his plant. I have seen him; seen his newest experiments and latest results, and these, I can assure my readers, are in their way as remarkable as Lumières are in theirs. His methods are mostly still unpublished, and the world knows but little of what he has in store for it. A revolution as far as the production of color plates for letterpress printing is concerned is close at hand, thanks to Albert's genius.

Albert is a rare man in more ways than one; his is a scientific mind combined with a goodly portion of natural artistic feeling. Upon my showing him Steichen's color transparencies he granted at a glance—the glance of a student and expert—that in color photograhy he had seen nothing quite so true and beautifully rendered as Shaw's hands and wrists. Probably nothing in painting has been rendered more subtly, more lovingly, than has been by the camera in this instance.

We all realize that the Lumière process is far from perfection. It has its limitations, like every other process, but these limitations are by no means as narrow as we were originally led to believe.

We know that for the present at least the rendering of a pure white† seems impossible. Yet, artistically considered, this is not necessarily a fault. The pho-

*Etc. includes Joly, Sanger Shepherd, Brasseur, Pinatypie, Miethe, McDonough and others.
†Read scientifically pure white.—EDITOR.

tographer who is an artist and who has a conception of color will know how to make use of it. Steichen's newer experiments, as well as those now being made by Frank Eugene and myself, have proven to our satisfaction that the Lumière method has quite some elasticity, and promises much that will be joyous and delightful to even the most sensitive eye.

Certain results I have in my mind's eye may eventually lead to endless controversy similar to that waged not so very long ago about sharpness and diffusion, and to that now being waged about "straight" and "crooked" photography. But why consider that of importance? I wish to repeat that the Lumière process is only seemingly nothing more than a mechanical one. It is generally supposed that every photographer will be able to get fine artistic pictures in color merely by following the Lumière instructions, but I fear that suppositions are based upon mere illusions. Given a Steichen and a Jones to photograph the same thing at the same time, the results will, like those in black and white, in the one case reflect Steichen, and in the other case probably the camera and lens—in short, the misused process. Why this should be so in a *mechanical* process—*mechanical* and *automatic* are not synonymous—is one of those phenomena not yet explained, but still understood by some.

The Lumière process, imperfect as some may consider it, has actually brought color photography in our homes for the first time, and in a beautifully ingenious, quick, and direct way. It is not the ideal solution of color photography by any means, but it is a beautiful one, and, with all its shortcomings, when properly used will give satisfaction even to the most fastidious. Those who have seen the Steichen pictures are all of one opinion. Lumière's own examples which I have thus far seen, as well as those samples shown me at the various dealers in Munich, would never have aroused me to enthusiasm nor led me to try the process myself. That in itself tells a story."

My own opinion about the plates is reflected in the two letters, and little need be added to them. Eugene and I continued our experiments in Tutzing, but owing to circumstances over which we had no control, they were only of a comparatively short duration and made under great difficulties. We satisfied ourselves, nevertheless, that the scope of the plates was nearly as remarkable as the invention itself. The tests for permanency, and for keeping qualities, were all considered in the experiments. The varnishing question, an important one, is still unsettled in my mind. In short, the process received a thorough practical test in my hands, and my enthusiasm grew greater with every experiment, although the trials and tribulations were many, and the failures not few. On getting to Paris, on my way back to New York, I found that Steichen had not been idle; he had far surpassed his early efforts. He had been experimenting chiefly to get quality and tone, and had obtained some beautiful pictures. In fact he had evolved a method of his own for treating the plates.* Handwork of any kind will show on the plates—that is one of the blessings of the process—and faking is out of the question. Steichen's methods are solely chemical ones, as

must be everyone else's. This for the benefit of the many ready to jump at erroneous conclusions. On September 18th, I sailed from Europe with a series of pictures made by Steichen, Eugene, and myself. On the 24th I landed, and on the 26th the Press received the following notice:

To the Press: New York, September 26, 1907.

GENTLEMEN:—Color photography is an accomplished fact. That this is actually true will be demonstrated at an exhibition, reserved exclusively for the Press, in the Photo-Secession Galleries, 291 Fifth Avenue, on Friday and Saturday, September 27 and 28, between the hours of 10 and 12 A. M., and 2 and 4 P. M.

Mr. Alfred Stieglitz, having just returned from Europe, has brought with him a selection of color photographs made by Eduard J. Steichen, Frank Eugene and himself.

They will demonstrate some of the possibilities of the remarkable Lumière Autochrome Process, only recently perfected and placed upon the French market. These pictures are the first of the kind to be shown in America. You are invited to attend the exhibition.

<div align="right">

Yours truly, ALFRED STIEGLITZ
Director of the Photo-Secession.

</div>

On the days designated the Secession rooms were crowded with the best talent from the Press. One and all were amazed and delighted with what was shown them. A few had seen pictures done in Lyons by the Lumières themselves, and were not favorably impressed with them. Our early verdict was unanimously upheld. Thus, color photography and its wonders were set loose upon America. As I write, no plates are in the American market. The agents expect them daily. The practical uses to which the process can be put are really unlimited; the purely pictorial will eventually be but a side issue. Nevertheless, the effect of these pictorial color photographs when up to the Secession standards will be revolutionary, and not alone in photographic circles. Here then is another dream come true. And on the Kaiser Wilhelm II, I experienced the marvelous sensation within the space of an hour of marconigraphing from mid-ocean; of listening to the Welte-Mignon piano which reproduces automatically and perfectly the playing of any pianist (I actually heard D'Albert, Paderewski, Essipoff, and others of equal note while they were thousands of miles from the piano); and of looking at those unbelievable color photographs! How easily we learn to live our former visions!

<div align="right">

ALFRED STIEGLITZ

</div>

*A special supplement to CAMERA WORK is in the course of preparation. It is to deal with this new color photography. Steichen is preparing the text. The celebrated firm of Bruckmann, in Munich, early in July received the order to reproduce four of Steichen's early efforts for the book. They are the pictures of Lady Hamilton, Mrs. Alfred Stieglitz, G. Bernard Shaw, and the portrait group made on Mr. George Davison's houseboat The date of publication will be announced later.—EDITOR.

Is Photography a New Art?

WHEN photography was first discovered, and it was realized that machinery and chemicals could make what had hitherto been held to be exclusively the product of man's most superior faculties, many asked the question, "What will the artists do when this process becomes more nearly perfected?" The amazement at the almost magical result that had been achieved was so great that enthusiasm, and expectation of further and equally startling revelations, knew no bounds. Perfect results in color were confidently expected to follow shortly—then the artists were to go into bankruptcy. The painters for their part denied the possibility of machinery ever producing art; they engaged in controversy with the photo-enthusiasts, and argued the case endlessly.

This was in the first part of the last century. What is said of photography now? Are the portrait- and landscape-painters told that their doom is sealed, and that when color photography shall be discovered, their stuff will no longer be a desideratum? To the contrary, the word photographic, in the minds of the general public, is synonymous with pedantic exactitude, illogical selection, absence of imagination, and feeling in general; in fact, anti-art. Of course, as every one interested in pictorial photography knows, there are little oases like the Secession, and corresponding European organizations, in which the tradition that photography is an art is still kept up; but, as a widespread rule, the discussion is looked upon as closed—the public has made up its mind, and so far to the other extreme has its feeling swung, that even painters dare not say that they sometimes use the camera as an aid to their work for fear of being thought inartistic.

Now, it appears to me that the whole discussion as to whether photography is or is not an art has always been, and is still being, conducted on an illogical basis. The question rightly put is, "Is photography one of the fine arts?" To either prove or disprove this question, the disputants have always entered upon long definitions of painting, etching, charcoal, watercolor, and what not, in order to find what resemblances or dissemblances there were between these arts and photography. But on the face of it, this method of reasoning is fallacious, for the question asked is not, "Is photography one of the *graphic* arts?" but is, "Is photography one of the *fine* arts?"—and even if it can be proven beyond doubt that photography is not one of the graphic arts, it does not at all follow that it is not one of the fine arts. The conclusion I have come to after much investigation is that photography is not one of the graphic arts, but that it is one of the fine arts, and more closely allied to architecture than to painting. To prove my point, I will ask the reader to follow me through a short analysis of the different fine arts, and a little deductive reasoning.

Music makes its appeal to the sensibilities through the sense of hearing. The symbols it uses are sounds, pure sounds, without any intelligible meaning attached. The element of time enters as an all-important factor, much of the effect produced depending upon the relative duration of the different sounds,

and upon the spacing between them. What is termed rhythm is another factor. Poetry, although considered an entirely different art from music, appeals largely in the same way—sounds controlled by time spacing and rhythm act through the ear upon the intelligence. In addition, then, to its muscial components it contains thought, and this thought-element plays upon the sentiments, either directly, through associations, by arousing the imagination, or indirectly, through the reasoning faculties. Painting addresses through the sense of sight. It contains no elements of time, but representations of space. Its symbols of expression are colored or black-and-white imitations of fragments of nature. Though quite unlike poetry, some classes of painting, called illustrative, as the old Italian, possess a certain amount of the "thought" or literary element—even if not expressed in words—and act upon us in part like poetry. There are kinds of painting, however, in which the literary component does not exist, and these please purely through color, light and shade, and line. The art of sculpture, instead of dealing in representations of space, as does painting, deals in actual space quantities, which manifest themselves through light and shade, and line. Sculpture, curiously, although at first sight not obviously so, is dependent upon the time-element. Any single view of a piece of modeled clay or marble from a single point is not sufficient to its complete understanding—it is necessary that there should combine in the mind innumerable different impressions, and these impressions are only obtainable through a series of successive views. Further, these successive views must be presented to the mind in a logical time-sequence, such as that obtained by slowly walking around the piece of sculpture, and this, because much of the beauty of sculpture is due to what may be called the rhythmic appearing, changing, and disappearing of lines, and if the time-sequence of the successive views is not logical, the proper rhythm will not be produced, and much of the effect will be lost. The fine art of dancing, although enhanced by the color of the dancer, is really largely the same as sculpture, only the time-element is as important as in music.

It will be seen from this analysis that the fine arts differ from each other, not in that their components are totally unlike each other, but more in that the proportions of these components vary in quantity. Music and dancing have much to do with time; poetry, a little less; sculpture, still less, and painting, not at all. Poetry has much to do with literary thought; painting, a great deal less; dancing, and sculpture, still less, and music, not at all. Poetry and music are independent of the space-element; sculpture and dancing could not exist without it, and painting makes believe it possesses it. None of the fine arts possess all of the possible qualities, but each has at least one quality in common with another, and thus they all blend into each other, sometimes so subtly that it is impossible to tell where one begins and the other ends.

It would appear, however—at least according to the dictum of many learned philosophers of many ages—that there is one quality which all arts must possess, and that is what is termed the personal touch. I concede the prop-

osition, but as almost the whole controversy as to whether photography is or is not a fine art, has turned on this single point, let us make an inquiry as to what the nature of this "personal touch" is, and see if all the arts must really possess it, and, if so, whether it can be found in photography. In painting, what is usually called the personal touch evinces itself in local touches and exaggerations, unmistakably bearing the stamp of the work of a human being. However, different paintings vary as to the quantity of the touch they possess, archaic work being more strongly flavored with it than some more recent productions. In music, the personal touch is the fingertouch of the player. That this touch is necessary for the production of true music is proven by the fact that such machines as musical piano-players, and Pianolas, even when exactly rendering the score, cannot make music, and the more perfectly they are constructed, the more diabolical they are. In dancing, the personal touch mutates into actual existence—it is the person, as well as the personality of the dancer. In oratory, the personality of the person becomes so important that it receives a special name, magnetism, and without it, a man may utter Aristotelian wisdom unheeded, while another, possessed of it, will talk semi- or fully-idiotic propositions to a crowd beside itself with enthusiasm. In sculpture, the personal touch is very small in quantity; it can produce its effect by running extremely close to nature. Plaster casts of parts of the living body, when that body is beautiful, produce the same esthetic sensations, although in a smaller quantity, that actual, handmade sculpture does. Not merely is this true, but when the roughnesses which imitate the coarseness of the human flesh have been smoothed down, the result is still more artistic. But, strangely, this operation of smoothing is mechanical, and rather takes from, than adds to, the personal touch. In architecture—except in primitive forms—the "personal touch" *does not exist*, and it appeals to the emotions solely through its proportions.

Now, from the above, it would appear that either architecture is not a fine art, or the personal touch is not needed in art, or there has been something wrong in my reasoning. My reasoning, however, has not been wrong, and the personal touch is necessary in the fine arts, and, also, architecture is one of these fine arts. What is, and has always been, wrong, is the conception photographers attach to the term, personal touch. There are two meanings of the word: the first is the kind we have been speaking of, of which the orator has the most; the sculptor, very little, and the architect, none—the corporeal touch. The second is the true and philosophic meaning, namely, to create with the brain, and bring into concrete existence, through one or other of the physical organs, as by the hand. But to give life by the touch of the hand does not at all imply that, after life has been given, any evidence of how it was produced shall remain—in architecture, as we have seen, it is eliminated, and whole schools of even the graphic arts, as the Asiatic, demand that the personality of the creator shall be suppressed as much as possible.

And what does creation by the brain, and bringing into existence by the hands, mean? It means only one thing—composing. Man cannot truly create; but he can stick things together in such a way as to illude into the belief that he has created; and it is this esthetic quality of composition which all the fine arts must possess, but is the only one which they must possess in common. As the truth of this proposition is possibly not evident at first sight, I must again ask the reader to follow me through a short investigation to determine what composition is. Let us begin with composition in the graphic arts.

Any and every transcription of nature to canvas or paper will not make a composition; it is essential that such elements should be present that some particular idea is conveyed to the mind of the spectator. Further, it is equally essential that no more elements than necessary shall be present, for the superfluous both contradicts and detracts from the particular idea. And it is also equally important that the composing elements be so disposed that their contours shall naturally lead the eye over the picture in such a way that there be presented an esthetically logical sequence of facts. A composition is in fact like an American anecdote. If the raconteur places the different parts of his anecdote in a wrong sequence, the point is either entirely lost or marred; if he omits or adds, the result is likewise incomplete. A composition differs, therefore, from a scientific statement, in that it is not a matter of facts which can be stated in any way, and in any order, without destroying their truth, but it is a series of facts whose truth is purely dependent upon their special juxtaposition. Now, just why a series of facts, possibly commonplace enough in themselves, and entirely uninteresting in the combinations they are usually found in in nature, should suddenly become interesting when "composed," nobody knows. Why the same rocks, fields, trees, and sky seen from one point of view should look ordinary, but when looked at from another, should tell a story which affects to our innermost depths, is a mystery that has never been solved. Ruskin, in *Modern Painters*, after solving to his own satisfaction many enigmas, gives up composition in despair. At the conclusion of this long work he says, speaking of composition, "The power of mind which accomplishes this, is as yet wholly inexplicable to me, as it was when I first defined it in the chapter on imagination associative, in the second volume." Psychologists tell us that composition in some way appeals to the subconscious part of the brain, and that they are at work on the problem, but have not yet quite solved it. Philosophers inform us that somewhere within ourselves a sense of absolute order exists, and that when this sense perceives absolute order in nature it is pleased; but when it sees disorder it is displeased. Undoubtedly, the scientists and philosophers, as well as John Ruskin, are right as far as they go; but, unfortunately, they take us no further than we were. Therefore, all we can say is, that to compose is to give order. The sculptor and architect give order through lines and proportions, and light and shade. The orator, besides placing his ideas orderly, expresses

order through his voice, gestures, and even depends upon his physical stature and bulk. The painter produces order through lines and colors, and also by means of that peculiar *painter touch*, which those entering photo-polemics have so frequently mistaken for the true personal touch. The musician orders through sounds and silences, leading the mind, we know not how, agreeably from one note to the other. All art is a matter of order, and nothing else, and where order has been produced, art has been produced.

Let us now see how the truths we have been gathering apply to photography; and let us first see if photography is capable of order; for if it is not, it is not possessed of the basis essential to all the fine arts, and we need proceed no further. Let us examine portraiture.

If a photographer should photograph his sitter just as he happened into his studio, the result would, with an almost absolute certainty, not be a composition. But if he were to exercise his sense of order, and arrange the folds of the dress, the action of the figure, the background, and light and shade into a composition, and then photograph it, he would produce a work of art. To this proposition, it is frequently objected that the posed model would be the work of art, and the photograph only a photograph of a work of art. If this is true, the portrait-painter, who brings to bear all his imagination and taste in posing his model, and then copies what he sees, is not making a work of art. The proposition is absurd. The posing of the model is only a means to an end — of course, if it is a *tableau vivant* that the artist is striving for, why then, that being the end, it itself becomes the work of art.

The question of composing a landscape is more difficult, as every photographer knows. Landscapes can not be easily composed. The order must be found. I know that it is generally held that nature herself will never make a picture. I also know that until recently it was universally maintained that it was impossible to talk to a person a thousand miles away. But that nature does compose, is proven by the fact that straight photographs of her have been made, which fulfill all the demands of perfect composition. How, and why, nature composes, and how, and why, philosophers have fallen into the error of arrogating the power of composition to man alone, is a subject which it would take us even longer to investigate than the present one. It is sufficient for our purpose to know that she does compose, and that the photographer can transfix her compositions to his negative. But let it be noted, fallacious as the proposition may appear, that the full credit for any such composition belongs to the photographer who has seen it, and seized it; for it is just as difficult to see and grasp the meaning of a natural composition, as it is, by the painter's more lazy method, to get a little piece here, and another little piece there, and glue them together according to the rules of the studio. In fact, if the truth be known as intelligent painters know it, the artist really never composes at all; he merely hunts nature for bits to make into such a whole as he has once actually seen, but which he was unable, owing to its fleetness or other reason, to transcribe to canvas.

Having now shown that a photograph can be a composition; that it can contain that basic life, which all works of art must contain, let us ask, through what manner of flesh, through what symbols, does the composition manifest itself to our senses. The only possible answer is, through scientific imitations of fragments of nature. In other words, photography is the art that expresses itself through symbols, which, in their imitativeness of nature, are like those used in painting, but which, in their being scientifically made, and not hand-marked, are also like those used in architecture. That art may express itself through mathematically exact forms, I think I have sufficiently demonstrated; but if there remains any doubt in the mind of the reader, I will remind him that poets have on occasions used scientific symbols. Edgar Allan Poe, in his "Eureka," which he calls a prose-poem, and which it certainly is, speaks solely in scientific terms. It is true that the poem recounts his conception of the creation of the Universe; but he employs logical and material terms and scientific conceptions to produce his effect. It is through the proper ordering of these impersonal concepts, through exactly the right juxtaposition of mathematical facts, and even figures, that he makes a song as beautiful as could be sung in terms of love.

The conclusion, then, that we have come to is, that photography is one of the fine arts, but no more allied to painting than to architecture, and quite as independent in the series as any of the other arts. As a necessary corollary, photography cannot be *pictorial*, any more than can music or oratory. Photography is photography, neither more nor less.

Mr. Stieglitz's "Expulsion" — A Statement

THE recent unprecedented and indefensible action of the Trustees of the Camera Club of New York,* in expelling Mr. Stieglitz — a Life Member — without regard to the decent amenities usual among gentlemen, and in direct violation of the Constitution and By-Laws of the Club, was a matter which concerned only the parties to the incident. But the notoriety given to this disagreeable episode through the public press, and the refusal of the officers of the Club to state any reason for the action they had taken, requires that someone familiar with the history of the misunderstandings and jealousies which culminated in Mr. Stieglitz's expulsion, in justice to Mr. Stieglitz and his friends, and in justice to the Camera Club, too (though most of its members

*The Trustees of the Camera Club, New York: Messrs. Charles I. Berg, *President*; Chauncey H. Crosby, *Vice-President*; Frank M. Hale, *Treasurer*; Monroe W. Tingley, *Secretary*; John E. Hadden (*Ex-Secretary*, resigned during sessions); Harry T. Leonard (resigned before "verdict"); Willard P. Little, Hugo S. Mack, George W. Blakeslee.

Acting conjointly with the above as the extraordinary "Committee on Safety" were: Messrs. A. H. Colgate, F. Benedict Herzog, C. M. Brooks, H. M. Close, Leonard Faibisy, Ferd. H. Stark, Harry Coutant, Sidney Herbert, Arthur Robinson (resigned; attended no meetings). Mr. Crosby acted as *Chairman* of this committee. EDITOR

would no doubt deny the necessity for such justification), should place upon record publicly a short statement of the facts as they exist.

As an associate of Mr. Stieglitz upon the staff of *Camera Notes;* as a former member of the Camera Club, at one time active upon several of its Committees; as a Fellow of the Photo-Secession and Associate Editor of this magazine since its foundation, as well as by a close personal acquaintance with most of the prominent and successful workers in pictorial photography, I conceive myself as being fully equipped to state the case. In order to do this I must take our readers back for a space of about ten years:

In 1896 there was effected a coalition of the two moribund photographic associations known as the Society of Amateur Photographers and the New York Camera Club under the name of the Camera Club, New York. During the first year of its existence this new Club gave little evidence of life; but, in 1897, Mr. Stieglitz at last acceded to the repeated importunities of the Club members and consented to take an active part in the attempt to build up a real photographic organization upon the foundation of the Camera Club. Refusing the Presidency, he accepted the Vice-Presidency as leaving him freer to take an aggressive position in matters relating to photography without thereby prejudicing the Club as an organization. At this time he presented to the Club a plan for the publication of a regular quarterly magazine to take the place of a sporadic leaflet (the *Journal of the Camera Club*) which had been theretofore published for its members at irregular intervals. His plan practically guaranteed the Club against any expenditures greater than had been previously incurred in the publication of this leaflet. Each member was to receive a copy of the new magazine gratis. This scheme was eagerly accepted by the Club and thus *Camera Notes* was founded. During the next five years, under the leadership of Mr. Stieglitz, the Club and *Camera Notes* both prospered and both became pre-eminent in the photographic world. The policy maintained by Mr. Stieglitz and his friends in connection with the Club and the magazine remained throughout consistently the same, that is to say: each was to stand for only the very best in photography. Exhibitions open to the public were to contain only such work as conformed to the highest standards; criticism was to maintain its function as criticism and was not to be allowed to degenerate into flattery nor to be used as a political means of gaining adherents. In short, all the activities of the Club and of the magazine were to be directed towards furthering photography; thus giving meaning to the hitherto empty phrase: "The object of the Club shall be the cultivation and advancement of the science and art of photography," which appears as the Second Article of the Constitution of the Camera Club.

How well this policy succeeded is shown by the fact that the Camera Club became a leading force in the photographic world. Financially and in every other way it became a success, a result hitherto unprecedented and thought impossible of accomplishment in New York. During its prosperity the Club was not without its quota of malcontents, some of whom were honestly at variance

with this regime, but most of whom resented the unimportant role to which they were relegated in the Club and in the photographic world by this impersonal policy. But, so long as it attracted to the Club, from far and near, workers of promise and ability the policy was maintained in its full vigor, and from time to time, as the exigencies warranted, the standards were even raised. Then the game of politics was introduced by some of the malcontents and the fun was fast and furious while it lasted. At length, in 1901–1902, while the club was at the height of its success, its membership and treasury filled and *Camera Notes* swollen to fourfold its original size, Mr. Stieglitz and his friends became disgusted with the continual struggle and strife and determined to hand over both the magazine and the Club to the management of the opposition. After five years of incessant work and devotion, it seemed to Mr. Stieglitz that he had earned the right to peace and rest, and to devote his attention to the advancement of pictorial photography, which had ever been his hobby. It seemed to him that to hand over the reins at the time of prosperity could not be construed as being against the interests of the organization.

Freed from the labors connected with *Camera Notes* and the Camera Club, though he still retained his interest therein as an ordinary member, Mr. Stieglitz founded the Photo-Secession for the purpose of further advancing the interests of pictorial photography along the same lines that had made the Camera Club a success. Not wishing to disrupt or in any way injure the Camera Club, no real organization was ever effected for the Photo-Secession nor were any workrooms or facilities furnished which might have tended to draw members out of the Camera Club. For nearly three years the Secession had no headquarters and held its meetings in public restaurants. Not until the autumn of 1905 did it establish its Little Galleries, and these have always been used for exhibitions only. All Club features have been carefully excluded from its program.

After the withdrawal of Mr. Stieglitz and his friends from any participation in the activities of the Camera Club, the Club continued *Camera Notes* for three issues and then suspended publication. It was then that Mr. Stieglitz felt free to continue his efforts in behalf of photography by the publication of a new magazine, founded upon the old lines, but upon an even higher plane, and this without antagonizing the Camera Club, whose publication was now defunct. Thus CAMERA WORK was called into existence. Since then the Photo-Secession and CAMERA WORK have won success and approbation and have aggressively and successfully waged the battle for the recognition of photography. During the same period the Camera Club under its new management and policy gradually lost its prestige in the photographic world until, finally, its treasury depleted, its membership reduced over two-thirds and its dues doubled, the question of dissolution stared it in the face.

Much was said within the Club during its period of decadence to the effect that Stieglitz and his friends were in duty bound to attempt its rehabilitation,

but their interest had waned and their primary allegiance was now due to pictorial photography and its success. Even had they wished to undertake the task, the Club was too far gone for resuscitation. They had been damned when they did and were now perfectly contented to be also damned when they didn't. Thus the matter stood until January 4th, 1908, when without warning, without quarrel or words the following letter was received by Mr. Stieglitz:

Letter I.
<div align="right">

The Camera Club, N.Y.
New York, Jan. 4th, 1908.
</div>

Mr. Alfred Stieglitz, City.
Dear Sir: I have been instructed by the Board of Trustees to request your resignation from the Camera Club.
<div align="center">

Yours truly,

(Signed) JOHN HADDEN, SECRETARY.
</div>

Upon the advice of his friends this was ignored. There was no valid reason given for this demand, and resignation under these circumstances was open to misconstruction. Letter No. I was followed on January 13th by the following:

Letter II.
<div align="right">

The Camera Club, N.Y.
New York, January 13th, 1908
</div>

Mr. Alfred Stieglitz,
 1111 Madison Avenue, New York.
Dear Sir: I have been instructed by the Board of Trustees "to inform you that you have been relieved from service on the Print Committee."
<div align="center">

Yours truly,

(Signed) JOHN HADDEN, SECRETARY.
</div>

Mr. Stieglitz had been requested to allow his name to appear as a member of the Print Committee, although he had distinctly declined to be active thereon.

Coincident with this there was received Letter III, which is herewith given:

Letter III.
<div align="right">

The Camera Club, N.Y.
New York, January 13th, 1908
</div>

Mr. Alfred Stieglitz,
 1111 Madison Avenue, New York City.
Dear Sir: I have been instructed by the Board of Trustees to advise you that the Board requests an answer to letter written you on January 4th, asking for your resignation. In the event of your failure to reply on or before Thursday, January 16th, action will be taken under Section 3, Article 2, of the By-Laws, and, in consequence, under Section 4, Article 4, of the Constitution.
<div align="center">

Yours truly,

(Signed) JOHN HADDEN, SECRETARY.
</div>

Again acting upon advice of his friends this, too, was ignored. Then followed Letter IV.

Letter IV.
<div align="right">The Camera Club, N.Y.

New York, January 18th, 1908</div>

Mr. Alfred Stieglitz,
> 1111 Madison Avenue, New York.

Dear Sir: No reply having been received to the two formal requests for your resignation, I am directed to notify you that in the opinion of the Board of Trustees you have been guilty of conduct prejudicial to the welfare and interests of this Club. A hearing will be afforded you by the Board of Trustees on February 3rd, 1908, at the Club Rooms at 8:30 P.M., at which time the Board will take action upon the question of your suspension or expulsion from the Club.

<div align="center">Respectfully yours,

(Signed) M. W. TINGLEY, Secretary *pro tem.*</div>

> As the Constitution and By-laws of the Camera Club provide that:—
> "SEC. 3, Article II: The Trustees shall have power, by a majority vote, to suspend or expel any member of the Club, after a hearing, for conduct likely, in the opinion of the Trustees, to be prejudicial to the welfare, interest, or character of the Club, after two weeks' previous notice, in writing, to the member, of the time and place of hearing, accompanied by a copy of the charges preferred,"

and as this provision had not been complied with, in that no charges had been specified either verbally or in writing, Mr. Stieglitz under the advice of his friends, decided again to ignore the communication. This remarkable document is worthy of careful perusal. No charges are specified nor is any accuser named, yet the Board of Trustees (which is supposed to act as judge in these cases) declares that in its opinion Mr. Stieglitz has been guilty of conduct prejudicial to the welfare and interests of the Club, and that thereafter a hearing will be afforded him. Does it not violate all ideas of justice and fair dealing that the same body should act both as accuser and as judge, and does it not border upon the opéra bouffe that this same body should declare itself as having reached the opinion that Mr. Stieglitz was guilty before any hearing had been afforded him? The proceedings in the trial of the French Captain Dreyfuss appear judicial and eminently fair by comparison. Though no charges were specified, though no hearing had been afforded, the Board of Trustees in its multiple capacity as accuser, witness, judge and executioner, puts itself in writing as convinced of the guilt of the accused long before the date which they set for the so-called hearing. Further comment upon this seems unnecessary.

Letter V.
<div align="right">Camera Club,

New York, February 4th, 1908</div>

Mr. Alfred Stieglitz,
> 1111 Madison Avenue, New York.

Dear Sir: It is my duty to advise you that at a meeting of the Board of Trustees of the Camera Club, held on February 3rd, 1908, you were expelled from

membership in the Club and from all rights in or to any of its property.

I am directed by the Board to ask you to remove all of your property from the Club Rooms forthwith.

<div style="text-align: center;">Yours respectfully,</div>

<div style="text-align: center;">(Signed) M. W. Tingley, Secretary.</div>

Although the action of the Board of Trustees was illegal and outrageous and had been followed by the resignation of two of the Trustees and many members of the Club as a protest against this violation of all legality and decency, Mr. Stieglitz upon his own volition and upon the advice of his friends decided to accept the situation as it was. He felt that to his friends and acquaintances and to the photographic world he needed no justification. As a matter of fact, besides its breach of good manners and gentlemanly conduct, the matter was too trivial and ridiculous to be noticed except as a joke. But when the matter was exploited in the public press and when the officers of the Camera Club asserted for publication that there had been charges against Mr. Stieglitz, at the same time declining to specify what such charges were, rumor became busy and the friends of Mr. Stieglitz insisted that he should take steps to force the Camera Club to its senses.

Steps have now been taken to bring the matter by mandamus before the courts and to compel the reinstatement of Mr. Stieglitz. After this has been accomplished I am authorized by Mr. Stieglitz to say that he desires no further connection with an institution of the caliber of the Camera Club and will gladly tender his resignation if the Trustees will specify the charges which prompted the original request for his resignation. From my own knowledge of the circumstances as they exist there is but one valid reason upon which such a request for his resignation can be founded and that is that he has lived up to Article II of the Constitution of the Camera Club, which he himself helped to draw up, and by his advancement of photography through the medium of the Photo-Secession and of Camera Work, he has been guilty of conduct prejudicial to the welfare and interests of the Camera Club, New York.

New York, February 29th.

<div style="text-align: right;">John Francis Strauss.</div>

Since the above article was set up in type, the Trustees of the Camera Club have made return to the writ, issued by the Supreme Court of the State of New York, sued out by Mr. Stieglitz. In this return the Club tacitly admits the illegality of its action by stating that Mr. Stieglitz in the interval had been reinstated by the Trustees, and that it was therefore now unnecessary for the Court to compel such action by them. Their graceful retraction will be found in Letter No. VI:

Letter VI. The Camera Club, N. Y.
 March 10, 1908.

Mr. Alfred Stieglitz,

 1111 Madison Ave., New York.

Dear Sir: Below I give you a copy of a Resolution adopted by the Board of Trustees at a meeting held March 6, 1908:

"*Resolved*, That the action of the Board of Trustees taken at a meeting on February 3d, 1908, expelling Alfred Stieglitz from membership in the Club, and from all rights in or to any of its property, be rescinded, and that Alfred Stieglitz be reinstated as a life-member of the Camera Club, and in and to all his rights, title to or interest in its property and assets, to which he may be entitled as such life-member."

Yours truly,

(Signed) M. W. TINGLEY, SECRETARY.

Mr. Berg, President of the Club, now requested a conference with one of Mr. Stieglitz's friends. Disavowing any intention on the part of the Board of Trustees to convey by its prior action an impression derogatory to Mr. Stieglitz in any way, he was informed that Mr. Stieglitz, under the conditions that had arisen, was quite ready to sever his connection with the Camera Club as soon as the Trustees would place themselves on record, in writing, specifying in detail the charges upon which their original action was ostensibly based. After several conferences and some correspondence between Mr. Berg and the gentleman whose advice he had sought, the Trustees took formal action, as quoted, in the following letter addressed to the gentleman above alluded to:

Letter VII. March 21st, 1908.

Dear Sir: In view of the impression which you state has gone abroad on account of the utterances at various interviews quoted in the papers, and as you further state, "involving serious reflection on Mr. Stieglitz's personal character," the Board, at a meeting held March 20th, passed a resolution of which the following is a true copy:

"*Resolved*, That the charges against Mr. Stieglitz were not based upon any act involving any reflection upon Mr. Stieglitz's morality or personal character, but were based upon the fact that both by deed and action he has for many years worked against the interests of the Camera Club.

"And further, That he has continued the practice of building up and increasing the membership in his own *Organization from within the Camera Club, creating a body which has no interest in the Club except to use its rooms for business purposes, and its facilities almost exclusively for the benefit of the body alluded to; that this Organization, as originated, enlarged, and continuously directed by him, has been from the start, and is today more than ever, the center of disaffection to the general interests of the Camera Club.

*The Photo-Secession. — EDITOR

"That it is a cause for regret that any published statement should have been construed into a reflection upon Mr. Stieglitz's morality or personal character, which construction we deem entirely unwarranted."

<div align="right">

Very respectfully yours,

(Signed) CHARLES I. BERG, President.

</div>

Although the resolution of the Board of Trustees contained statements that Mr. Stieglitz's activities had been directed against the interests of the Camera Club, which statements are contrary to the facts and are susceptible of being disproved, yet the whole matter has proven so distasteful to him that despite his identification with the Camera Club and its predecessors for a period of eighteen years, Mr. Stieglitz prefers to bring this issue to a close, and he has accordingly presented his resignation from the Club. This was at once accepted.

Letter VIII.

<div align="right">

The Camera Club.
March 22d, 1908.

</div>

Mr. Alfred Stieglitz.

Dear Sir: I beg to notify you that your resignation, dated March 22d, 1908, from membership in the Camera Club of New York, has been presented to the Board, and I am instructed to notify you that the same has been accepted, to take effect at once.

<div align="right">

Respectfully yours,

(Signed) FRANK M. HALE, Secy. *pro tem.*

</div>

The Rodin Drawings at the Photo-Secession Galleries

IN art matters the month of January was a very live one in New York; several important exhibitions took place simultaneously, but none attracted more or probably as much attention as that of the Rodin drawings at the Little Galleries of the Photo-Secession. During the three weeks these were shown, connoisseurs, art lovers of every type, and students from far and near flocked to the garret of 291. It was an unusual assemblage—even for that place—that gathered there to pay homage to one of the greatest artists of all time. It may be said to the credit of New York—provincial as it undoubtedly is in art matters generally—that in this instance a truer and more spontaneous appreciation could nowhere have been given to these remarkable drawings. For the benefit of the readers of CAMERA WORK who did not have the pleasure of seeing the exhibition we reprint the text of the Catalogue in full:

In this exhibition an opportunity is, for the first time, given the American public to study drawings by Rodin. The fifty-eight now shown were selected for this purpose by Rodin and Mr. Steichen. To aid in their fuller understanding we reprint from Arthur Symons' "Studies in Seven Arts" the following extract from his sympathetic essay on Rodin:

"In the drawings, which constitute in themselves so interesting a develop-

ment of his art, there is little of the delicacy of beauty. They are notes for the clay, 'instantanes,' and they note only movement, expression. They are done in two minutes, by a mere gallop of the hand over paper, with the eyes fixed on some unconscious pose of the model. And here, it would seem (if indeed accident did not enter so largely into the matter) that a point in sentiment has been reached in which the perverse idealism of Baudelaire has disappeared, and a simpler kind of cynicism takes its place. In these astonishing drawings from the nude we see woman carried to a further point of simplicity than even in Degas: woman the animal; woman, in a strange sense, the idol. Not even the Japanese have simplified drawing to this illuminating scrawl of four lines, enclosing the whole mystery of the flesh. Each drawing indicates, as if in the rough block of stone, a single violent movement. Here a woman faces you, her legs thrown above her head; here she faces you with her legs thrust out before her, the soles of her feet seen close and gigantic. She squats like a toad, she stretches herself like a cat, she stands rigid, she lies abandoned. Every movement of her body, violently agitated by the remembrance, or the expectation, or the act of desire, is seen at an expressive moment. She turns upon herself in a hundred attitudes, turning always upon the central pivot of the sex, which emphasizes itself with a fantastic and frightful monotony. The face is but just indicated, a face of wood, like a savage idol; and the body has rarely any of that elegance, seductiveness, and shivering delicacy of life which we find in the marble. It is a machine in movement, a monstrous, devastating machine, working mechanically, and possessed by the one rage of the animal. Often two bodies interlace each other, flesh crushing upon flesh in all the exasperation of a futile possession; and the energy of the embrace is indicated in the great hand that lies like a weight upon the shoulders. It is hideous, overpowering, and it has the beauty of all supreme energy.

"And these drawings, with their violent simplicity of appeal, have the distinction of all abstract thought or form. Even in Degas there is a certain luxury, a possible low appeal, in those heavy and creased bodies bending in tubs and streaming a sponge over huddled shoulders. But here luxury becomes geometrical; its axioms are demonstrated algebraically. It is the unknown X which sprawls, in this spawning entanglement of animal life, over the damped paper, between these pencil outlines, each done at a stroke, like a hard, sure stroke of the chisel.

"For, it must be remembered, these are the drawings of a sculptor, notes for a sculpture, and thus indicating form as the sculptor sees it, with more brevity, in simpler outline, than the painter. They speak another language than the drawings of the painter, searching, as they do, for the points that catch the light along a line, for the curves that indicate contour tangibly. In looking at the drawings of a painter, one sees color; here, in these shorthand notes of a sculptor, one's fingers seem actually to touch marble."

As a further record we also reprint what some of the chief art critics of the

daily press had to say. These are the opinion-formers of the large majority of the American public. In no other city does this rule apply so generally as it does in New York, and for that reason the art critic really holds a more responsible position there than is usually realized. Is he always conscious of it?

J. N. Laurvik in the *Times*:

The exhibition of drawings by Rodin at the Little Galleries of the Photo-Secession, 291 Fifth Avenue, is of unusual artistic and human interest. It is also a challenge to the prurient prudery of our puritanism. As one looks at these amazing records of unabashed observations of an artist, who is also a man, one marvels that this little gallery has not long since been raided by the blind folly that guards our morals.

In these swift, sure, stenographic notes a mastery of expressive drawing is revealed—a sculptor's mastery—which is seldom beautiful, according to accepted standards of beauty, but that never fails to be interested and imbued with vital meaning. They have a separate, individual beauty of their own—the beauty of all expressive, characteristic things. Here are set down with an all-embracing scrawl the most curious contortions and unlikely postures of the human body. The soft undulations of the female form are recorded with a few hastening lines that speak eloquently of life. It is the quintessence of brevity, the essence of art expression that has here been flashed upon a piece of paper, illuminating unsuspected corners of the genus Man—the procreating machine.

There is a force elemental and appalling in these simple outlines, that has never before been presented in art. Life has been surprised and stands shivering, breathless and all absorbed in its passionate, flesh-crushing embrace. In these mad, glad yearnings of man, the female form is like an undulating, writhing, sinuous reptile that will not be denied its prey. It squats, toad-like, on all fours, it sprawls on the ground like the snake on its belly, face forward, arms outstretched with frog-like digits; it reveals the rippling, wave-like line of its profile as, with arms overhead, it fixes its hair, and, crouching on hands and knees, it exposes the flat base of the feet and the beautiful, broad expanse of the back as seen from above.

Some of these are colored with primitive Egyptian blues and reds and yellows, spread on the paper in delicate washes and puzzling blotches, as incomprehensibly childlike at times as the scrawl that envelops the color. A few facetious ones have likened these drawings to Gellett Burgess's "goups," and perhaps the analogy is not so farfetched, but surely more significant than these ready wits imagined. It is this unbiased quality, the very essence of good humor which becomes satire the moment it becomes biased, that gives to these drawings their great and abiding value. They express the child's wonder at the great facts of life as seen by a man who has lived and become acquainted with its spirit. It is this good humor and this wonder that keep them from being both vulgar and immoral. Nothing that concerns man is alien to him, and all natural acts are to him clean and beautiful.

In his work there is a modesty that defies prudishness and a manly outspokenness that confounds the licentious rantings of libertinism. In this he has something in common with Whitman and every other man who has not looked askance at life.

It is a hopeful sign of the changing order of things when work such as this can

be shown here in New York. No one interested in the development of the modern spirit in art should miss the opportunity of seeing these drawings.

Charles DeKay in the *Evening Post:*

One or two little galleries of the Photo-Secession at No. 291 Fifth Avenue and Thirtieth Street displayed, in a rather uncommon and very pretty fashion under glass plates affixed to the wall, a lot of line sketches of the nude. If their surroundings are highly esthetic and severely artistic, with a large A, the drawings themselves may be called X, if not XX. They are by a sculptor whom his admirers call *the* sculptor, without qualification or comment; they are by Auguste Rodin.

Living in a community which insists that even babies must wear clothes, not for warmth and health, but in the interest of what we are pleased to call morality, Rodin for years has tried to supply the lack of nudity which was visible on every hand in Old Greece and Recent Japan, by keeping his studio at the temperature that Princess Pauline Bonaparte would have approved, and by causing a number of persons to loaf about in that balmy air without a stitch upon them. Imagine a Turkish bath, without steam, plus plaster and plaster casts, clay figures in various stages of anatomical disturbance, a few sofas, divans, and chairs—and a half-dozen Adams and Eves walking, sitting, and lying about, talking to each other or engaged in some game, all the while striving to forget that they are not clothed and are models hired by the day, and that someone is always watching them, ever on the alert to capture their lines and curves, their unconscious poses and actions as they move.

The drawings at the Photo-Secession tell the story from the sculptor's point of vantage. Here we have the daily or rather hourly report by Rodin of what he found in the outlines of some of his nude models. Faces are the merest twist of the pencil; hands and feet are like those of gingerbread figures, all in outlines, some with addition of faint colors.

Gigantic female forms more repulsive than those of the daughters of Anak, whom Zorn finds in his native Sweden, lounge or kneel, or sprawl, or stand with uplifted arms. Sometimes one gets a bold line indicating a cheek, a breast, a thigh; sometimes a second line corrects the contour of a Gargantuan calf. They form a small part of a mass of memoranda for a student of the human form in every conceivable position, conscious or unconscious, and as such were clearly of great use to the maker. Possibly they may be of value to students, but the Secessionists of photography can scarcely expect the wider circle of amateurs to feel more than a gentle sense of curiosity satisfied.

Rodin is by all odds the most interesting, the most talked-of sculptor to-day, and anything that comes from his hand is worth seeing. We have here a hint of the preliminary studies for groups when several figures are placed in contact. We see the germ of "L' Homme qui Marche," the headless, armless torso on unfinished feet which appeared in plaster at the last Salon, a figure that forced the critics to see the modeling of the back to the exclusion of everything else. These colored and uncolored sketches are like that figure. Each contains a note understood by the sculptor. Each is a big thumbnail sketch for further reference.

W. B. McCormick in the *Press:*

Strange are the things that are done in a great man's name and under the beclouding influence of "art": This moral reflection is induced by the opening of an exhibition of fifty-eight drawings by Auguste Rodin in the Photo-Secession Gallery, No. 291 Fifth Avenue, which we believe are the first of their kind ever to be shown in this country and which may be seen until January 21. For the purpose of the exhibition the members of the Photo-Secession have issued a pamphlet containing some inspired nonsense about Rodin's drawings, by Arthur Symons, who writes with equal glibness and with equal fatuity on all manifestation of art. As a matter of fact these drawings should never have been shown anywhere but in the sculptor's studio, for they are simply notes dashed off, studies of the human form—chiefly of nude females—that are too purely technical to have much general interest except that of a not very elevating kind. Stripped of all "art atmosphere" they stand as drawings of nude women in attitudes that may interest the artist who drew them, but which are not for public exhibition. With the pencil sketches are also wash-drawings of the same sort, only one of which has any apparent beauty, this being a standing nude figure of a young woman holding a drapery of blue and white, but in such a manner that no detail of her figure is lost. Some of these wash-drawings were touched up with ink, and so loosely brushed in, that the medium has flown down over the drawing in such a manner as to mar the general effect of the sketch. It may be all very well to talk about the "drawing" and the other qualities of a purely technical kind in these studies. But they are most decidedly not the sort of thing to offer to public view even in a gallery devoted to preciosity in artistic things.

Rumpus in a Hen-House

BIRDS in their little nest agree? Nit. The term is vulgar, but the fact remains. For, once upon a time, there was a hen-house. Somebody must have built it; but the memory even of poultry, is short-lived. The cocks and hens in this sanctuary of fowldom had lost sight of history, and complacently believed themselves to be the originators and sole owners of this finest hennery on earth. They sunned themselves in the warmth of their self-admiration, and led the pleasant routine of laying eggs and fattening themselves for the ends of commerce.

All might have continued well but for the presumption of one of their number. He had started his career in the hennery like any other young rooster, cocky and quick in his desires, a little intolerant in his crowing. But it had been expected that this would wear off in time. As he advanced in years, it was taken for granted that he would settle down into a staid rooster, studiously solicitous about the feelings of the middle-aged hens. But he didn't.

If one can conceive of such a thing in a hen-house, he was an idealist. The very fluffle of feathers, that gave his head the appearance of an agitated hearth broom, showed him to be of some vagabond and adventurous breed, unbecoming the stolid conventions of a hen-house. But not less aggressive than

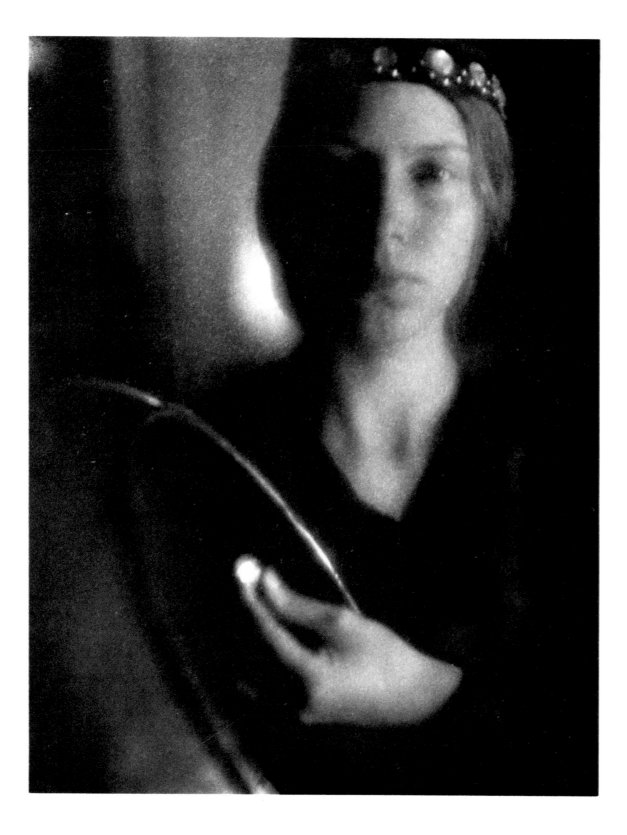

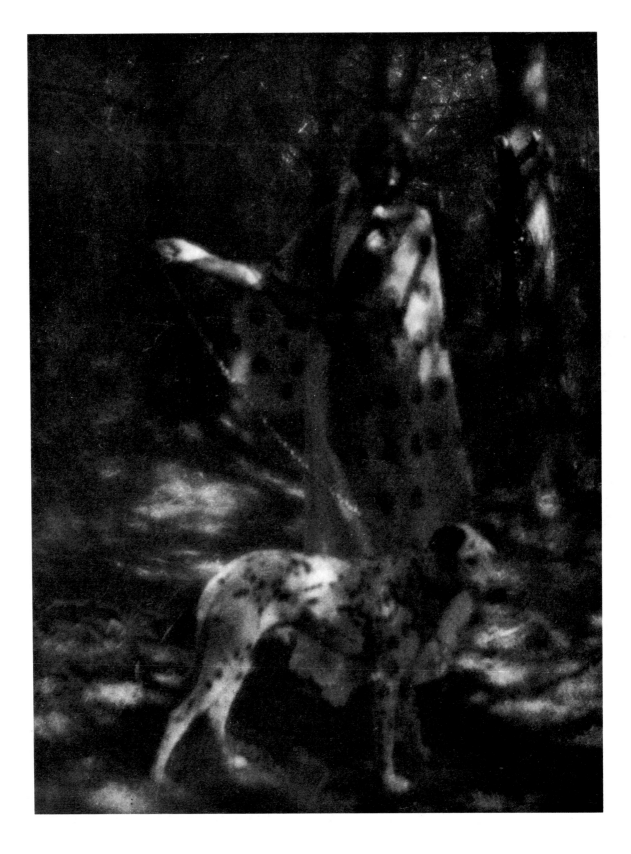

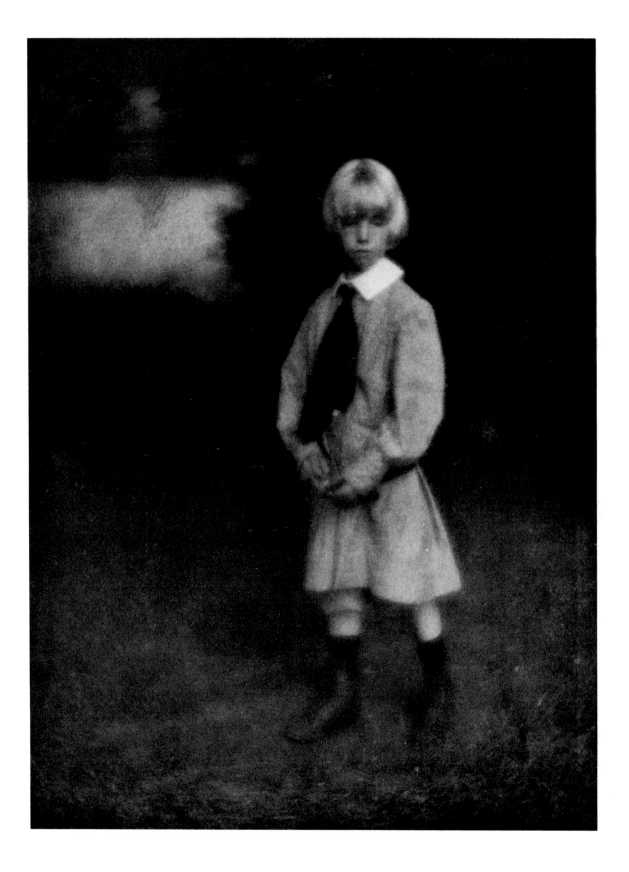

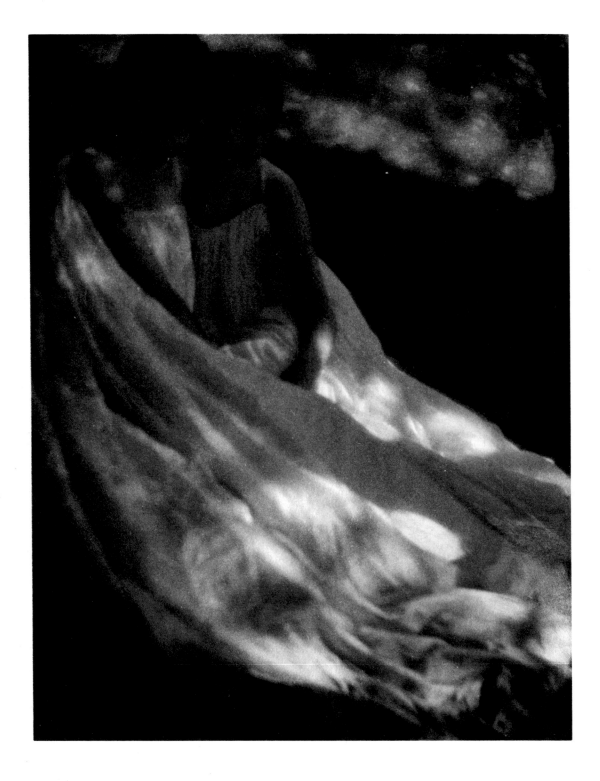

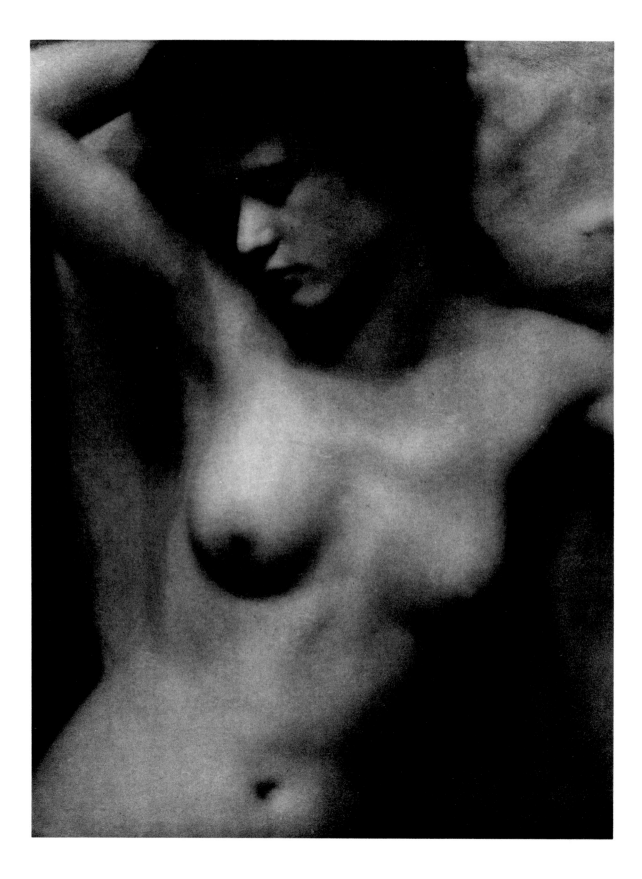

152

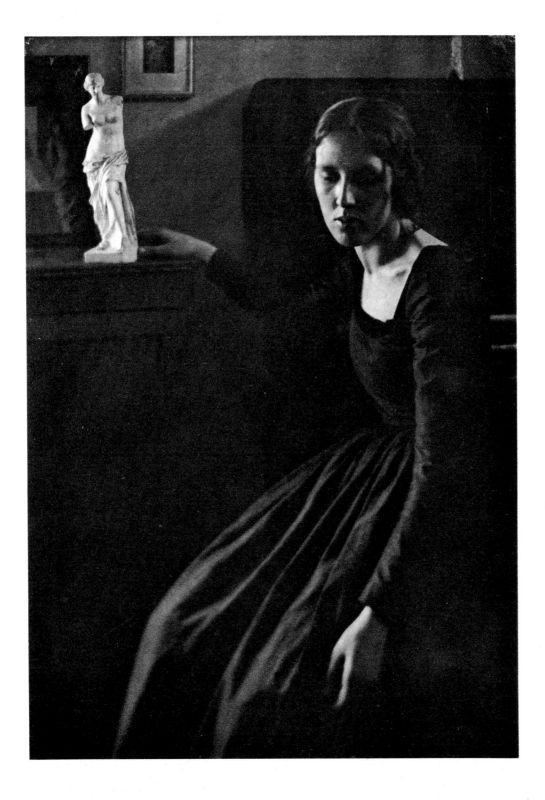

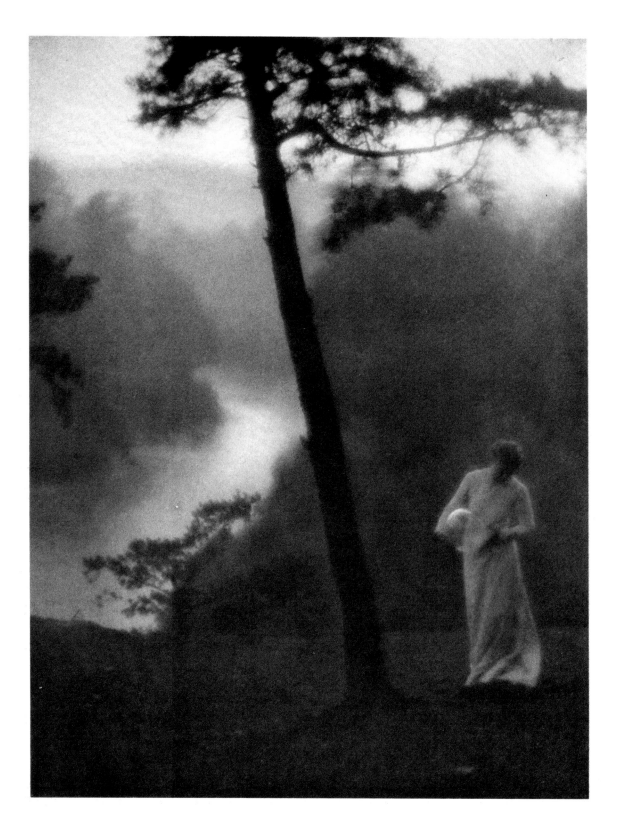

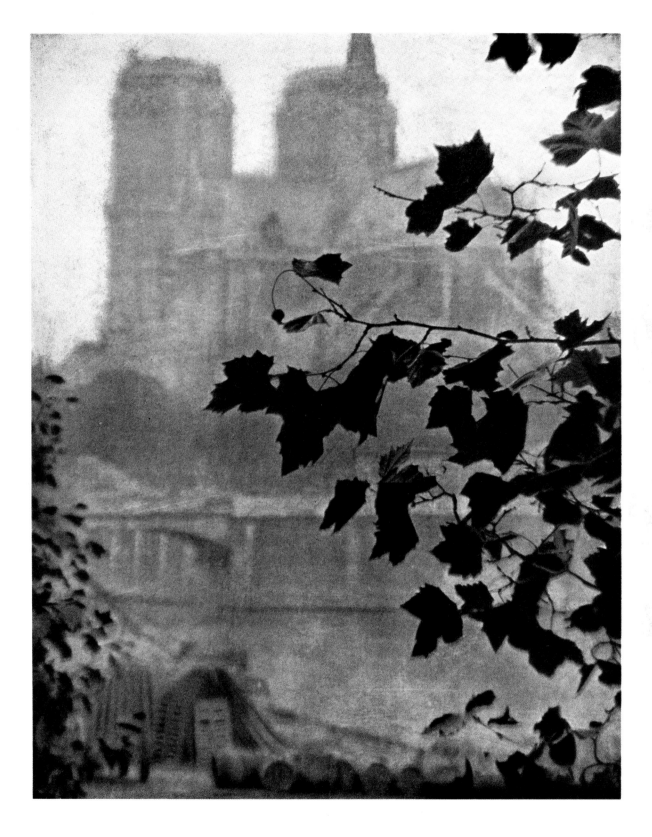

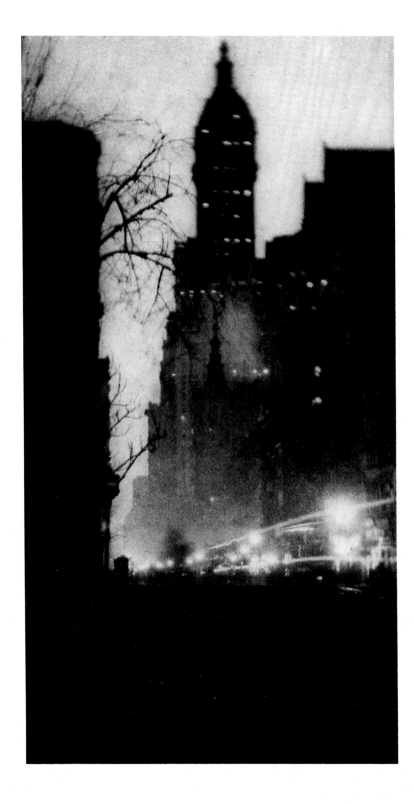

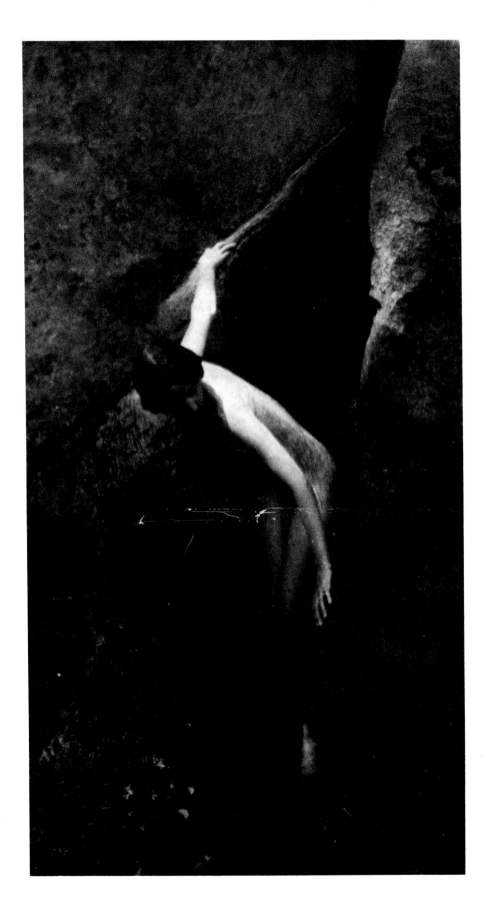

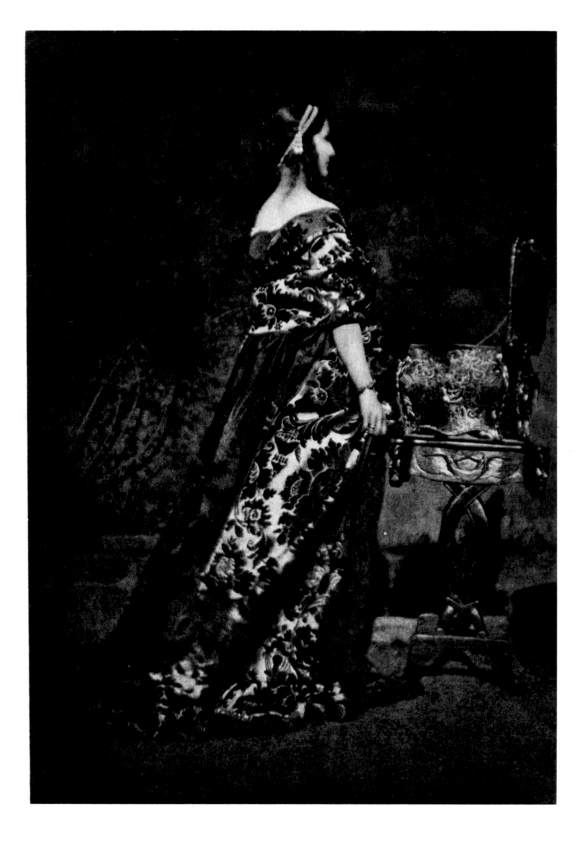

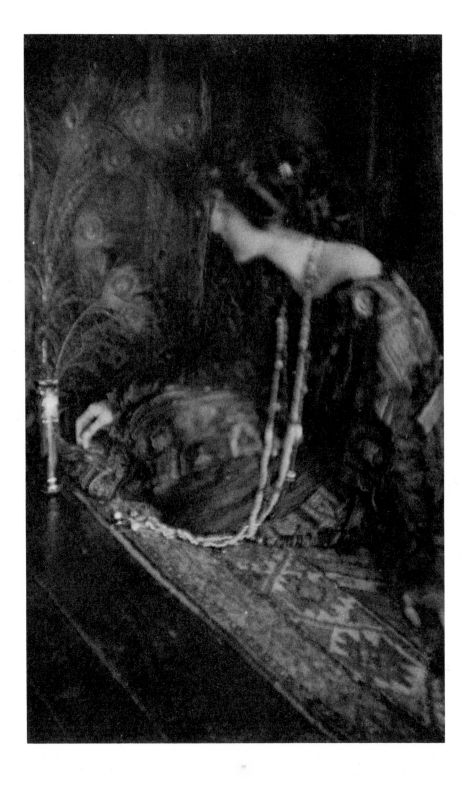

David Octavius Hill Lady Ruthven

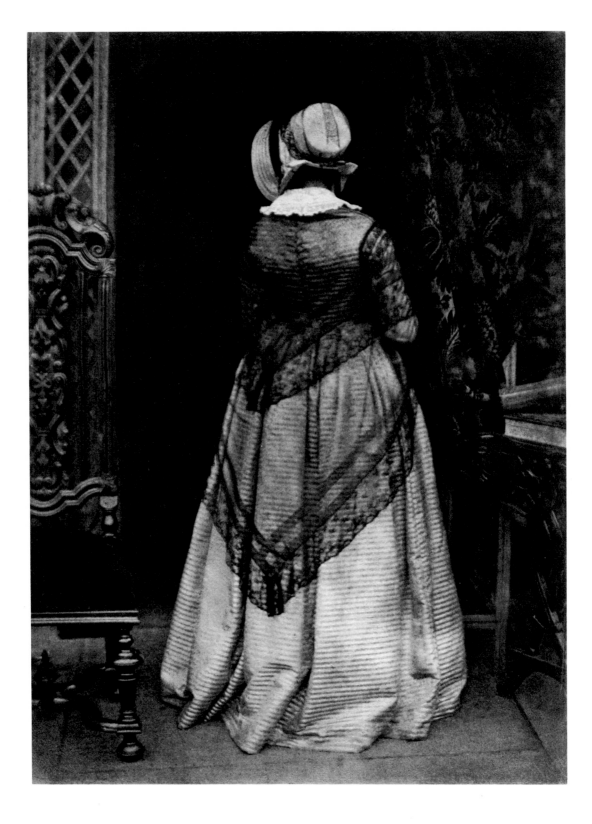

his top-knot were his habits. Baffling the attempts of outside influences to clip his wings, and of the hennery to have him behave like a nice fowl, he was vagarrious alike in his habits and his sentiments. He made flights into far-off potato-patches; roosted in trees, and used the hen-house only for his conveniences. Moreover, from his wanderings he brought back strange ideas: notions of his own importance and of possibilities of life hitherto undreamed of by poultry. In fact, he made ructions in the hennery. The roosters he exasperated by his extra-cocky airs; for he declared that their complacency had made them careless in their personal habits, so that bare spots in unbecoming places showed through the dowdiness of their feathers. This was bad enough, but his treatment of the hens was worse. He brought them to a pitch of bewilderment, quite excruciating, by maintaining that they ought to make the laying of eggs an act of personal expression.

You can see how it would be. He became, what a Brahma-pootra called, with a poultrified affectation of legal astuteness, a *persona ingrata.*

"Cluck! Cluck!! Cluck!!!" resounded from all parts of the hennery, at this voicing of the general indignation. Pressed for a further advice of counsel, the pootra used words that made some of the hens thrust their heads into tomato cans to hide their blushes. Still, it was generally agreed that the situation warranted some strong expression of opinion, and the pootra was applauded. But what action should be taken?

It was now that was revealed the amazing profundity of the Brahma-pootra. He advised the assemblage to empower the cocks and hens, whose maturity made them the natural governors of the hennery, to appoint an advisory committee to advise them how to adjudicate in the case of this obnoxious rooster, whom they had decided to expel from the hennery. The motion was put to the vote and the Clucks had it. So the pootra and his committee of bold-patched roosters and elderly hens retired into consultation behind the hen-house, while all the fowls waited. In due time the committee came out in the open with a pootra-inspired opinion: The fluffy-ruffles rooster should be requested to resign.

Great was the joy of the poultry yard. Already the day seemed brighter, the atmosphere of the hennery purged; and the fowls skipped over one another's backs, chased each other's tails or the spots where they had been, gleefully scratched the ground and generally raised—dust. Meanwhile the pootra, mounted on the hennery roof, emitted a pugnacious cockle-doodle-do and knew himself to be a very fine bird.

The first notice to quit was served at sundown. But the offender on his perch in the treetop paid no heed. He appeared to be roosting profoundly. The second notice was served at daybreak, but he had business elsewhere; a third at feeding time, but his consciousness seemed buried beneath the fluff of his top-knot. The fluffy-ruffles rooster, in fact, proved inaccessible to notices.

Here was a pretty to-do! The pootra-counseled committee had its theory of

what should be done, but was met with a condition. The offender wouldn't contribute to the doing. It was in vain that the pootra cackled his opinions *de facto* and *de jure*. The fact remained that the fluffy-ruffles disturber of the hennery's peace wouldn't quit; while already some of the cocks and hens, for even among poultry there will be found reactionaries, began to peck at the argument *de jure* and to call it injustice. Finally, so hot grew these dissentients that they trailed out of the hennery and started a new one of their own. Moreover, the clacks of the perturbed survivors in the original poultry yard became such a nuisance to the neighborhood that the cook came on the scene and did quick work with a broom handle.

So discomforted were the remnants of the hennery by this outside interference and the loss of their quondam friends, that they turned upon the Brahma-pootra. He had got them into this scrape; let him get them out of it. So, being a slick and many-sided pootra, he hastened to express his long standing and profound affection for the fluffy-ruffles rooster, and, on behalf of the hennery, begged him to step inside again and make himself at home.

But at this point, I regret to say, the story ends abruptly.

CHARLES H. CAFFIN

Clarence H. White

AMONG Clarence H. White's prints are several woodland scenes. Rocks and trees are interspersed, and a *Hermes* looks down smiling on some boys wrestling in play, whose straight young bodies are dappled with sun and shadow. They are pictures that suggest the idea, old even in Greek times, of a young world, fresh as the buds that in the past three days have gathered on the poplar which I see from my city window, a spray of delicate purity against the shabby bricks beyond it. It is an exquisite reminder that the world, the real world of nature and the spirit, is still young; and it is in this young world that the artist in White, it seems to me, lives and has its being.

Then I recall another of his prints. A woman's figure, moving away from us along a garden pathway. She is abroad in the fragrance of the early morning sunshine, that is as yet too cool to disperse the film of mist which clings to the trees and grass and even envelops her form. Then another picture in which, as the twilight slips away, a woman and a child stand, motionless as shades, gazing down over a vista of descending grassland, ending in a mystery of trees. And yet another. It is but a slope of foreground, and a stretch of water separated from the sky by the thread-line of the opposite shore. In the distribution, however, and relation of the masses, the selection of lines, and the tonality of color-values, it is a composition that recalls the choiceness of a Japanese print.

Remembering these pictures, I seem to find in them a clue to the charm that White's work possesses. There is, firstly, a peculiar refinement of feeling in

the conception of the subject and choice of details to embroider it, and an unfailing resourcefulness in the arrangement of the composition. Secondly, a reverence of feeling, due to a consciousness of the mystery of beauty. Thirdly, the source of expression in all his pictures is a susceptibility to the effects of light. And fourthly, informing expression, feeling and composition, is a spirit that maturity of experience has not divested of its essential youthfulness. And all these qualities are in him the product of instinct.

Psychologically considered, he represents a curiously interesting example of an artist being born, not made. His early environment—a small western town, and his particular occupation of a clerkship in a store offered neither encouragement nor impediment to his artistic development. Nor had he any opportunities of private study, except such as *Camera Notes* suggested to him. He bought a camera and, for the most part, was forced to go his own way. It lead him in directions opposed to the current traditions of photography. Thus he leveled his camera directly toward the light. It was the mistake of ignorance, as any photographer would have told him. Yet it proved to be the opening up of new possibilities. He had followed an instinct that was truer than tradition. That instinct was toward light; to make light, rather than light and shadow, the basis of his study. In doing so, he was not aware that he was setting photography in line with the most progressive motives of modern painting; still less did he reason out, that, as the photographic process is the product of light, it is through light that its highest potentiality must be sought. He simply followed an instinct.

He did the same in selecting subjects for his early experiments. He was ignorant of the principles of composition, as expounded in the schools; but he felt that such and such an arrangement was more pleasing than another and accordingly adopted it. And this very ignorance of tradition gave an elasticity and freedom to his habit of looking at his subject, that encouraged inventiveness. How he should arrange his subject was suggested to him by the subject itself; and it is so still. Thus, if you look over a number of his prints, their compositions do not stale by repetition; each has its own note of freshness, and all are distinguished by an exceeding tactfulness and reserve. They have the charm of novelty without bizarrerie: and a most expressively close relation to the character of the subject.

A similarly keen and subtle instinct for the propriety of balance has taught him the secrets of tonality. A false note hurt his instinctive sense of fitness and must be avoided. Thus, without any knowledge of the jargon of "values," he found his own way to the principles involved in it. So too, he discovered for himself the meaning and the need of "quality" in the various values of color in the print. It probably grew out of his instinct for light, since quality is merely a convenient term to express that the colors, whether they contain more or less of light, suggest the vibration of light and thus unite with one another in completing the rhythm of the whole picture.

But, informing all this growth in technique, was what one may call an instinctive reverence. It colors the way in which he sets about a portrait. There is never a suggestion of exploiting the sitter, to secure a technical achievement or to pursue a personal notion of his own. It is to the personality of the subject that he looks for suggestion, sets the key of his motive, and attunes, for the time being, his technique. This fine reverence, however, becomes impregnated with personal feeling when his model is nature, or when he combines a figure with surroundings to express some idea of his own. Then he sheds around his subject an atmosphere of spiritual significance that is poignantly alluring. Whether pitched to a lightsome strain or to a minor key, it is arrestingly pure and plaintive; sometimes suggestive of the youthful intensity of the Italian Primitives, at other times burdened with a modern seriousness. Yet, even so, not encumbered with age and worldliness. Always, as I said at first, it suggests the fragrance and the freshness that one associates with the springtime of the spirit,

It is this rare combination of a natural instinct for beauty, refined and trained by an impulse from within, and of an imagination, pure and serious, that gives to all White's work not only a pronounced individuality, but also a peculiarly rarified charm. They are the emanations of a beautiful spirit.

<div align="right">CHARLES H. CAFFIN</div>

Henri Matisse at the Little Galleries

ON April first the Photo-Secession sent out the following invitation: "An Exhibition of Drawings, Lithographs, Watercolors, and Etchings by M. Henri Matisse, of Paris, will be held at the Little Galleries of the Photo-Secession, 291 Fifth Avenue (between thirtieth and thirty-first streets), New York, opening on April sixth and closing April twenty-fifth. The Galleries are open from ten A.M. till six P.M. daily, Sundays excepted.

"Matisse is the leading spirit of a modern group of French artists dubbed 'Les Fauves.' The work of this group has been the center of discussion in the art-world of Paris during the past two to three years. It is the good fortune of the Photo-Secession to have the honor of thus introducing Matisse to the American public and to the American art critics."

The invitation had its expected effect. The public, the critics, and the artists came and saw. As there were no catalogues of any kind and there was no tradition or history about Matisse's work, every one was left to his own resources. Here was the work of a new man, with new ideas—a very anarchist, it seemed, in art. The exhibition led to many heated controversies; it proved stimulating. The New York "art world" was sorely in need of an irritant and Matisse certainly proved a timely one. We herewith reprint some of the principal criticisms that appeared in the New York press about the exhibition:

J. E. Chamberlin in the *N.Y. Evening Mail:*

"In France they call Henri Matisse 'le roi des fauves.' A 'fauve' is not exactly a wild beast in our sense—it may even mean a gentle fallow deer—but when the French students apply the term to an artist they certainly mean a wild one. The 'fauves' are the French equivalent for the out-eighters of our 'eight,' and Matisse is their limit.

"That being the case, of course Mr. Stieglitz has his pictures at the Photo-Secession gallery. They show Matisse, whose idea is that you should in painting get as far away from nature as possible. If nature is to be followed, why, let the camera do that. The artist should paint only abstractions, gigantic symbols, ideas in broad lines, splotches of color that suggest the thoughts that broke through language and escaped, and all that.

"No doubt this sort of thing should be treated with respect, just as adventism, Eddyism, spiritualism, Doukhobor outbreaks, and other forms of religious fanaticism, should be. One never knows when or where a new revelation is going to get started.

"But Matisse's pictures, while they may contain a new revelation for somebody, are quite likely to go quite over the head of the ordinary observer—or under his feet. A few broadly simple sketches are strangely beautiful, perhaps. Yet they are not beyond the power of any other trained artist.

"And there are some female figures that are of an ugliness that is most appalling and haunting, and that seems to condemn this man's brain to the limbo of artistic degeneration. On the strength of these things of subterhuman hideousness, I shall try to put Henri Matisse out of my mind for the present."

James Huneker in the *N. Y. Sun:*

"For agility of line, velocity in its notation and an uncompromising attitude in the presence of the human machine, we must go to the exhibition of drawings, lithographs, water-colors, and etchings by Henri Matisse at the Little Galleries of the Photo-Secession, 291 Fifth Avenue. Take the smallest elevator in town and enjoy the solitude of these tiny rooms crowded with the phantoms of Stieglitz and Steichen. No one will be there to greet you, for Stieglitz has a habit of leaving his doors unlocked for the whole world to flock in at will. And it is in just such unconventional surroundings that the work of Matisse is best exhibited. The brown bit of paper that does duty as a preface tells us that this fierce rebel is a leading spirit of a modern group of French artists dubbed 'Les Fauves.' Durand-Ruel owns pictures by Matisse and will probably show them here next season. The French painter is clever, diabolically clever. Lured by the neo-impressionists, by Gauguin's South Sea sketches, he has outdone them all by his extravagances. His line, its zigzag simplifications evidently derived from the Japanese, is swirling and strong. With three furious scratches he can give you a female animal in all her shame and horror. Compared to these memoranda of the gutter and brothel the sketches of Rodin (once exhibited in this gallery) are academic, are meticulous. There is one nude which the fantasy of the artist has turned into a hideous mask. The back of a reclining figure is on the wall opposite, and it is difficult not to applaud, so virile and masterly are its strokes. Then a creature from God knows what Parisian shambles leers at

you—the economy of means employed and the results are alike significant—and you flee into another room. The watercolors are Japanese in suggestion, though not in spirit. They are impressionism run to blotches, mere patches of crude hectic tintings. What Matisse can do in his finished performances we shall see later. His sketches are those of a brilliant, cruel temperament. Nor has he the saving cynicism of a Toulouse-Lautrec. To be cynical argues some interest; your pessimist is often a man of inverted sentiment. But Matisse is only cold, the coldness of the moral vivi-sector."

Elizabeth Luther Cary in the *N.Y. Times:*

"In the 'Little Galleries of the Photo-Secession,' 291 Fifth Avenue, a collection of drawings, lithographs, watercolors, and etchings by M. Henri Matisse, of Paris, are on view. The watercolors, which are in the first room, are examples of the theory of the decomposition of light pushed to its extreme limits and expressed with a kind of sophisticated naïveté. Although the uninitiated eye will be confused by the application of the color in streaks and dots of pure pigment, the idea is, of course, far from a new one, and M. Matisse has a sense of form quite sufficient to lead him to build up compositions in which dignity and balance are controlling factors.

"One or two of his little views of water and shore, vibrating with light and gay in color, have a charm like that of broken snatches of song in the open air, discon-nected yet suggestive of the whole and spontaneously blithe. The drawings in the inner room are in the nature of academics, showing a trained insight into problems of form and movement with a Gothic fancy for the ugly and distorted, many of them amounting to caricatures without significance."

Henri Matisse and Isadora Duncan

AMONG the sculptors, painters and critics, quoted in the latest issue of CAMERA WORK, there were only two men who dissented from the proposition that photography may be a form of artistic expression, and one of these was Henri Matisse. He regards photography as a source of documents, valuable to the artist for their richness of suggestion; a means to an end, not an end in itself. Therefore the photographer should not tamper with the record. Let the objectivity of the latter be completely preserved.

This opinion is interesting in its self-revelation of Matisse, whose own mo-tive is to get away from objectivity and to make his pictures interpret an ab-stract idea. While he has a small but ardent following in Paris, to the great ma-jority of artists and critics his work is *bétise*. Some one dubbed him and his group *Les Fauves;* and the name has stuck; and certainly from the ordinary standpoint of appreciation and criticism "The Wild Men" have justified it. To the academic painter their pictures are an inconceivable outrage; to the impres-sionist, as offensive as those of the original impressionists were to the conserva-tives of their own day.

To the student, however, who keeps aloof from the clatter of cliques and tries to understand each man in the light of the man's own intentions, some

questions arise: Is Matisse a charlatan? If not, is he, though not trying to deceive others, a victim of self-deception? On the other hand, is it possible that a later generation may endorse at least his motive, just as today we endorse the motive, if not all the productions, of impressionism?

What is his motive? As he himself explains it, it is the effort to interpret the feeling which the sight of an object stirs in him. This has a familiar sound. Yes, there is nothing novel in the general motive of Matisse. The novelty begins to appear in its application. He too is an impressionist, but with a difference. It is not the ocular but the mental impression that he is intent on rendering, which again has a ring not unfamiliar. But his difference consists in the big gap which appears between the ocular and the mental impression. For example, I saw a picture of a woman. The original I was told, had a band of orange and scarlet ribbon around her throat and waist; otherwise she was dressed from head to foot in black. So much for the ocular impression. This, however, when it had filtered through his mental vision, emerged as a brilliant color scheme of rose, purple, peacock-green and blue, with a prevalence throughout of greenish suggestion. Why not, you reply? He was not bound to represent the woman as you or I might have seen her. How much better, if the contrast of yellow, red and black suggested to his imagination a sumptuous and subtle color harmony, that he should create it.

Yes, as an abstract proposition, such a course seems admirable. But you examine the picture in detail, the features of the face have been drawn in with lines of the brush, very crudely as it seems, almost like a child's handling of the brush. Then you turn to another picture, this time of a nude. The features again are portrayed in this rudimentary way, and the chin slopes into the neck with a suggestion of imbecility. But the drawing of the limbs and torso are worse yet; one leg, for example, is palpably bigger than the other; and, while some of the lines have a fine sweep of movement, passages occur that seem to you like the fumbling of a person who cannot draw. The grotesqueness of the whole thing shocks you. It is impressionism run mad!

But a visit to Matisse does not endorse this hasty surmise. When I entered the big building—a disused convent—in which he works, the first sight I encountered was that symbol of domestic conformity, a baby carriage, and the next the father himself, a stocky simple person, in appearance a sane and healthy bourgeois. No suggestion of the decadent esthete; still less of the poseur or charlatan. He shows me a series of drawings from the nude. In the first, he explains that he has drawn "what exists"; and the drawing shows the knowledge and skill, characteristic of French academic art. Then others follow in which he has sought for further and further "simplification," until finally the figure, as he expressed it, was *organisé*. To the academician it may appear spoilt, brutalized or enfeebled, at any rate ridiculous. But for Matisse's own purpose it has been "organized," brought into conformity with his controlling purpose. And the latter, he explains, is to sacrifice everything to unity; so that you may

be able to see the composition as a whole without any interruption.

He sees me looking at some wooden figures carved by African natives. These with some fragments of Egyptian sculpture are almost the only objects, besides pictures, in his studio. As he passes his hand over the wooden figures, he utters one word, "Simplification." Meanwhile, it does not escape me that the incised lines and the treatment of the planes in these figures, bear a close analogy to his own method of drawing and modeling; and I note that his figures have a feeling of quiet self-contained bulk, corresponding to the old African carver's expression in wood.

Then, as he talks about the importance of form, and especially the need of preserving and relying on its plasticity, he leads me to another room, where in the big emptiness of the surroundings he is modeling a figure in clay. It is a woman, seated cross-legged, and it has the proud, poignant aloofness of Chinese hieratic sculpture, and something also of the plastic stability, yet nervous calm, of an Egyptian statue.

In fact it is toward Oriental art that Matisse leans in his study of how to simplify. His simplification is not for the purpose of rendering more vividly the actuality of form; it is to secure a unity of expression in the interpretation of an abstract idea. And he is seeking for the source of the motive and the means of achieving it in primitive art, even in what in our sophistication we too hastily reject as the era of the child-man in art.

A few days ago I saw Miss Isadora Duncan in her dance interpretive of Beethoven's Seventh Symphony, which Wagner described as "An Apotheosis of the Dance." It appears that some of the musical pundits of the press were shocked. It was a desecration of such music to associate with it so "primitive" an art as dancing; too much, I suppose, like opening a cathedral window and letting nature's freshness blow through the aisles and vaulting. It ruffles the hair of the worshipers, and disturbs the serene detachment of their reveries.

From their own standpoint, quite possibly, the pundits are right. Like so many musical folks, they have trained their ears at the expense of their eyesight, and accustomed their brains to respond exclusively to aural impressions. Why should they sympathize with an effort to reach the imagination simultaneously through the avenues of sight and sound? So they belittled the dancer and her art.

If you have seen her dance, I wonder whether you do not agree with me that it was one of the loveliest expressions of beauty one has ever experienced. In contrast with the vastness of the Metropolitan Opera House and the bigness of the stage her figure appeared small, and distance lent it additional aloofness. The personality of the woman was lost in the impersonality of her art. The figure became a symbol of the abstract conception of rhythm and melody. The spirit of rhythm and melody by some miracle seemed to have been made visible.

A presence, distilled from the corporeality of things, it floated in, bringing

with it the perfume of flowers, the breath of zephyrs, and the ripple of brooks; the sway of pine trees on hill sides, and the quiver of reeds beside woodland pools; the skimming of swallows in the clear blue, and the poise of the humming bird in a garden of lilies; the gliding of fish, and dart of firefly, and the footfall of deer on dewy grass; the smile of sunlight on merry beds of flowers and the soft tread of shadows over nameless graves; the purity of dawn, tremble of twilight, and the sob of moonlit waves. These and a thousand other hints of the rhythm which nature weaves about the lives and deaths of men seemed to permeate the stage. The movement of beauty that artists of all ages have dreamed of as penetrating the universe through all eternity, in a few moments of intense consciousness, seemed to be realized before one's eyes. It was a revelation of beauty so exquisite, that it brought happy, cleansing tears. Brava, Isadora!

But why should I think of her while writing about Matisse? Simply, I believe, because the musical critic thought her performance primitive and therefore beneath his notice. It *was* primitive; old as the world, and it was for that reason that I loved it. And yet toward Matisse's motive, notwithstanding that it also is an expression of primitive elemental feeling, I find myself like the musical pundit. At least, not quite; I can appreciate the motive, but not understand the interpretation of it. That may be my fault or Matisse's. I may still be too sophisticated to appreciate; too wedded to the need of scholarly drawing and the preconceived ideas of beauty; too much at the mercy of our habit of expecting to find in pictures accurate representation of the ocular impressions; not yet able to detach the spiritual idea of abstract beauty sufficiently from the accidents of concrete appearance.

On the other hand, it may be that Matisse has too completely cut himself off from our traditions, and has not yet bridged over the wide space with methods reasonably persuasive. For the present, maybe, he is but blazing a path, that as yet he does not himself know how to coordinate with the rhythm and melody of nature.

Meanwhile, I found that after I had been with his pictures some time, they exerted a spell upon my imagination. So much so, that after I had left them I could not immediately look at "ordinary" pictures. For the time, at least, the latter seemed banal in the comparative obviousness of their suggestion.

CHARLES H. CAFFIN

Henri Matisse; A Retrospect

THERE were eight ladies in the room. One of them (she hung on the wall) was dressed in a black polka-dot and lay on her side in a garden of green angleworms. Another (also hung) was composed entirely of lake-madder spots and stood on a beach made opalescent by pale mauve squiggles. The other six were visitors. Four of them wore spring hats like Italian gardens. Two of them—I hesitate to say it—two of them wore trousers. But then, what would you have? After all, sex is a mere embryological coincidence, while ladyhood is a vocation.

I had been spending an hour with Henri Matisse in the "Little Galleries," inviting my soul—and having the invitation refused. Somehow my soul acts like that at times. And I had been very nice about it, too. I had not just thrown out a careless, general invitation; a sort of "Now run down and see us sometime, do, there's a good fellow." I had been punctilious and particular. I had said, "Allow me to introduce you to a lady composed entirely of lake-madder spots standing on a beach made opalescent by pale mauve squiggles." I had said, "I say, old man, come and look at this sunset. You never saw anything like it." I had said, "Here's a charming girl I want you to meet. She dresses in a black polka-dot and lives in a garden of green angleworms." But there was nothing doing. And so, in default of what I had chosen to think better company, I turned my attention to the visitors. One of the ladies in a flowery hat was explaining to the three other ladies in flowery hats and to the two other ladies in trousers, the meaning of the lady in a black polka-dot. She was interpreting the message of Matisse. She was extra-illustrating it. She was adding footnotes. She was making an exegesis. And it was a labor of love. Her eyes glowed with the joy of discovery, and the pride of possession, and the fanaticism of the maternal. And as I listened, I understood. I understood Matisse, and the eight ladies, and many things. And my soul stirred, and accepted my invitation, and came out, and we looked at each other and smiled. For we had remembered my cousin Kate.

It was one of those still days in summer when all the windows stand open and the cicadas in the elm trees go Z−z−z−z−zzzzzt and cousin Kate had dropped in to lunch and had brought the baby. Now the baby was just starting in on her second year and was expected, by those who were in the know, to begin talking at any moment. But as yet, to the philistine observer, her medium of individual expression was scarcely classable as art. It consisted, for the most part, of dabs of the primary noises placed in arbitrary juxtaposition. Lunch, I remember, included red tomatoes and green lettuce against a background of polished walnut with touches of yellow lemonade. Nothing could possibly have made you feel hungry, but this almost made you feel cool. Kate was telling us all the things Anne had tried to say since Tuesday week and Anne was sitting on the floor with a large Uneeda biscuit in one hand and a fly on the end of what, later on, will probably be her nose. Now we do not keep babies in our house, but we have a cocker spaniel that for sheer—however, never mind that

now. Just as Anne brushed the fly off her face with the biscuit, the cocker, with a most ingratiating grin, walked up and offered to go halves.

"Ow!" said Anne, leaning backward at a dangerous angle and holding the biscuit high overhead with one chubby arm, "Ow!—Ow!"

"See!" exclaimed Kate, her eyes glowing with the joy of discovery, and the pride of possession, and the fanaticism of the maternal. "Did you hear her? She says, 'Bowwow!'"

<div align="right">J. B. KERFOOT</div>

On Beauty

THINGS move to Power and Beauty; I say that much and I have said all that I can say.

But what is Beauty, you ask, and what will Power do? And here I reach my utmost point in the direction of what you are free to call the rhapsodical and the incomprehensible. I will not even attempt to define Beauty. I will not because I cannot. To me it is a final, quite indefinable thing. Either you understand it or you do not. Every true artist and many who are not artists know— they know there is something that shows suddenly—it may be in music, it may be in painting, it may be in the sunlight on a glacier or shadow cast by a furnace or the scent of a flower; it may be in the person or act of some fellow creature, but it is right, it is commanding, it is, to use theological language, the revelation of God.

To the mystery of Power and Beauty, out of the earth that mothered us, we move. I do not attempt to define Beauty nor even to distinguish it from Power. I do not think indeed that one can effectually distinguish these aspects of life. I do not know how far Beauty may not be simple fullness and clearness of sensation, a momentary unveiling of things hitherto seen but not dully and darkly. As I have already said there may be beauty in the feeling of beer in the throat, in the taste of cheese in the mouth, there may be beauty in the scent of earth, in the warmth of a body, in the sensation of waking from sleep. I use the word Beauty therefore in its widest possible sense, ranging far beyond the special beauties that art discovers and develops. Perhaps as we pass from death to life all things become beautiful. The utmost I can do in conveying what I mean by Beauty is to tell of things that I have perceived to be beautiful as beautifully as I can tell of them. It may be, as I suggest elsewhere, Beauty is a thing synthetic and not simple; it is a common effect produced by a great medley of causes, a larger aspect of harmony.

But the question of what Beauty is does not very greatly concern me, since I have known it when I met it and almost every day in life I seem to apprehend it more and to find it more sufficient and satisfying. It is light, I fall back upon that image, it is all things that light can be, beacon, elucidation, pleasure, comfort and consolation, promise, warning, the vision of reality.

<div align="right">H. G. WELLS (Fom "First and Last Things")</div>

American Indifference

IN artistic matters, the crime of the American is indifference. Squat on her haunches, sucking at the dripping dugs of the Golden Calf, Columbia would use a Monet or a Whistler for a seat—if they were not worth gold. Stupidity and Vulgarity, thy name is America!

The rare, the strange, the beautiful, the new—whether in art or literature—is taboo to the American mind. No word exalts the American mind like the word Respectability. It is its shibboleth. Poe was its most famous victim.

The average American passes dumbly, hat in hand, before the Accepted Names as though he had entered a fane dedicated to Mammon. In the paradise of cowards, he is the tetrarch.

On the waxed and shining ramparts of this Eden of Indifference struts Conformity dressed like a flunky. Behind him shambles the lackey Hypocrisy, muffled in gold leaf. From beyond the walls, from deep within this laboratory of the vulgar, the stupid, the mediocre, the bourgeois, is blown a sickening odor. It comes from those millions upon millions of beings whose souls are without drainage.

This giant conspiracy of mediocrity, this race-thesaurus of the average, has in all ages been the sworn enemy of all that is new, radical, anti-academic, in art. Artistic respectability is the crime of the American. In the sphere of morals this spirit invents anti-vice societies to protect its own mind against its own pornographic instincts. In the sphere of art it shuns genius like a plague. It has never given the world a brave act, a big thought, a beautiful idea, a great poem, a great picture, a great book. Food and sex—they are the axes on which indifference and respectability turn; for it, life is only significant below the navel.

In this country it is impossible to compute the number of artistic geniuses that have been chloroformed in the House of Indifference. Bribed, beaten, threatened, crushed under debt and poverty, the spark of artistic and mental revolt has been extinguished in these minds; and so they have continued to exist in this House of the Great Garlic Stench and have died with the chaplet of the ordained virtues on their brows, pews paid up to date, the coffin neatly beflowered by opera subscribers.

At birth, handed iron lances to fling at the sun, they have come to cut them into darning needles and book-cutters. Foundlings of ideas, pregnant with dreams, they farmed themselve out to Rote, their dreams paling to ashy fears. Their hands outstretched toward the open seas of the Strange, the Beautiful, the Unknown, they have felt in their muscles the palsy of will-lessness before the giant icy hand of Indifference or the croonings of senile Respectability. The fine purple coat of artistic and moral rebellion has become a seedy house jacket and the sandals of fire are exchanged for carpet slippers that convey one noiselessly over the plush conventions.

And behold the wealthy American patrons of the arts! Ring Olympus with thy laughter! They carry their exhausted souls to Europe and buy "art objects," the great money value of which is the only thing they were made to appreciate.

While the American artist who has an original note, who has seceded in order to preserve the inviolability of his own artistic genius, rots in his rags in his hole of a studio. These "patrons" (or should we call them padrones?) ransack museums, purchase old palaces, bragging with the brazenness of all vulgarity of the enormous prices they paid for them. They are the Medusas of Indifference, the exposed guts of Respectability.

What can these Medusas of Indifference know of the eternal renascence in art of the rebel? The epiphany of a Rodin—it is, in truth, the instinct to live. The rebel is the eternal knocker at the door of the House of Indifference, the Voice that calls in all centuries to the pursuit of the Intangible. Revolt is the cloven flame that consumes age after age the citadels of authority and their dull commanders sheathed cap-à-pie in their ethical petticoats.

In the United States it is the hardest thing in the world to preserve your artistic individuality. The Horla of Indifference will absorb you at last. Threatening missives are borne to you upon every wind and the hint of penalties falls on your ears from the moment you pronounce that word sacred to all genius—I. You will have visions of the bread line. Fear—the obscene bird—circles over your soul like a kite amorous of carrion. The cabals of Indifference and Respectability are always in session. and your inspiration begins to flutter like a candle in its fetid breath. The insinuative imps of temptation swarm in and out of your clay. Bread line or automobile? You must decide. You are in the United States. You will, if you are not of the Viking strain, end a mush of concessions.

BENJAMIN DE CASSERES

Unphotographic Paint: The Texture of Impressionism

AT the beginning of May a small collection of paintings by Marsden Hartley of Main found shelter at the hospitable Little Gallery of the Secessionists. They were examples of an extreme and up-to-date impressionsim. They represented winter scenes agitated by snow and wind, "proud music of the storm"; wood interiors, strange entanglements of tree trunks; and mountain slopes covered with autumn woods with some island-dotted river winding along their base.

The depth and distance across the valley to the mountain, the plastic modeling and faithful detail, the hardiness and vigor of representation, showed knowledge of form and sincerity of sentiment. It was the color scheme, however, that startled the beholder. It produced a strictly physical sensation. It irritated the retina and exhausted it. After leaving the gallery Fifth Avenue looked more gray than usual. A melancholy vocation for such a robust phase of art!

Hartley's technique is interesting though not necessarily original. It is a version of the famous Segantini "stitch," of using colors pure and laying them side by side upon the canvas in long flecks that look like stitches of embroidery. I

overheard some artist remark: "Lots of young painters in Germany paint in this crazy fashion." This may be true. Hundreds of painters all over the world are busy experimenting to expand and improve the original impressionist technique, and there is no reason why somebody else should not lay on the paint in a similar way to Marsden Hartley. As long as the latter applies his colors in a temperamental, self-taught manner, he is above the approach of imitation. I for my part believe that he has invented his method for himself, up there in Maine amidst the scenery of his fancy, and that only gradually he has learnt to reproduce nature in her most intense and luminous coloring.

Yet neither his courage nor sincerity necessary to accomplish such a task, nor any understanding and mastery that he may possess, put my mind in an analytical mood and induced me to write this article, but rather the peculiarity and freshness of his viewpoint. Why do people paint this way! This simple question asserted itself again and again and called for an explanation. Why do painters more and more renounce the conventional ways of handling colors? Is it solely for the one supreme purpose of getting the effect of vibrating color, of light in motion!

It is an acknowledged fact that impressionism has heightened the key of tone throughout the studios of the world. It has given us an intenser and more varied study of illumination, a higher pitch of light. One thing is certain, the dramatic element has vanished. It no longer knows the mysterious harmonies of a Leonardo or the soft sparkling shimmer of a Rembrandt. Light has lost its gleam and glitter as if vibrant with gold dust. The glamour of romance has faded out of it. In its stead we have the poetry of lighting that the days and hours bring to a single scene, as Monet has so loyally demonstrated in his series of haystacks, popular trees, and the Rouen Cathedral. Whether these high-pitched light and color notations are a fair equivalent for the sudden spiritual light bursts that quiver through the gloom of medieval art, future art historians will decide.

The modern painter, treating different pictorial motives than his predecessors, felt the need of a new technique. The impressionist prefers to suggest form rather than to actually draw it, he desires to envelop figures and objects in space and atmosphere. A blurred definition ensues, in which the minutiae and subtleties of line are often lost. To accomplish this aim he invented a looser and more broken touch that neglects drawing (unless the painter possesses the sense of plasticity to a marked degree) and the old standards of composition.

But why this revolution of *facture*, this strange technique of squeezing on color thick, giving the canvas a tapestry or mosaic effect. It is solely for the purpose of letting the eye look at the picture from a distance, to mix and melt the colors together on the canvas, and thereby give an effect of more air, more light, and truth. Were these effects not possible with a smoother surface and more uniform continuity of texture!

The paintings of Franz Hals and Goya, the foremost representatives of *bravura* brushwork, look smooth in comparison with an impressionist canvas.

Monet's large flowing touches recall Velasquez. Even Monet's earlier work in small broken touches was still related to the cross hatching pastel and stippling of watercolors of Watteau and his followers. Only gradually the painters began to lay the paint on thicker and thicker until the texture had an actual structural tendency, as in many of Segantini's works. Also Rembrandt at times encrusted his canvas a quarter of an inch thick with color to imitate jewelry and strongly illuminated objects. Among modern painters, Monticelli and Ryder use a rough dough-like impasto, and Mancini while painting his shadows very thinly, models the lighted form with paint like a sculptor. With these painters it is merely a vehicle of momentary inspiration. They do not proceed scientifically. With the impressionist the regulated patch or stroke of plastic color, laid one beside the other, has become a professional mechanism, just as the smooth brushmarks must have been to a Guido Reni or Andrea del Sarto.

I believe, that the artists individually have very little to do with the new development. It is nothing but a natural consequence of the modern tendency of art. And even as great an artist as Segantini deceives himself when he makes the statement that "this secret of technique, nowadays an approved fact, had been perceived by painters of all times and all countries (the first of whom was Beato Angelico) and that it came to him through his loving and earnest study of Nature, and as something personal and individual."

Modern art prefers to be realistic. And in this ardor to express the fleetingness of things just as the eye sees them, artists have turned scientists (or at least try to see objects in a more scientific way), and for this purpose selected and developed a more *realistic* technique. The Old Masters tried to create an illusion, to reproduce the actual roundness of things and the esthetic possibilities of the three dimensions, and did not wish to interfere with the produced impression by any violence of texture. The main object of the impressonist, on the other hand, is to create an impression by suggestion and he asks assistance from the very medium he employs. The plastic aspect of color, no matter whether executed in the commas of Monet, the dots of Pissaro, the irregular patches of Sisley, the cross hatching of Degas or the stitches of Segantini, have to help physically to construct the image in the eye.

The result was a curious one. The canvases began to resemble wool, pottery, mineral surfaces, and Oriental carpets, and through this very peculiarity of texture combined with color themes they acquired a decorative tendency that was not anticipated by its originators. And this transformation of a realistically conceived technique into one of idealizing quality was largely due, as I hope to prove, to the choice of subjects.

The impressionist painters adhere to a style of composition that is strictly photographic. It apparently ignores all previous laws. They depict life in scraps and fragments, as it appears haphazard in the finder or on the ground glass of the camera (viz Renoir's "On the Terrace"). The mechanism of the camera is essentially the one medium which renders every interpretation impressionistic, and every photographic exposure, whether sharp or blurred, really represents

an impressionist composition. The lens of the camera taught the painter the importance of a single object in space, to realize that all subjects cannot be seen with equal clearness, and that it is necessary to concentrate the point of interest according to the visual abilities of the eye. It is a curious fact that all compositions of the Old Masters were out of focus. True enough they swept minor light and color notations into larger ones, but there seldom was any definite indication in their work whether an object was in the foreground or middle distance. Their way of seeing things no doubt was a voluntary one—they had a different idea of pictorial interpretation. In their pictures as in nature, we continually allow our attention to flit from one point to the other in the endeavor to grasp the whole, and the result is a series of minor impressions, which unconsciously influence the final and total impression we receive from a picture.

The artist of the new school endeavors to reproduce any impression he has received, unchanged. He wants the impression to explain itself, and wants to see it on the canvas as he has seen and felt it, hoping that his interpretation may call forth similar esthetic pleasures in others as the original impression made on him. And it was largely the broadcast appearance of photographic images that taught him to see nature in a new light, as the human eye sees it in ordinary practice. At the same time the increasing popularity of these images emphasized in them the smoothness of texture which we were accustomed to for ages, and which is so peculiar to the photographic print that even artistic hand manipulation cannot entirely overcome it. Delacroix was the first to recognize in photography a serious competitor. And thus the young men of his period began to fight the imaginary danger, they experimented and within a score of years succeeded in developing a structural technique that guaranteed a vivacity and intensity of aspect. By this argument I do not mean to convey that photography was the sole cause of this technical innovation. Japanese art, color lithography, and scientific researches into the principles of color interaction, all played important parts in it. But the influence of photography on painting is undeniable, and no doubt proved a most vigorous and beneficial stimulant in that direction.

In the meanwhile photography in order to assert its esthetic possibilities strenuously strove to become "pictorial"; and this endeavor produced in recent years the singular coincidence that, while men of the lens busied themselves with endowing their new and most pliable medium with the beauties of former art expressions, those of the brush were seeking but for the accuracy of the camera plus a technique that was novel and—unphotographic.

To the Artist who is Eager for Fame . . .

To the artist who is eager for fame, his work finally becomes but a magnifying glass which he offers to everyone who happens to look his way.

NIETZSCHE

EXHIBITION CALENDAR FOR THE PHOTO-SECESSION GALLERY. [] []

***COLOR-PHOTOGRAPHS:**
EDUARD J. STEICHEN. NEW YORK & PARIS
WATER-COLORS, PASTELS, ETCHINGS:
JOHN MARIN. NEW YORK & PARIS
DRAWINGS & ETCHINGS:
GORDON CRAIG. LONDON
DRAWINGS:
AUGUSTE RODIN. PARIS
DRAWINGS:
HENRI MATISSE. PARIS
PAINTINGS:
ALFRED MAURER. NEW YORK & PARIS
PAINTINGS:
LAURENCE FELLOWS. NEW YORK & PARIS
PAINTINGS:
ARTHUR CARLES. PHILADELPHIA & PARIS
DRAWINGS:
ELIE NADELMANN. POLAND
PHOTOGRAPHS:
ANNIE W. BRIGMAN. SAN FRANCISCO
PHOTOGRAPHS:
FRANK EUGENE. MUNICH & NEW YORK
ETCHINGS:
ELEN THESLUPP. FINLAND
PAINTINGS:
MAX WEBER NEW YORK & PARIS
PAINTINGS:
PATRICK BRUCE. VIRGINIA & PARIS
PAINTINGS:
PUTNAM BRINLEY. NEW YORK & PARIS

*TO BE HELD SIMULTANEOUSLY WITH THE EXHIBITION OF STEICHEN'S PAINTINGS AND PHOTOGRAPHS AT THE MONTROSS GALLERY, NEW YORK.

CAMERA WORK: An illustrated quarterly magazine devoted to Photography. Published and edited by Alfred Stieglitz. Associate Editors: Joseph T. Keiley, Dallett Fuguet, John Francis Strauss, J. B. Kerfoot. Subscription price Six Dollars and Fifty Cents (this includes fee for registering and special packing) per year; foreign postage, Fifty Cents extra. All subscriptions begin with current number. Back numbers sold only at single-copy price and upward. Price for single copy of this number at present, Five Dollars. The right to increase the price of subscription without notice is reserved. All copies are mailed at the risk of the subscriber; positively no duplicates. The management binds itself to no stated size or fixed number of illustrations, though subscribers may feel assured of receiving the full equivalent of their subscription. While inviting contributions upon any topic related to Photography, unavailable manuscript or photographs will not be returned unless so requested and accompanied by required return postage. Address all communications and remittances to Alfred Stieglitz, 1111 Madison Avenue, New York, U. S. A. The photogravures in this number by The Manhattan Photogravure Company, New York. Arranged and printed at the printinghouse of Rogers & Company, New York. Entered as second-class matter December 23, 1902, at the post-office at New York, N. Y., under the act of Congress of March 3, 1879. This issue, No. 29, is dated January, 1910.

That Toulouse-Lautrec Print!

I T does not really matter to which print I refer—it happens to be that of a young courtesan, snugly tucked away in bed, and with the bulky form of an older female, some monstrous representative of the "oldest profession in the world," standing before her in an admonishing attitude,—but I do not mean to talk about Toulouse-Lautrec, his art, or the first exhibition of a few examples of his work at the Little Gallery of the Photo-Secession.

In presence of such a collection I am apt to fall into a state of melancholy depression. Realizing the life of such an artist, his bitter struggle, his solitary position in the material world, the lack of encouragement and the scarcity of genuine appreciation, even when fame has knocked at his studio door, I wonder at the futility of it all. And when I hear altruists in murky eloquence speak of an art for the masses, common to the whole people, an idea which grows more and more rampant with the steady advance of socialistic politics, I feel as if I should burst out into laughter, hoarse and sardonic as that which echoes through the art of Toulouse-Lautrec.

How should an art as virile and fascinating, individually local and bitter as that of this Montmartre bohemian, be appreciated by the many! What fatuous, quixotic optimism is necessary to give credence to such a fallacious doctrine. A lamp, an umbrella stand, a salt cellar, a Morris chair, may enjoy the distinction of popular respect. They may grant pleasurable excitement to the majority, but art is not a furniture store nor an exhibition hall of industrial crafts. There is just as much difference between a Morris chair and a Toulouse-Lautrec print, as between a Toulouse-Lautrec print and a Botticelli.

No, this talk about universal art worship is contrary to all rules of sound reasoning. Democracy in art is the most illogical formula of reformatory ideals. Whitman realized this to his great astonishment when he was "in the sands of seventy." It is naught but the belief of good-natured, harmless, sermonizing little souls, foolish enough to think that they can remodel the world. If we could know what people think (or more frequently do not think) while they look at a picture, if we could put on record their fleeting emotions and fragmentary thoughts before a work of art, we would be able to deduct therefrom complete confessions of their state of culture. To take their esthetic temperature, I fear, would prove a most ghastly experience.

As Whistler has so truly said, there never was an art-loving nation. There never can be one. Every art expression—music, painting, drawing, dancing, poetry—has its peculiar technique, and without a certain knowledge of the technique appreciation is difficult, instinctive or accidental. The vast majority have no time to train their eyes to the vivacious and colorful, and to analyze why one object appeals more to the sense of beauty than another. Art can be taught only technically. Froebel was on the right track when he gave to children's play an inventive tendency. It is of no avail, however, as the methods become mechanical and imitative as soon as the child leaves the kindergarten. The present system of teaching drawing is one by rule and rote. Even Chase,

Henri and Hawthorne, our foremost teachers of painting, are not exempt from this criticism. Of course all true painters love things for themselves; and it is doubtful whether a painter could perfectly paint a brass or pewter vessel, if he did not love its surface for itself. But it is a dangerous method, nevertheless; an exclusive study of the resistance an object offers to light, determining thereby its color and variation of values, is apt to make *still-life* painters of the students. They see all things as objects, as surface beauty, without any virile or spiritual interest.

But the trouble lies not merely in lack of technical education. There are many who, although continually associated with art, as some of our critics, lack all the finer sensibilities of appreciation. And, for narrow-mindedness those scores of petty, academic, pompous little men who aimlessly but persistently cover yards of canvas, have no equal. Art appreciation cannot be taught. It may be fostered, gradually developed in some naturally responsive and neglected individual, but even then it will lack freedom and spontaneity. Appreciation is an individual growth, like art itself, and it necessitates inborn talent from the start.

For that reason art is by the few and for the few. The more individual a work of art is, the more precious and free it is apt to be; and at the same time, as a natural consequence, the more difficult to understand. To hang a Botticelli reproduction on the wall does not imply true comprehension. Those people who, like trained dogs, first shrink back in ignorance at some new phase of art, and then at the command of fashion leap through the paper loops of approval, degrade art to a sport.

How rarely is the complexity of any human being understood. This evades analysis even by continual and most intimate associates. A work of art is equally inaccessible. The true artist possesses first of all the rare faculty of disengaging the poetical significance from the commonplace act and fact. It denotes an escape from the strict, hard, vulgar and commonplace in which most people are satisfied to exist. How then can the multitude, slaves of dark prejudices, admire his proud disdain of the humdrum artificialities of life, his frenetic protest against existing civilization. The artist works, travails and suffers that a few may enjoy the result. It is his extreme generosity and his extreme selfishness.

Daily existence parodies art. Art does not come and sit down at your table to share a prosaic meal with you whenever you feel bored with the banalities of life. Enjoyment of art demands superior sensibilities; it is pleasure, joy, an ideal, a vision, that stays with you, that enriches your life. It is for those who have the love for beauty and revolt. Oscar Wilde, himself, the apostle of a socialistic art ideal, says, "To live is the rarest thing in the world. Most people exist—that is all." Why, then, should they suddenly awake from their habitual drowsiness? Toulouse-Lautrec popular! What a horrid thought! His grim craftsmanship admired by a brave, industrious, docile humanity! It will never happen. The range of estheticism may be approached from many sides. The

summits are reached but by the staunchest of hearts. Only one man climbed Mt. McKinley, and even his veracity is doubted. And if suddenly the unforeseen should occur, and the majority should actually have climbed to a higher level of culture than heretofore, the art of the day would already have soared far beyond their horizon. Genius walks with seven league boots. Its plumed hat waves and beckons in the wind. Its broad cloak balloons as its gaunt figure stalks away from the multitude and is lost in solitary distances. Only a few can keep in seeing distance. The others straggle far behind.

And well that it is so. For appreciation is dearly gained by fanatic devotion and constant self-sacrifice. That Toulouse-Lautrec print!—I have roughed life sufficiently to feel some sympathy with the ways of "vulgar endearment," of gilded lust and infamous barter, particularly if recorded with such beautiful irony and subtle skill. Should a pale seamstress or a fatted tradesman feel the same joy in contemplating it? Preposterous! No, it is one of my conquests. It would lose its subtlest, most intimate charm, if it were shared by the diffident crowd. This implies no contempt for the proletarian. To the masses belong millionaires as well as laborers, washerwomen as well as slim aristocratic girls. Nor does art wear the mask of apathy. Art may be wooed by everybody, but successfully only by those who court her exclusively.

S. H.

Some Reflections of the Functions and Limitations of Art Criticism— Especially in Relation to Modern Art

THE subject of Art, we all feel, is one of the most difficult to handle. In art, even more than in matters of religion or politics, tastes and opinions vary so insubstantially as to leave them forever apparently without prospect of settlement. That, indeed, may be of the life-blood of its existence; but it also accounts perhaps for that curious first anomaly which we find in respect of the general attitude towards art, namely: of a large department of human interest and activity which, while it is one of the least understood (and often one of the best abused), is nevertheless one of the most generously tolerated. In art, we are told (and this is true of a great number of artists themselves) there can be no exegesis; we may like or dislike, praise or blame, but we cannot explain. And there the matter is supposed to end.

That art, however, can have any really vital and direct application to the age in which we live is a notion which, naturally enough, rarely enters the popular mind at all, except it be in a popular sense. But can it be said that even our more trained and cultured critics are free from this blame?—in whom, so often, the wiser they grow, the more Hamlet-like does their attitude towards art become; either in finding the present times most woefully out of joint, or else past times most dismally and tardily great. While the masses are confessedly interested but ignorant, such men on the contrary are but too often uninterest-

ed or simply biased. It is as if the weight of their learning had tethered their judgment, and their much study had brought them, in place of joy, a weariness of the flesh, whereby the unrest that is in their own souls is too often the prism through which they view the quaint and original productions of those who are alive and working around them. Of this kind of criticism there seems to be no end, and we may say of it that it is to be found in the high, rather than in the proud places of the earth, and is the fruit of knowledge rather than of understanding, of culture rather than of genuine sentiment, and belongs to the fashion rather than to the inalienable democracy of true art. It will be only necessary to give one instance to understand the whole order to which this class of Great Britain recently remarked that "Art in our time seems *by contrast* like an iridescent oil spread about on the muddy surface of our civilization; it and life don't mix." That, then, is the whole viewpoint in a nutshell, and constitutes what I would name the second anomaly in respect of the general attitude towards art, namely: that tolerance, even while it exists (and often even amounts to a kind of dull enthusiasm) is mainly extended to what is beautiful in ancient art, and seldom to what is beautiful or strange in contemporary art.

A third and last anomaly is the almost universal habit of witholding from the artist (or indeed from the creator and innovator in almost any genre) the right to as nearly personal a point of view in his work as his critics reserve for themselves in theirs. These three are the prime embarrassments which, if they could, would forever inhibit the living artist from accomplishing his own destiny or the progress and destiny of his art. For what art does carry forward the banner in a vital issue with the decaying or stagnating forces of its time must be reckoned as one of the only causes that could entitle it to our respect.

In a book entitled *What Is Art?*, Count Leo Tolstoi, among others, once entered the lists with a sweeping condemnation of almost all that had risen to a place of first distinction in the ranks of literature, music, or painting since a certain period situated in the beginning of the last century. The criterion which Tolstoi sets up for adjudging works of art is that only that is good and worthy to be considered great in art which excites the interest and the approval of the masses; with which dictum in a broad and synthetic sense there can be no cause for complaint. But to proceed to argue from that, as he does, that the interest and approval of the masses should therefore be immediate and *en masse* is to pass from the language of philosophy to that of a kind of knight-errantry or Don Quixotism of humanitarian belief and benevolence. That in the main, however, his first premise may be true without his second can scarcely be questioned.

If a savage from some unsophisticated quarter of the globe were called upon to decide between the merits of various works of art that were presented to his judgment, his selection, it seems fair to assume, together with his reasons for making it (if he could assign any) would differ materially from the ordinarily accepted ones. Or if some more or less uncultivated person from our own

midst were asked to perform the same function with regard to the same objects, then we should already expect different results for reasons which we could already begin to anticipate or explain. So that, if by a repetition of this process we were to take the measure of the opinion of different people throughout every grade and type of human society, we should probably arrive in the end at the most perfect heterogeneity of choice; but with a far more simple and definite arrangement of ideas on the whole subject than any which a more complex definition of art than the one which Tolstoi has selected could offer. What we should find indeed would be the unimpeachableness of his first premise, that only that was good or was considered good in art which *each one liked;* only a more profound way of saying "what everyone liked"; whilst to carry the inquiry a stage farther would be to render it absurd, if by a process of selection and analysis known only to ourselves we were to *substitute*, as he has done, any other dogma in the second order of ideas which was already contradicted by the first. The flaw in the Tolstoian art-syllogism is of the commonest and most misleading type. And leads us indirectly to the verification of the fundamental lie, lying at the basis of almost all commonly accepted art criticism; namely, the inability to distinguish between the fact that while *we are all of us judges of art*, only a few of us can be or are artists. Or, in other words, that only art can explain art, as only diamond can cut diamond; and that art criticism to be effective, to be any other than a dull echo and feeble reiteration of that which we already know, or at the best can better study for ourselves and become acquainted with *at first hand* in the works themselves of great artists, must evolve a new art form, or symbol, for its expression. In short, when we come to think of criticism as the paradigm and *primum mobile* of all the arts we shall better understand why so many fail in that which it can only be given to the greatest artists of all to practice and to understand.

Thus far, however, the argument has confined itself to the consideration of those fallacies which are commonly contained in the practice and conduct of art criticism. A *rationale* of the functions and limitations of art itself. Art itself is of the type of an arch-paradox; it is always contradicting itself. It is the whole armory of dogmatism and of persuasion and speaks, of course, always in the language of exaggeration. Its humility is no less astounding than its egoism; its breath and amplitude are no more significant than its sheer intensity.

A recent biologist, one whose aim was to show that there was what he named "a need or Drang for life" in the universe; or in other words, that the desire for life was the end of all things, happily stumbled on this noble induction: "Life, not Beauty, is the mark of Art; but beauty is the signal that the mark has been hit." It seems doubtful if the meaning of that can ever be bettered. It is true in an analytical sense that a center of gravity, or centripetal force, round which art forms are first produced and are than forever afterwards enjoyed or dishonored, is the innate feeling in every human individual (and perhaps in every atom of organic, as well as of inorganic life) for personal

affinity; for attraction and repulsion, selection and rejection. Also we have seen that, short of an ideal (and that is as it seems an impossible) republic of human opinion, a final standard of art can never be set up. Yet it is true that among the ancient Greeks such an ideal was aimed at, and it may even be true that among ourselves such a goal is tacitly agreed upon. What that is becomes the business of esthetic criticism to discover.

Paul Verlaine once fashioned what would seem to be a very commonplace remark when he said or wrote: "L'art, mes amis, c'est d'être absolument soi-même." The phrase has all the charm of ambiguity and of explaining nothing—for what "soi-même" is, what Paul Verlaine himself may be, is one thing to me, quite another to Tolstoi assuredly, and as many different things again no doubt as the different people who think about him or about themselves. But whether his definition be true or not may depend on the view which we take of art and of the artist in relation to society.

If we think of society as of an organization for "the greatest good of the greatest number," then the claims of the individual within that sphere assuredly cannot be considered as unlimited. Yet the sphere of art is, on the contrary, so unlimited as to embrace in one shape or another men of every creed, of every quality, training, disposition and even race. The beginnings of art, indeed, go deeper than, and perhaps alone constitute, the earliest records of human society. Of art in its inception and its growth we may say even more truly than the historian Freeman said of the structure of human society as a whole, that there is no part of it, howsoever ancient, "that was not eloquent of commonwealths in foreign lands than undiscovered." The principle which underlies art is the same today as it was yesterday, or as it will be forever. Its source is in a sense of individual eclecticism reaching out through the whole body of correlatedly human, or universal, desire. Assuredly, then, the artist in the highest and strictest sense of the term can have no business, no immediate business at all events, with society, or with the offices and affairs of an organization supposedly intended for the great (or little) good of a great or little number. The artist's concern must be primarily with himself, not in the artifices of man, but innocency of Nature. In short, as Mathew Arnold said of the functions of poetry in particular, so we may say of the artist in general that his business is "the criticism of life," and therein exactly lies the supreme differentiation between society and the artist, that whereas society is engaged in the interpretation of things in relationship to itself and that is in the relation of parts to a whole (or at the best a diverse, temporary and mock whole), the artist on the contrary is only concerned with their resolution in terms of himself, that is, in the relationship of their apparent identity or interchangeability. Now if we believe in the latter as the symbol of a more enduring type, then we may have to adopt as an imperative maxim, that the business of the artist and its value for us lies rather in its differentiation from, than in its conformity to, past or existing models or modes of society.

And hence the application of the argument to the functions and limitations of art or of art criticism. If art has a supremely vital, even though a commonly unrecognized, relation to the thought of the age in which it lives; we may have to add thereto, that its value as an interpretative gage lies rather in its differing from, than adherence to, past or existing modes of thought. For if the last were not true then it would be difficult to account for that gross stamp of originality and independence with which great men have always sealed their work, and the widening of our sympathies which has been its direct result; or if the first were not so, then the chronology of art, like the chronological facts of history itself, could have no meaning and no interest for us. Yet we know that that is not so either: that the monuments of ancient Greece and Rome, or the wall-paintings of old Assyria, or the churches and palaces of a later age with their interior decoration; all these and their like are as authentic documents in the survival of remembrance, as the testamentary records themselves of the peoples and races to which they belonged. And still it may very well be that what we have come to regard as commonplace, or at the best as merely decorative in the large procession of time, may have had an interest as intense and vital in the order and contingency of things to which they first belonged as events the most ephemeral or the most perdurable which attract our attention today or at any passing hour. And thus, if we are so minded, we at last probe into that profound relationship which exists between what has been named the Time-Spirit in art (or its workaday, stained and mutable costume) and its fast anchorage in the immixity and sempiternity of things.

The artist, then, in the high meaning and example of the term, is no mere child loosed at large in a garden stocked with all playful colors, but rather one whose hand has become dyed with the colors that his mind worked in. And it will be safe to assume that if his inspiration be not drawn from the common earth on which he lives and find not a logicality in the sun or in the stars that lend him their light, his work will be unearthly and so unreal, or unaspiring and so unideal. That we may not hope to find such qualities in all who call themselves artists is obvious; while it is at least equally obvious that not all who set themselves up to be the critics of art will be ready in those virtues which they are so fain to deny to others.

WM. D. MacCOLL

The Fight for Recognition

IT was in the early sixties that Edouard Manet sent to the Paris Salon his famous "Breakfast on the Grass," painted before he was thirty, depicting nudes among clothed figures, a favorite theme with the Old Masters. It was rejected with a howl of moral derision. Several years before the jury had refused his "Fifer" on the ground of technical brutality. His paintings had the same effect on the critics as a red flag has on a bull. He was roared at as though

he were a horned beast of the Apocalypse. It had become fashionable to gibe and sneer at Manet. Everything was good for an attack on him, everything was a pretext.

He shrugged his shoulders and tossed the gauntlet to his critics. He hurled immortal blasphemies at academic authority; and brandished his brush in the face of official painters many of whom should have been pastry cooks and laundry men. He attacked everything that represented routine. He fought the petty and pallid taste in art, the artificial admiration of the connoisseur. He knew he had something original to say and fought to say it. He felt himself as a reformer and was proud of his innovations. He talked himself hoarse in the evening among his friends in the obscure Cafe Berguois defending his theories. He told the same story to his intimate friends Whistler, Legros and Fantin-Latour who came to see him at his studio in the rue Guyot. He devoted as much time to repudiate prejudice as to painting.

Every incident he utilized to gather strength and power. His friends of the press, among them Baudelaire, Gautier, Zola and Mallarmé, made the most of it. They dragged the impressionist canvases out of obscurity. The public laughed, and hailed these efforts with mockery and hisses. He was generous enough to take upon himself all the reproaches and bursts of anger leveled not only against his work but theirs. For he fought alone.

Monet, Renoir, Degas, Sisley, Pissaro, Jongkind, Besnard had no fighting blood in them. They were resigned to their unpopularity. They despised glory. Indifferent to the public, they went their colorful way. They faced ignorance and hostility with serene impassibility, disdainfully wrapped their cloaks about them and returned to their easels and their dreams.

Manet enjoyed rowing against the stream. He never tired of assuming a fighting attitude. Like some hildago, he tried to sword-prick his opponents out of his path. Insults served him as coronations. To many he seemed monstrous and gross. He was in reality accomplished and audacious. He was of a robust and lusty nature, astoundingly frank and sincere, and above all a natural man who could *paint*, paint better than Courbet, better than the majority of his contemporaries, with the exception of three or four who were perhaps his equal. Genius is generally aware of its strength. Manet at any rate was. If he had remained silent he might have been forgotten; the success of the whole school of impressionists would have been retarded for a score of years; the mob would have swept over them, pushed them to the wall, and trampled them in the ravel.

For years his life was a turmoil. One year they admitted his canvases under loud protests, another year they flatly refused them. To throw stones at him was law among men of wit who had no genius. They scorned and ridiculed his "Christ." His "Olympia" never would have been bought except by subscription. His "Nana" was rejected. The exhibition of his "Execution of Emperor Maximilian" was prohibited by the government. The "Garden" and "Bon Bock,"

masterpieces that created a *furore* among painters, were disposed of as "coarse images." So 1875 was a repetition of 1869.

Manet did not mind opposition, he simply continued. He thirsted for the expression of life and performed the hard labor of the grand and beautiful, eating his bread dry, smiling at want, rather than to make the slightest concession to popularity. His ambition was to mature, to develop a style of his own. He painted like an Old Master when he was thirty. He rediscovered the magnificent technique, the direct virile paint of Goya, Hals, Velasquez, in twenty years of incessant study and application, and the next thirteen years he struggled to gain absolute artistic independence, to become thoroughly modern in subject and treatment and to conquer light. Thirty-three years, to his very death in 1883, he strove for nothing but to perfect his mode of utterance. There is something glorious and infinitly noble in fighting like that—to die, so to speak, in uniform, fully armed, on the battlefield.

What a great flamboyant energy there was in this man! He was one of the "hard riders of the winged steeds overleaping all boundaries, having their own goal"; one of the eternal fighting men who let their blood riot and their passions blaze unchecked, who keep up resistance, who never bow or cringe to any accepted authority, who at the age of fifty have the same spirit of revolt, the same fire and enthusiasm as in their youthful dreams.

And now, Manet is enthroned in classic glory. How absurd, and inconsistent! The comedy played through the centuries, which has for its hero the man of ideas, seems to repeat itself again and again. Twice or thrice in his career he received the praises of his contemporaries, splendid public recognitions; fame came only after death. It has ever been thus. The men who slaughter other human beings, wholesale, in order to suppress another portion of humanity, with a pretense of liberating them from despotism, are honored with triumphal arches, dinners, parades and diamond badges—perhaps rightly, I surely have nothing against it, but why is a man who fights for an ideal of humanity, no matter whether a poet, reformer, philosopher or artist, always hooted by the crowd, and pelted with mud, even by his friends!

It can not be otherwise. What can we expect of a public that admires Vibert and is ashamed of hanging a nude. The public has no time to reflect. It is only concerned with the effect. Its esthetic appreciation lives on memories or reminiscences. It admires only what it has seen before. It is always opposed to real originality. The road of novel ideas is too rough for them. They prefer to leap through the paper loops of the modish art dealer and critic. Discrimination is not granted to the Philistines. Paint, like verse and music, is something which the technically ignorant cannot understand. Technically they know art as little as the artists know stocks and wireless telegraphy. At the best they want forgetfulness from the banality of life. Few dare to feel for themselves—all that the laymen require is their enjoyment of art. They do not dare to go into the large open places of life, shaken by the winds of space. They envy the artists because

they possess powers and liberties that they do not possess. They will always filch the destiny and thoughts of great men.

This may be perhaps the reason why so many men of genius, at all times, were considered madmen by their contemporaries. The true contemporaries of such men are not those among whom they live, but the few elect of all ages. The world which they comprehend with their abnormal faculties is not the world in which they really live, theirs has entirely different proportions and limitations.

On the Possibility of New Laws of Composition

THE wealth of reproductive processes has enlarged our visual appreciation of form and general aspect of things to a marvelous degree.

Photography, no doubt, has furnished the strongest impetus. It is the most rapid interpreter known to pictorial expression, and has given the person of undeveloped mind, of little skill and few ideas, an opportunity to become a picture maker. The results of photography permeate all intellectual phases of our life. Through the illustrations of newspapers, books, magazines, business circulars, advertisements, objects that previous to Daguerre's invention were not represented pictorially have become common property.

Former ages offered no opportunities to the common people to acquire this facility of discerning accurate representations of life on a flat surface in black and white. The draftsmen and stonecutters of primitive times, realizing that their delineation was a simple form of picture writing, had no thought of any more forceful delineation than that which sufficed people to clearly understand the meaning of figures and symbols. They had no conception of what modern artists call effect, the pictorial study of appearances, which even the most ordinary newspaper illustration can claim. On one hand we see figures in pure accurate outlines, facts of easily legible forms; on the other hand delineations in the round, with the application of life and shade, perspective, environment, which demand a more delicate knowledge of appearances.

Photographic illustration has become a new kind of writing, and it would be strange if this evolution in our sight perception had not been accompanied by some changes in composition. Composition, tersely expressed, is the complete unity of parts. If we wish to emphasize any one part of the representation it cannot be done without subordinating the other elements. Only in this way will we succeed in concentrating the attention upon the principal figure without any embarrassment to the rest. The more pronounced our intention is, in conveying a certain idea, the more careful must we be in balancing the other parts. This general principle will be true for all time. The symmetrical art of the Occident based on geometrical forms, and the unsymmetrical arrangement of Oriental art based on rhythm, are guided by the same idea.

A new spirit of composition, however, may arise in periods of increased

esthetic activity. The relation between artists and the world at large is reciprocal. New laws cannot be elaborated by the mere will of a single individual. The composition of the Old Masters, used for centuries, has passed through its first decadence and by constant application has degraded into conventionalism. It grew more and more stereotyped, until Impressionist composition—which explores obscure corners of modern life, which delights in strangeness of observation and novel viewpoints (strongly influenced by Japanese art and snapshot photography)—gave it a new stimulant. In photography, pictorial expression has become infinitely vast and varied, popular, vulgar, common and yet unforeseen, it is crowded with lawlessness, imperfection and failure, but at the same time offers a singular richness in startling individual observation and sentiments of many kinds. In ordinary record-photography the difficulty of summarizing expression confronts us. The painter composes by an effort of imagination. The photographer interprets by spontaneity of judgment. He practices *composition by the eye*. And this very lack of facility of changing and augmenting the original composition drives the photographer into experiments.

Referring to the average kind of photographic delineation we perceive how composition may exist without certain elements which are usually associated with it. A haphazard snapshot at a stretch of woodland, without any attention to harmony, can only accidentally result in a good composition. The main thoroughfare of a large city at night, near the amusement center, with its bewildering illumination of electrical signs, must produce something to which the accepted laws of composition can be applied only with difficulty. Scenes of traffic, or crowds in a street, in a public building, or on the seashore, dock and canal, bridge and tunnel, steam engine and trolley, will throw up new problems. At present the amateur has reached merely the primitive stage. The most ignorant person will attempt a view or a portrait group out-of-doors. Even children will strive for accidental results. The amateur has not yet acquired calligraphic expression. Like the sign painter who takes care to see that his lettering is sufficiently plain to be understood at one glance, the amateur only cares to make statements of fact. As we examine amateur photographs as they are sent into the editorial offices of photographic magazines, we now and then will experience a novel impression. We do not remember of ever having seen it done just that way, and yet the objects are well represented and the general effect is a pleasing one. I have seen trees taken in moonlight that were absolutely without composition and yet not entirely devoid of some crude kind of pictorialism. It was produced by the light effect. Such a picture cannot be simply put aside by the remark that we hear so frequently, "That is a bad composition." It may be poor art but it is physically interesting.

Climatic and sociological conditions and the normal appreciation of the appearances of contemporary life, will lead the camera workers unconsciously to the most advantageous and characteristic way of seeing things. The innovations which will become traditional will be transmitted again and again, until

some pictorialist will become the means of imposing the authority of the most practical manner upon his successors. In this way all night photographers, good or bad, will help to discover and invent a scheme or method that will be suitable for the subject and consequently become universally applicable. And so it will be with every branch of pictorialism, may it be in the domain of foreground study, of moonlight photography, of animal or flower delineation, of portraiture, figure arrangement or the nude.

The most important factors in these discoveries will be those qualities that are most characteristic of photography as a medium of expression. The facility of producing detail and the differentiation of textures, the depth and solid appearance of dark planes, the ease with which forms can be lost in shadows, the production of lines solely by tonal gradations and the beautiful suggestion of shimmering light, all these qualities must be accepted as the fundamental elements of any new development. Photographic representation, no doubt, will become addicted more and more to space composition, to the balancing of different tonal planes and the reciprocal relation of spaces. This may be an advantage from the point of physical optics. Beauty is chiefly concerned with the muscular sweep of the eye in cognizing adjacent points. It is generally conceded that the impression is more gratifying if these points are limited to a few. Every spot requires a readjustment of the visual organs, as we can only observe a very small space at a time. Too many spots, as may occur in modern compositions, no doubt will prove wearisome and fatiguing, but if the spotting is skillfully handled, it after all will represent the fundamental principle of esthetic perception, and the sense of sight will adjust itself gradually to the necessity of rapid changes.

Also the relationship of lines, so confused and intricate in scenes like a railroad station or a machine shop, factory, derrick or skeleton structure of a building, will need special consideration. The variety and the irregularity of such lines, in which the straight and angular line will predominate, may be compared to the unresolved discords, unrelated harmonies, little wriggling runs and all the external characteristics of the modern French composers. Debussy mastered these apparently incongruous elements sufficiently well to construct novel combinations of sound that, after all, are pleasing to the ear.

If new laws are really to be discovered, an acquaintance with the various styles is prejudicial rather than advantageous, since the necessary impartiality of ideas is almost impossible, inasmuch as the influence of study and the knowledge of pre-existent methods must inevitably, although perhaps undesignedly, influence new creations and ideas. All natural objects have some sort of *purpose*. And the photographer should strive primarily for the expression of the *purpose*. Each object (like the free verse of Whitman) should make its own composition. Its forms and structure, lines and planes should determine its position in the particular space alloted to the picture. More than ever must the artist be gifted with a happy appreciation of beautiful proportions, which often are sufficient

to bestow a noble expression on a pictorial representation.

Much will depend on the amateur who by sheer necessity will work unconsciously in the right direction. His knowledge will increase and his ambitions soar higher. And as he grows in esthetic perception it will react upon the artist and urge him to attain a new and more varied, subtle and modern (though not necessarily more perfect) state of development.

S.H.

The Awakening

The man held talk with death; with burning eyes
He pierced the veil of life; then did he cry:
"Complacent rabble, now at last I know!
Ye want no signs of new-tide verities;
But flatteries, for workers of shallow thought;
And for such facile doers of daily nothings,
Again the furbishing of trite ideals!"—
Then they who stood around said, "How he raves!"—
And so he died.

DALLETT FUGUET

The Fourth Dimension From a Plastic Point of View

IN plastic art, I believe, there is a fourth dimension which may be described as the consciousness of a great and overwhelming sense of space-magnitude in all directions at one time, and is brought into existence through the three known measurements. It is not a physical entity or a mathematical hypothesis, nor an optical illusion. It is real, and can be perceived and felt. It exists outside and in the presence of objects, and is the space that envelops a tree, a tower, a mountain, or any solid; or the intervals between objects or volumes of matter if receptively beheld. It is somewhat similar to color and depth in musical sounds. It arouses imagination and stirs emotion. It is the immensity of all things. It is the ideal measurement, and is therefore as great as the ideal, perceptive or imaginative faculties of the creator, architect, sculptor, or painter.

Two objects may be of like measurements, yet not appear to be of the same size, not because of some optical illusion, but because of a greater or lesser perception of this so-called fourth dimension, the dimension of infinity. Archaic and the best of Assyrian, Egyptian, or Greek sculpture, as well as paintings by El Greco and Cézanne and other masters, are splendid examples of plastic art possessing this rare quality. A Tanagra, Egyptian, or Congo statuette often gives the impression of a colossal statue, while a poor, mediocre piece of sculpture appears to be of the size of a pinhead, for it is devoid of this boundless sense of space or grandeur. The same is true of painting and other flat-space arts. A form at its extremity still continues reaching out into space if it is im-

bued with intensity or energy. The ideal dimension is dependent for its existence upon the three material dimensions, and is created entirely through plastic means, colored and constructed matter in space and light. Life and its visions can only be realized and made possible through matter.

The ideal is thus embodied in, and revealed through the real. Matter is the beginning of existence; and life or being creates or causes the ideal. Cézanne's or Giotto's achievements are most real and plastic and therefore are they so rare and distinguished. The ideal or visionary is impossible without form; even angels come down to earth. By walking upon earth and looking up at the heavens, and in no other way, can there be an equilibrium. The greatest dream or vision is that which is *regiven* plastically through observation of things in nature. *"Pour les progrès à réaliser il n'y a que la nature, et l'œil s'éduque à son contact."* Space is empty, from a plastic point of view.

The stronger or more forceful the form the more intense is the dream or vision. Only real dreams are built upon. Even thought is matter. It is all the matter of things, real things or earth or matter. Dreams realized through plastic means are the pyramids and temples, the Acropolis and the Palatine structures; cathedrals and decorations; tunnels, bridges, and towers; these are all of matter in space—both in one and inseparable.

MAX WEBER

The Photo-Secession and Photography

THE season, which ended with but a single photographic exhibition, has led many of our friends to presume that the Photo-Secession was losing its interest in photography and that "That Bunch at 291" was steering the association away from its original purpose. The best answer is to be found in the pages of CAMERA WORK,—the official organ of the Photo-Secession—in which the best examples of photography are presented regularly to its subscribers. In the announcement of the coming Buffalo Exhibition, printed in our last issue, is to be found a complete vindication of the fact that the interests of photography have never been lost sight of by the Director of the Photo-Secession and that this fact is realized by those who have closely followed the work done at "291." If the position of photography among the arts is to be firmly and permanently established, this can be accomplished by proving it capable of standing the test of comparison with the best work in other media and not by isolating it. The last word has not yet been said in photography. A great advance in the use of the medium is still possible and much to be hoped for. Those photographers who hope and desire to improve their own work can derive more benefit from following the modern evolution of other media than by watching eternally their own bellies like the fakirs of India. This is the help the exhibitions of the Photo-Secession are giving to photographers.

P.B.H.

Chinese Dolls and Modern Colorists

I HAVE seen Chinese dolls, Hopi Katcinas images, and also Indian quilts and baskets, and other work of savages, much finer in color than the works of the modern painter-colorists. Yet the dolls were very modest and quiet about their color, not to speak of their makers; and their makers knew they were making dolls and toys and were satisified at that. But at the *Salon d' Automne* and the *Salon des Artistes Indépendents*, the canvases of some of the color masters seem to shriek out, "Why, the whole universe depends upon me! Don't you know that?" And pretty soon a mob gathers in front, and on all sides of these masterly colored pieces, and all join the chorus in unison. This is so even with the very poorly colored paintings as long as they are in red and green, blue and yellow, or other scientific harmonies, freshly squeezed from the pure tubes. But the purely colored doll, with its intense and really beautiful color and form, is nothing but a pleasing toy, while a Cézanne or Renoir, with its marvelously rare and saturated, yet grey colored forms, is a masterpiece, and a very unpretentious and distinguished one. — I'll take a Cézanne and keep my Chinese doll.

There are today painters who lay open the tubes upon their canvases, according to the laws of modern chromatics, then step upon them until the canvas is well and purely covered, and uncovered canvas is a happy accident. After this marvelous achievement they expect trees, pots, heads, figures, or other forms, and even *l'expression absolue*, to grow out of these colored steps. Impossible! No smear of Veronese green, juxtaposed with one of vermilion, or other formless complimentary daubs or splashes, however brilliant in color, can ever take the place of even the dullest toned or moderately colored painting that has form. There can be no color without there being a form, in space and in light, with substance and weight, to hold the color. I prefer a form, even if it is in black and white, rather than a *tache* of formless color. And as we think of these matters, we question: "Will there ever be a science of art?"

MAX WEBER

Puritanism, Its Grandeur and Shame

IT WAS Karl Larsen, a young Danish writer, who made the strange quotidian remark that "every person over thirty who still believes in an *ism* is deficient in mental calculation, and logical analysis."

It is one of those brilliant, explosive formulæ of absolute individualism, that contain more fascination than exactness. Of course, the desultory creeds of anarchism, socialism, single tax, theosophy, Hinduism, Christian Science, and all the various new thoughtisms—harmless, futile dreams of rejuvenating and reconstructing society—do not afford opportunities to the boldest and freest use of reason. They furnish profitable meditations to the mediocre mind, as they represent an ideal, or rather a dogma, for the ordinary demonstrations of the human intellect. Their adherents can thunder to their hearts' content

against traditions and conventional authorities and feel elated in expounding opinions of "infinite wisdom." Absolutely free is only the original thinker with an exceptional, far-seeing philosophy who speculates solely on the basis of personal observation and deduction therefrom; and I doubt that even he could escape the influences of contemporary thought, and if he were an American, evade the tyranny of Puritanism.

Puritanism is no longer a creed, it has deteriorated into an "existing condition," yet despite its inability to make new converts it has lost little of its domineering strength, inasmuch as its doctrine has become ingrained in most of us, no matter how much we may at one time or another have opposed its baneful influences. We may rail against Puritanism in bitter denunciations but its tentacles, octopus-like, have entangled our very customs and manners. We may laugh at its tyranny, but cannot prevent it from introducing itself into our opinions and modes of life and from curtailing our pleasures and predilections in matters of taste.

What monsters of intolerance and fanaticism the old Puritans must have been. I believe St. Gaudens was too much of a Puritan himself to have revealed to us in his statue (at the City Hall Square, Philadelphia) the true significance of their harsh principles of Christian gravity and zeal. There was a chance for epic proportions. He shows us merely a stern attitude and the externals of a simple homespun garb and heavy drooping mantle. His Puritan stalks along sadly and solemnly, with staring eyes that are indifferent to visible things. It is somber and historically accurate, but it lacks the symbolical, illuminative quality. Imagine what a Rodin could have made of it if he had treated it like his Balzac, like an idea shimmering through matter.

He would have shown us the skeleton in the family closet, which saps the best life blood of our nation and makes it impossible to literature and art to expand in a free and wholesome manner.

In the life of the Puritans all worship of the beautiful was wanting. The natural expression of the heart's emotions was proscribed. Amusement was considered vice. They condemned every pleasure, even out-of-door festivals. They advocated a joyous superiority to sensual life. The external and natural man was crushed, only the inner and spiritual man survived. If heaven means to be blind to palpable facts, the "stains of experience," and the seduction of the senses, they very nearly established the kingdom of heaven upon earth.

And yet from the viewpoint of impartiality we cannot help admiring some traits of their theory of life. No doubt we would not particularly enjoy to sit at the same table with Rev. Mather or Jonathan Edwards. They would prove exceedingly dry and obstinate reasoners, pulling up our souls and their own to see how the roots are spreading, and permit us no reference to diffident kisses, yellow moons, and windblown hair. Nevertheless we might feel something akin to sympathy for their manly vigor, their austerity of purpose and preciseness of action.

The truth of this is brought home to me whenever I make an excursion to the New England States. I merely have to look at the faces of the passersby as I wend my way through the quaint towns of Newport or Gloucester. In the larger cities all faces seem to resemble each other. They only express energy and eagerness. The desire to better their material welfare seems to have blotted out and wiped away all finer traits of facial construction. In a New England village nearly every face has a distinct physiognomy, its angular features reveal breed, character, independence, a distinct type and individuality. This is refreshing but scarcely profitable to the artist, as their owners have inherited the shortcomings of their forefathers, and despite an increase in worldly culture and milder maxims of conduct, are still very practical and prosaic and affect to be moral at any cost. The New England conscience, morbid and oversensitive, yet inexhaustible in patience and sacrifice, still troubles them.

Vows of chastity and corporeal penance have gone out of use. The singing of psalms, family prayers and religious exercises have retreated to their proper place in church and homes.

But alas, the hand of God and the claw of the devil are still upon us. The menaces of the prophets, the pitiless doctrine of Calvin, still seem to linger in the air and work havoc in our midst. Half of our difficulties in public and private life are due to the Puritanic spirit. And the former belief of predestination to eternal damnation has changed into a rigid sense of propriety that is prohibitive, dismal, and destructive to art and all higher intellectual pursuits.

There is no happy beauty, no warmth, music, color in our art, no splendid flashes, no stormy splendor, no indignation, and no revolt. It is the old fight of reason against imagination. Art is dominated by decency, propriety, regularity. The Sunday laws and all the other prohibitive measures have made cowards of us all. In sculpture we only meet with frock-coated and well-booted men. In painting, scarcely a breath of the great passions is palpable. In literature there is much pretense, but no deep thought and lofty imagination, and no trace of realistic truth. The painter does not dare to paint a nude. The writer is afraid of writing a realistic love story. The artist as well as the public bear the troubled conscience of sinners. The slightest trespass may scandalize the taste of the drawing room and forfeit success. Puritanism still deals out banishment, confiscation, punishment to unfettered poetic souls. The nude has no place in the home, but is relegated to the barroom for the gratification of lewd sensations. It is the insincere modesty of the fig leaf. The hypocrisy of a dyspeptic generation of pedants.

In the evolution of our race, Puritanism is performing miracles. It disciplines immigration. Its methods are rude and perfunctory, but combative and self-assertive and help to smooth down the solicitations and contradictions of new surroundings. Morality is the pretext. Graft the real *modus operandi*, and material improvement the offered recompense. Our immigrants, unable to

form any personal or precise opinions about public functions, are forced into the yoke. It overbalances the whole combination of their vague principles, blind emotions and foreign customs. No solitary man and community can oppose the professional politician and his mediocre and selfish version of Puritanism.

It is no longer plain and homespun verity which guides our municipal affairs, which is enthroned on editorial chairs, and which is heard from the pulpit and judiciary bench. We are too remote from the A-B-C's of Puritanism to have preserved the grandeur of strange theological dreams, groping reflection, and contemplation of human destiny. We are haunted merely with a phantom of the past out of which all beautiful meaning has faded. All we possess in the domain of higher esthetics is the art of delicate transitions, of refinement, freshness of immediate observation and mechanical skill. And there can be no vital art of any sort until there has grown up an appreciation of the Rubens-Goya spirit; until we dare face our passions, until we are unashamed to be what we are, until we are frank enough to let wholesome egotism have its sway. Human nature is above all the artifices of law, of moral and legal constraint.

The number of young artists may be on the increase who ponder over these incongruities, as they labor in the silence of their studios, and darkly and passionately their brain may work. This may be the inauguration of free art expression, but little as yet has struggled to the surface.

And as long as we—as Heine said of the Berliners—sit in snow up to our navels, and torment ourselves with conscientious scruples we will have no candor, no fire and dash in any intellectual act. We will remain a gray race, our passions will be cold, and a petty and pallid taste will pervade our world of art and letters.

S.H.

The Buffalo Exhibition

THE impression left by this exhibition was so subtly deep that after the first complete view of it, one was not immediately conscious of any impression other than a curious sense of intellectual quiet and satisfaction. That one could come away from an exhibition of pictures with such a feeling was in itself a unique experience. The mind at once began to endeavor to analyze the effect, in its effort to arrive at the cause. What was it that had produced this result? Through the entire exhibition everything bespoke a quiet earnestness and sincerity of purpose. There had been no claptrap, no appeal to the hyperemotional, no melodramatic touches, no effort at pictorial climaxes and crescendos. The whole was pervaded with a curiously rare sense of harmony; the individual parts were complete and harmonious in themselves; harmonious in their relation to each other; harmonious in their combined results as a whole. Everything was exquisitely refined and well-balanced down to the smallest setting of the exhibition. Then, as one analyzed and gave thought to it,

one began to understand that it was the very bigness and perfection of the exhibition that seemed to fail to create an impression by the very bigness of the impression that it did create through so entirely lifting one out of the customary exhibition atmosphere as to take away all standards of comparison.

II

The modern pictorial exhibition, with few exceptions, has, by those familiar with the subject, come to be regarded as a possibly necessary evil, and, in most cases, as the corruptor instead of the educator of public taste. Admirable in their original purpose, academic and art-organization exhibitions, with few exceptions, have degenerated into being conservators of esthetic snobbery or of the commercialization of art. The academy exhibitions have grown to be high-class marts for artistic wares, and are but a few degrees removed from the art dealer's gallery. By "making" certain artists and creating a demand for a certain class of work, they have educated the public along certain popular lines, and often shut the doors of recognition and success in the face of originality and progress. It is always unfortunate when an artist is dependent on his art for his living. It is degenerating when an artist's inspiration finds incentive in cupidity. It is vulgarizing, the longing for academic honors. The real artist is so much bigger as a man when he stands alone than he is as an academician, when he becomes one of a crowd. And yet it is all this that the modern academies and exhibitions have largely fostered.

It may surprise some readers when the assertion is made that this exhibition has been over a quarter of a century preparing. Yet such is the fact. For over twenty-five years I have watched exhibitions come and go and their wrecks as monuments to much wasted and misdirected endeavor. But, through it all, like a coral island being built up slowly, surely, under the surface has grown the spirit that finally unveils itself in its full ideality in this exhibition. It is said that whatever is good is worth fighting for. Every step of the way has been fought. The same elements that in the past made the old "Joint Exhibitions" impossible, and that diverted the Philadelphia Salons from their original high purpose into a sort of County Fair photo show, where vulgarity vied with vanity to be classed as artists with Rembrandt and Rubens, these same elements sought by every means to pull down this exhibition as they had others, and failing in that, to misrepresent it afterwards through dishonest misrepresentation. But the days of the power of these elements for mischief were passed. They had faded into mere shades, whose thin crackling voices were all that was left of them.

The force of purpose behind the "Secessionistic Idea," and the truth of the great principle it sought to shape into definite being—like all high and sound ideals when backed up by uncompromising, fearless truth—slowly but surely conquered, and set a standard of beauty that must eventually influence the world of modern art. ——

Largely to one man does the success of the Buffalo Exhibition, with all that that implies, belong. Over twenty-five years ago he recognized the possibilities of photography. He realized that there were many persons who, if they came to regard photography seriously as a possible means of original pictorial expression, would give to the world individual conceptions of the beautiful that could be produced through no other medium and for which the race would be richer; and that through a medium with which the general public was more intimately familiar than with any other, the public taste could through understanding be trained to a keener and truer and more catholic perception of beauty in all fields of artistic expression; and, furthermore, through such education of artistic perception to emphasize the principle that a large class of paintings—many of which are even housed in art galleries—will be superseded by works produced more beautifully and less mechanically through the medium of photography. This was the germination of the Secessionistic idea. Through writings and exhibitions the battle was begun and tirelessly waged with this end in view; and so it has gone on tirelessly for a quarter of a century, to be finally crowned with this splendid achievement—the Buffalo Exhibition.——

III

The charm and interest of this exhibition was so engrossing that it was only after several vistis that I found myself able to regard it from the purely critical standpoint. It is the one complete presentation of the development (anabasis I was almost tempted to say, as it has been very like a military advance) of photography as a means of pictorial expression as an art. It is such an exhibition as will never again be gotten together, and might almost be said to be the final word, for, while new and beautiful work will continue to be created through this medium, no higher standards of expression will ever be reached.

In saying that it is complete, I do not overlook the fact that the exhibition did not include examples of the works of Mrs. Cameron and some others; but what Mrs. Cameron did in portraiture was more than done by Hill, whose work today after nearly fifty years represents the finest portraiture ever done by aid of photography. The Hill collection is splendid, vital, virile and by comparison, some of the finest of the modern portraiture shown in this collection seems thin, anemic and over-conscious. The exhibition afforded a rare opportunity for a comparative study of the work of the different exhibitors. The delicate poetic charm of White left the impression of the music of line, and the soft singing whisper of tone with only the ghost of a shadow of the personality behind their making. While the almost brutal strength of Steichen with its highlight accentuation carried the mind directly to the dominating personality of Steichen himself—big, rugged, full of activity, emotional, a veritable Danton among pictorialists, a mind whose mental horizon is very broad and whose convictions are very strong and eager to force themselves on others—a man certain to make staunch friends and bitter enemies, and with all, a good fighter and one free from petty jealousies. In the fine collection of Eugene's work, which in

certain aspects possesses some of the characteristics of Hill, one feels the paint-er, the man who loves rich color for itself, who loves life, beautiful, jovial, healthy, full-blooded life, and glories in protraying it—a very meistersinger of the joy of living. Strongly and curiously did the pictures of Seeley contrast with those of Eugene—striking in composition, flat in treatment, decorative in character, and suggestive of the dreamy sadness of living ghosts. Coburn, on the other hand, dealt with neither the joy of living nor the sad dreams of living ghosts, but the problems of compositions as suggested by city scenes and streets. Here was the very evident influence of Japanese art in which there was little suggestion of feeling or color—but strong feeling for urban pictorial pos-sibilities—that contrasts curiously with the purely architectural sense of Evans. The work of De Meyer proved one of the most attractive groups in the exhibi-tion. Refined to a degree in both conception and treatment, at times quaint, at times piquant—always vivacious, finished and delightful, always showing exqui-site taste and a masterful knowledge of technique, everything he displayed was of interest and his "Silver Skirt" was one of the most attractive pictures of the exhibition. How marked the contrast between this and the exhibition of Ger-trude Käsebier, with its artistic irresponsibility and indifference to mere tech-nique; its curious impulsiveness; its inner blind groping to express the protean self within—that finer, bigger self that cannot always find voice and that resents any seeming lack of appreciation on the part of others; of the respect that she feels is the due of the muse she worships. Annie W. Brigman, on the other hand, seems to have sought to grasp the very soul of nature, and her entire collection is rhythmic with the poetry of nature, its bigness, its grandeur, its mystery. It is reminiscent of the Ovidean metamorphoses, and the "Midsum-mer Night's Dream"—pervaded with a certain bigness of feeling that the splen-dor of our Western nature seems to infuse into the soul. In this collection we quite lose sight of the personality of their maker in the poetry and charm of the themes portrayed.

By all odds the most complete and finest in every respect were the collec-tions of D. O. Hill, J. Craig Annan and Alfred Stieglitz. The Hill collection was largely confined to portraiture. Those of Annan and Stieglitz covered a wider range and showed finely artistic perception and masterly technique, together with an unswerving sincerity of purpose. Both marked by a curiously keen sen-sitiveness, of which Annan's was perhaps the more poetic and gentle, Stieglitz's the more symphonic and aggressive, but both sure of touch and fertile of fan-cy. Amateurs in the real sense of that word, they represented at its best the work of their several countries, and I derived from the study of their work much the same pleasure that I enjoyed in going over the collection of original prints of some of the master etchers in the British Museum. As I enjoyed those etchings for their individual charm and beauty, for the sheer pleasure that their contemplation gave me, so did I enjoy these prints.———

IV

My last visit to the Albright Art Gallery was on a dark, stormy day when snow and rain kept most people indoors. There were not many people there at the time and the overcast weather left the gallery interior in a semitwilight. After I had wandered round in final review, I sat down for a while to rest. In the quiet and semidusk of the nearly deserted gallery I fell open-eyed into a dream that metamorphosed all about me into vitally palpitating life. Out of each frame there seemed to flow a vital current of life, which commingling created a complex living, swirling, revolving miniature world. Visible to me were the creative forces behind all of these pictures—the lives that had gone into their making. Many of these forces were warring with themselves, warring with each other, seeking violently to rend the whole asunder. Many of them, apparently, if left to themselves, would have destroyed their own work. Clouds of jealousies from time to time obscured the whole. But all the while some central force held the mass together, drawing out and sometimes shaping the best work, helping those who stumbled and uniting all the complex, imaginative energy into one purposeful whole towards a definite end. This central observing, guiding mind appeared to see and understand the evolving minds about him, and to be endeavoring to evoke from each that which was finest and best, to be endeavoring to make each bigger and finer and immortal. And as he worked and planned a great structure seemed to be growing under his building—and all the while his eyes were fixed on a distant horizon from behind which shone a soft beautiful light, which was the glow of Beauty. And as this complex structure on which he worked expanded, grew, was raised up above the earth, slowly it became enveloped in the golden glow of this soft light. And somehow that for which this exhibition about me stood, that which it represented, seemed to be the structure that had been raised by the tireless watcher out of the combined energy of these evolving, complex, divergent forces, which, left to themselves, would have wrought only destruction; and, votaries of beauty though they were, learned but slowly and imperfectly the great lesson of beauty.

<div align="right">JOSEPH T. KEILEY</div>

To Xochipilli,* Lord of Flowers

Thou art a flower, tender of attitude
　　yet virile of form.
Oh, lord of flowers, Xochipilli!
Of clay art thou made;
But thy maker thee embodied
With spirit vibrating and filling.
Thou starest with an all seeing,
　　all penetrating eye.

Thou fillest boundless space,
Watcher of endless time,
Speaker of the universal tongue.
Thou art more living than
Ten thousand others made of flesh.
'Tis because of thy maker
That thou art thus.

<div align="right">MAX WEBER</div>

*Xochipilli, primitive Mexican sculpture

Rodin and the Eternality of the Pagan Soul!

WHAT is pagan ecstasy? What is the meaning of that deathless passion that has come to flower in the sublime art of Rodin and Matisse? It is this: The perception of the mystery of surfaces; the delirious delight of touch; the transports of joy bred of the melodies of motion; the worship of Venus for the sake of her divine body, that body that is a love-canticle of mystic lines and shadows.

And again it is this: The adventure of the mind in matter; the adventure of the senses in air, water and sunlight; the deliria of creation; the divinizing of the sensual and the materializing of the sensuous.

The Pagan Spirit in art, that eternal renaissance of Passion and Beauty, dethroning in its wild Dionysian frenzy all the anemic gods of renunciant impotents, skirts the coasts of strange lands, houses itself in unfamiliar moods, forages on all men's thoughts. It mints the gold and silver of daily experience in the smithies of its passionate will, and forth from those molds come the things of nameless beauty that Phidias, Leonardo, Rodin and Matisse have given us.

The Pagan Spirit pillages life and marauds on the last secrets of the Ineffable God—the Ineffable God of open spaces, the God of light and laughter, the God of color and sex, the God that halloos his invitation from every line and pore and witching curve of woman's body.

The miraculous! There is nothing but the miraculous. The miraculous does not happen now and then. The miraculous is—ask Rodin whether he believes in miracles and his answer would be: "Am I not alive?" The pagan attitude, then, assumes the miracle of beauty and life. It opens its eyes on the universe with wonder, amazement and childish delight graven there.

All matter is haunted. Everything that is is a perpetual miraculous epiphany. Winter is the womb of springtime. Withered branches with the ice glittering upon them hold latent within them the perfumed rose. The atom is a tiny house with many ghosts. Sunlight on my shoe is inexplicable. The joy that comes to me from the bodies of nude women is religious. Sunlight is haunted; else how came this world to be?

So the souls of those great wonder-working magicians, the great artists, stand swathed in this sense of elemental mystery, translating, with brush or chisel, all things back to their private, original glamour, and with the witchcraft of this holy pagan innocence unwinding the cords of complexity that use and wont and the emasculating Christian virtues have wound round and round the Holy Ghost of Beauty.

By the mechanism of the association of ideas we generally ally the word "paganism" with the words "ancient Greece." But that admirable flowering of the human spirit—those few centuries wherein Mind and Matter played the impenitent prodigal with its own native inheritances—was no isolated phenomenon. Paganism is the instinct for liberty. It is a tendency, not a bundle of opinions. A "pagan movement" is always a "new movement." It is always a rebellion against dogmas, codes, conventions, dry-rot morality and the profes-

sional instinct. Every artist who sees in a new way is a pagan. Monet and Manet and Boecklin and Rodin and Matisse and Walt Whitman and Wagner and Richard Strauss were pagans. It is the deep, procreant spirit that wages war against all forms of death. The pagan spirit is the red blood of our dreaming, and its products spring from the loins of our esthetic rapture.

There is always a renaissance somewhere in the world. The human spirit will not long be set in limits. It will invite pain, but it never invites immobility. The pagan spirit calls the dead from their tombs and blasts the sight with its supernal vistas. It may be sudden epiphany of a Nietzsche in philosophy, a Whitman in poetry, a Wagner in music, or a Rodin in sculpture, but it is always a murderous and creating Force—murderous in that it batters at the rotting ramparts of the orthodox gods; creative in that is brings to the human race a new gospel.

This spirit takes for its loom the whole visible and invisible universe, and weaves with the golden thread of its dreams the mighty tapestries of Art. It conjugates the things seen with the eye and the things touched with the body in all their moods. It transfigures and rejuvenates a staled world. Only one thing it is not—it is not "moral."

And thus forever and forever will this divine spirit recur. Always somewhere in the world there is being birthed a human *revenant* of the Great God Pan, who comes to finger his immortal pipe, to jettison his fullness of joy over on outworn world, to spill into the golden matrices of art his hyperborean chant.

If the divine erotic Sappho was a pagan, so was the austere Epicurus. In our day Rodin and Anatole France, Goethe and Keats, Swinburne and D'Annunzio stem from Olympus. Rabelais and Montaigne left records that smug gentility has not yet found the means of annulling. And now we hear the parochial piffle about Rodin and Matisse, and the little dry cough of prudery is heard in the land. And Philistia passes in obese seriousness before the products of the masters of the age. And the lazarus-rattle of the leper, Hypocrisy, is heard at the door. And those midwives of mediocrity, the art critics and art editors, croon and mumble their nothings.

But over all reigns Aphrodite; and look at that kissprint on the breast of Rodin—it is where the divine goddess kissed him!

BENJAMIN DE CASSERES

The Unconscious in Art

A WORK of art that we can understand at sight is mediocre or worse. Genius stirs our ignorance first. That which comes out of the deeps must make its appeal to the deeps. It is the unknown, the indefinable, the thing that "worries" you in Rodin, Whistler, Matisse, Rops that fascinates you. It brings you back again and again, and each time that we know more of them we know less of them. That is the paradox of the Infinite.

Every thought has its corresponding emotion; no thought, no emotion— that is a philosophic axiom. But there are esthetic emotions for which there are no corresponding thoughts; emotions that awaken the Unconscious alone and that never touch the brain; emotions vague, indefinable, confused; emotions that wake whirlwinds and deep-sea hurricanes.

Before the Beautiful some of us are in danger of esthetic catalepsy. Thought knows not what to paint on these states of esthetic subconsciousness. There are no idea-pigments that correspond to these emotions, these nostalgic shadows that never quite come out of their tombs.

Monet, Poe and Blake were three types wherein the Unconscious tried to render itself intelligible. And the world always questions the sanity of this kind of art but the sanity of the world is the sanity of common sense and common sense in art we can dismiss.

So profoundly is the mind of genius rooted in the Unconscious that it never has a clear idea of just what it is doing. It obeys. From this the idea of "having been chosen" is born in the brain of the great painter, the great sculptor, the great musician. Who knows the exact effect or worth of his precious work? What great artist knows what he is doing at any particular time? He is a tool in the hands of the Unconscious. He brings a message to the world that he himself does not know the import of.

Conscious effort, conscious willing, the open-eyed act is always the *last* of a series, and not the first, It is the flower of preceding incalculable sowings in the Unconscious. Consciousness in art is only the antenna of the blind unknowable Force and intelligence is only its nerve.

Imagination is the dream of the Unconscious. It is the realm of the gorgeous, monstrous hallucinations of the Unconscious. It is the hashish of genius. Out of the head of the artist issues all the beauty that is transferred to canvas, but the roots of his imagination lie deeper than his personality.

The soul of the genius is the safety vault of the race, the treasure-pocket of the Unconscious soul of the world. Here age after age the Secretive God stores its dreams. And the product of genius overwhelms us because it has collaborated with the Infinite.

BENJAMIN DE CASSERES

Plato's Dialogues — Philebus

PROTARCHUS: But what pleasures are those, Socrates, which a person deeming to be true, would rightly think so?

SOCRATES: Those which relate to what are called beautiful colors, and to figures, and to the generality of odors, and to sounds, and to whatever possesses wants unperceived and without pain, yet yields a satisfaction palpable, and pleasant, and unmixed with pain.

PROT.: How, Socrates, speak we thus of these things?

SOC.: What I am saying is not, indeed, directly obvious. I must therefore try to make it clear. For I will endeavor to speak of the beauty of figures, not as the majority of persons understand them, such as those of animals, and some paintings to the life; but as reason says, I allude to something straight and round, and the figures, formed from them by the turner's lathe, both superficial and solid, and those by the plumb line and angle rule, if you understand me. For these, I say, are not beautiful for a particular purpose, as other things are; but are by nature ever beautiful by themselves, and possess certain peculiar pleasures, not at all similar to those from scratching; and colors possessing this character are beautiful and have similar pleasures. But do we understand? or how?

PROT.: I endeavor to do so, Socrates; but do you endeavor likewise to speak still more clearly.

SOC.: I say then that sounds gentle and clear, and sending out one pure strain, are beautiful, not with relation to another strain, but singly by themselves, and that inherent pleasures attend them.

The Relation of Time to Art

AFTER living constantly for two years in the quiet and seclusion of a London suburb, and then suddenly being plunged into the rush and turmoil of New York, where time and space are of more value than in any other part of our world, this consideration of the relation of time to art has been forced upon me.

As photography has, up to the present time, been my sole means of expression, I can best understand and attempt to explain my meaning by consideration of the part time plays in the art of the camera.

Photography is the most modern of the arts, its development and practical usefulness extends back only into the memory of living men; in fact, it is more suited to the art requirements of this age of scientific achievement than any other. It is, however, only by comparing it with the older art of painting that we will get the full value of our argument plainly before us; and in doing so we shall find that the essential difference is not so much a mechanical one of brushes and pigments as compared with a lens and dry plates, but rather a mental one of a slow, gradual, usual building up, as compared with an instanta-

neous, concentrated mental impulse, followed by a longer period of fruition. Photography born of this age of steel seems to have naturally adapted itself to the necessarily unusual requirements of an art that must live in skyscrapers, and it is because she has become so much at home in these gigantic structures that the Americans undoubtedly are the recognized leaders in the world movement of pictorial photography.

Just imagine anyone trying to paint at the corner of Thirty-fourth street, where Broadway and Sixth avenue cross! The camera has recorded an impression in the flashing fragment of a second. But what about the training, you will say, that has made this seizing of the momentary vision possible? It is, let me tell you, no easy thing to acquire, and necessitates years of practice and something of the instinctive quality that makes a good marksman. Just think of the combination of knowledge and sureness of vision that was required to make possible Stieglitz's "Winter on Fifth Avenue." If you call it a "glorified snapshot" you must remember that life has much of this same quality. We are comets across the sky of eternity.

It has been said of me, to come to the personal aspect of this problem, that I work too quickly, and that I attempt to photograph all New York in a week. Now to me New York is a vision that rises out of the sea as I come up the harbor on my Atlantic liner, and which glimmers for a while in the sun for the first of my stay amidst its pinnacles; but which vanishes, but for fragmentary glimpses, as I become one of the gray creatures that crawl about like ants, at the bottom of its gloomy caverns. My apparently unseemly hurry has for its object my burning desire to record, translate, create, if you like, these visions of mine before they fade. I can do only the creative part of photography, the making of the negative, with the fire of enthusiasm burning at the white heat; but the final stage, the print, requires quiet contemplation, time, in fact, for its fullest expression. That is why my best work is from American negatives printed in England.

Think for a moment of the limitations of photography. You are confined to what a friend of mine sums up in the high-sounding words, "contemporary actuality," and now I find that my vision of New York has gradually taken upon itself a still narrower range, for it is only at twilight that the city reveals itself to me in the fulness of its beauty, when the arc lights on the Avenue click into being. Many an evening I have watched them and studied carefully just which ones appeared first and why. They begin somewhere about Twenty-sixth street, where it is darkest, and then gradually the great white globes glow one by one, up past the Waldorf and the new Library, like the stringing of pearls, until they burst out into a diamond pendant at the group of hotels at Fifty-ninth street.

Probably there is a man at a switchboard somewhere, but the effect is like destiny, and regularly each night, like the stars, we have this lighting up of the Avenue.

ALVIN LANGDON COBURN

Exhibition of Prints by Baron Ad. De Meyer

THE exhibition of photographs by Baron Ad. De Meyer, recently held in the Gallery of the Photo-Secession, created its air of distinction. This is to say, that the prints were out of the ordinary, since the little room has acquired for itself an atmosphere which is quite foreign to routine impressions. For the visitors who frequent it, whether they sympathize or not with the work shown, at least have the habit of expecting to see something that differs from the staple art-ware of other exhibitions. They look for a *choc* and, even if what they receive is a shock in the plain ordinary English sense, are disposed to tolerate the outrage, because it stimulates thought and speculation. They have the satisfaction of being piqued to rebellion if not appreciation. They are at least stirred to think, which itself may be something out of the ordinary.

To those who do not sympathize with, because they cannot understand, the motive which inspires Mr. Stieglitz in his work at the Little Galleries, this will sound like sensationalism. And, indeed, it is unfortunately impossible for a man to blaze a trail which is out of the ordinary without running the risk of incurring this charge. For example it is alien to usual experience that a man should promote exhibitions without any idea of gain or even of pleasing the public. That his motive should be, on the one hand, to give the public a chance of seeing what he thinks it ought to be pleased to see and will be able to see nowhere else in New York—at least until the example set at the Little Gallery has been followed, as in the case of Rodin's and Matisse's drawings, by the Metropolitan Museum—seems like an amiable form of lunacy. That he should be on the lookout for evidence of honest individuality in young unknown painters and strive to encourage it by exhibitions which display the weakness as well as the strength of the beginner—what can this be but sensationalism?

No one more than Mr. Stieglitz recognizes that there is a danger of this sort of thing degenerating into sensationalism, or is more afraid of it. Accordingly, he tries to balance one exhibition with another; offsetting, for example, the startling radicalism of a Picasso with the stable conservatism of an Octavius Hill; the experimental work of some young painter with the assured achievement of another photographer, such as De Meyer. Nor does the delicious irony of this escape one. For years, Mr. Stieglitz has taken the advanced position that photography is entitled to be considered a medium of pictorial art, and has been ridiculed by the critics of painting. Now that the latter are foaming in impotent bewilderment at the vagaries of modern painting he offers as an antidote the sanity of the photographic process. After claiming for photography an equality of opportunity with painting, he turns about and with devilishly remorseless logic shows the critics, who have grown disposed to accept this view of photography, that they are again wrong. As long as painting was satisfied, as it has been for half a century, to represent the appearances of things, photography could emulate it. Now, however, that it is seeking to render a vision of things not as they are palpable to the eye but as they impress the imagination,

Mr. Stieglitz proves, what he has known all along, that photography is power-less to continue its rivalry with painting. He has, in fact, called the bluff on the recent pretensions of painting by showing that it is in its motive essentially pho-tographic.

There was, therefore, a streak of malice aforethought in arranging this ex-hibition of De Meyer's prints. For the latter are far above the average; repre-sent an honest and exceedingly skillful use of the medium, and display more pictorial imagination than is discernible in the majority of photographs and paintings. They illustrate to an unusual degree the flexibility of the camera's resources; and thereby are all the stronger evidence of the latter's limitations, as compared with those of the draughtsman and painter.

For De Meyer unquestionably has vision. He sees beyond the mere prose of his subject; his imagination realizes how the significance of the facts may be enhanced by pictorial expression. ———— Baron De Meyer is a man of the world, of wide culture and sympathy with diverse forms of esthetic expression. All this has tended to broaden and refine his vision; but has never tempted him to distort the possibilities of the process to the requirements of his vision. On the contrary, with the logic and conscience of a true craftsman he has adjusted the latter to the technical resources. ————

[De Meyer's work] is a product of intuition rather than of the intellectual faculty; a point which is worth consideration, since at first appearance [it] is modern *au point des ongles* and yet, when analyzed, is found not to involve the most modern quality, namely that of intellectualized sensation. It stimulates an exquisite refinement of feeling, but stops short of that higher stimulus to rarified intellectual content. ————

CHARLES H. CAFFIN

The Ironical in Art

As irony is the supreme method of perception, so it would seem in art that all esthetic impulse must at last end in the comic calvary where-in the painter, the poet and the musician play the crucified before their own sly eyes.

This thought was evoked in me as I stood before the extraordinary sculp-tures of Matisse lately exhibited in the Gallery of the Photo-Secession. Matisse, Picasso, Baudelaire, Nietzsche, Flaubert, Felicien Rops, Geiger: what do they represent except Art doubling on itself, thought and feeling achieving a sub-lime mockery of itself, Columbus cursing his new-found America?

To write "the book of revenge" (as James Huneker calls Flaubert's "Bou-vard et Pecuchet"), to paint the picture of revenge, to chant the psalm of re-venge—is not that the secret dream of all great artists? In the last analysis, all revolutionary art, like all religion, is a kind of vengeance. The dreams of artists are nympholeptic dreams of Perfection. Never being able to reach perfection

they revenge themselves by ridiculing it. Have not Matisse and Picasso done this? Is it not that the secret of Futurism and Post-Impressionism and all the other isms that now run riot and will continue to run riot in a glorious and impenitent world in spite of the bleatings of the obscure employe of the Wall Street Edition of a bright and spleeny evening sheet?

Irony in art is the expression of a lifelong vendetta of a penned-up, often impotent Ego against the commonplace and the limited; the cry for perfection *à rebours*. Richard Wagner was a demigod, and he dreamed of heroic fornications and Olympian sex-frenzies. Not being able to satisfy this madness in the "Ring" and "Tristan und Isolde", he wrote "Parsifal," the apotheosis of venom, spite and unassuaged lust. He spat on women and deified the eunuch. Wagner should have lived in a harem of Junos; but being only mortal with the voluptuous dreams of a thousand Joves packed into his body, he flung at the world his opera of revenge, — "Parsifal," the epic of spleen.

Every great painter dreams of doing a "Parsifal" in color.

The root of nihilism in art is spite. "Le Fleurs du Mal" is spite. "Thus Spake Zarathustra" is spite, "The World as Will and Idea" is spite. All Futurism, Post-Impressionism, is spite. Great men are known by their contempts. There have been geniuses who have never given their spite to the world; it was because they lacked the time, not the will.

All great movements begin with the gesture of hate, of irony, of revenge. This is as true in art as in social history. Irony is the perpetual heaven of escape. Nothing can follow the mind into that sanctuary. Against self-disdain and self-mockery the world wars in vain. It redistributes and revalues everything that comes to it for appraisal.

There is a revaluation going on in the art of the world today. There is a healthy mockery, a healthy anarchic spirit abroad. Some men are spitting on themselves and their work; and that is healthy, too.

After thinking of some of the things that Matisse and Picasso have done I thought that all seriousness is a defect of vision. It is quarry for Fate and Fury. There is no form of seriousness, even in art, that has not in it the germ of disaster for the mind that is a slave to it. It is the soul of tragedy, the protagonist of every emotional and mental ill that besets the human being. There is something in seriousness that runs counter to the spirit of things. No ideal is complete until you have smashed it. No art is perfect until the creator of it has caricatured it. Do not affront the God of Carelessness! In a universe that wavers and totters and flows and blends, that melts and reappears eternally, Seriousness attempts the static pose. It tries to stanch motion by predicating a cohesive finality. Before an imponderable, riant god it assumes a cumbrous avoirdupois. There is a hidden diabolism, Puck-like, in this New Movement. Will the bright employe of the Wall Street Edition take it all too seriously?

Has Matisse, has Picasso, has De Zayas whispered into the ear of his generation what Satan whispered into the ear of St. Anthony, "Suppose the absurd

should be true?" The absurd has an inexorable logic; it is the mother of irony and the wing of Perception and the Cain-brand on the forehead of every new movement. There is life itself to prove the supremacy and legitimacy of the absurd.

Why should the dreamers and thinkers and painters of the Other Plane despise this age we live in?—this age of shreds and pasteboard, of superficialties and stupidities, of inanities and material prosperity? Has it not given to us the divine ironists, the supreme haters, the mockers, the merry-andrews of art? Has it not given to us the disequilibrated geniuses of destruction, the pessimistic analyzers and dissociaters of all the humbug done under the sun in the name of classicism? Out of the entrails of this disorderly age have come Thomas Hardy, Swinburne, Baudelaire, Rodin, Monet, Cézanne, Manet, Schopenhauer, Whitman, Nietzsche, Verlaine, Debussy, Wagner, Matisse, Picasso, Carlyle, Bloy, De Maupassant, Remy de Gourmont, Redon, Geiger, Anatole France, Marinetti, James Huneker, De Zayas, Maeterlinck, Jules Laforgue, Arthur Symons, Hauptmann, Tolstoi, Ambrose Bierce. It is a glorious age and a glorious anarchic world of color, motion vibration and scintillating creative-destructiveness! We have made our wounds sing, and sometimes we have put a tongue into them and made them spit out the venom in our souls. We have drawn the unguents of ideal beauty and the acids of healthy mockery from our sores. Blessed be the devil of material progress! It stands forever redeemed in Ibsen's venom and the diabolic spleen of Felicien Rops.

There is a kind of mind that grows more beautiful the closer and the more continued its contact with the ugly. It is the kind of mind that grows in direct contrast to physical and economic development. It becomes stronger through an enkernelled principle of revolt and dissent as it comes into contact with the things that tend to weaken it. It is the revolt of the cell against the organism. It is the root-principle of genius, of ironic genius and spleen genius.

After all illusions have gone the prying Intellect still remains—the stealthy ghoul who creeps to the grave after the interment of the corpse. That is irony. That is the phase the intellectual and esthetic worlds have reached.

Is all painting, all art, ascending into the heaven of irony, the zenith of scorn and mockery?

<div align="right">Benjamin De Casseres</div>

The Esthetic Significance of the Motion Picture

No other form of popular amusement today enjoys as steady and general a patronage as the moving picture shows receive.

The people in the larger cities can hardly imagine what this entertainment means to town and village populations. It is cheap and within the reach of all. And it is in many communities the one regular amusement that is offered. A town of six thousand inhabitants will easily support three to four

houses with continuous performances of three reels each. Larger towns of sixty thousand residents, where concerts, lectures and theatrical performances occur more frequently, furnish sufficient patronage for eighteen to twenty of these amusement halls. This shows a decided decrease in the percentage of attendance. In the larger cities where the motion picture is taken less seriously, the percentage is still smaller. It takes the place of the theater only among the lower strata of society.

But its popularity is undeniable. It contains some element that appeals to the masses, and whenever I see one of these auditoriums packed to standing room only, I become conscious that I am in the presence of something that touches the pulsebeat of time, something that interests a large number of people and in a way reflects their crude esthetic taste. And is it not curious, with the popularity of this kind of pictorialism, regular art exhibits should be deprived of a similar appreciation. Generally no admission is charged and yet the public does not take advantage of these opportunities with any sort of enthusiasm.

The public is as fond as ever of illustrations, stationary art, and cheap reproductions, perhaps more so than formerly, but it does not feel at home in art galleries. The fine arts seem to evade popularity. Works of art are generally so high-priced that they are beyond the means of the middle class. And merely to study them is too much of an intellectual exertion. People understand a Tchaikovsky symphony as little as an Impressionist exhibit, nevertheless ninety-nine out of a hundred will prefer to hear the concert, while one solitary individual will derive a similar pleasure and satisfaction from the paintings, for the simple reason that music is easier to enjoy. One pays a comparatively small admission, sits down and listens, and the music drifts without any personal effort into one's consciousness.

Paintings are seen to the best advantage in daylight, when most people are busy in the more material things. They have to be enjoyed standing and walking about. One is forced to make one's own selections. Rather a laborious task, even for connoisseurs and critics.

No, there is something wrong in the present distribution of art products. Exhibitions are naught but battlefields for the survival of the fittest, and museums the morgues for pictures that are unsuitable or too unwieldy for private possession. Pictures and books should be owned by the people. Museums and circulating libraries are the products of a trust civilization. They are abnormal. Historical collections and reference libraries, like those of the Louvre and the Vatican, are not included in this statement.

Of course, there are many solitary works of art that can claim a certain popularity. Botticelli's "Spring" shares this distinction with "The Doctor's Visit" by Lucas Fildes. Madame Le Brun's portrait of herself and daughter is popular and so is Gibson's latest drawing. It is largely the problem of quality—of the work, versus quantity—of the appreciation. An explanation is difficult. My con-

tention is that every masterpiece must possess some of the "buckeye" element, or in other words, no matter how elaborate, fascinating and exquisite in finish a painting may be, it must offer some tangible, ordinary interest that the average mind can seize in order to be truly popular. And it is this element which modern painting lacks, and which the motion picture possesses to an almost alarming degree, for it contains all the pictorialism the average person wants, plus motion.

Readers may ask whether I take these pictures seriously and whether I see any trace of art in them. Yes, honestly, I do. I know that most cultivated people feel a trifle ashamed of acknowledging that they occasionally attend moving picture shows. This is due to caste prejudice, as the largest percentage of the attendance belongs to the illiterate class (at least as far as art esthetics are concerned). To my mind there is not the slightest doubt that these performances show much that is vivid, instructive, and picturesque, and also occasionally a fleeting vision of something that is truly artistic.

Judging from the ideal standpoint that a moving picture reel should reveal action in a series of perfect pictures, of course the majority are still very imperfect and unsatisfactory. There is too much bad acting and stage scenery in most of them. And many are absolutely tawdry and foolish, in execution and sentiment. My arguments in favor refer necessarily to the more practical ones.

The French filmmakers are in every way our superiors. They succeed in making excursions even into purely imaginary realms. I saw a Pathé reel in color representing Poe's *The Masque of the Red Death* which was done in a masterly way. There was more real art in the composition and arrangements of these groups and natural backgrounds than can be found in the majority of paintings of our annual exhibitions. The French command better talent and more picturesque scenery. They know how to handle costume and scenes of dramatic interest. The Americans excel only when they put aside cheap studio interiors, go into the open and handle realistic episodes of modern life.

Of course, it is generally not the story which interests me but the representation of mere incidents, a rider galloping along a mountain path, a handsome woman with hair and skirts fluttering in the wind, the rushing water of a stream, the struggle of two desperate men in some twilight atmosphere. These fragmentary bits of life, or merely of scenery, with the animating spirit of motion as main attraction, contain all the elements of pure esthetic pleasure, although we still hesitate to acknowledge it. But the motion picture will steadily gain in recognition, for it has come to stay. No doubt it will undergo many transformations. It will be in color and accompanied by phonographic speech. It may become like the piano-player, a home amusement, and also enter the domain of home portraiture. And the reels will be free of all blemishes that will obscure the image on the screen. All this, however, will not make it more artistic.

More artistic it will become solely by more artistic handling, and there is no reason why some genius like Henry Irving, Gordon Craig, or Steichen should

not invade the realm of motion picture making and more fully reveal its esthetic possibilities. As long as dramatic action, storytelling or records of events will constitute the principal aim, it will remain imitative of the stage. Only when poetic and pictorial expression become the main object will it develop in esthetic lines. Some literary theme will always be necessary to support the action, but it could be the theme of a painter that is stage-managed by a poet or vice versa.

Imagine Böcklin's *Villa at the Sea* as a motion picture: — Old Roman architecture, with waving pinions, and the approach of a coming storm. The waves would caress the shore, the leaves would be carried away by the wind, and into this scene of melancholy and solitude would enter a dark draped figure who in a few superb gestures would express the essence of grief. Many paintings of Leighton could be rendered in such a poetic fashion. And also themes of more realistic painters, like Breton, Cottet and Liebermann, would be available. Short episodes in which all the laws of composition, color and chiaroscuro are obeyed, just as in a painting, only with the difference that there would come to our vision, like a series of paintings, one perfect picture after the other, linked together by action.

Would this not be an art equally as beautiful as the painting of today — while more intricate, and more in harmony with our present life's philosophy!

<div align="right">SADAKICHI HARTMANN</div>

Pablo Picasso

ONE whom some were certainly following was one who was completely charming. One whom some were certainly following was one who was charming. One whom some were following was one who was completely charming. One whom some were following was one who was certainly completely charming.

Some were certainly following and were certain that the one they were then following was one working and was one bringing out of himself then something. Some were certainly following and were certain that the one they were then following was one bringing out of himself then something that was coming to be a heavy thing, a solid thing and a complete thing.

One whom some were certainly following was one working and certainly was one bringing something out of himself then and was one who had been all his living had been one having something coming out of him.

Something had been coming out of him, certainly it had been coming out of him, certainly it was something, certainly it had been coming out of him and it had meaning, a charming meaning, a solid meaning, a struggling meaning, a clear meaning.

One whom some were certainly following and some were certainly following him, one whom some were certainly following was one certainly working.

One whom some were certainly following was one having something com-

ing out of him something having meaning, and this one was certainly working then.

This one was working and something was coming then, something was coming out of this one then. This one was one and always there was something coming out of this one and always there had been something coming out of this one. This one had never been one not having something coming out of this one. This one was one having something coming out of this one. This one had been one whom some were following. This one was one whom some were following. This one was being one whom some were following. This one was one who was working.

This one was one who was working. This one was one being one having something being coming out of him. This one was one going on having something come out of him. This one was one going on working. This one was one whom some were following. This one was one who was working.

This one always had something being coming out of this one. This one was working. This one always had been working. This one was always having something that was coming out of this one that was a solid thing, a charming thing, a lovely thing, a perplexing thing, a disconcerting thing, a simple thing, a clear thing, a complicated thing, an interesting thing, a disturbing thing, a repellent thing, a very pretty thing. This one was one certainly being one having something coming out of him. This one was one whom some were following. This one was one who was working.

This one was one who was working and certainly this one was needing to be working so as to be one being working. This one was one having something coming out of him. This one would be one all his living having something coming out of him. This one was working and then this one was working and this one was needing to be working, not to be one having something coming out of him something having meaning, but was needing to be working so as to be one working.

This one was certainly working and working was something this one was certain this one would be doing and this one was doing that thing, this one was working. This one was not one completely working. This one was not ever completely working. This one certainly was not completely working.

This one was one having always something being coming out of him, something having completely a real meaning. This one was one whom some were following. This one was one who was working. This one was one who was working and he was one needing this thing needing to be working so as to be one having some way of being one having some way of working. This one was one who was working. This one was one having something come out of him something having meaning. This one was one always having something come out of him and this thing the thing coming out of him always had real meaning. This one was one who was working. This one was one who was almost always working. This one was not one completely working. This one was one not ever com-

pletely working. This one was not one working to have anything come out of him. This one did have something having meaning that did come out of him. He always did have something come out of him. He was working, he was not ever completely working. He did have some following. They were always following him. Some were certainly following him. He was one who was working. He was one having something coming out of him something having meaning. He was not ever completely working.

<div align="right">GERTRUDE STEIN</div>

The Sun Has Set

ART is dead.

Its present movements are not at all indications of vitality; they are not even the convulsions of agony prior to death; they are the mechanical reflex action of a corpse subjected to a galvanic force.

Yes, Art is dead. It died when the atmosphere which was necessary for its life became rarefied and exhausted. It died when pure faith died; when the passive fear of the unknown disappeared; when religious hope was dissipated. It died when the positivistic spirit proclaimed that Art was no longer necessary to humanity; when it convinced humanity that Science and not Art was the solver of the great riddles of the Sphinx. Pagan Art died when the gods died, and when God was suppressed, Christian Art died.

In the sociological movement of modern times, the principle of authority was substituted for that of individualism. Now individualism is being replaced by the principle of fraternity.

What relation can exist between these principles of sociologic science, and pure Art? Everything in the universe is linked, and Art is but one of the manifestations of the thought of an epoch, one of its facets. If it be true to say that every people gets the government that it deserves, then it is also true to say that every epoch develops its own particular Art.

The principle of authority founded the life of Nations on the rock of faith. In Religion, this faith showed itself as content to accept without questioning its dogmas. In Politics, it took the form of a superstitious respect for tradition. And in both Religion and Politics it was a subjection to force as a system.

That is why, during the long period of the Middle Ages, physical force took refuge in the Castle, and moral force or civilization found its home in the Monastery.

There, within the narrow limits of the Monastery, all intellectual and manual activities, the soul and the body of Art, found themselves. Paganism being dead, the new religion took upon itself the charge of maintaining and giving new vigor to the plastic arts.

Latin architecture was succeeded by Roman architecture, and this was followed by the Gothic. Raoul Glaber, a famous Benedictine from Bourgogne,

explains how the architectural transformations permitted by the churches were not imposed by a material necessity, but were the outcome of the new idea that had appeared, compared with which the old seemed to be out of date.

This principle of authority prevailed in all its power until the appearance of Luther, who, unconsciously, sowed the seed of individualism.

It would seem that the principle of individualism ought to have killed inspiration, since it tends to eliminate the conception of the ideal. But this did not take place because the elimination did not occur. The Reformation was neither Atheist nor Rationalist. Luther, Calvin and Zwingli, appear to be as fanatic as the Pontiffs, Bishops and inquisitors of Catholicism. It was an epoch of great armed struggles, and of tremendous moral and intellectual conflicts. These offered a wide scope for artistic inspiration.

Why is it that in that epoch of tremendous political and religious upheavals, in which everything was revolutionized, Art, instead of revolutionizing, evolutionized? In my opinion, it was because of individualism. The Artist, independent of the Monk, took refuge within himself.

Individualism considers man by himself and not as a member of society. It makes him the only judge of everything that surrounds him, giving him an exaggerated opinion of his rights, without pointing out to him his duties, and abandons him to his own resources. Something of the same result is due to Art so far as the personality of the artist is concerned; but it is quite different in regard to the idea. In order to find out the highest reach of the idea of man, we have to look for it beyond his individuality, and the totality of expressions of the ideas of an individual is but the synthesis of the collective idea. These collective ideas, condensed and synthesized by the individual genius, are precisely those which are expressed in the masterpieces of Art.

Undeniably, no man can live outside of humanity, for no matter how great his power of abstraction or how complete his isolation, the idea he conceives is inalienably related to the race, the time and the place.

While humanity eagerly devoted herself to the conquest of absolute truth, and the solution of the problem of Divinity, Art was an auxiliary, for it contributed to the same end through the sentiment of the superhuman. But as soon as humanity abandoned the study of the abstract for that of the concrete, when she abandoned the search of the absolute, to consecrate herself to the relative, Art lost its preeminence, and was reduced to a diversion for idle intellectual people.

The principle of fraternity came to be accepted. It was faintly murmured by Rousseau and later openly enunciated by the French Revolution. Always denied by some, and defended by others in arresting controversies, it gave rise to the formation of Altruistic, Socialistic, Communistic and Anarchistic sects. As if to counterbalance those forces, Capitalism and Industrialism have been born as emanations of positivism. Man wants, first of all, to enforce the right to his immediate life on this planet, seeking the largest measure of welfare with the

least amount of labor. Philosophy has been drowned in the sea of political economy. Art, which is a striving towards the Ideal, has succumbed to Industry, which is a striving for the Real.

But great ideas are like gigantic trees. At their death they leave their massive trunk standing for many years, often for centuries, and their immense roots still take nourishment from the deep soil. Sometimes, from these roots sprouts forth shoots, of a very ephemeral life, and these give the illusion that the tree is still alive.

And this must explain how it is that in our own day a group of men are desirous to keep alive the spirit of Art, of the Great Art, of the Only One. They aim, however, to produce an effect without a generating cause.

They find no fountain of inspiration because present conditions offer them none. For this reason they go to past epochs for their inspiration.

In the artistic movement of this historical moment, we see the so-called "Too-advanced-for-their-epoch" geniuses rummaging about in ancient cemeteries, looking for the artistic truth, and when one of them thinks he has found it, he does not reproduce it, but alters it to the point of exaggeration and ridicule. The expressions of the artistic truth being conventionalism, the artists, inspired by faith, deformed the anatomy of the human body and all forms in nature to suit the arbitrary and incomprehensible whims of symbolism. They study the art of an ethnic group or of a historical epoch, and they try to convert it into the genuine and exclusive expression of the Art of all times. They search for new ideas in the repertoire of the old, or they cast the new ideas into the old molds.

In the conversation of Rodin with Paul Gsell, published under the title of "L'Art," the latter says: — "The gesture of *Saint John the Baptist* hides like the one of *L'Age d'Airain* a spiritual significance. The prophet, moves forward with a solemnity almost automatic. One would expect to hear his footsteps reecho like those of the statue of the *Commander*. One feels that a mysterious and formidable power lifts and pushes him onward. And so, the act of walking, that motion ordinarily so banal, becomes here glorious, because it is the accomplishment of a divine mission. ' — Have you ever attentively examined men walking in photographic snapshots?' asked Rodin suddenly.

"And upon my answering in the affirmative, he said: — 'Well, what have you noticed?'

— " 'That they have not the air of advancing. As a rule, they seem to remain motionless upon one foot or to be jumping with both feet together.'

— " 'Exactly! While my Saint John is represented with both feet upon the ground, it is probable that a photographic snapshot, made of a model executing the same movement, will show the hind foot already raised and going towards the other. Or, on the contrary, the forward foot will not yet be on the ground if the hind leg occupies the same position in the photograph as in my statue.

" 'Now, it is just for this reason that this photographed model will present the queer aspect of a man suddenly struck with paralysis and petrified in his pose, as happens to the servants in the pretty tale of Perault, "La Belle au Bois Dormant," who suddenly became motionless in the attitudes of their actions. And this confirms what I have just demonstrated to you on the movement in Art. If, in fact, as shown in snapshots, the personages, though taken in ordinary action, seem suddenly transfixed in the air, it is because all parts of their body being reproduced in exactly the same twentieth or fortieth of a second, there is not present, like in art, a progressive development of gesture.' "

We find the same pose of Saint John, the same spiritual significance, the same mysterious and formidable power that lifts and pushes, the same accomplishment of a divine mission, the same two feet on the ground, and the same progressive development of the gesture in the Egyptian statue of Horfuabra, Co-Regent of Amenemhats III (1849–1801 B.C.) in the museum at Cairo.

Is not Matisse's work the anthology of the authors of Greek vases, of the Hindu and Cambodian idols, and of the religious paintings of the earliest Catholics? Picasso and his followers, the Cubists, do they not endeavor to be the spiritual and morphological reincarnations of the savages of Africa?

Each one of these pretended discoverers of artistic truth, moved by egotism, imposes himself upon us as an apostle of a new art, so new that they claim to be of the future. They gather pupils among the not inconsiderable human group, which in all epochs, has its nervous system affected, predisposed to all fanaticism, easily infected by anything, provided it is extravagant. Those were the people who, in the Middle Ages, produced and spread the intellectual epidemics known by the names of "Theomania," "Demonopathia," and "Demonolatry," etc., and who, in modern art, produce and propagate the epidemics, no less pernicious, of "Naïve-Mania," "Primitivolatry," and "Savageopathy."

And these latter-day possessed ones, in their psychic dislocation, present to us Mother Eve, with the proportions and under the aspect of a Congolian fetish symbolism of the horrible, created to frighten and banish the powers of Evil; or of a reclining Venus, with the anatomy of the Mayan Chacmol.

Those who suffer from Naïve-Mania, or from Primitivology, boast of taking in art the same attitude as does the child. I believed it to be so until I had the opportunity of seeing the recent Exhibition of Children's Work in the Galleries of the Photo-Secession. The study of these works convinced me how unjustified are these pretensions.

Modern psychology admits the principle that the less filled the brains are with knowledge, the more deeply the impression it receives penetrates. That is why the impressions received in childhood are the deepest, and last the longest. That is also why the work of children is always impressive.

Form, in the abstract, has for the child, and the savage, a psychical significance which disappears with familiarity with things.

The child in producing his works, or in reproducing his sensations, does

not use his reflective faculties. It works in an unconscious way, hence its extraordinary spontaneity. It keeps the remembrance of the emotion it feels, but it does not study the manner in which to express it. It is satisfied to express it and does not aspire to do more. Children's spontaneity compels them to express only that which has impressed them most in the form, and that is what appears in their works in the first place, and, indeed, that only is what appears.

Can we consider the works produced by children as works of art? If we demand that a work of art contain the element of imagination and the result of the operation of the reflective faculties, then the work of children is not a work of art. The direct rendering of an impression without giving it a mental significance, cannot, in my opinion, constitute a genuine work of art. The work of children is the product of only one of the principal elements of art—intense perception. This intensity of perception blinds them to the element of beauty, a sentiment generated by education. Form always suffers deformation in their brains. Children's works always carry in them the spirit of ugliness.

When the child begins to observe, and uses his reflective faculties, the intensity of his perception diminishes. Education finally destroys it and instills the spirit of imitation.

What compels the child to reproduce his impressions in plastic form is an innate necessity to use that medium of expression. This we see in the children of every country, especially among primitive peoples. The impression caused by form, the conception of it, its interpretation, obeys in every race an inevitable law. Its progressive evolution marks the anthropological estate of the races, the representation of form being more intense the more inferior the race is; for it is a principle recognized by psychology that the psychic intensity of the work is in inverse ratio to the state of civilization of the individual who produces it, while the intensity of artistic comprehension of an individual is in direct ratio to his degree of civilization.

From this, we conclude that those who consciously imitate the work of children, produce childish work, but not the work of children. This confirms, too, the principle that "unconsciousness is the sign of creation, while consciousness at best that of manufacture." The modern artist is the prototype of consciousness. He works premeditatedly, he dislocates, disharmonizes, exaggerates premeditatedly. He is an eclectic in spirit and an iconoclast in action.

Are these men an anachronism? Are they a logical absurdity? By no means. They express the character of their time; they are the fatal consequence of a false syllogism; they are the product of modern conditions.

Our epoch is chaotic, neurotic, inconsequent, and out of equilibrium.

Art is dead. I made this statement at the beginning of this article, and I repeat it now. But we know that death is not absolute but relative, and that every end is but the beginning of a new and a fresh manifestation.

M. DE ZAYAS

In Memoriam

LIFE AND DEATH: LITTLE VIRGINIA MYERS, SIX‑YEAR‑OLD DAUGHTER OF MR. AND MRS. JEROME MYERS, HAS STIRRED IN ME AGAIN THAT DISTURBING SENSE OF BEAUTY WHICH IS THE ESSENCE OF LIFE. □

□ SHE IS AN EXQUISITE DANCER, UNTAUGHT AND CONSCIOUSLY ARTISTIC. SHE DANCES SPONTANEOUSLY TO CLASSICAL MUSIC, OR TO ANY IDEA, HOWEVER EXPRESSED, WHICH SUGGESTS RHYTHM TO HER IMAGINATION. HER DANCES ARE HER OWN, THE EXPRESSION OF HER OWN NATURE, WHICH IS BOTH THAT OF A CHILD AND THAT OF AN ADULT. WHEN I SAW HER DANCE THE OTHER DAY, IN HER FATHER'S STUDIO, I HAD THE FEELING THAT SHE HAD NO AGE OR SEX, BUT A SINGULARLY MATURE ARTISTIC SENSE, ONE THAT HAD FORMED ITSELF FREELY BUT PERFECTLY, RECOGNIZED ITS OWN JOY AND ITS OWN LAW.

□ AND I THOUGHT OF AN ARTICLE I WROTE LAST WEEK CALLED "THE DANCE," IN WHICH I SUGGESTED HOW THE SPONTANEOUS INSTINCT IN CHILDREN FOR DRAWING AND FOR DANCING IS OFTEN CRUSHED OUT BY CONVENTIONAL AND MECHANICAL INSTRUCTION. SO I WAS DE‑LIGHTED WHEN I FOUND THAT THIS CHARMING LITTLE ARTIST IS NOT BEING TAUGHT AT ALL. □

□ HER FATHER, WHO IS AN ARTIST HIMSELF, AND HER MOTHER TREAT LITTLE VIRGINIA WITH WISE RESPECT AND A KIND OF TOUCHING HUMILITY. ALL THEY TRY TO DO IS TO ENCOURAGE THE LITTLE GIRL TO BE HER OWN LOVELY SELF; TO PUT HER IN THE RIGHT EN‑VIRONMENT FOR HER NATURE TO FLOWER. THEY ARE SEDULOUSLY AVOIDING ANY ATTEMPT TO HAVE HER FOLLOW THEIR IDEAS OR THOSE OF ANYBODY ELSE. IN A SENSE, THEIR ATTITUDE TOWARD HER IS RELIGIOUS. THEY REGARD HER AS TOO DIVINE A THING FOR THEM TO TRIFLE WITH EVEN IN THAT SERIOUS SPIRIT WHICH MOST PARENTS CALL "DUTY." □

□ WHEN I SAW VIRGINIA DANCE, THE SPIRAL OF LIFE AGAIN ASCEND‑ED RAPIDLY FOR ME AND I FELT THAT EXHILARATING BUT AT THE SAME TIME SAD ENHANCEMENT WHICH IS THE ESSENCE OF LIFE AND THEREFORE OF ART. THE SADNESS AS WELL AS THE BEAUTY IS THAT OF LIFE INTENSELY REALIZED. □

□ SHORTLY AFTER I SAW THE LITTLE GIRL DANCE I READ AN INTER‑VIEW WITH KENYON COX IN THE TIMES ON THE RECENT MUCH–TALKED–OF ART EXHIBITION AT THE ARMORY. THIS ARTICLE GAVE ME THAT COLD COMPRESSION, THAT DEPLETION OF LIFE, WHICH IS THE ESSENCE OF DEATH. AND I THOUGHT OF HIS SPIRIT AND THAT OF LITTLE VIRGINIA AS DIRECT OPPOSITES—DEATH AND LIFE. □

□ COX REPRESENTS UNINSPIRED AUTHORITY, TECHNICAL BUT NOT IMAGINATIVE LAW, AND A BRAIN UNILLUMINED BY THE INSTINCT FOR BEAUTY. ARTISTS RECOGNIZE THAT COX'S PAINTINGS ARE FAITHFUL AND INTELLIGENT REPLICAS OF INSTITUTIONAL RULES AND REGULA‑TIONS. BUT THEY ARE SINGULARLY LACKING IN BEAUTY. HE IS FOND OF PAINTING THE NUDE, BUT ON HIS CANVASES THE NUDE IS SIMPLY

THE NUDE. HE DOES NOT SPIRITUALIZE THE NUDE BY GIVING AN EMOTIONAL OR IMAGINATIVE ATTITUDE TOWARD IT. IN LIFE THE NUDE IS BEAUTIFUL TO THE EYE OF THE POET OR THE ARTIST BECAUSE OF THE INTERPRETATION GIVEN IT BY THE POET OR THE ARTIST— BECAUSE OF THE MEANING GIVEN IT. BUT COX TAKES ALL BEAUTY FROM THE NUDE OF LIFE. HE KILLS THE NUDE. IT IS THE DEATH OF THE NUDE. ☐

☐ IN HIS ARTICLE HE CRITICIZES MATISSE—SAYS THAT SOME OF HIS WORK IS LIKE THE DRAWINGS "OF A NASTY BOY." ☐

☐ TO ME SUCH A CRITICISM IS INCOMPREHENSIBLE—OR WORSE. MATISSE GETS HIS EFFECT, HIS "ENHANCEMENT," THROUGH HIS LINE, WHICH IS SINGULARLY ALIVE. NOW, THERE ARE SOME PERSONS WHO THINK THERE IS ONLY ONE SOURCE OF EMOTION—CRUDE SEX. IT IS MY GUESS THAT MR. COX, FEELING EMOTION FROM MATISSE'S LINE, ATTRIBUTES SEX AS THE CAUSE, AS HE IS PERHAPS NOT SENSITIVE TO THE EXCITEMENT OF ABSTRACT OR PURE SPIRITUALITY. ☐

☐ THERE IS MUCH LEGITIMATE DOUBT OF MATISSE, BUT CRITICISM OF HIM ON THE GROUND OF "NASTINESS" IS UNSPEAKABLY DIS- TRESSING. ☐

☐ BUT THE MOST DEATH-DEALING PART OF MR. COX'S REMARKS IS WHAT HE SAYS ABOUT RODIN'S LATER DRAWINGS. HE CALLS THE RODIN DRAWINGS IN THE METROPOLITAN MUSEUM OF ART "A CA- LAMITY. THEY HAVE MADE PEOPLE TRY TO SEE WHAT DOES NOT EXIST." ☐

☐ IF SHAKESPEARE HAD NOT BEEN ACCEPTED AS A GREAT POET, MR. COX WOULD NOT HAVE SEEN THE BEAUTY OF ONE OF SHAKESPEARE'S LAST AND MOST BEAUTIFUL PLAYS—"THE TEMPEST." THAT SO-CALLED PLAY IS AN EXHALATION, A BREATH OF PURE BEAUTY, DONE BY A MASTER WHO DID NOT NEED TO OBTRUDE THIS TECHNIQUE, NOR EMPHASIZE THE RULES OF THE DRAMA, NOR GIVE "BONE," NOR GIVE "REALITY." HE GAVE US WHAT "DOES NOT EXIST." HE MADE US SEE THE BEAUTY OF WHAT MR. COX WOULD CALL THE NON-EXISTENT.

☐ RODIN'S RECENT DRAWINGS ARE PURE BEAUTY. THEY ARE THE BREATH, THE EXHALATION, THE SPIRITUAL EXHALATION OF AN OLD MASTER WHO IS SET FREE FROM STRUCTURE IN THE OBVIOUS SENSE, WHO IS SO MUCH THE MASTER OF HIS TECHNIQUE THAT HE IGNORES ALL OF IT EXCEPT THAT WHICH IS ESSENTIAL TO EXPRESS HIS PURE LYRICISM. ☐

☐ COX'S FAILURE TO FEEL THE BEAUTY OF THE RODIN DRAWINGS PROVES TO ME THAT THE HIGHEST PART OF HIM IS DEAD. HE HAS A GOOD CRITICAL TRAINING AND HAS WHAT IS CALLED LOGIC BY THOSE WHO LACK UNDERSTANDING. THIS IS THE WORST FORM OF DEATH, BECAUSE IT HAS AUTHORITY TO PUT ITS COLD, FORBIDDING FINGER ON THE INSTINCT FOR BEAUTY AND FOR THE HIGHER LIFE.

HUTCHINS HAPGOOD.

REPRINTED FROM "THE GLOBE" FOR "291" AND "CAMERA WORK."

Portrait of Mabel Dodge at the Villa Curonia

THE days are wonderful and the nights are wonderful and the life is pleasant.

Bargaining is something and there is not that success. The intention is what if application has that accident results are reappearing. They did not darken. That was not an adulteration.

So much breathing has not the same place when there is that much beginning. So much breathing has not the same place when the ending is lessening. So much breathing has the same place and there must not be so much suggestion. There can be there the habit that there is if there is no need of resting. The absence is not alternative.

Any time is the half of all the noise and there is not that disappointment. There is no distraction. An argument is clear.

Packing is not the same when the place which has all that is not emptied. There came there the hall and this was not the establishment. It had not all the meaning.

Blankets are warmer in the summer and the winter is not lonely. This does not assure the forgetting of the intention when there has been and there is every way to send some. There does not happen to be a dislike for water. This is not heartening.

As the expedition is without the participation of the question there will be nicely all that energy. They can arrange that the little color is not bestowed. They can leave it in regaining that intention. It is mostly repaid. There can be an irrigation. They have the whole paper and they send it in some package. It is not inundated.

A bottle that has all the time to stand open is not so clearly shown when there is green color there. This is not the only way to change it. A little raw potato and then all that softer does happen to show that there has been enough. It changes the expression.

It is not darker and the present time is the best time to agree. This which has been feeling is what has the appetite and the patience and the time to stay. This is not collaborating.

All the attention is when there is not enough to do. This does not determine a question. The only reason that there is not that pressure is that there is a suggestion. There are many going. A delight is not bent. There has been that little wagon. There is that precision when there has not been an imagination. There has not been that kind abandonment. Nobody is alone.

If the spread that is not a piece removed from the bed is likely to be whiter then certainly the sprinkling is not drying. There can be the message where the print is pasted and this does not mean that there is that esteem. There can be the likelihood of all the days not coming later and this will not deepen the collected dim version.

It is a gnarled division that which is not any obstruction and the forgotten swelling is certainly attracting, it is attracting the whiter division, it is not sink-

ing to be growing, it is not darkening to be disappearing, it is not aged to be annoying. There cannot be sighing. This is this bliss.

Not to be wrapped and then to forget undertaking, the credit and then the resting of that interval, the pressing of the sounding when there is no trinket is not altering, there can be pleasing classing clothing.

A sap that is that adaptation is the drinking that is not increasing. There can be that lack of any quivering. That does not originate every invitation. There is not wedding introduction. There is not all that filling. There is the climate that is not existing. There is that plainer. There is the likeliness lying in liking likely likeliness. There is that dispensation. There is the paling that is not reddening, there is the reddening that is not reddening, there is that protection, there is that destruction, there is not the present lessening there is the argument of increasing. There is that that is not that which is that resting. There is not that occupation. There is that particular half of directing that there is that particular whole direction that is not all the measure of any combination. Gliding is not heavily moving. Looking is not vanishing. Laughing is not evaporating. There can be the climax. There can be the same dress. There can be an old dress. There can be the way there is that way there is that which is not that charging what is a regular way of paying. There has been William. All the time is likely. There is the condition. There has been admitting. There is not the print. There is that smiling. There is the season. There is that where there is not that which is where there is what there is which is beguiling. There is a paste.

Abandon a garden and the house is bigger. This is not smiling. This is comfortable. There is the comforting of predilection. An open object is establishing the loss that there was when the vase was not inside the place. It was not wandering.

A plank that was dry was not disturbing the smell of burning and although there was the best kind of sitting there could never be all the edging that the largest chair was having. It was not pushed. It moved then. There was not that lifting. There was that which was not any contradiction and there was not the bland fight that did not have that regulation. The contents were not darkening. There was not that hesitation. It was occupied. That was not occupying any exception. Any one had come. There was that distribution.

There was not that velvet spread when there was a pleasant head. The color was paler. The moving regulating is not a distinction. The place is there.

Likely there is not that departure when the whole place that has that texture is so much in the way. It is not there to stay. It does not change that way. A pressure is not later. There is the same. There is not the shame. There is that pleasure.

In burying that game there is not a change of name. There is not perplexing and coordination. The toy that is not round has to be found and looking is not straining such relation. There can be that company. It is not wider when

the length is not longer and that does make that way of staying away. Every one is exchanging returning. There is not a prediction. The whole day is that way. Any one is resting to say that the time which is not reverberating is acting in partaking.

A walk that is not stepped where the floor is covered is not in the place where the room is entered. The whole one is the same. There is not any stone. There is the wide door that is narrow on the floor. There is all that place.

There is that desire and there is no pleasure and the place is filling the only space that is placed where all the piling is not adjoining. There is not that distraction.

Praying has intention and relieving that situation is not solemn. There comes that way.

The time that is the smell of the plain season is not showing that the water is running. There is not all that breath. There is the use of the stone and there is the place of the stuff and there is the practice of expending questioning. There is not that differentiation. There is that which is in time. There is the room that is the largest place when there is all that is where there is space. There is not that perturbation. The legs that show are not the certain ones that have been used. All legs are used. There is no action meant.

The particular space is not beguiling. There is that participation. It is not passing any way. It has that to show. It is why there is no exhalation.

There is all there is when there has all there has where there is what there is. That is what is done when there is done what is done and the union is won and the division is the explicit visit. There is not all of any visit.

GERTRUDE STEIN

Vers L'Amorphisme

L'HEURE est grave, très grave. Nous sommes à un tournant de l'histoire de l'Art. Les recherches patientes, les tentatives passionnèes, les essais audacieux de novateurs hardis sur lesquels une verve aussi féroce que stupidement facile s'est trop longtemps excercée, vont enfin aboutir à la formule tant convoitée; la formule une et multiple qui renfermera en elle tout l'univers visible et sentimental; la formule libre et tyrannique qui s'imposera aux esprits, dirigera les mains, inspirera les coeurs; la formule définitive encore que transitoire et n'ayant, au fond, qu'une valeur d'indication subtile et précise à la fois.

Expliquons-nous.

Il y a des années qu'on bataille et qu'on marche vers un but éclatant. Les précurseurs, les Claude Monet, les Renoir, les Cézanne promptement surpassés, par la petite troupe néoimpressionniste et la vaillante phalange pointilliste où brillent d'un pur éclat les Signac et les Seurat ont indiqué largement la route à suivre. A leur suite, se sont rués les fauves, Gauguin en tête. Vinrent ensuite les Matisse. Disons-le tout de suite. *Ces peintres savaient encore peindre;*

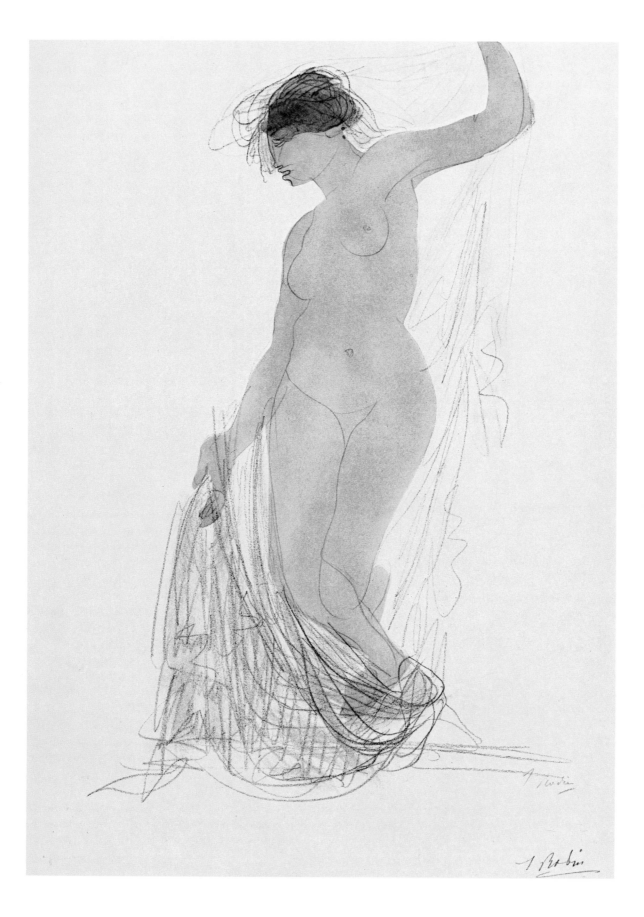

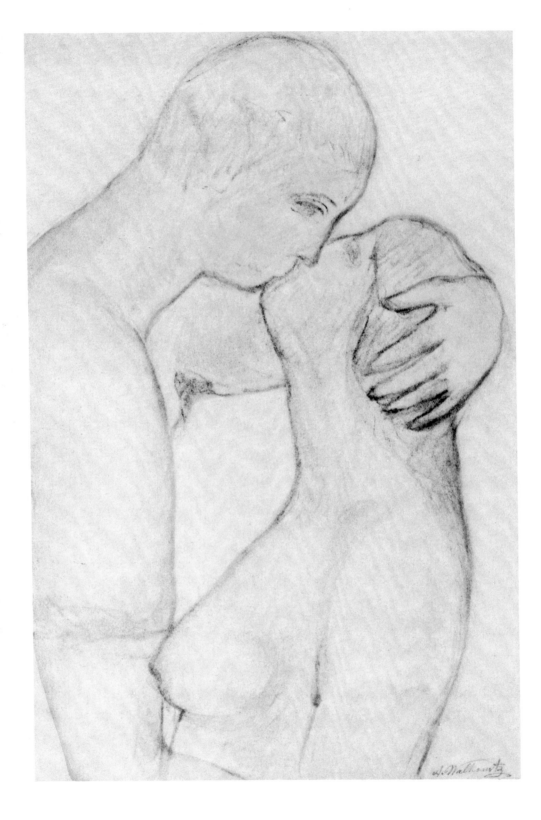

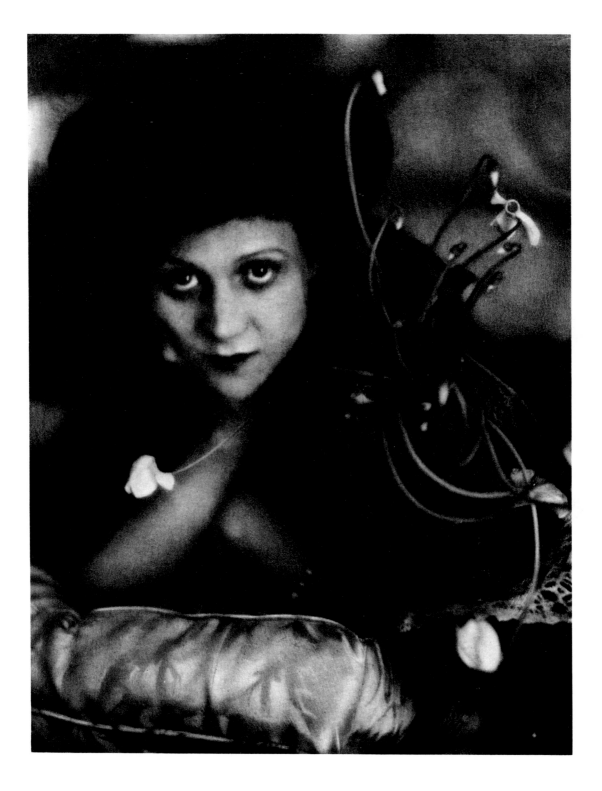

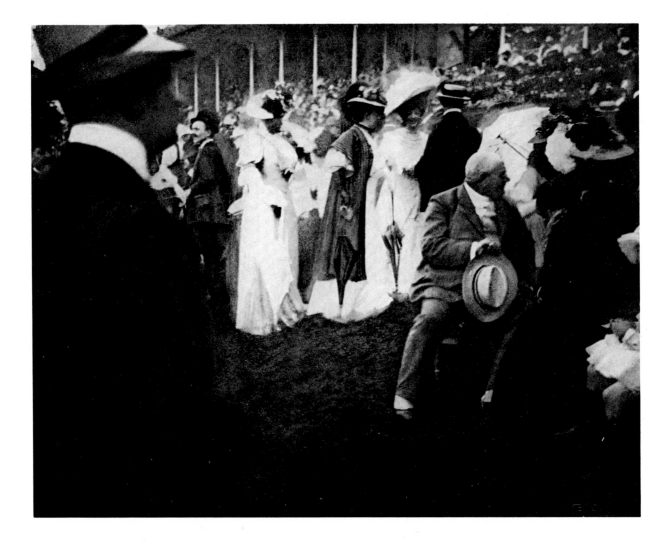

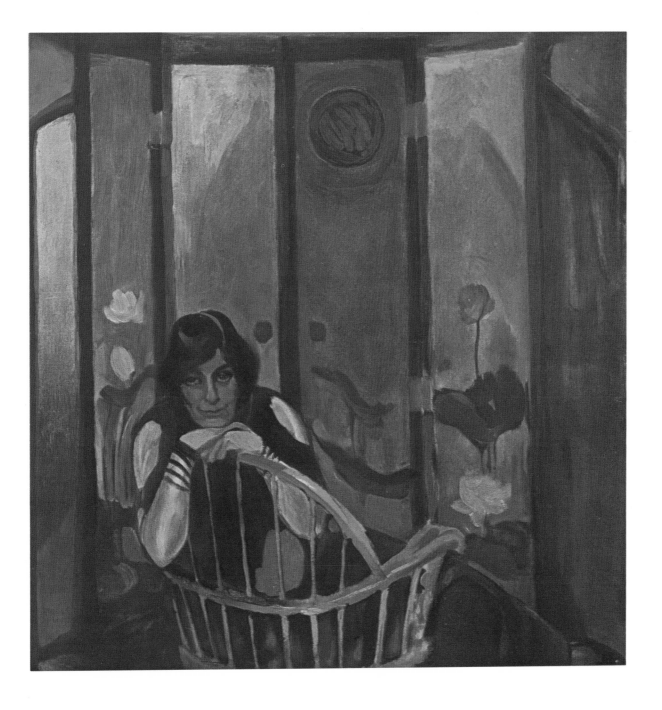

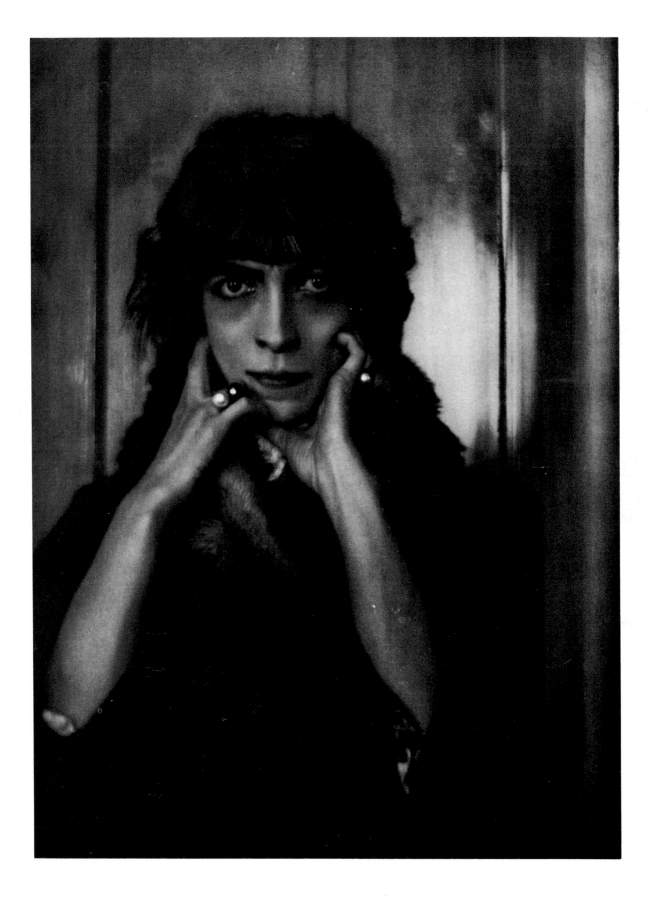

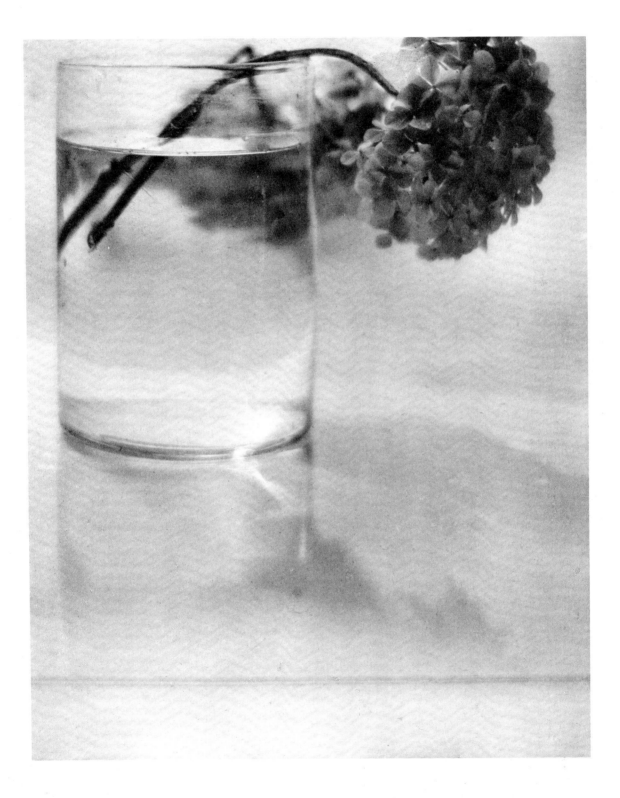

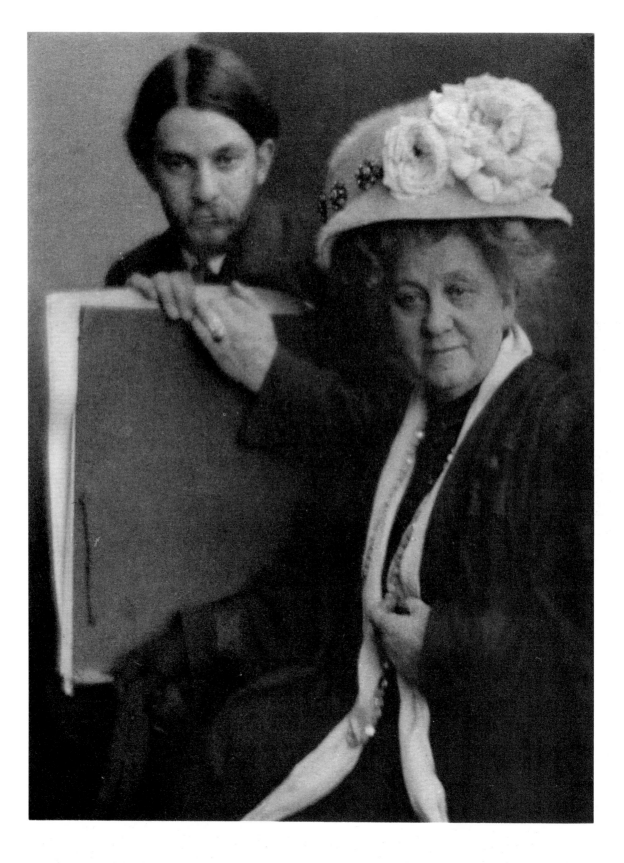

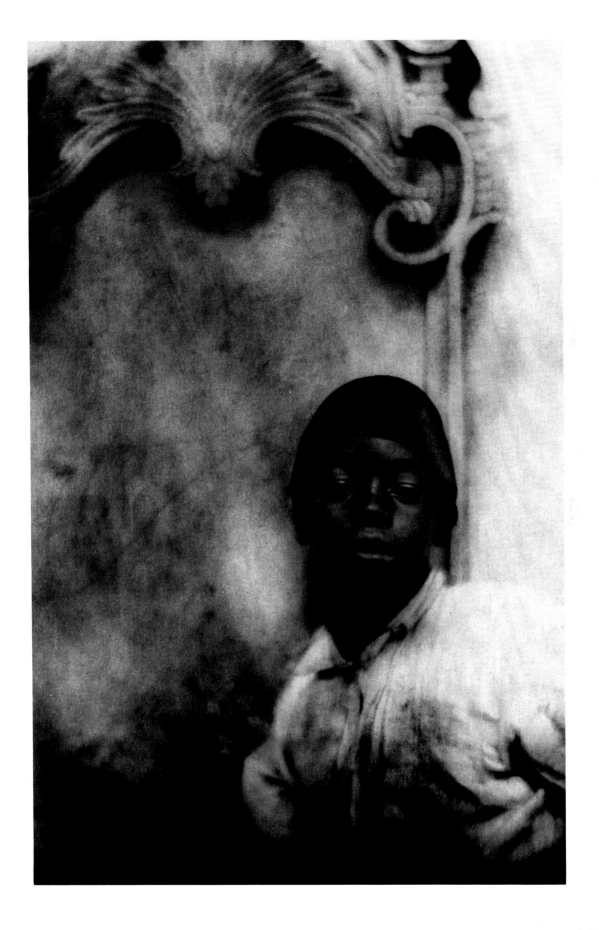

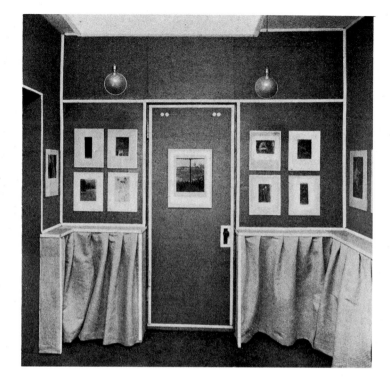

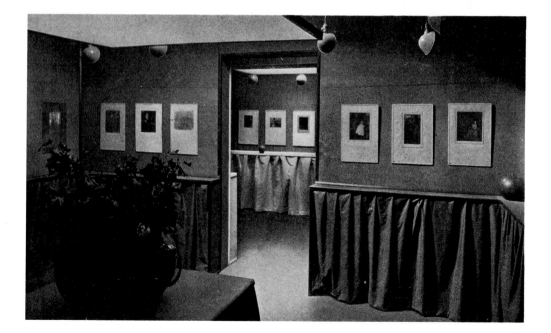

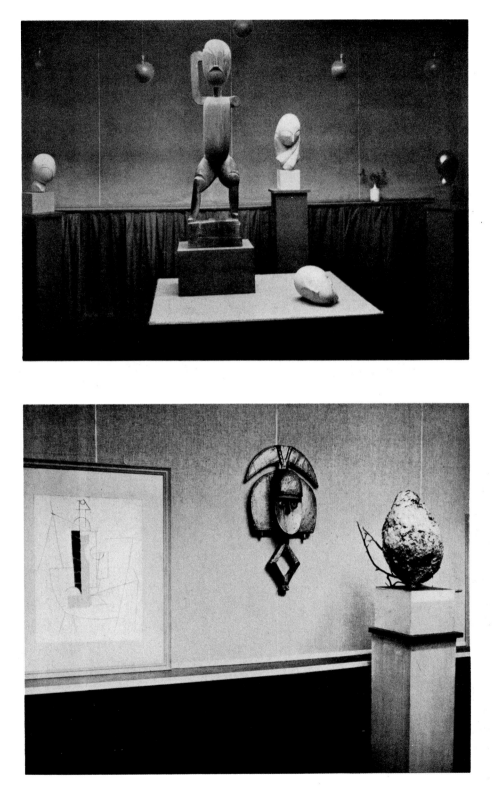

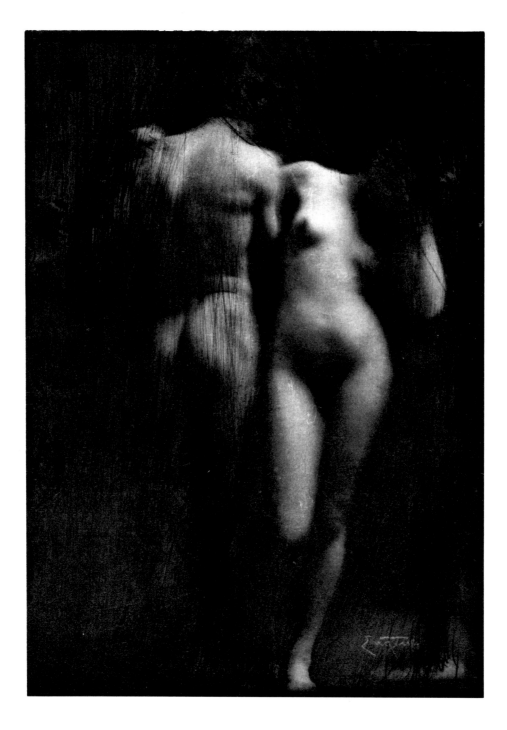

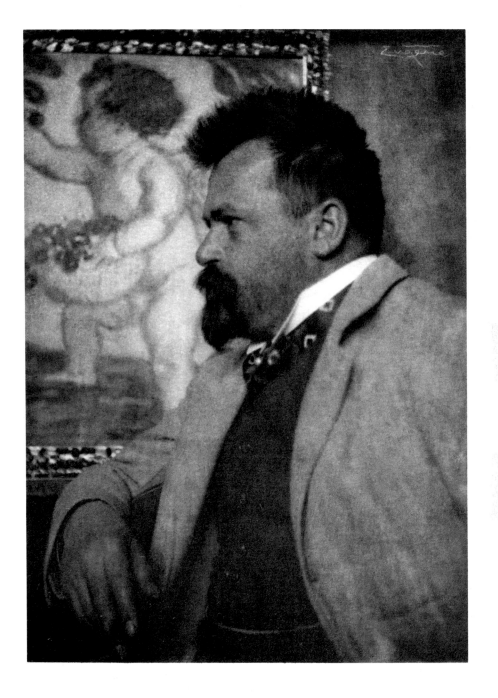

quelquesuns même dessinaient. On peut juger par là du retard inouï de leurs conceptions d'une esthétique surannée. Toutefois, ils faisaient de louables efforts pour parvenir à l'Art véritable, lequel consiste à négliger purement et simplement la forme pour ne s'occuper que de la chose en soi et à ne point voir l'universel en tant qu'apparence fatalement provisoire. De toute évidence, après avoir rendu un juste hommage à ces purs artistes, il fallait les abandonner à mi-côte et se lancer vertigineusement sur le clair chemin de l'amorphisme.

C'est alors que le cubisme fit son apparition, bientôt suivi par le conisme. Pourquoi avoir reproché à ces peintres leurs préoccupations géométriques? Il leur était difficile de concevoir les objets sous une forme moins rudimentaire et ils demeuraient, dans une certain mesure, victimes des préoccupations et des préjugés de leur époque. A premiére vue, l'objet doit être ramené à l'état de simple notion de dimensions. Il ne vaut que par ses dimentions et ses rapports avec l'ambiance lumineuse rapports qui varient avec les positions de l'objet et l'intensité de la lumière qui le baigne. Remarquons que, dans cette conception déjà téméraire et dans cette vision étrangement lucide de l'interprétation de la beauté disséminée et parsemée dans le flot universel, aucune place n était réservée à l'âme des choses. Mais passons. Les cubistes ont apporté leur pierre, si l'on peut dire. Ils ont donné leur effort . Nous n'avons pas à leur réclamer davantage.

Le cubisme, d'ailleurs, comme tous les grands Arts, s'est replié sur lui-même et subdivisé en plusieurs courants. D'abord scientifique, puis physique, il est devenu, instinctif et enfin — c'est là la forme supérieure — orphique. L'orphisme, jusqu' à ce jour — si nous négligeons le futurisme, essai impétueux, mais manquant de science véritable — est le dernier mot de l'art contemporain. C'est l'aboutissant logique de toutes les tentatives d'hier. C'est le premier pas fait vers la formule inévitable, ver l'amorphisme.

Déjà, les Rouault, les Matisse, les Derain, les Picasso, les Van Dongen, les Jean Puy, les Picaba, les Georges Braque, les Metzinger, les Gleizes, les Duchamp (dont on ne peut oublier l'irrésistible *Nu descendant un escalier* (1912), ni le *Jeune Homme* (1912), semblent avoir compris et admis la nécessité de supprimer absolument la forme et de s'en tenir uniquement à la couleur. Il y a mieux à faire, cependant. Il y a à décomposer la couleur qui peut évoquer jusqu'a un certain point la forme et à la désassocier, pour laisser à l'oeil le soin de synthétiser et reconstruire.

Ainsi, peu à peu, l'amorphisme s'impose. Certes, on poussera des cris de putois, en présence des œuvres prochaines des jeunes pionniers de l'Art. Mais nous sommes quelques critiques indépendants, ennemis du bluff, et sans rapport aucun avec les marchands de tableaux, pour défendre l'Art nouveau, l'Art de demain, l'Art de taujours. Pour aujourd'hui, contentons-nous de publ'ier ici le manifeste, trop court, mais combien suggestif, de l'école amorphiste. Les esprits non prévenus et les véritables intelligences jugeront.

Manifeste De L'Ecole Amorphiste

Guerre à la Forme!

La Forme, voilà l'ennemi!

Tel est notre programme.

C'est de Picasso qu'on a dit qu'il étudiait un objet comme un chirurgien dissèque un cadavre.

De ces cadavres gênants que sont les objets, nous ne voulons plus.

La lumière nous suffit. La lumière absorbe les objets. Les objets ne valent que par la lumière où ils baignent. La matière n'est qu'un reflet et un aspect de l'énergie universelle. Des rapports de ce reflet à sa cause, qui est l'énergie lumineuse, naissent ce qu'on appelle improprement les objets, et s'établit ce non-sens: la forme.

C'est à nous d'indiquer ces rapports. C'est à l'observateur, au **regardeur**, *de reconstituer la forme, à la fois, absente et nécessairement vivante.*

Exemple: Prenons l'œuvre géniale de Popaul Picador: **Femme au bain:**

POPAUL PICADOR.

Cherchez la femme, dira-t-on. Quelle erreur!

Par l'opposition des teintes et la diffusion de la lumière, la femme n'est-elle pas visible à l'œil nu, et quels barbares pourraient réclamer sérieusement que le peintre s'exerce inutilement à esquisser un visage, des seins et des jambes?

Prenons maintenant **La Mer**, *du même artiste.*

POPAUL PICADOR.

Vous ne voyez rien au premier regard. Insistez. Avec l'habitude, vous verrez que l'eau vous viendra à la bouche.

Tel est l'amorphisme.

Nous nous dressons contre la Forme, la Forme dont on nous a rebattu les yeux et les oreilles, la Foorme devant laquelle s'agenouillent les Bridoisons de la peinture.

From "Les Hommes du Jour"

Toward Amorphism

Now is the hour! We are at a turning point in the history of art. Patient research, impassioned attempts and the bold experiments of daring innovators, who have for too long borne the brunt of rhetoric as intense as it was simple-minded, are finally about to result in the long coveted formula. The inclusive formula which will encompass all the visible and sensible universe; the broad and tyrannical formula which will impose itself on the mind, direct the hands, inspire the heart; the formula which is definitive although still transitory and which, in the long run, has value as an indicator both subtle and precise.

Let me explain.

For some years we have battled and progressed toward a magnificent goal. The precursors, Claude Monet, Renoir, Cezanne, were quickly surpassed by the small group of neo-impressionists and the valiant pointillist army in which the sparkling brilliance of Seurat and Signac indicated the route to be followed. In their wake rushed the fauves with Gaugin in the lead, then Matisse. Let me say right away: *These painters still knew how to paint; some of them even drew.* We see therefore that their esthetic was far behind the time. Nevertheless, they did make commendable efforts to arrive at true Art which consists of the pure and simple neglect of form in order to be concerned only with the thing itself, perceiving the universal only as an inevitably temporary manifestation. Having rendered a just homage to these pure artists it is necessary to abandon them along the way and launch ourselves dizzily on the luminous road of amorphism.

It was then that cubism made its appearance, soon followed by cone-ism. Why do we reproach these painters with their geometric preoccupations? It was difficult for them to conceive of objects in a less rudimentary way and they remain, to a certain extent, victims of the preoccupations and prejudices of their epoch. A first approach is that the object must be returned to the state of simple dimensions. It only has value through its dimensions and its relationships with its luminous surroundings. These relationships vary with the position of the object and the intensity of the light which bathes it. Let me note that in this bold conception, in this strangely lucid vision of the beautiful which is disseminated and strewn in the universal stream, there is no place for the soul of things. But let us go further. The cubists carried their own weight, one might say. They made their contribution and we don't have to ask more of them.

Cubism, moreover, as all the great arts, turned inward and divided into several currents. First scientific, then physical, then instinctive and finally—and this is its highest form—orphic. If we ignore Futurism (an impetuous attempt but deficient in true science) orphism is, to this day, the last word in contemporary art. It is the logical result of all previous endeavors. It is the first step toward the inevitable formula, toward amorphism.

Already Roualt, Matisse, Derain, Picasso, Van Dongen, Jean Puy, Picabia, Georges Braque, Metzinger, Gleizes, Duchamp (let us not forget the irresistible

Nude Descending a Staircase or the *Young Man*, both of 1912) seem to have understood and accepted the necessity of completely suppressing form and adhering only to color. Yet there is more to be done. Color, which can only evoke form in a limited fashion, must be broken up and disassociated in order to leave the job of synthesizing and reconstruction to the eye.

In this way, little by little, amorphism asserts itself. Certainly we will shout for joy in the presence of the next works of the young pioneers of Art. But we are only a few independent critics, enemies of bluff, with no connections with art dealers, who will defend the new Art, the Art of tomorrow, the Art of forever. For today, let us be content with publishing this all too short but suggestive manifesto of the amorphist school. Those with open minds and true intelligence will be the judge.

Manifesto of the Amorphist School

War on form!

Form is the enemy!

This is our program.

It was said of Picasso that he studied an object as a surgeon dissects a corpse.

We want no more of these embarrassing corpses — these objects.

Light is all we need. Light absorbs objects. Objects have value only through the light which bathes them. Matter is only a reflection and an aspect of universal energy. From the relationship of this reflection to its cause, which is luminous energy, is born what we improperly call objects, and thus we arrive at the nonsense called form.

It is up to us to indicate these relationships. It is for the observer, the onlooker, *to restore the absent yet necessarily living form.*

For example, let us consider the inspired work by Popaul Picador: Woman Bathing:

POPAUL PICADOR

Cherchez la femme, they will say. What a mistake!

Isn't the woman perfectly visible to the naked eye through the contrast of colors and the diffusion of light? Only a barbarian could seriously claim that the painter must strive to sketch a face, breasts and limbs!

Now let's look at The Sea *by the same artist.*

Popaul Picador

You see nothing at first glance. Keep trying. With practice your mouth will water.
That is amorphism.
We rise up against form. We are sick of seeing and hearing about form. Before form the
Cognoscenti of painting fall on their knees.

From *"Men of the Hour"*

Photography*

PHOTOGRAPHY is not Art. It is not even an art.
Art is the expression of the conception of an idea. Photography is the plastic verification of a fact.

The difference between Art and Photography is the essential difference which exists between the Idea and Nature.

Nature inspires in us the idea. Art, through the imagination, represents that idea in order to produce emotions.

The Human Intellect has completed the circle of Art. Those whose obstinacy makes them go in search of the new in Art, only follow the line of the circumference, following the footsteps of those who traced the closed curve. But photography escapes through the *tangent* of the circle, showing a new way to progress in the comprehension of form.

Art has abandoned its original purpose, the substantiation of religious conception, to devote itself to a representation of Form. It may be said that the soul of Art has disappeared, the body only remaining with us, and that therefore the unifying idea of Art does not exist. That body is disintegrating, and everything that disintegrates, tends to disappear.

So long as Art only speculates with Form, it cannot produce a work which fully realizes the preconceived idea, because imagination always goes further than realization. Mystery has been suppressed, and with mystery faith has disappeared. We could make a Colossus of Rhodes, but not the Sphinx.

Each epoch of the history of Art is characterized by a particular expression of Form. A peculiar evolution of Form corresponds to each one of the states of

*The attention of readers of this essay is called to Mr. De Zayas's essay, "The Sun Has Set," published in *Camera Work*, Number XXXIX. — Editors.

anthropological development. From the primitive races, to the white ones, which are the latest in evolution and consequently the most advanced, Form, starting from the fantastic, has evolved to a *conventional naturalism*. But, when we get to our own epoch, we find, that a special Form is lacking in Art, for Form in contemporary Art is nothing but the result of the adaptation of all the other forms which existed previous to the conditions of our epoch. Nevertheless we cannot rightly say that a true eclecticism exists. It may be held that this combination constitutes a special form, but in fact it does not constitute anything but a special *deformation*.

Art is devouring Art. Conservative artists, with the faith of fanaticism, constantly seek inspiration in the museums of art. Progressive artists squeeze the last idea out of the ethnographical museums, which ought also to be considered as museums of art. Both build on the past. Picasso is perhaps the only artist who in our time works in search of a new form. But Picasso is only an analyst; up to the present his productions reveal solely the plastic analysis of artistic form without arriving at a definite synthesis. His labor is in opposite direction to the concrete. His starting point is the most primitive work existing, and from it he goes toward the infinite, de-solving without ever resolving.

In the savage, analysis and discrimination do not exist. He is unable to concentrate his attention upon a particular thing for any length of time. He does not understand the difference between *similar* and *identical*, between that which is seen in dreams and that which happens in real life, between imagination and facts; and that is why he takes as facts the ideas inspired by impressions. As he lives in the sphere of imagination, the tangible form to him does not exist except under the aspect of the fantastic. It has been repeatedly proved that a faithful drawing from nature, or a photograph, are blanks to a savage, and that he is unable to recognize in them either persons or places which are most familiar to him; the real representation of form has no significance to his senses. The many experiments that Europeans have made with African Negroes, making them draw from nature, have proved that the Negroes always take from form that only which impresses them from the decorative point of view, that is to say, that which represents an abstract expression. For instance, in drawing an individual, they give principal importance to such things as the buttons of the clothes, distributing them decoratively, in an arbitrary manner, far different from the place which they occupied in reality. While they appreciate abstract form, the abstract line is to them incomprehensible, and only the combinations of lines expressing a decorative idea is appreciated by them. Therefore what they try to reproduce is not form itself, but the expression of the sentiment or the impression, represented by a geometrical combination.

Gradually, while the human brain has become perfected under the influence of progress and civilization, the abstract idea of representation of form has been disappearing. To the expression through the decorative element has succeeded the expression by the factual representation of form. Observation

replaced impression, and analysis followed observation.

There is no doubt that, while the human brain has been developing, the imaginative element has been eliminated from Art. There is no doubt also, that all the elements for creative imagination have been exhausted. What is now produced in Art is that which has caused us pleasure in other works. The creative Art has disappeared without the pleasure of Art being extinct.

The contemporary art that speculates with the work of the savages, is nothing but the quantitative and the qualitative analysis of that which was precisely the product of the lack of analysis.

Imagination, creative faculty, is the principal law of Art. That faculty is not autogenous, it needs the concurrence of another principle to excite its activity. The elements acquired by perception and by the reflective faculties, presented to the mind by memory, take a new form under the influence of the imagination. This new aspect of form is precisely what man tries to reproduce in Art. That is how Art has established false ideas concerning the reality of Form and has created sentiments and passions that have radically influenced the human conception of reality. To those under this influence, its false ideas of Form are considered as dogmas, as axiomatic truths; and to persuade us of the exactitude of their principles they allege their way of *feeling*. It is true that nature does not always offer objects in the form corresponding to those ways of feeling; but imagination always does, for it changes their nature, adapting them to the convenience of the artist.

Let us enter into some considerations upon imagination, so many times mentioned in this paper. Leaving aside all the more or less metaphysical definitions offered by the philosophers, let us consider it for what it is, that is to say, *creative* faculty, whose function consists in producing new images and new ideas. Imagination is not merely the attention which contemplates things, nor the memory which recalls them to the mind, nor the comparison which considers their relationship, nor the judgment which pronounces upon them an affirmation or a negation. Imagination needs the concourse of all these faculties, working upon the elements they offer, gathering them and combining them, creating in that way new images or new ideas.

But imagination, on account of its characteristics, has always led man away from the realization of truth in regard to Form, for the moment the latter enters under the domination of thought, it becomes a chimera. Memory, that concurrent faculty of imagination, does not retain the remembrance of the substantial representation of Form, but only its synthetic expression.

In order fully and correctly to appreciate the reality of Form, it is necessary to get into a state of perfect consciousness. The reality of Form can only be transcribed through a mechanical process, in which the craftmanship of man does not enter as a principal factor. There is no other process to accomplish this than photography. The photographer—the true photographer—is he who has become able, through a state of perfect consciousness, to possess such a

clear view of things as to enable him to understand and feel the beauty of the reality of Form.

The more we consider photography, the more convinced we are that it has come to draw away the veil of mystery with which Art enveloped the represented Form. Art made us believe that without the symbolism inspired by the hallucination of faith, or without the conventionalism inspired by philosophical auto-intoxications, the realization of the psychology of Form was impossible; that is to say, that without the intervention of the imaginative faculties, Form could not express its spirit.

But when man does not seek pleasure in ecstasies but in investigation, when he does not seek the anaesthetic of contemplation, but the pleasure of perfect consciousness, the soul of substance represented by Art appears like the phantasm of that *Alma Mater* which is felt vibrating in every existing thing, by all who understand the beauty of real truth. This has been demonstrated to us in an evident manner, if not in regard to pure Art, at least in regard to science, by the great geometricians, like Newton, Lagrange and La Place; by the great philosophers, like Plato, Aristotle and Kant; and the great naturalists, like Linnaeus, Cuvier and Geoffray Saint Hilaire.

Art presents to us what we may call the emotional or intellectual truth; photography the material truth.

Art has taught us to feel emotions in the presence of a work that represents the emotions experienced by the artist. Photography teaches us to realize and feel our own emotions.

I have never accepted Art as infinite nor the human brain as omnipotent. I believe in progress as a constant and ineludible law, and I am sure we are advancing, though we are ignorant how, why and whither; nor know how far we shall go.

I believe that the influence of Art has developed the imagination of man, carrying it to its highest degree of intensity and sensibility, leading him to conceive the incomprehensible and the irrepresentable. No sooner had the imagination carried man to chaos, than he groped for a new path which would take him to that "whither," impossible to conceive, and he found photography. He found in it a powerful element of orientation for the realization of that perfect consciousness for which science has done and is doing so much, to enable man to understand reason, the cause of facts—Truth.

Photography represents Form as it is required by the actual state of the progress of human intelligence. In this epoch of fact, photography is the concrete representation of consummated facts. In this epoch of the indication of truth through materialism, photography comes to supply the material truth of Form.

This is its true mission in the evolution of human progress. It is not to be the means of expression for the intellect of man.

<div style="text-align:right">Marius De Zayas</div>

Photography and Artistic-Photography

PHOTOGRAPHY is not Art, but photographs can be made to be Art. When man uses the camera without any preconceived idea of final results, when he uses the camera as a means to penetrate the objective reality of facts, to acquire a truth, which he tries to represent by itself and not by adapting it to any system of emotional representation, then, man is doing Photography.

Photography, pure photography, is not a new system for the representation of Form, but rather the negation of all representative systems, it is the means by which the man of instinct, reason and experience approaches nature in order to attain the evidence of reality.

Photography is the experimental science of Form. Its aim is to find and determine the objectivity of Form; that is, to obtain the condition of the initial phenomenon of Form, phenomenon which under the dominion of the mind of man creates emotions, sensations and ideas.

The difference between Photography and Artistic-Photography is that, in the former, man tries to get at that objectivity of Form which generates the different conceptions that man has of Form, while the second uses the objectivity of Form to express a preconceived idea in order to convey an emotion. The first is the fixing of an actual state of Form, the other is the representation of the objectivity of Form, subordinated to a system of representation. The first is a process of indigitation, the second a means of expression. In the first, man tries to represent something that is outside of himself; in the second he tries to represent something that is in himself. The first is a free and impersonal research, the second is a systematic and personal representation.

The artist photographer uses nature to express his individuality, the photographer puts himself in front of nature, and without preconceptions, with the free mind of an investigator, with the method of an experimentalist, tries to get out of her a true state of conditions.

The artist photographer in his work envelops objectivity with an idea, veils the object with the subject. The photographer expresses, so far as he is able to, pure objectivity. The aim of the first is pleasure; the aim of the second, knowledge. The one does not destroy the other.

Subjectivity is a natural characteristic of man. Representation began by the simple expression of the subject. In the development of the evolution of representation, man has been slowly approaching the object. The History of Art proves this statement.

In subjectivity man has exhausted the representation of all the emotions that are peculiar to humanity. When man began to be inductive instead of deductive in his represented expressions, objectivity began to take the place of subjectivity. The more analytical man is, the more he separates himself from the subject and the nearer he gets to the comprehension of the object.

It has been observed that Nature to the majority of people is amorphic. Great periods of civilization have been necessary to make man conceive the

objectivity of Form. So long as man endeavors to represent his emotions or ideas in order to convey them to others, he has to subject his representation of Form to the expression of his idea. With subjectivity man tried to represent his feeling of the primary causes. That is the reason why Art has always been subjective and dependent on the religious idea.

Science convinced man that the comprehension of the primary causes is beyond the human mind; but science made him arrive at the cognition of the condition of the phenomenon.

Photography, and only Photography, started man on the road of the cognition of the condition of the phenomena of Form.

Up to the present, the highest point of these two sides of Photography has been reached by Steichen as an artist and by Stieglitz as an experimentalist.

The work of Steichen brought to its highest expression the aim of the realistic painting of Form. In his photographs he has succeeded in expressing the perfect fusion of the subject and the object. He has carried to its highest point the expression of a system of representation: the realistic one.

Stieglitz has begun with the elimination of the subject in represented Form to search for the pure expression of the object. He is trying to do synthetically, with the means of a mechanical process, what some of the most advanced artists of the modern movement are trying to do analytically with the means of Art.

It would be difficult to say which of these two sides of Photography is the more important. For one is the means by which man fuses his idea with the natural expression of Form, while the other is the means by which man tries to bring the natural expression of Form to the cognition of his mind.

Marius De Zayas

The Skylark

Oh, the skylark, the skylark,
The beautiful skylark
I heard in the month of June,
It was nothing but a dark, dark
Speck. And nothing but a tune.
And Oh! If I had some wings
I would fly up to him
And I would look down upon the things
Until the day grew dim.

Mary Steichen*

*Age not quite nine.

Our Plates

In this Number of CAMERA WORK we introduce to our readers, for the first time, Steichen, the painter. Owing to the great difficulty of obtaining the quality of reproduction we insist upon, time plays an important role. This Number of CAMERA WORK has been in hand for several years. The latest phase of Steichen's evolution as a painter is not, for obvious reasons, incorporated in the present series. In the reproductions of both photographs and paintings some of the quality of the originals is unavoidably lost. Yet it is marvelous how wonderfully well the Bruckmann Company, of Munich, — who have done all the plates except four, — under the direction of our friend Goetz, has managed to keep the spirit of Steichen in all the reproductions. Likewise, the Manhattan Photogravure Company, of New York, has done its work well. Of course all the proofs were submitted to Steichen for corrections at various times before the editions were printed.

We take this opportunity again to put on record, inasmuch as we believe that CAMERA WORK is making history, our indebtedness to Steichen. The work of "291" could not have been achieved so completely without his active sympathy and constructive cooperation, rendered always in the most unselfish way. It was he who originally brought "291" into touch with Rodin, the recognized master, and with Matisse, at the time that he was regarded as "The Wildman." It has been Steichen also who, living in Paris, has constantly been on the watch for talent among young Americans there, and, as for example, in the case of Marin, has introduced them to the spirit of "291."

He has embodied that spirit in the most vital and constructive form.

Cosmism or Amorphism?

THE new Movement in art confirms the Hegelian rule that theory follows practice. It has now reached a stage when it becomes conscious of its ways and aims. Growing out of a purely practical life-urge it felt its way by desultory effort and sporadic attempt, unorganized, questioning and doubting. Its now evolving philosophy, at last, makes it tangible and accessible to a determination of its latent vitality, of its potential way and limit.

Whatever the assertions of its detractors, the New Art expresses a sincere endeavor to live up to the artist's racial mission, which consists in summing up, by self-revelation, the life of mankind. Whatever his plastic conquest, he has dared to defy the powers of retrogression and has established a standard for an artist's free manifestation. He has consciously labored to create a soil favorable for the growth of true art.

At no time in history was the artist more fully aware of art's universality than he is today. Rejecting Zola's idea of art as a "corner of nature reflected in one's intellect," the New artist declares his more comprehensive point of view: all cosmos must be distilled in the eternal soul-depths of a full man. Only the medieval mystics, those apostles of fearless thought who sought to reach the

very seat of the Almighty by an act of supreme voluntarism, only those protesters of individualism dared to aspire as freely, as infinitely, as does the New artist in his conscious universality. ——

No longer conceivable within a final perspective, the New Artist's world is focused from a distance whence the corporeality of things becomes diffused in their atmosphere. Then all objects abide only as form, — shape as an idea; reality as a mood. Ever higher altitudes of the New movement have been signalized by ever increasing elimination of concreteness. Picasso, Picabia, Kandinsky have built their straight road tangent to our globe. They are marching undauntedly toward its other end. By the wayside they have left their encumbering conventional equipment — to the dismay of the onlookers. Soon they will have stripped themselves to bareness; yet the march toward infinity is hardly begun. Is the lightening of the "material" burden an adequate means to reach cosmic heights?

The vicious circle of dualism — the serpent gnawing at his own tail — now makes New Art pay its penalty. Its successive self-deprivation of all elements of expression has brought about plastic anemia. Attempting to seize the noumenon of form it has caught the expiring breath. Aiming at Cosmism, it has led toward Amorphism; to a *tabula rasa*. It has put the sign of equality between the symbols of infinity and naught: $\infty = 0$.

The unmitigated admittance of all empirical elements into Kandinsky's compositionism leads, when pursued to its logical end, to the same blank plastique. Setting out to hide the mystic seed of the creative "innere Notwendigkeit" beneath the conglomerated ensemble of "entmaterialisierte" details, this neo-platonism professes to obtain an increase of "inner sound" in proportion to a suppression of limiting concreteness. The whole of one's time must even be shunned to combat successfully the pollution of materiality in art. Hence, the total absence of limitations in a *tabula rasa* offers the most unobstructed field for imaginative ramification. A panel all white is the ultimate end of this art, in white, which Kandinsky's color-psychology lauds as "a symbol of a world whence all colors, all material properties and substances have vanished . . . which sounds, inwardly, as non-sound . . . a silence which is not dead, but full of possibilities — which may suddenly be comprehended. . . ."

How did this sterile bud come to bloom on the glorious tree of the 19th century's art, that meant to synthesize all virile and quintessential matter in its Cézannesque force? The introduction of elements hostile to the innermost nature of the great living body; the straining of its positive tissues by a fatal enrichment through infusion of negative substance — as I hope to prove — was the cause of a deformed growth and abortive outcome. A logical miscarriage is what has happened to New art. Let me make this clear by the psychology of it.

There are three postulates that have gradually grown out of contemporary material and ideological conditions which now are fundamental to the New Movement:

I. An infinite world of experience.

II. A man, spiritually free from social conventions.

III. An art free because devoid of concrete limitations.

The first of these three principles, which the word Cosmism conveniently symbolizes, gives the modern man's psychology. A new world has arisen before our eyes. Towering billows of social unrest force their echoes into our mind. New life-conditions, newly awakened forces, give a new impetus to imagination. A steadily growing cumulative consciousness of unfathomed possibilities threatens to burst the frail embankments of reason. A well-nigh endless development of science sharpens man's powers of acquisition, discrimination and aspiration to god-like proportions. All this engenders a mental sensitiveness, a psychic profundity of unknown magnitude. No more can a man's eye rest on one point in space, on one moment of time. All space, all time, all phenomena, all experience are to the modern man the crossing and interwoven lines that make one wondrous carpet of modern intellect.

The evolution of the latest type of super-social consciousness is the sociological process from which the New artist's mind can be readily traced. The new social order has fostered the growth of a soul that renounces its allegiance to the man-made social forms. These have been demasked and shown up as mere whirlpools, or eddies, or bays of a mighty stream, which is the eternal soul-life. The racial impetus is the moving force of it; the social forms have failed to stay it. Sociology is fully aware of the newly revealed truth, and therefore seeks to mine the social clay from the profoundest depths of man's soul-life. It looks to raciality as the new social bond; hence it revives the ancestral forces in man to better serve new-human ends. All this has been lived through by philosophers, poets, and painters. As a sociological basis of New art it accounts for its establishment of racial norms in plastic expression, in place of the conventional ones.

When the church-man, tribe-man, and state-creature are no more typical embodiments of social life; when the blood of a Giordano Bruno, a Rousseau, a Stirner, and Nietzsche has risen to a young artist's head, then the New Prometheus is born in him.——Only the infinity of evolutional experience, crystallized in our racial characteristics, could contain the Olympian aspect of reality. Universality and individuality were thus made categories of New art. Inner compulsion was made the source of expression, against the environmental. "The true artist works first of all to satisfy a natural need of expressing himself for his own satisfaction . . . a work of art may be the product of beliefs, feelings and emotions of a kind not known to the public," declare De Zayas and Haviland.* By proclaiming himself a law unto himself the New artist means to assert his racial sovereignty.

*See "Modern Plastic Expression," by M. De Zayas and P. B. Haviland.

Was the enthronement of racial categories in place of conventional ones—born of temporal institutions—a justified procedure in art? Was it not a reckless leap into infinity, into the great Unknown, where all human forms become parts of the primordial chaos? Is this not a clue to the amorphous leanings of recent plastic manifestations? Surely not!——[The] New art, building upon racial principles, is far from courting amorphous illusions, but is consciously in search of eternal plastic forms. Their infinite reach alone can comprehend modern Cosmism.

This, therefore, is the inner force as well as the inner circle out of which pure art must spring. To be pure it must be purged from accessory, non-racial elements. The incidents of recent origin, of external discipline, adaptation, imitation and all of the traditional influences which are not racially human must be washed off as so much dust that has settled on the canvas of true art.

Art,——is aiming at an objectification of racial experience, which alone is the source of undivided emotion. It measures the greatness of a masterpiece by the profound depths of human history it summons into our consciousness by its plastic bidding. Thus the infinitude of race-life asserts itself as a self-end in form of the art instinct. In free art the voice of eternity totally drowns temporal clamor; and then "it seems," writes Bergson, "as if an appeal had been made within us to certain ancestral memories belonging to a faraway past—memories so deep-seated and foreign to our present life that this latter, for the moment, seems something unreal and conventional."

The New artist seems fully justified in his distrust of traditional "spontaneity and individuality." He defies the influences of church, state, class, and "idola fori," who are the ghosts guiding the artist's brush and chisel; who still demand self-suppression, esthetic orthodoxy, and asceticism in the name of sainted traditional bogeys, hallowed institutional taboos and deified class-talismans.

He sees the violent contexture of social organization giving way to one built upon racial voluntarism. And that is why he proceeds to tear the thousand obsolete social tendrils, and anticipates the birth of true art.——

It is well known that Courbet, Proudhon's friend, regarded art as a handmaid of class struggle.

His realism was a didactic imperative, a social institution that gave way to that of science, when Impressionism came to its own.

The idol of science planted in art's holy groves was shattered by Neo-impressionism. Imagination, without which, according to Gauguin, there is no art, was the weapon of those who protested against the impersonal rule of science. All other contemporary ideologies—beauty, justice, freedom, progress, etc., etc.—were promptly substituted. Art then became a record of popular creeds, of "vulgarism" and social phosphorescence. Daumier, Meryon, Rops, Meunier, Gavarni, Millet, Degas, Guys, Lautrec, Carrière, Denis, etc., ad infinitum,—often unrelated natures,—saw their mission in institutional reality.

Van Gogh and Gauguin felt strongly this social compulsion. Cézanne, the arch-primitive, was almost impervious to it. They have seized nature and contracted it out to didactic purposes. The tragic fire in the heaven-rending scream of Van Gogh's self-portrait and the color-glory in Gauguin's "Les Misères Humaines" had a social mission: to summon man's conscience into his eye.

Today we hear the same sociological imperative in the most "dematerialized" art-system of which Kandinsky is a theorist. This spokesman of the "inner compulsion" and "evangelical talent" speaks often of the elevating and refining quality of his sort of art, which it is the *duty* of the artist to apply to personal and social purposes. His mysticism did not raise him above our sociological clamor. Only French Post-cubism aspires to the logical self-end of art. In it the artist is concerned with only his own-self-realization, leaving it to the sociologists to turn to popular use the new revelation of racial humanity. All he asks for is freedom—not even for understanding.

Cézanne and Van Gogh, the arch-artists, could conceive only in art-terms, i.e., in raciality, which can no more be seized from the focus of a logical system, than medieval life could be dwarfed to monasticism. When Poe and Maeterlinck summon racial-feelings by imagination-stirring word-construction and visual suggestion they follow the imperative of art: to operate within a synthesizing sphere. When they ponder upon the secret of poetry and art, they analyze and make science. Then they consciously forsake the raciality of their art, because they are then after art's abstract skeleton. They pluck the flower, flatten it between the leaves of a book, then find it fit for service in their scientific collection.

French Post-cubism, equally dualistic in its conception of reality, more completely sacrifices the most troublesome one of the two warring principles. It gradually absolves itself from the pollution of form-manipulation. From Matisse's simplification, and Picasso's geometrical de-composed compositions a steady denial of concrete detail has aimed at a destruction of objectivity, as that foreshadowed by Picabia's latest work. That this road is one crossing the boundary of former art, this they fully admit. The domain of "pensée pure," which is the content of their canvases, lies beyond all that centuries have grown accustomed to regard as the exclusive region of art. They repudiate all that modern German aestheticians, of the school of Lipps, with Worringer's revision, would call style, and which, in line with this essay's argumentation, is no more than the temporal social imposition upon racial creative force. Furthermore, they reject, not only the aesthetic teleology of plastic cognition of nature, but all natural fixity of content. "Ce monstre de la beauté n'est pas éternel," exclaims Apollinaire. ——

Conscious of their self-imposed ostracism from traditional realms of art, the Post-cubists reiterate nevertheless their allegiance to the motherland by identifying their plastic creations with music. They claim to have dematerialized their art so completely that there remains only the inner voice, whose sound is the

common keynote of all arts, the sign of their kinship, and the means of their ultimate practical correlation. Through it, they claim, it becomes possible to unite all forms of expression—tonal, verbal, and plastic—into an elementally powerful unison of art-effect—the high aim of Richard Wagner, missed by that innovator, because hung upon a material scheme. This is now propounded by the daring group of contributors to the "Blaue Reiter." The sound-color transposition tables by Scriabin and Kandinsky are conscious efforts in this direction. Scriabin's color-accompanied music is an attempt at practical realization of the new unison.

Gabrièle Buffet connects Picabia's "peinture pure" with the search for the objectivity of color and sound elements. She claims a superiority over music for pure line and pure color as agents for abstraction.——I believe that New musicians as Arnold Schoenberg, Scriabin, Von Hartmann, etc., will promptly disown Mme. Buffet's statement concerning their art. They claim the very opposite for free music. The desire to penetrate to depths inaccessible to the "educated" music leads them to a revolutionary introduction of non-classified tonal values, of unknown sounds, strange chords, dissonance, fractional tones, etc., etc. They feel the need of a reconquest of raciality in music, i.e., of a world divined in eternal sounds. A purely scholastic interest in noises, thirds or twelfths of tones, or other elements of expression is as foreign to their art as the objectivity of line and color is to painting.

Consciously possessed of art's heritage, undaunted by the opposition of a whole epoch's callousness and ignorance, divinely optimistic in the face of an Archimedes' task to move a world, from their newly revealed fulcrum, the Post-cubists are now in the forefront of the movement for true art. Summing up universality, they have evolved an infinite measure: the New man. He, in his racial infinity, is the one of whom Protagoras said two thousand years ago: Man is the measure of all things. Proceeding to endow this measure of all being with all inclusive capacity, the Post-cubists have taken his logical faculty as a starting point—a fatal procedure. They have obtained mere truth, a peep at the universe through an intellectual keyhole. The awakening is bound to come; for truth is a candle lit at both ends. When reaching to its conclusion it burns the holding hand.

The candle is not long.

It is up to the New artist to build a reality which is endlessly wider than logical insight. He must live up to his raciality, which is at the basis of his art-conception. With undivided mind he must grasp life, which speaks to him, as it did, in a mighty synthesis, to Cézanne and Van Gogh, in terms of movement, magnitude, mass, strength, attitude, will, direction, revelation, light, glimpse, vibration, whisper, rhythm, and harmony—besides innumerable other racial tongues.

The free artist will hear them and reveal their message.

<div align="right">JOHN WEICHSEL</div>

JOSEPH T. KEILEY

JULY 26, 1869 — JANUARY 21, 1914

"MY EXPERIENCES OF LIFE HAVE TAUGHT
ME THAT THE GREAT CONQUEST OF LIFE
IS THE CONQUEST OF ONE'S INNER SELF,
AND THAT A MAN'S REAL WORTH IS MEAS-
URED, NOT BY WHAT HE HAS AMASSED,
BUT BY THE EXTENT TO WHICH HE HAS
MASTERED AND PERFECTED THE FACUL-
TIES OF HIS SOUL, TO WHICH HE HAS
REALIZED HIS IDEALS. —— JOS. T. KEILEY."

Aphorisms on Futurism

DIE in the Past
Live in the Future.

THE velocity of velocities arrives in starting.

IN pressing the material to derive its essence, matter becomes deformed.

AND form hurtling against itself is thrown beyond the synopsis of vision.

THE straight line and the circle are the parents of design, form the basis of art; there is no limit to their coherent variability.

LOVE the hideous in order to find the sublime core of it.

OPEN your arms to the dilapidated, to rehabilitate them.

YOU prefer to observe the past on which your eyes are already opened.

BUT the Future is only dark from outside.
Leap into it—and it EXPLODES with *Light.*

LOVE of others is the appreciation of one's self.

MAY your egotism be so gigantic that you comprise mankind in your self-sympathy.

THE Future is limitless—the past a trail of insidious reactions.

LIFE is only limited by our prejudices. Destroy them, and you cease to be at the mercy of yourself.

TIME is the dispersion of intensiveness.

THE Futurist can live a thousand years in one poem.

TODAY is the crisis in consciousness.

CONSCIOUSNESS cannot spontaneously accept or reject new forms, as offered by creative genius; it is the new form, for however great a period of time it may remain a mere irritant—that molds consciousness to the necessary amplitude for holding it.

CONSCIOUSNESS has no climax.

LET the Universe flow into your consciousness, there is no limit to its capacity, nothing that it shall not re-create.

UNSCREW your capability of absorption and grasp the elements of Life— *Whole.*

HERE are the fallow-lands of mental spatiality that Futurism will clear—

MAKING place for whatever you are brave enough, beautiful enough to draw out of the realized self.

TO your blushing we shout the obscenities, we scream the blasphemies, that you, being weak, whisper alone in the dark.

THEY are empty except of your shame.

AND so these sounds shall dissolve back to their innate senselessness.

THUS shall evolve the language of the Future.

THROUGH derision of Humanity as it appears—

TO arrive at respect for man as he shall be—

ACCEPT the tremendous truth of Futurism
Leaving all those
 —Knick-knacks.—

<div align="right">MINA LOY</div>

Marius De Zayas—Material, Relative, and Absolute Caricatures

THE Century Dictionary defines caricature: "A representation, pictorial or descriptive, in which beauties or favorable points are concealed or perverted and peculiarities or defects exaggerated, so as to make the person or thing represented ridiculous, while a general likeness is retained." Caricature is said to be derived from *caricare*, to load, overload, exaggerate.

This definition does not adapt itself to such work as De Zayas calls caricatures, and I would prefer to spell the word *characature*, deriving the work from the root *character*. We will refrain, however, from coining a new word and will only claim that the definition given by the Century Dictionary is too narrow and that *caricature* should also be understood to mean: "A pictorial representation, through emphasis of certain traits, of physical or mental characteristics, a representation of character through form."

Personal caricature or the caricature of persons therefore concerns itself with the representation of the character of people. In other words it selects or emphasizes that which is characteristic of the person it seeks to represent.

De Zayas conceives that a human being can be represented in one of the following ways:

First: Through photography which gives us only the exterior or objective appearance of the subject, and only so much of his character as we would be able to discover by looking at the person himself according to our faculties for judging of character. Ordinary portraiture reflects the same point of view as photography, and differs only in the use of the medium used for fixing the

image permanently, a mechanical means being employed in one case and the human hand in the other.

Second: Material caricature which represents the morphological traits of the subject emphasizing those which are characteristic or reveal some personal trait of character.

Third: Relative caricature which combines the physical and psychological principles represents the person at a given time when under the influence of a definite mood, or manifestation of the personality.

Fourth: Absolute caricature represents the person in his relation to the outside world, his place in the evolution, and his individual characteristics.

If we draw a diagram showing the component parts of the individual to be: (1) Matter; (2) Spirit, subdivided into personality and individuality; and, (3) the Force which marks our trajectory through life; we can say that material caricature represents matter and the personality, the matter predominating. Relative caricature represents the personality dominated by a temporary force; while absolute caricature represents matter, the force of direction, and primarily the individual psychological characteristics.

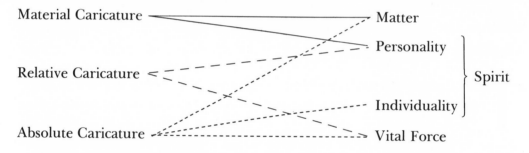

Picabia summarizes De Zayas's absolute caricatures by calling them "the psychological expression of man's plurality."

To me the greatest handicap of the modern worker in obtaining a hearing from the community is that he seeks to manifest his individuality without seeking a point of contact with the public.

As stated in De Zayas's and Haviland's booklet "Study of the Modern Evolution of Plastic Expression": 'In exclusive individuality the individual works with his own individual resources for his own individual self. The moment he excludes himself from the feelings of the community, the community excludes itself from his feelings.' Marius De Zayas seems to have found a solution to the problem of giving full sway to his personal evolution of expression, entering boldly the field of the abstract, without losing his point of contact with the community. He has found this point of contact in the fact that instead of using abstract form to express ideas awakened in him by excitation from the outside world, i.e., making his ideas the subject of his expression, his subject remains the outside world, the people whom he represents, and his personality comes into play only to extract from his subject that which is significant. The signifi-

cant thing is the psychology of his subject, not his own psychology, so that when we look at his absolute caricatures we think, not of the artist, but of his subject, i.e., the outside world represented in its abstract significance.

This point of view also gives his work more variety as there is represented in each new caricature the interplay of new personalities instead of variations of impressions on one personality.

Some of the modern workers consider portraiture as outside the field of modern expression. The reason is that in the attempts made so far to apply abstract form to portraiture the artist has attempted to represent his impression of the material body through the abstract significance of form. De Zayas, realizing that concrete form is adaptable to the representation of the concrete and abstract form to the representation of the abstract, uses concrete form in his realistic caricatures and abstract form in his absolute caricatures, remaining logical in his use of the medium.

He has avoided the inconsistency of using the abstract significance of Form to express concrete ideas. He uses logically abstract Form to express abstract characterization. That is why his work is convincing.

Paul B. Haviland

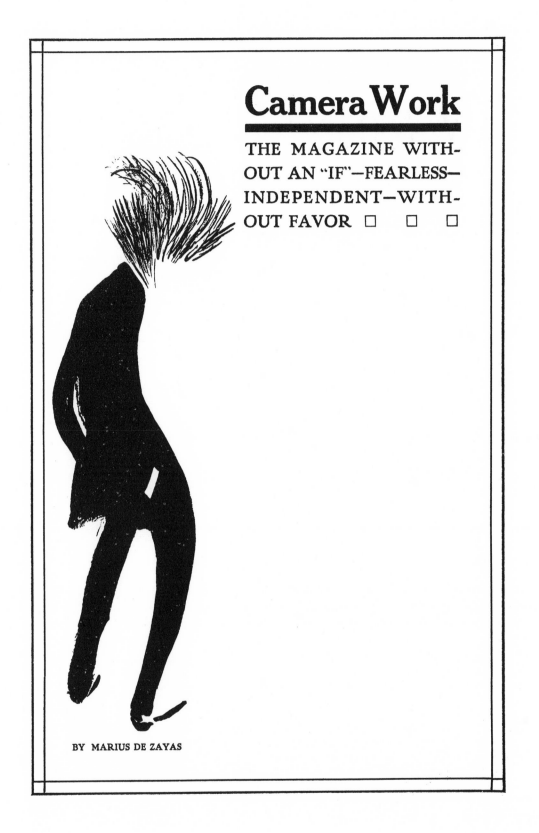

BY MARIUS DE ZAYAS

CAMERA WORK:

An illustrated quarterly magazine devoted to Photography and to the activities of the Photo-Secession. Published and edited by Alfred Stieglitz. Associate Editors: Joseph T. Keiley, Dallett Fuguet, J. B. Kerfoot, Paul B. Haviland. Subscription price, Eight Dollars (this includes fee for registering and special packing) per year; foreign postage, Fifty Cents extra. All subscriptions begin with the Present Number. Back numbers sold only at single-copy price and upward. Price for single copy of this number at present, Two Dollars. The right to increase the price of subscription without notice is reserved. All copies are mailed at the risk of the subscriber; positively no duplicates. The management binds itself to no stated size or fixed number of illustrations, though subscribers may feel assured of receiving the full equivalent of their subscription. Address all communications and remittances to Alfred Stieglitz, 1111 Madison Avenue, New York, U. S. A. Arranged and printed at the printing house of Rogers & Company, New York. Entered as second-class matter December 23, 1902, at the post-office at New York, N. Y., under the act of Congress of March 3, 1879. Copyright, 1915, by Alfred Stieglitz. This issue, Number XLVII, is dated July, 1914. Published in January, 1915.

ANOTHER year of experimenting done. Nine years of public experimenting. Experimenting in the little garret — variously termed Photo-Secession, Little Gallery, "291" — at 291 Fifth Avenue, New York. Several thousand visitors. Not, by far, as many as in former years. Curiosity seekers have fallen away.

A May night. Nearly June. I sat in my room thinking, weighing, what had been done during the year. Had anything been done? Anything added? Comparing the year to past years, subconsciously visualizing the year in connection with the coming year. What work was to be done during the coming year? As I was thinking of these things — without crystalizing any thought — it flashed through my mind that, during the past year, a certain question had been put to me, more and more frequently. The question: "What does '291' mean?" I remembered the half-conscious, invariable answer. I remembered shrugging my shoulders amusedly, smiling as I replied: "291, what *does* it mean?" Letters too had come from Europe, quite a few, asking me that same question, "What is it, this '291' that people are talking about?" Most of these inquiries remained unanswered, filed away. Some were answered in the same spirit as the questioners in the little garret had been answered. There was no particular reason why some inquiries were filed away, why some were answered. And as all this passed through my mind it suddenly struck me to ask myself, "What is '291'?" Do I know? No one thus far had told the world. No one thus far had suggested its real meaning in CAMERA WORK, and so again it flashed upon me to ask myself, "What is '291'?" I would like to know. How find out? Why not let the people tell me what it is to them. And in telling me, perhaps they will tell each other. Some say 'tis I. *I know it is not I.* What is it?

And then and there I decided that a number of CAMERA WORK should be devoted to this question. I decided that the number should contain no pictures; I decided that forthwith I would ask twenty or thirty people, men and women, of different ages, of different temperaments, of different walks of life, from different parts of the country, and some in Europe, to put down in as few words as possible, from ten to no more than fifteen hundred, what "291" means to them; what they see in it; what it makes them feel. Not what it is. And I would ask them to eliminate, if possible, any reference to myself. I felt that in this way I might possibly find out what "291" is, or come near to finding it out. For if all would write what they felt in their hearts, a common note in all probability would run through all the worded heartbeats. And thus too the world might learn to know.

The next morning as people began coming into the little garret, I began my selection. To those who did not come, and could not come, and whom I felt should be represented, I wrote. In due course the MSS. came in. Instead of twenty or thirty there were over sixty-five. Some who heard of the idea volunteered because they were delighted with the opportunity of saying something. And now, herewith, I publish what has been received. There has been no editing, and what has been received is published.

ALFRED STIEGLITZ

Contributors

MABEL DODGE: a woman actively interested in vital expressions of the day; New York, and Florence, Italy.

HUTCHINS HAPGOOD: author, journalist, social worker; New York.

CHARLES E. S. RASAY: Episcopalian clergyman; Little Falls, New York.

ADOLF WOLFF: sculptor, poet, anarchist; New York.

HODGE KIRNON: West Indian elevator boy at 291 Fifth Avenue since 1912.

ANNE BRIGMAN: photographer; Oakland, California.

CLARA STEICHEN: mother; Youlangis, France, and Sharon, Connecticut.

WARD MUIR: journalist, photographer; London, England.

ABBY HEDGE CORYELL: first teacher, Ferrer School; Readfield, Maine.

FRANK PEASE: daredevil soldier in Philippines, ex-labor agitator, writer; New York.

STEPHEN HAWEIS: painter, writer, photographer; London and New York.

REX STOVEL: butler, soldier, actor, playwright; Canada and New York.

ALFRED KREYMBORG: poet and chess professional; New York.

FRANCIS BRUGUIERE: photographer; San Francisco, California.

ETHEL MONTGOMERY ANDREWS: photographer; New York.

FRANCES SIMPSON STEVENS: painter; New York.

DJUNA BARNES: illustrator and writer; New York.

PAUL B. HAVILAND: Haviland & Company, lover of art, photographer, writer, associate editor of CAMERA WORK; Limoges, France, and New York.

C. DEMUTH: painter and writer, New York.

KONRAD CRAMER: painter; Karlsruhe, Germany, and New York.

CHARLES DANIEL: retired saloon proprietor whose passion for pictures moved him to retire in order to become a collector-dealer; New York.

ANNA C. PELLEW: lives in New York.

HELEN R. GIBBS: teacher of children, and writer; Newark, New Jersey.

H. MORTIMER LAMB: engineer, writer, photographer; Toronto, Canada.

MARSDEN HARTLEY: painter; Berlin, Germany, and New York.

ARTHUR B. DAVIES: painter, ex-president of International Society of Painters and Sculptors; New York

ARTHUR G. DOVE: painter and farmer; Connecticut.

JOHN W. BREYFOGLE: painter; New York.

WILLIAM ZORACH: painter; New York.

VELIDA: writer; New York.

MAX MERZ: director of Elizabeth Duncan School, composer; Darmstadt and New York.

EUGENE MEYER, JR.: banker; New York.

ARTHUR B. CARLES: painter; Philadelphia.

E. ZOLER: observer; New York.

J. N. LAURVIK: art critic; New York.

S. S. S. (MRS.): observer and so-called dilettante; New York.

CHRISTIAN BRINTON: art critic, author, lecturer; New York.

N. E. MONTROSS: art dealer, pioneer specialist in American paintings; New York.

HUGH H. BRECKENRIDGE: painter, ex-professor of painting at Pennsylvania Academy of Fine Arts; Philadelphia.

HELEN W. HENDERSON: art critic of the *Philadelphia Enquirer* and of the American Art News; Philadelphia and New York.

ERNEST HASKELL: etcher and lithographer; Maine.

FRANK FLEMING: printer; New York.

LEE SIMONSON: painter and writer; New York.

ARTHUR HOEBER: painter, author, art critic, national academician; New York.

WILLIAM F. GABLE: leading merchant, collector of rare books, manuscripts, etc.; Altoona, Pennsylvania.

A. WALKOWITZ: painter; New York.

F. W. HUNTER: lawyer, collector of Chinese art, authority on American glass; New York.

OSCAR BLUEMNER: architect and painter; New York.

C. DUNCAN: sign painter and painter; New York.

KATHARINE N. RHOADES: painter and writer; New York.

AGNES ERNST MEYER: "The Sun Girl"; New York.

MARION H. BECKETT: painter; New York.

CLIFFORD WILLIAMS (Miss): painter; New York.

SAMUEL HALPERT: painter; Paris and New York.

MAN RAY: painter, designer, writer; Ridgefield, New Jersey.

MARIE J. RAPP: music student (20 years old), and, on the side, stenographer at "291" since 1912.

CHARLES H. CAFFIN: author, art critic, lecturer; New York.

DALLETT FUGUET: writer and poet, associate editor of CAMERA WORK; New York.

BELLE GREENE: librarian—Mr. J. P. Morgan's library; New York.

EDUARD J. STEICHEN: painter, photographer, plant breeder; Paris, Voulangis, and New York.

HIPPOLYTE HAVEL: dishwasher, editor of *Revolutionary Almanac*, editor of *Don Quixote*; New York.

HENRY MCBRIDE: art critic, formerly director of art department, Educational Alliance, and director of School of Industrial Arts, Trenton, New Jersey; New York.

TORRES PALOMAR: kalogramaist; Mexico.

JOHN WEICHSEL: civil engineer, teacher, lecturer, writer: New York.

J. B. KERFOOT: writer, literary critic of *Life*, associate editor of CAMERA WORK; New York.

FRANCIS PICABIA: painter; Paris, France.

MARIUS DE ZAYAS: caricaturist, analytical writer on art; Mexico and New York.

JOHN MARIN: water-colorist and etcher; New York.

The Mirror
"Man is the measure of all things." — Protagoras

I am the mirror wherein man sees man,
Whenever he looks deep into my eyes
And looks for me alone, he there descries
The human plan.

I am the mirror of man's venturing mind,
And in my face alone he yet may read
The only reason for the every need
Of humankind.

I am the mirror of man's eager heart,
Within me lies the secret of his quest:
I hear the hidden part that is the rest
Of every part.

I am the mirror of man's weary flesh,
From my deep eyes looks back the valiant soul
Endlessly thriving on the endless dole
Of man's distress.

I am a mirror to the young and old.
The young see in me all their dear desire,
The old find in my ardor their lost fire
Now growing cold.

All things in turn glide o'er my mirror face.
Man looks — and sees the poor forgotten dead —
Looks: And remembers, with a sudden dread,
The old lost grace.

Eyes that are pure find purity in me,
Lips that are gross seek grossness like to theirs,
Freely gives back the mirror all it bears —
Free to the free.

Old sins, old hopes, old struggles and old days
Come back to mock you for a little space.
The old hopes mock the new, upon my face,
And all new ways.

I am the many yet I am the few;
Like and unlike are side by side in me,
Changeless and varying, only I may seem
Both false and true.

I am the fruit of all that man has sowed,
I am the ground he ploughs upon his way
Thro' time and space. Eternally today
I am the road.

I am the force that quickens all but death,
I am the death that generates the force,
I am the plowman, breathless on his course,
I am his breath.

I am the mirror of the insatiate,
I am the good, the bad, the infinite all,
In me lie the answers to each human call
For I am Fate.

I am the many and the one, the odd
As well as even. Ever in my form
God is renewed each time a man is born—
For I am God.

I am the alternating peace and strife—
I am the mirror of all man ever is—
I am the sum of all that has been his—
For I am life.

<div align="right">MABEL DODGE</div>

A Letter from Prison

Mr. Wolff was imprisoned thirty days for a political "crime." This letter was written without any idea of publication. Upon the request of the Editor, Mr. Wolff granted permission to incorporate the letter in this book.

<div align="right">

October 1, 1914.
Workhouse,——
Blackwells Island, N.Y.

</div>

MY DEAR STIEGLITZ:

Sleepless on my prison cot in the stillness of night I was thinking of you, of "our little gallery; of the spirit of '291'." This place reminds me awfully of the other place—it is so different!!! Here on the Isle of Sighs and Curses but no songs, alas! everything is depression, suppression, and repression; at "291" everything is expression, impression, and more expression. Here in prison everything is institutional, uniform, routinal, dogmatic, academic, counted, fastened, barred and hopeless; there at "291" everything is free, informal, enthusiasm, struggle, attainment, realization, expansion, elation, joy, life. I have always felt it, but I feel it now more than ever that next to my own little studio, "291" is for me the freest and purest breathing place for what is commonly called the soul. There one is free to delight in the freedom of expression in

others, thus making it one's own freedom and one's own expression.

I do earnestly hope that all the rotten, filthy, corrupting prisons will be wiped away and the system that necessitates prisons will vanish from the face of the earth while the spirit of "291" will grow and multiply, for it is the spirit of freedom, of self-expression, of art, of life in the highest and deepest.

ADOLF WOLFF

What 291 Means to Me

Visitors to "291" will find no difficulty in calling to mind how readily Mr. Stieglitz replies with his usual "I cannot tell you that" in response to some inquisitor who pleadingly entreats him for an explanation of what the paintings mean to him. I fail to see how Mr. Stieglitz could justly claim an adequate reply to this subject, when it is quite apparent that it is through the many exhibitions of these paintings, coupled with an inexplicable something else, which have given the Secession its unparalleled record, and have also rendered its meaning so significant. Without losing sight of his wonderful Socratic ability, I think that Mr. Stieglitz will be obliged to plead his inconsistency this once.

It would be sheer impertinence to encourage the idea that words are efficient to convey all that I gleaned from "291." I well remember how baffled and perplexed I became when I first saw the exhibitions there. I could see nothing inviting or attractive in paintings so devoid of "beauty," yet judging from the conversations and controversies which were hourly occurrences, I grew convinced that "291" had a potent meaning and a mission which I did not comprehend. It was at this time that I fortunately came across Mr. Keiley's article entitled, "What Is Beauty?" and after a third perusal, I took an agnostic attitude of mind toward the idea of "the beautiful." I gradually yielded up most of my previous opinions, and now my confusions and perplexities have become pleasant reminiscences.

I have found in "291" a spirit which fosters liberty, defines no methods, never pretends to know, never condemns, but always encourages those who are daring enough to be intrepid; those who feel a just repugnance towards the ideals and standards established by conventionalism.

The fallacies of underestimating and censuring with severity that which does not readily appeal to us; of insisting on a unity which offsets progress and leads to stagnation are evils which threaten institutions. I see in "291" their inevitable decline and extermination.

What does "291" mean to me? It has taught me that our work is worthy in proportion as it is the honest expression of ourselves.

HODGE KIRNON

291

I sewed and hemmed and hung the first curtains for "291." Since then others have hemmed and hawed and hung there: but never with more appreciation than I, for so large a spirit in so small a space. The curtains have long since gone to the ragman—but my appreciation for the spirit of "291" is still unfrayed!

<div align="right">CLARA STEICHEN</div>

What 291 Means to Me

Each is ill with his own malady. And there are, happily, as many maladies as there are humans. Yours may be a craze to bite a bit of the moon. No one knows why—you, yourself, least of all. But that it is something which has eaten its way throughout the sum total of you, you know. At times, you are discouraged. You say, I am a no-good. I am not like others. I eat, drink, sleep, breathe this bite-a-bit-o'-the-moon. Nobody else does. What use am I? Let me die.

No, let me not die. There might be some hospital, some nurse, some spirit who would soothe me back to health, to my belief in this bite-a-bit, without which I am somebody else, and being somebody else, do not wish to be. Then you remember somewhere. You smile. A funny worm is tickling you. And you go there.

There may be six pictures on a wall. Six pictures about onions. They say something to you. Or there may be six words spoken by someone to someone. Six words about capon being more palatable than chicken. They, too, say something to you.

Go ahead. Try again. We believe in you and your bit of the moon. 'Tis the only craze worth while. Bite away. And you return home, the happiest invalid that ever was. You are not a no-good. That night, you nearly break your neck trying to reach the moon. And for many nights thereafter, and days, as well. Until you have to go somewhere again.

That is what "291" means to me.

<div align="right">ALFRED KREYMBORG</div>

What 291 Means to Me

It is the most helpful place to be in for anyone whose mind is open to suggestion. There is no feeling of smallness there. Frank, honest criticism of a constructive kind always. No subject is too small to be ignored, no idea is too great not to find a response. All kinds of people go and come. If you go there often enough you will find just how big or how small you are. Sometimes the awakening comes as a shock. But after all it is an oasis in the desert of American ideas.

<div align="right">FRANCIS BRUGUIERE</div>

291

A place where I can think aloud without fear of being misunderstood.

<div align="right">ETHEL MONTGOMERY ANDREWS</div>

291 is the Attic near the Roof. It is nearer the roof then any other attic in the world.

There insomnia is not a malady — it is an ideal.

<div align="right">DJUNA BARNES</div>

Between Four and Five

The forenoon had been this and that.

The afternoon dragged through an exhibition or two, a saloon or two, — some art talk.

Then, somehow, — tired and discouraged, we found ourselves at Fisk's suggestion, in a place, a gallery, that, I like the word place better than the word gallery, for this place.

"May we see the new Picasso?"

It was brought into the room. A Picasso.

That was a moment.

"What does it mean?" — even with that felt by someone in the room, it was a moment.

Again the forenoon had been this and that.

Again the afternoon had been given to this and that — had been wasted.

"Let us go in here," — and we went in again to the place which is more that than gallery, — just a place in movement; just — rather, one of the few.

The walls this time were emotionally hung with African carvings, — there was also yellow and orange and black; yellow, orange, black. There were photographs of African carvings. There was a photograph of two hands.

That was a moment.

"Let *us* start a magazine, — a gallery, — a theatre": This is always in the air; seldom: "Let *me* create a moment."

"What is he trying to say?"

<div align="right">C. DEMUTH</div>

Dear Stieglitz:

I am sorry I cannot write a fitting appreciation of the modern elixir you are giving America — your foresight has gripped the imagination of the country with the vitality and eloquence of the vocational movement in art.

<div align="center">Faithfully,</div>

<div align="right">ARTHUR B. DAVIES
October 27, 1914</div>

291

The question, "What is '291'?" leaves one in the same position in explaining it as the modern painter is in explaining his painting. The modern painting does not present any definite object. Neither does "291" represent any definite movement in one direction, such as Socialism, Suffrage, etc. Perhaps it is these movements having but one direction that makes life at present so stuffy and full of discontent.

There could be no "291ism." "291" takes a step further and stands for orderly movement in all directions; in other words it is what the observer sees in it — an idea to the nth power.

One means used at "291" has been a process of elimination of the non-essential. This happens to be one of the important principles in modern art; therefore "291" is interested in modern art.

It was not created to promote modern art, photography, nor modern literature. That would be a business and "291" is not a shop.

It is not an organization that one may join. One either belongs or does not.

It has grown and outgrown in order to grow. It grew because there was a need for such a place, yet it is not a place.

Not being a movement, it moves, so do "race horses," and some people, and "there are all sorts of sports," but no betting. It is finer to find than to win.

This seems to be "291" or is it Stieglitz?

ARTHUR G. DOVE

291

An arena for disembodied souls; for stardust, molecules, animalcula. House of crying dust and living winds.

An upside-down house; idealistic backward and reformatory; builded upon empty space between existences as a Forum for speechless life essence.

Place for utterance of unformable thoughts; for cries of cosmic labor. Birthplace of psychic electrons. Fountain of Youth. Phoenix nest.

To enter is to leave life; to rest, to rejuvenate; to remain is decay.

JOHN W. BREYFOGLE

291 — The home of a Living Rebel!

WILLIAM F. GABLE

Two-Ninety-One and Rockefeller Institute are doing research work.
291 — Art as a living thing in relation to life.
291 — Where one can live and feel one's own life.

A. WALKOWITZ

A Nursery Crime Dedicated to A to Z From A to Z

Believe me,
Twixt you and me,
Indeed He's it,
From A to Z,
In the little
Gallerie!

Once you go,
You go again,
To hear what's what,
From A to Z,
In the little
Gallerie!

Space is small,
But oh, such vision,
That you get
From A to Z,
In the little
Gallerie!

What is Life,
And what is not,
Is what you hear,
From A to Z,
In the little
Gallerie!

Gee whiz!
Hot Air,
And atmosphere,
You get in there,
From A to Z,
In the little
Gallerie!

Some say, it's rot,
And some say not,
But rot or not,
Or hot or not,
He knows what's what,
Does A to Z,
From A to Z,
Of the little
Gallerie!

S. S. S.

What 291 Means to Me

When you asked me, my dear Alfred, to write down some impressions of just what "291" has meant to me, I felt you were entering the enemy's camp to request an opinion as to what was thought of the campaign just waged. I can write now much more dispassionately than I could have some five years ago, because then, frankly, the shows got on my nerves. Since that time, so many strange happenings have occurred in art, I am inclined to take them with complacency, if not toleration. It is a tearing down of the old faith, however, without substituting anything in its place, that one sees in "291." To me, the years have brought no order out of the chaos of the new men you have exploited. When they or you talk — and I seem to have heard many theories within your walls — one is impressed by the logic, the sanity of intention, but when I see the results hanging about, I cannot perceive they have any relation whatsoever with the subject of the conversation. I have told you this many times and I can only reiterate it. When most of these men are not unspeakably dreary, they are pathetically weak in expression, or so strange and impossiple as to say absolutely nothing to me, though I have — largely out of regard for you — striven hard to grasp their point of view.

Their utter disregard of form, or beauty as I understand it, their stupidity in the arrangement of composition lines are all things my art notions rebel at, recoil from in disgust. Now and then an exhibitor comes along at "291" who is less impossible than the rest, but I have yet to see one who has had the slightest appeal. It is all like a Barmecide Feast at which you tell me there are appetizing dishes, but which for the life of me, I can make nothing of and upon which I should starve. To me the value of the place has been perhaps that it has given some of the modern painters courage to work away from the conventional lines, to experiment, to dare, and as such I doubt not, it has had its place in the great economy of things. I am not sure however, but that it has done quite as much harm as good and I know after all, the men who have been most enthusiastic followers of your leaders have deteriorated into men who have blindly copied the Matisses, Picassos and the Picabias, and imitation while intensely flattering, is most unhealthy. I am too much a believer in the absolute necessity of knowledge of one's craft to accept feeble, uncertain lines, poor construction and absence of modeling so obvious in the mass of things you have shown in your gallery. It all seems to my old-fashioned mind, an effort to arrive at some result without training, to attract attention not through artistic delight in nature, but through a novelty secured at any cost. No, Alfred, pleasant as it has been to drop in the rooms and listen occasionally to a discussion, I have yet to find inspiring things on the walls in the way of paintings, or in the sculptures on the shelves and I regret now more than ever, the distinct loss to photography that has been caused by your neglect of your camera through your attention to a field so different, for in photography you were supreme.

ARTHUR HOEBER

Impressions of 291

The gray walls of the little gallery are always pregnant.

A new development greets me at each visit, I am never disappointed. Sometimes I am pleased, sometimes surprised, sometimes hurt. But I always possess the situation. A personality lives through it all. Each time a different element of it expressed by the same means appears. There is a unity in these succeeding and recurring elements.

Cézanne the naturalist; Picasso the mystic realist; Matisse of large charms and Chinese refinement; Brancusi the divine machinist; Rodin the illusionist— Picabia surveyor of emotions—Hartley the revolutionist—Walkowitz the multiplier; Marin the lyrist; De Zayas insinuating; Burty the intimate; the children, elemental.

A Man, the lover of all through himself stands in his little gray room. His eyes have no sparks—they burn within. The words he utters come from everywhere and their meaning lies in the future. The Man is inevitable. Everyone moves him and no one moves him. The Man through all expresses himself.

<div align="right">Man Ray</div>

291

It is probably natural that many people should have wanted to know what it was, but it is amazing that some sixty individuals should have been ready and able to give some kind of an answer as to what it means to them. —"291?"—I have never known just what it was, I don't know now, and I do not believe anyone else does. "291" only seems to us what we as individuals want it to be, and because I have my particular "want it to be" stronger today than ever before, do I resent this inquiry into its meaning as being impertinent, egoistic and previous. Previous insofar that it makes the process resemble an obituary or an inquest, and because it further tends to establish a precedent in the form of a past.

The spirit of "291" can never manifest itself through any definitely expressive label, or scheme of organization, it can never have anything resembling a constitution or an eternal policy, for the very good reason that any one of these would be sufficient to dull its receptivity to new elements, especially to the one element which has ever arrived opportunely and kept "291" a living issue:—the great unforeseen. Assuming there is always present the fundamentally necessary intelligent independence, "291" must be kept as free to discard absolutely as it must be free to be enthusiastically receptive; and on this premise its men, its ideas and its ideals can always be severely and intensively yet fairly tested. Therefore, there is no permanent room for dogma or even the trace of anything that moves toward dogma.

In the beginning of August, 1914, dogma demonstrated its failure again and as far as "291" was concerned I was then ready to put an art movement such as futurism with anarchy and socialism into the same bag as Church and State to be labeled "Dogma" and relegated to the scrap heap—History.

The essential progress of "291" has not so much been due to a gradual process of evolution as to sudden and brusque changes caused largely by an eager receptivity to the unforeseen. Each of these mutative movements found reactionary spirits in "291" and in transforming these or in eliminating them Stieglitz has shown his greatest "291" potentiality. My appreciating and presenting this particular quality as the most important one and the one which virtually makes of him a despot, does not mean that I do not recognize the importance of the broad generous understanding and support that Stieglitz has given to the individuals, as individuals, that form the aggregate "291." It is in this respect that to many of us he has been of greater importance in our personal development than it would ordinarily seem any single unrelated individual could possibly be.

During the past year, possibly two years, "291" has seemed to me to be merely marking time. It had obviously reached a result in one of its particular efforts and had accomplished a definite result within itself and for itself:—and for the public at large it had laid the way for others to successfully organize the big International Exhibition of Modern Art held at the Armory in 1913.

Whether it was the discouragement that follows achievement, or a desire to cling to success and permanently establish its value, or merely a consequent inertia caused by the absence of new or vital creative forces I am not prepared to discuss here—but "291" was not actively a living issue. I also fail to see any reason other than one or all of those enumerated above that explains to me the attitude leading to the publishing of this number of CAMERA WORK, unless it is simply the result of 291's finding itself with nothing better to do.

Again arrives the unforseen—came the War.

If ever there came, within our time, a psychological element of universal consequence that could rouse individuals out of themselves as individuals and grip humanity at its very entrails, surely it was this one.

"291" continued the process of producing a book about itself,—and calmly continued its state of marking time. As "291" it had failed for once, and on this, an occasion of the greatest necessity, to realize its relationship to the great unforeseen. It failed, as every human institution failed, demoralized by the immensity of the event and blinded by the immediate discussion of it, instead of instantly grasping the significance of the great responsibility that was suddenly ours. It failed to grasp the necessity of making of itself a vast force instead of a local one. Furthermore by this failure it still left many individuals outside of its immediate circle riding about with the solemn conviction that "291" was merely a "rival to the old Camera Club" or "Mr. Stieglitz's Gallery for the newest in art."

By doing the convincing things conviction is carried and results achieved that can never be accomplished by simply explaining them.

In this our endeavor to find wherein lies our best effort and to register its appreciation let us be intelligent enough, then strong enough to recognize our failure and write them both upon the same page.

EDUARD J. STEICHEN

Que Fais Tu 291?

J'y sème dit 291 mon coeur est une source au caractère difficile elle se surmène un poète lui en a donne le livre revêtu de la forme humaine —

291 arrange ses cheveux sur son front — Mais impossible de prendre feu et l'âme est gonflée de vie qui remplit toutes les heures d'un soleil ses yeux ses oreilles prédisent une intelligence c'est pourquoi on ne lui apprit ni métier ni art mais il trouvera sa place dans l'enchaînement sublime —

Deux âmes et le ciel dans cette ville bruyante elles trouvent moyen de s'unir parmi cette rumeur de commerce scène mystique — Pour moi je crois que la fenêtre s'ouvre jusqu'a la perspective tout près de l'embouchure proximite de la mer — Insouscience des choses matérielles — La vérité mais sans polémique — Il faut voir en lui une proclamation sans affirmation nuée matinale c'est l'unique terrain devant l'univers qui refusera de voir la valeur de son enseignement — Le conservateur "vive la France" "vive la Guerre" le temps de fumer une cigarette — J'ai répondu que je refusais toute discussion —

291 c'st un grand pas de fait qui commence et qui finit d'inépuisable abondance accoudés a la fenêtre des catêchumènes — Si clairvoyant et scrupuleux évènement sensational généreux pour sa clientèle qui se coudoie pressée dans cet espace restreint — Comprenons bien la pensée de 291 voilà un façon nouvelle de concevoir la vie il aime son métier je suis content de te voir — Son prestige montera rapidement jusqu'aux marches du trône et les services télégraphiques et téléphoniques ont été interrompus en maints endroits — C'est pourquoi il fait de la musique et sa musique est un source inépuisable — Le conservateur si tu me rapportes je te donnerai — Il ne le connait pas il est bon c'est un Dieu je l'aime —
St. Cloud 17 Juillet 1914

FRANCIS PICABIA

What Doest Thou, 291?

There do I sow says 291; my heart is a spring of fastidious disposition; 291 overworks itself; a poet has written the book and has clad it in human form.

291 arranges the locks on its forehead — but the flames cannot scorch it; its soul is filled with a life that fills each hour with sunshine; its eyes, its ears announce an intelligence; that is why it has been taught neither craft nor art, but it will find its place in the sublime sequence.

Two souls and the sky in this clamorous city; they manage to unite in the midst of the commercial uproar; a mystical communion. For my part, I believe the window opens to the perspective close to the proximate intermingling of the sea—indifference to concrete matter—truth without polemics. We must see in him a proclamation devoid of affirmation, morning dew; 'tis the only place in the Universe which will refuse to see the value of his teaching. The conservative "Viva la France." "Viva la Guerre;" time to smoke a cigarette. I answered that I refused to discuss. 291 is a big step forward which begins and which ends from inexhaustible abundance, leaning on its elbows at the window of the catechumens. Clear-sighted and scrupulous, a sensational event, generous towards his patrons who elbow one another hurriedly in the small quarters. Let us get a good understanding of the spirit of 291; here is a new way to conceive life; he enjoys his work; I am glad to see thee. His prestige will ascend rapidly the steps of the throne and telegraphic and telephonic communications have been interrupted in many places—that is why he is a musician and his music is an inexhaustible spring—the conservative "if thou bringest to me I will give to thee." He knows him not; he is good; he is God; I love him.
St. Cloud, July 17, 1914.

<div style="text-align:right">Francis Picabia</div>

 I know a place
 where reason halts
 in season and out of season
 where something takes the place
 in place of reason
 a spirit there hovers roundabout
 a something felt by those who feel it
 here together and to those who come
 a place of comfort
 a place electric a place alive
 a place magnetic
 since it started it existed
 for those sincere: those thirsty ones
 to live their lives
 to do their do
 who feel they have
 yet cannot show.
 The place is guarded,
 well guarded it
 by He — who jealously guards
 its innocence, purity, sincerity
 subtly guarded it
 so that—it seems—not guarded at all

no tyrant he — yet tyrant of tyranny

so shout — we who have felt it

we who are of it

its past — its future

this place

what place?

Oh Hell 291 JOHN MARIN

"291" Exhibitions: 1914–1916

As has been our custom, for the sake of record, we reprint some of the criticisms published in the press on exhibitions:

Charles H. Caffin in the *New York American:*

The tenth season at the Little Gallery of "291" Fifth Avenue opens with an exhibition of statuary in wood by African savages. Hitherto objects corresponding to such as are shown here have been mostly housed in natural history museums and studied for their ethnological interest. In the Paris Trocadero, however, their artistic significance has been recognized, as it also has been by certain French art collectors and by some of the "modernists" among artists — notably Matisse, Picasso and Brancusi.

It is as the primitive expression of the art instinct, and particularly in relation to modernism in art, that the present exhibition is being held, and it is said that "this is the first time in the history of exhibitions that Negro statuary has been shown from the point of view of art."

These objects have been obtained from the middle-west coast countries of Africa — Guinea, the Ivory Coast, Nigeria and the Congo. Nothing is known of their date or of the races who produced them, the natives in whose possession they were found having come into some sort of contact with white civilization and lost the traditions of the art.

I have talked with Marius de Zayas, the well-known caricaturist, who for many years has been studying ethnology in relation to art with the view of discovering the latter's root idea, and who accumulated these eighteen examples during his recent visit to Paris. He begins by reminding one of the accepted premise in the study of the evolution of civilization, namely, that every stage in the progress of mankind, wherever it may have occurred, has been characterized by a corresponding attitude toward life and a corresponding expression of it in the handiworks.

While hitherto historians of art have looked for its roots in such directions as the lake dwellers and the caves of Dordogne, they have overlooked the fact that the white race in itself represented an evolution in advance of the black. Consequently, to get at the root of art one must dig deeper than the white primordial and look for it in the black.

The objects, however, which are here shown do not go down to the deepest elemental expression of the savage. They represent him at a comparatively advanced stage, by which time he had evolved a very marked feeling for beauty.

These specimens, when once you have got over the first impression of gro-

tesqueness, are easily found to be distinguished by qualities of form, including the distribution of planes, texture and skillful craftsmanship that are pregnant with suggestion to one's esthetic sense.

With what motive and under what kind of inspiration did the primitive artist carve these works? Mr. de Zayas explains that the savage looked out upon a world that seemed full of threats; that his imagination involved no idea of good, but only one of fear of mysterious agencies whose evil purposes he must avert.

He had recourse to fetishes; in earliest stages some stone or stock of wood. As he evolved he increased the efficacy of these by fashioning them into forms of his own devising. Such are the objects here shown; they are fetishes.

Characteristic of all is the purely objective way in which the carver approached his subject. He set out to make his public see just what he saw in the object. But the way in which he saw it was entirely opposed to the photographic way. It was not representation, as in the case of white savage art; it was rather what we call today the caricaturist's way

If he wished to objectivize the fierce bulging of the eyes, he makes them protrude like pegs; if a covert expression of the eye, he parts the closed lids by a decisive slit. Note, again, in one face the power expressed by the massive protuberance of the features and in another the refinement, actually subtle, obtained by varying the surfaces of the planes. And in almost every case it is not representation, but suggestion, that secures the objective reality. Here is the essential difference between this art and that of white savages.

In a word, the main characteristic of these carvings is their vital objectivity, rendered by means that are abstract. This or that objective fact has been, as it were, drawn out into constructive prominence, and has been given such a shape as would most decisively emphasize it.

Another feature of these carvings which must not be overlooked is their decorative character. It was necessity in the first place that prompted the making of these fetishes. They were needed for the preservation of the race. But by this time the instinct to beautify the needful things of life had been evolved. One can discover it in the details, added for no other purpose than that of ornament, as well as in the treatment of the hair, and of the surfaces generally.

It is impossible, for example, to believe otherwise than that the carver was satisfying his instinct of beauty when he sloped down the contours of one face and curved the lips of another. Over and over again there are details of form and surface that are replete with esthetic feeling.

And one other characteristic among many more that could be mentioned distinguishes these objects. To a greater or less degree all are expressive of movement, be it but the opening or shutting of the eyes. A feeling for the static does not belong to the savage. He is ever on the move, encountering the changes of the seasons and weather. To him life is movement, which, by the way, brings his primordial instinct into touch with modern philosophy as well as modern art.

Charles H. Caffin in the *New York American*:

Some recent drawings and paintings by Picasso and by Braque are being shown in the gallery of the Photo-Secession, No. 291 Fifth Avenue. The two men are friends and work in common, Picasso being the leading spirit. His is, in fact, the most original, intrepid and logical mind among all those which today are bent upon intellectualizing their sensations in pictorial terms.

It is the kind of mind that, though one may not be able to appreciate its products, is worth examining for the sake of its processes. How shall one approach them? By way of an experiment, let us imagine ourselves in St. Patrick's Cathedral. We have been present at a service perhaps; the sound of voices is hushed and the last strains of the organ are dying away amid the aisles and vaulting. Our eyes and ears have been saturated with sensations; but in the pause that follows, instead of being more or less hypnotized by the various impressions, let us suppose that our intellectual faculties are quickened to an intense degree of activity. We become acutely aware of the embodied forces that produced the sensations.

The column, as a column, is forgotten in the sense of its being a support; the arch is realized in its capacity of sustaining the weight of the clerestory, and the vaulting is analyzed as an adjustment of conflicting strains, the lateral pressures of which are offset by side aisles and flying buttresses. Intellectually, or, as we say, in our mind's eye, we have pictured the edifice as a bodiless structure of innumerable forces, some in correspondence, some in conflict, but all organically harmonized by the engineering intellect of the architect.

Then, into this skeleton of intellectualized sensations, may pass an intellectualized impression of the music. Part of it was human, part instrumental. But the consciousness of the congregation and the organ have all but left our memory; it is the varieties and qualities of sound, its crescendos and diminuendos, and, above all, its rhythms, that hold our mind in this moment of intense activity.

Again, the impulse to sensation has been one of corresponding and conflicting forces, organically harmonized into rhythmic structure.

Now, supposing one wished to communicate these intellectualized sensations to someone else. Personally I should try to do it by a few words, selected to indicate my train of thought, and uttered with suitable variety of pitch and tonal shading, while I filled in the expression by pantomimic gesture. Meanwhile, if it were possible to photograph the inflection of the voice and the cadence of gesture with the words appearing in print as they occur, the result would be a moving picture of my intellectualized sensations.

This in a way is what Picasso does; only his picture is once and for all in front of us, and instead of rambling on as mine would do, is itself a structure of harmonic completeness.

Whether you care to have even intellectualized sensations conveyed to you in so rarified an abstract form is another matter. Meanwhile the processes of Picasso's mind, as laid bare in these drawings, might well be studied by our artists, not for imitation—they are too personal to this particular artist—but for the purpose of eliminating from their work its concrete superfluities and raising its capacity of intellectual suggestiveness.

Peyton Boswell in the *New York Herald:*

John Marin, one of the first of American extremists, is showing forty-seven of his works in the Photo-Secession Gallery, No. 291 Fifth Avenue. Some of them are disjointed dabs of pure color on white ground, designed to be suggestions of land-scapes, and some are views of skyscrapers, their sides bent in impossible directions and their skies apparently full of the suspended debris of dynamite explosions.

The exhibition makes good food for the new art cult, but only the initiated and the faithful can get anything out of it except a bored feeling. This style of art is now about the most common thing in the world. Its novelty is gone.

Willard Huntington Wright in the *Forum:*

Still another type of artist who is striving for a personal vision, or rather, I should say, who feels that his vision is different from any man now painting, is Oscar Bluemner. Formerly an architect, the work of this man bears traces of a certain coldness and stiffness due perhaps to his early training with mechanical draughts-man's instruments. His desire is to produce on canvas, by a highly synthetic method of picturization, the actual emotional experiences he senses before nature. Highly intelligent, he realized that this can never be done by merely copying what is before him. He recognizes that the actual volume of emotion one has in the out-of-doors cannot be transmitted to a small square of cloth by copying values. He therefore strives to heighten all color forms and lights to such a degree that, in the immense-ly restricted space of a picture, their intensity will overshadow the sensitive specta-tor even as he is awed by nature's effects. With Bluemner there is a desire for big-ness, for extent of effect—an ambition to condense and concentrate, as it were, into a small area the forces of nature, which by their intensity will produce the colossal volume of emotion we have before an actual landscape. Here is a highly commend-able ideal, and an original one. At present Bluemner sacrifices much toward the achievement of his ambition. But this is only natural, for compromise is always the path of him who is not yet master of himself. Bluemner would be the first to repu-diate the assertion that he has arrived; to him it would be a sacrilege to have one think he aspired to nothing higher than his present achievements. He is now in the making: he says it will take him twenty years to achieve his aim. Personally, I be-lieve that his goal will have become modified in less than a quarter of that time. As he progresses in his ability to handle his medium, he will be confronted by other, and perhaps profounder, esthetic complications. His color now has a hardness and dryness which will undoubtedly pass away; and in his drawing is a certain stiff-ness which also is due to disappear. He has set himself the task of doing a certain thing. Whether or not he succeeds in his present aim is unimportant; but he will unquestionably find himself *en route*. And this self-expression—this recreation of a highly personal intellect and temperament—is, after all, the thing that counts.

Henry J. McBride in the *New York Sun:*

One swift glance at the sculptures of Eli Nadelman, now exposed in the gallery of the Photo-Secession, reveals that their author is a man of talent. It is not a talent that will be appreciated or even understood by Mr. Joseph Pennell, who says he doesn't understand modern art and considers it indecent. It will be readily appar-

ent, however, to younger, less prejudiced observers and to those with a less keen scent for immorality.

Mr. Nadelman is himself a young man, and it is almost too soon to weigh his powers for uplift or downpull in the world of art, but it is clear that his faculties are the sort that influence others. What he does will be looked at. His work, whether you like it or not, forces your consideration. This is the essential faculty an artist must have. If Mr. Nadelman lives and is permitted to work out his special tasks in conditions that are fairly sympathetic (which is always a matter of luck, for the most sensitive artists are the least fitted to combat a repellent environment) there is no question but that he will be an influence of the future to be reckoned with.

As things are there is more danger that he will be overpraised by the young contemporaries who bring garlands to those who succeed in expressing the spirit of the time, in quantities proportionate to the abuse that is heaped upon them by the bigots, than that he will be harmed by the critics, of which class I for the nonce am not one.

The new sculptor, you will have already surmised, is a modern of the moderns. He is excessively refined, although those who hold that modern sculpture should imitate Greek sculpture, in spite of the fact that modern life is nothing like the Greek, will hold otherwise. He models in the modern "plastic" method.

He tries for the things that Rodin tried for, but being younger he tries in a more exuberant way. He is in the lyric stage of his life and is busy singing. It is the Rodin of the drawings that influenced him. He has not as yet looked through the "doors of hell." He is so young that no one so far has dared to tell him that there is a hell. I see no indications myself that he will ever get hell into his work. But he should not be underestimated for that.

Even modern life has its lyric side. Only, only, lyricism has its dangers. Nature ordains that pure singers die early. It's the law. Shelley went quickly, and Chatterton quicker. But who wouldn't be a Shelley?

Some of this work is artificial. Almost as artificial as modern life. Profound observers of humanity are aware that the three little locks of hair that curl so gracefully upon the smooth foreheads of modern Parisiennes are not entirely the work of nature. No, indeed! Curious, and I am told expensive, emollients are used upon rebellious tresses in order to overcome the laws of gravity and the effect of contrary winds.

The sculptor has taken almost as much pains to emphasize these curls as did the young person herself who suggested the motif. Nevertheless, many people who wish to govern art production with rules of steel will say such curls in art are immoral. I find that they do not worry me at all.

There are other essays of art in the exhibition, such as drawings and reliefs, that have so much strangeness that they will be at once seized upon by the opponents of "plasticity" as justification for charges of insincerity against the artist. It is a matter of debate whether such things should be shown, especially at a debut. They are experiments in different lines, and some of these lines the artist will abandon later. It is scarcely necessary to take the public into absolute confidence at a first appearance, or to show laboratory practice. One complete bit of self-expression is more to the public than a hundred half truths — or ought to be.

Charles H. Caffin in the *New York American:*

An exhibition of watercolors, oils, drawings and etchings by John Marin is being held in the gallery of the Photo-Secession, No. 291 Fifth Avenue.

When I first met him in Paris some years ago, he showed me a number of etchings. They did not so much express his own way of seeing as suggest that he had been seeing through Whistler's eyes. Later he returned to New York and became identified with the spirit of "291," of which his subsequent development has been very intimately a product. For here he found encouragement to seek the source of his inspiration in himself and to experiment with his own way of seeing and feeling. To his maturer experience New York presented an amazement of impressions.

They were amazing because so vast and incoherent. For, as I divine his art, the things of sight appeal to Marin as manifestations of force. He sees in the forms and color of nature the symbols of its inward workings; in the handiwork of man in cities, the symbols of intellectual, material and spiritual energy. And in New York he found, as do most other thinking souls, that these forms of energy are confused and incoherently related. To the optical eye the city may seem solid and stable; but to the eye of the spirit, visioning, the elements and qualities of energy that created and inform it, it may seem a very vortex of conflicting forces.

He tried to symbol forth these visions of invisible reality, swirling, thrusting, soaring, tottering around him. But it was not until he had spent a summer in the Tyrol, communing with the colossal, but comparatively stable, phenomena of mountains, forests and valleys that he began to find himself and learn how to control the magnitude of his impressions.

Control in art, as in any other department of human activity, is the result of organization; the adjustment of conflicting values and the establishment of harmonious relations. In Marin's case this was not the balancing of big masses; mountain against sky, forest with valley. His temperament refuses to see nature thus adjusting herself into large conventional distinctions, as the world has systematized society into classes. It refuses to see the mass as mass, but views it as an aggregate of infinite individual units, correlated into a whole of living organic unity. To organize this unity of impression among the innumerable strokes and touches by which he tries to interpret his vision, and in a medium that permits so little fussing with effects as watercolor, was his problem. It was in the Tyrol, I repeat, that he began to gain control over it.

When again he returned to New York and applied himself to the phenomena of the city, his work at once revealed superior organization. He probably made as many failures as successes, for the kind of expression he is intent upon, so elusive, as easily twisted awry by a little discord of color, or a touch of tone too big or too little, as the mechanism of a watch is upset by a grain or two of dust, can only be attained through failures. Indeed, it is only through failure that anything worth while can be accomplished in the spiritual world, and Marin's expression is as truly a product of the spiritual imagination as poetry. If you seek to align it with material comparison, you may as well leave it alone. Unless you can feel it as the symbol of spirit speaking with spirit, it is not for you.

Then, after grappling with the forces of our leviathan city, he spent last summer by the seashore in Maine. His reaction to nature was now more comprehensible to

himself. The paintings that he has gleaned from this quiet spell of nature-study show remarkable development.

In most of these he has ceased to experiment; he has successfully achieved. They carry on the face of them a certainty of confirmed assurance. Brain has wrought a finer organization and feeling discovered fuller utterance. It speaks in greater clarity of color, in mellower and more subtle harmonies. It is more flexible in expression, more immediately imaginative. Noticeable, too, is the variety of expression. No formula is discoverable in choice of subject or treatment. Everything speaks of a liberation of spirit, working in harmony with its surroundings and actively alive.

Nor does the charm of these watercolors suggest finality. The grand thing about Marin is that one step leads always to another, and always is prompted by the consciousness of force within himself that must be brought to birth. It would be hard to name a man less swayed in his art by outside influences. His impulse is purely from within; and he is so rarely single-minded that the following of his own promptings has become as inevitable as breathing.

To many, like myself, his exhibition will bring a singularly choice enjoyment.

"291" and the Modern Gallery

In the Publication "291," Number Nine, which was published early in October, 1915, the following announcement appeared:

> "291" announces the opening of the Modern Gallery, 500 Fifth Avenue, New York, on October 7th, 1915, for the sale of paintings of the most advanced character of the Modern Art Movement—Negro Sculptures—pre-conquest Mexican Art—Photography.
>
> It is further announced that the work of "291" will be continued at 291 Fifth Avenue in the same spirit and manner as heretofore. The Modern Gallery is but an additional expression of "291."

Underlying the above announcement the circular reprinted below had been prepared for public dissemination. This was withheld because "291" felt it owed no explanations to anyone, and the above was substituted in its stead. But the course of events necessitates a recording in CAMERA WORK the genesis of the Modern Gallery. The withheld circular announcement read as follows:

> "291" announces the opening in the first week of October of a branch gallery at 500 Fifth Avenue, called the Modern Gallery.
>
> Here modern and primitive products of those impulses which for want of a more descriptive word, we call artistic, will be placed on exhibition and offered for sale.
>
> We are doing this for several reasons.
>
> We feel that the phase of our work which has resulted in arousing an interest in contemporary art in America has reached a point where, if it is to fulfill itself, it must undertake the affirmative solution of a problem which it has already negatively solved.

We have already demonstrated that it is possible to avoid commercialism by eliminating it.

But this demonstration will be infertile unless it be followed by another: namely, that the legitimate function of commercial intervention — that of paying its own way while bringing the producers and consumers of art into a relation of mutual service — can be freed from the chicanery of self-seeking.

The traditions of "291," which are now well known to the public, will be upheld in every respect by the new gallery.

It is the purpose of the Modern Gallery to serve the public by affording it the opportunity of purchasing, at unmanipulated prices, whatever "291" considers worthy of exhibition.

It is the purpose of the Modern Gallery to serve the producers of these works by bringing them into business touch with the purchasing public on terms of mutual justice and mutual self-respect.

It is the purpose of the Modern Gallery to further, by these means, the development of contemporary art both here and abroad, and to pay its own way by reasonable charges.

To foreign artists our plan comes as a timely opportunity. Their market in Europe has been eliminated by the war. Their connections over here have not yet been established.

Photography has always been recognized by "291" as one of the important phases of modern expression. The sale of photographic prints will be one of our activities.

We shall also keep on hand a supply of photographic reproductions of the most representative modern paintings, drawings, and sculptures, in order to give to the public an opportunity to see and study modern works of art that are privately owned in Europe and elsewhere.

The literature of modern art will also be dealt with.

Indeed, as time goes on, we propose that nothing shall be omitted that may make the Modern Gallery a helpful center for all those — be they purchasers, producers, or students — who are in developmental touch with a modern mode of thought.

To these products of modernity we shall add the work of such primitive races as the African Negroes and the Mexican Indians because we wish to illustrate the relationship between these things and the art of today.

Marius De Zayas, who had been a very active worker at "291" for years past, — as is evidenced in the pages of CAMERA WORK — was, as the proposer of the idea and the chief believer in the need of such an enterprise as the Modern Gallery, naturally given the management of the experiment. The opening exhibition consisted of paintings and drawings by Braque, Burty, De Zayas, Dove, Marin, Picabia, Picasso, Walkowitz; sculpture by Adolf Wolff; photographs by Alfred Stieglitz; and Negro art.

Mr. De Zayas, after experimenting for three months on the lines contemplated, found that practical business in New York and "291" were incompatible. In consequence he suggested that "291" and the Modern Gallery be separated. The suggestion automatically constituted a separation.

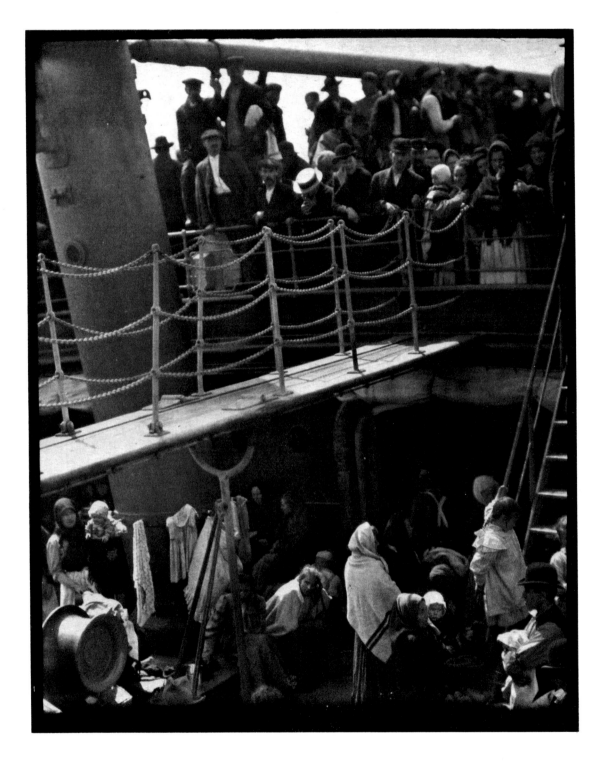

Paul B. Haviland Passing Steamer

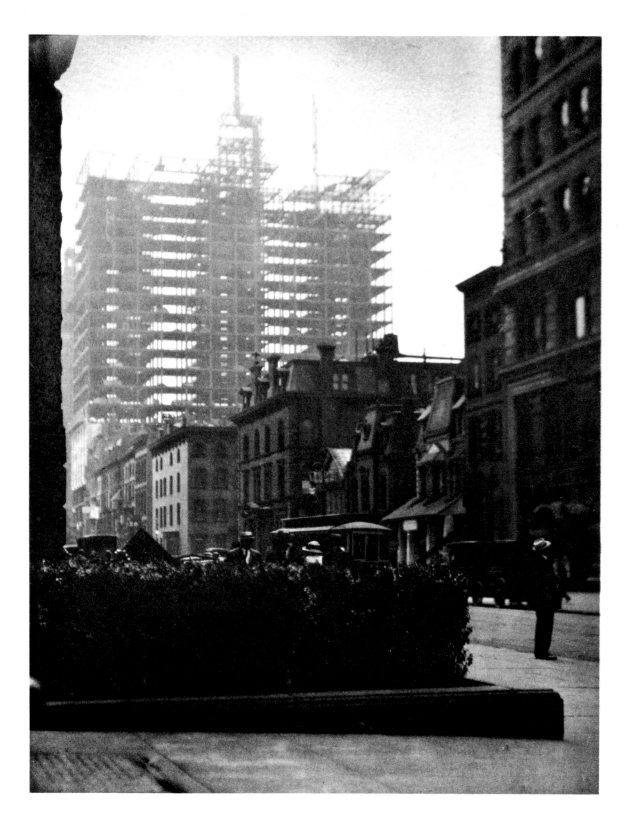

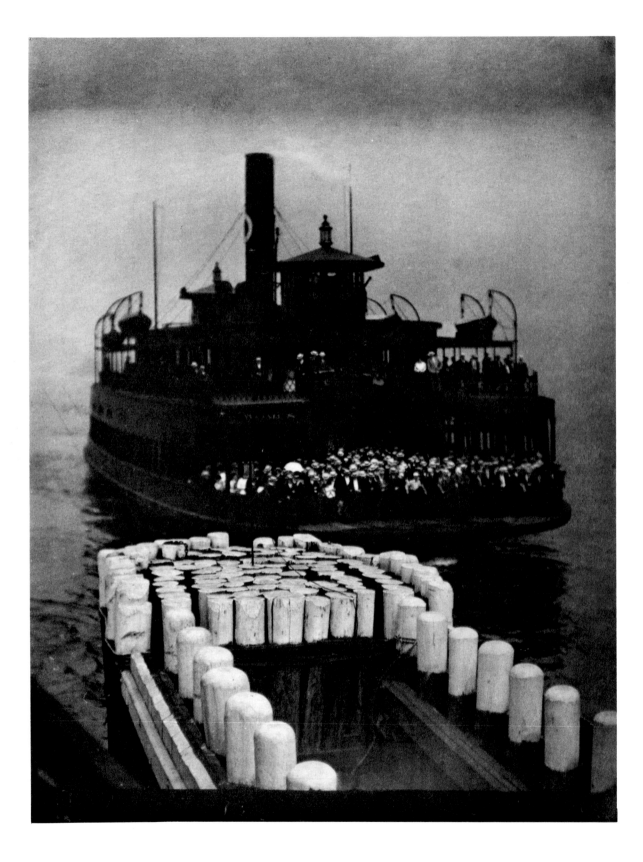

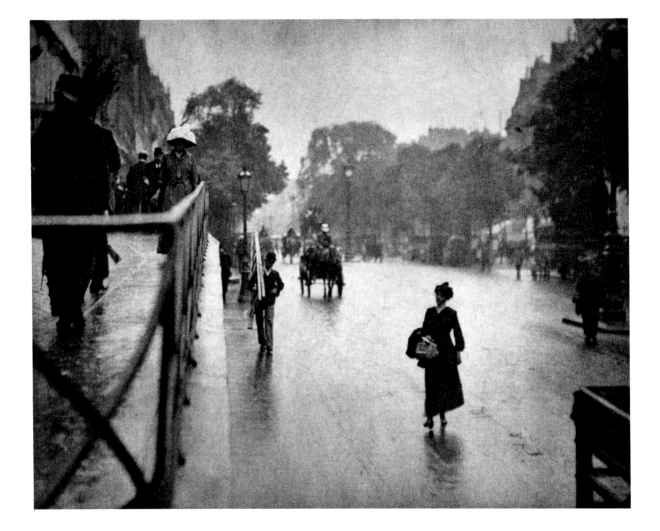

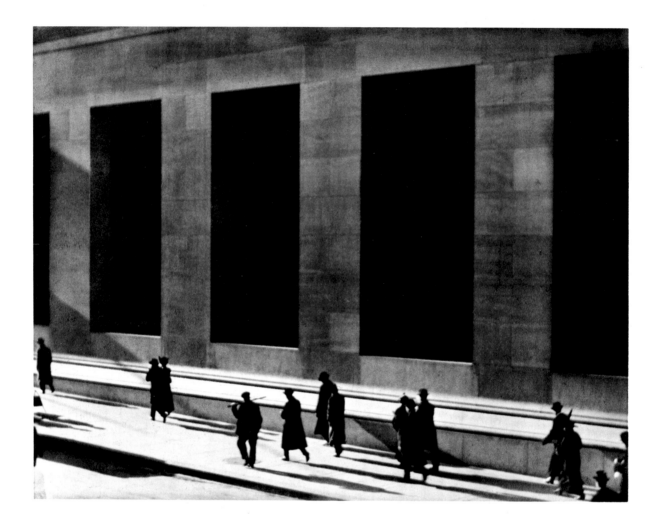

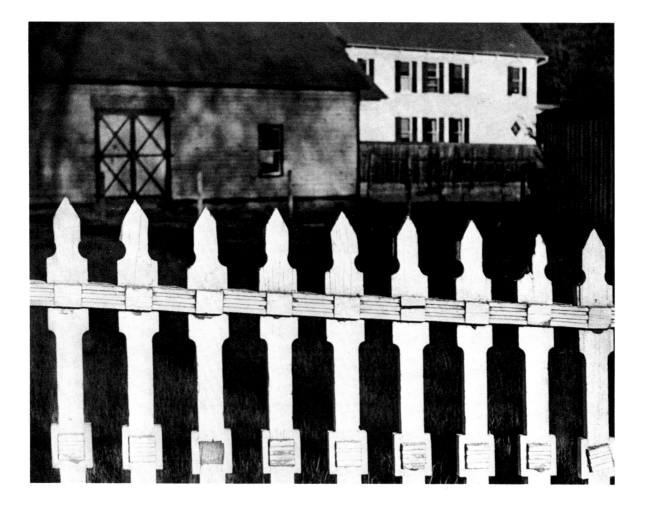

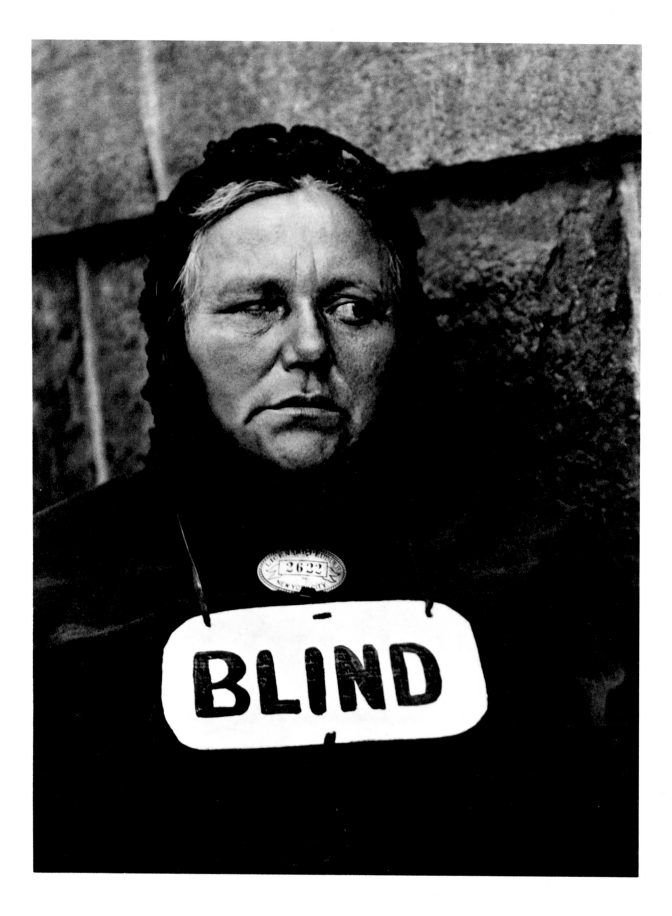

From *291* — July-August Number, 1915

New York, at first, did not see. Afterward she did not want to see. Like a circumspect young girl or a careful married woman, she has taken all possible precautions against assimilating the spirit of modern art; rejecting a seed that would have found a most fertile soil. All genuine American activities are entirely in accord with the spirit of modern art. But American intellectuality is a protective covering which prevents all conception. This intellectuality is borrowed, exotic. Better still, it is a paste diamond.

Beware, messieurs the Americans, of your intellectuals. They are dangerous counterfeits. They believe themselves to have a luminous mission; but their light dazzles the eyes instead of illuminating. They wish to impregnate you, believing themselves stallions when they are but geldings. They are not a product of their country. Their ideal does not reach beyond their personal interests.

The critics do not work to develop their knowledge, or to spread knowledge. They work for a salary.

The press has established a false notion of American life. It has succeeded in creating in the American people a fictitious need for a false art and a false literature. The press has in view but one thing: — profit.

The real American life is still unexpressed.

America remains to be discovered.

Stieglitz wanted to work this miracle.

He wanted to discover America. Also he wanted the Americans to discover themselves. But, in pursuing his object, he employed the shield of psychology and metaphysics. He has failed.

In order to attain living results, in order to create life — no shields!

Each manifestation of a progressing evolution must derive from an organism which has, itself, evolved. To believe that artistic evolution is indicated by artists copying Broadway girls instead of copying trees — is inane.

We have also moved on from the age of symbolism. It is only the day after that we believe in the orange blossoms of the bride.

Art is a white lie that is only lying when it is born of truth. And there is no other truth than objective truth. The others are but prejudices.

Stieglitz tried to discover America with prejudices.

He first, and he alone, has placed before New York the various foundation supports of the evolution of modern art.

He wished to work through suggestion.

But soon, commercialism brought an avalanche of paintings. Those lepers, those scullery maids of art, those Sudras of progress—the copyists, got busy. They even believed themselves to be part of the evolution because, instead of copying trees, they copied a method.

America remains to be discovered. And to do it there is but one way:—DISCOVER IT!

Stieglitz, at the head of a group which worked under the name of Photo-Secession, carried the Photography which we may call static to the highest degree of perfection. He worked in the American spirit. He married Man to Machinery and he obtained issue.

When he wanted to do the same with art, he imported works capable of serving as examples of modern thought plastically expressed. His intention was to have them used as supports for finding an expression of the conception of American life. He found against him open opposition and servile imitation. He did not succeed in bringing out the individualistic expression of the spirit of the community.

He has put the American art public to the test. He has fought to change *good taste* into *common sense*. But he has not succeeded in putting in motion the enormous mass of the inertia or this public's self-sufficiency. America has not the slightest conception of the value of the work accomplished by Stieglitz. Success, and success on a large scale, is the only thing that can make an impression on American mentality. Any effort, any tendency, which does not possess the radiation of advertising remains practically ignored.

America waits, inertly, for its own potentiality to be expressed in art.

In politics, in industry, in science, in commerce, in finance, in the popular theater, in architecture, in sport, in dress—from hat to shoes—the American has known how to get rid of European prejudices and has created his own laws in accordance with his own customs. But he has found himself powerless to do the same in art or in literature. For it is true that to express our character in art or in literature we must be absolutely conscious of ourselves or absolutely unconscious of ourselves. And American artists have always had before them an inner censorship formed by an exotic education. They do not see their surroundings at first hand. They do not understand their milieu.

In all times art has been the synthesis of the beliefs of peoples. In America this synthesis is an impossibility, because all beliefs exist here together. One lives here in a continuous change which makes impossible the perpetuation and the universality of an idea. History in the United States is impossible and mean-

ingless. One lives here in the present. In a continuous struggle to adapt oneself to the milieu. There are innumerable social groups which work to obtain general laws — moral regulations like police regulations. But no one observes them. Each individual remains isolated, struggling for his own physical and intellectual existence. In the United States there is no general sentiment in any sphere of thought.

America has the same complex mentality as the true modern artist. The same eternal sequence of emotions, and sensibility to surroundings. The same continual need of expressing itself in the present and for the present; with joy in action, and with indifference to "arriving." For it is in action that America, like the modern artist, finds its joy. The only difference is that America has not yet learned to amuse itself.

The inhabitants of the artistic world in America are cold-blooded animals. They live in an imaginary and hybrid atmosphere. They have the mentality of homosexuals. They are flowers of artificial breeding.

America does not feel for them even contempt.

Of all those who have come to conquer America, Picabia is the only one who has done as did Cortez. He has burned his ship behind him. He does not protect himself with any shield. He has married America like a man who is not afraid of consequences. He has obtained results. And he has brought these to "291" which accepts them as experience, and publishes them with the conviction that they have the positive value which all striving toward objective truth possesses.

<div align="right">M. De Zayas</div>

Epitaph for Alfred Stieglitz*

> Question not
> My soul's demise
> My friends consult
> The query is the answer.
> To my peace.

<div align="right">Marsden Hartley</div>

*From a letter to Alfred Stieglitz from Marsden Hartley, August 10, 1916: "I fancy if there is an epitaph ever one day it will read like this somewhat."

Photography*

PHOTOGRAPHY, which is the first and only important contribution thus far, of science to the arts, finds its raison d'être, like all media, in a complete uniqueness of means. This is an absolute unqualified objectivity. Unlike the other arts which are really anti-photographic, this objectivity is of the very essence of photography, its contribution and at the same time its limitation. And just as the majority of workers in other media have completely misunderstood the inherent qualities of their respective means, so photographers, with the possible exception of two or three, have had no conception of the photographic means. The full potential power of every medium is dependent upon the purity of its use, and all attempts at mixture end in such dead things as the color-etching, the photographic painting and in photography, the gum-print, oil-print, etc., in which the introduction of handwork and manipulation is merely the expression of an impotent desire to paint. It is this very lack of understanding and respect for their material, on the part of the photographers themselves which directly accounts for the consequent lack of respect on the part of the intelligent public and the notion that photography is but a poor excuse for an inability to do anything else.

The photographer's problem therefore, is to see clearly the limitations and at the same time the potential qualities of his medium, for it is precisely here that honesty no less than intensity of vision, is the prerequisite of a living expression. This means a real respect for the thing in front of him, expressed in terms of chiaroscuro (color and photography having nothing in common) through a range of almost infinite tonal values which lie beyond the skill of human hand. The fullest realization of this is accomplished without tricks of process or manipulation, through the use of straight photographic methods. It is in the organization of this objectivity that the photographer's point of view toward Life enters in, and where formal conception born of the emotions, the intellect, or of both, is as inevitably necessary for him, before an exposure is made, as for the painter, before he puts brush to canvas. The objects may be organized to express the causes of which they are the effects, or they may be used as abstract forms, to create an emotion unrelated to the objectivity as such. This organization is evolved either by movement of the camera in relation to the objects themselves or through their actual arrangement, but here, as in everything, the expression is simply the measure of a vision, shallow or profound as the case may be. Photography is only a new road from a different direction but moving toward the common goal, which is Life.

Notwithstanding the fact that the whole development of photography has been given to the world through CAMERA WORK in a form uniquely beautiful as well as perfect in conception and presentation, there is no real consciousness, even among photographers, of what has actually happened: namely, that America has really been expressed in terms of America without the outside

*Reprinted, with permission, from *Seven Arts*.

influence of Paris art schools or their dilute offspring here. This development extends over the comparatively short period of sixty years, and there was no real movement until the years between 1895 and 1910, at which time an intense rebirth of enthusiasm and energy manifested itself all over the world. Moreover, this renaissance found its highest esthetic achievement in America, where a small group of men and women worked with honest and sincere purpose, some instinctively and few consciously, but without any background of photographic or graphic formulae much less any cut and dried ideas of what is Art and what isn't; this innocence was their real strength. Everything they wanted to say, had to be worked out by their own experiments: it was born of actual living. In the same way the creators of our skyscrapers had to face the similar circumstance of no precedent, and it was through that very necessity of evolving a new form, both in architecture and photography that the resulting expression was vitalized. Where in any medium has the tremendous energy and potential power of New York been more fully realized than in the purely direct photographs of Stieglitz? Where a more subtle feeling which is the reverse of all this, the quiet simplicity of life in the American small town, so sensitively suggested in the early work of Clarence White? Where in painting, more originality and penetration of vision than in the portraits of Steichen, Käsebier and Frank Eugene? Others, too, have given beauty to the world but these workers, together with the great Scotchman, David Octavius Hill, whose portraits made in 1860 have never been surpassed, are the important creators of a living photographic tradition. They will be the masters no less for Europe than for America because by an intense interest in the life of which they were really a part, they reached through a national, to a universal expression. In spite of indifference, contempt and the assurance of little or no remuneration they went on, as others will do, even though their work seems doomed to a temporary obscurity. The things they do remains the same; it is a witness to the motive force that drives.

The existence of a medium, after all, is its absolute justification, if as so many seem to think, it needs one and all, comparison of potentialities is useless and irrelevant. Whether a watercolor is inferior to an oil, or whether a drawing, an etching, or a photograph is not as important as either, is inconsequent. To have to despise something in order to respect something else is a sign of impotence. Let us rather accept joyously and with gratitude everything through which the spirit of man seeks to an ever fuller and more intense self-realization.

PAUL STRAND

The Georgia O'Keeffe Drawings And Paintings at "291"

WHILE gladly welcoming new words into our vocabulary, words which intensify and increase our sense of the complexity of modern life, it is often quite impossible not to regret the lapse of older, simpler ones, especially as such lapse implies that the meaning and force of the words has also become obsolete. I am thinking, in this connection, of a phrase much loved by Lionel Johnson: *the old magnalities*, and I feel sure he used it so often in the hope that others would not willingly let it die. But I have met with it in no other modern writer. Is it because it no longer has significance for us? Have the old magnalities indeed crumbled to dust and ashes, together with all sense of the sublime, the worshipful, and the prophetic? Is it no longer good form, in this avid and impatient age, to mention the things that are God's? Must all tribute, then, go to Caesar? These reflections are forced upon the contemplative mind, and one must take counsel with one's own self in meeting them. And it is in so communing that the consciousness comes that one's self is other than oneself, is something larger, something almost tangibly universal, since it is en rapport with a wholeness in which one's separateness is, for the time, lost.

Some such consciousness, it seems to me, is active in the mystic and musical drawings of Georgia O'Keeffe. Here are emotional forms quite beyond the reach of conscious design, beyond the grasp of reason—yet strongly appealing to that apparently unanalyzable sensitivity in us through which we feel the grandeur and sublimity of life.

In recent years there have been many deliberate attempts to translate into line and color the *visual* effect of emotions aroused by music, and I am inclined to think they failed just because they were so deliberate. The setting down of such purely mental forms escapes the conscious hand—one must become, as it were, a channel, a willing medium, through which this visible music flows. And doubtless it more often comes from unheard melodies than from the listening to instruments—from that true music of the spheres referred to by the mystics of all ages. Quite sensibly, there is an inner law of harmony at work in the composition of these drawings and paintings by Miss O'Keeffe, and they are more truly inspired than any work I have seen; and although, as is frequently the case with "given writings" and religious "revelations," most are but fragments of vision, incompleted movements, yet even the least satisfactory of them has the *quality* of completeness—while in at least three instances the effect is of a quite cosmic grandeur. Of all things earthly, it is only in music that one finds any analogy to the emotional content of these drawings—to the gigantic, swirling rhythms, and the exquisite tendernesses so powerfully and sensitively rendered—and music is the condition towards which, according to Pater, all art constantly aspires. Well, plastic art, in the hands of Miss O'Keeffe, seems now to have approximated that.

WM. MURRELL FISHER

Our Illustrations

THIS number of CAMERA WORK is devoted entirely to the new work of Paul Strand. The last number too was devoted, in part, to Strand's photographs. In it we wrote:

"No photographs had been shown at '291' in the interim, primarily because '291' knew of no work outside of Paul Strand's which was worthy of '291.' None outside of his had been done by any new worker in the United States for some years, and as far as is our knowledge none had been done in Europe during that time. By new worker, we do not mean new picture-maker. New picture-makers happen every day, not only in photography, but also in painting. New picture-makers are notoriously nothing but imitators of the accepted; the best of them imitators of, possibly at one time, original workers. For ten years Strand quietly had been studying, constantly experimenting, keeping in close touch with all that is related to life in its fullest aspect; intimately related to the spirit of '291.' His work is rooted in the best traditions of photography. His vision is potential. His work is pure. It is direct. It does not rely upon tricks of process. In whatever he does there is applied intelligence. In the history of photography there are but few photographers who, from the point of view of expression, have really done work of any importance. And by importance we mean work that has some relatively lasting quality, that element which gives all art its real signficance."

The eleven photogravures in this number represent the real Strand. The man who has actually done something from within. The photographer who has added something to what has gone before. The work is brutally direct. Devoid of all flim-flam; devoid of trickery and of any "ism;" devoid of any attempt to mystify an ignorant public, including the photographers themselves. These photographs are the direct expression of today. We have reproduced them in all their brutality. We have cut out the use of the Japan tissue for these reproduction, not because of economy, but because the tissue proofs we made of them introduced a factor which destroyed the directness of Mr. Strand's expression. In their presentation we have intentionally emphasized the spirit of their brutal directness.

The eleven pictures represent the essence of Strand.

The original prints are 11 × 14.

Extract from a Letter*

". . . I have not received CAMERA WORK for a very long time, probably due to the war, censorship, etc., etc., . . . The older I grow the more I appreciate what you have accomplished with your very wonderful publication. When I see you I shall be delighted to tell you, how largely the possession of CAMERA WORK has helped me in my work as a teacher, and what an incentive it has always been to my pupils toward a higher standard. It does that for the man with the camera, what the Bible has, more or less vainly, for centuries, tried to do for the man with a conscience. . . .

FRANK EUGENE SMITH"

*Frank Eugene Smith, generally known as Frank Eugene, and who is an American, is Professor of Pictorial Photography at the Royal Fine Arts Academy, Graphic Department, in Leipzig, Germany. This letter was written on November 17, 1916, and was addressed to Alfred Stieglitz.

❡ ARE you interested in the deeper meaning of Photography?

❡ ARE you interested in the evolution of Photography as a medium of expression?

❡ ARE you interested in the meaning of "Modern Art"?

❡ ARE you interested in the meaning of "291"?

❡ ARE you interested in the Development and Exposition of a living Idea?

❡ ARE you interested in Freedom of Thought and Freedom in Expression?

❡ If you are interested in any of these, you will surely be interested in the Numbers of Camera Work so far published. Thus far forty-nine Regular Numbers and three Special Numbers have been issued.

❡ They contain unique reproductions of the work of Annan, Brigman, Coburn, Mrs. Cameron, Davison, De Meyer, Demachy, Eugene, Evans, Herbert G. French, Haviland, Henneberg, Hill, Hofmeisters, Käsebier, Keiley, Kuehn, Puyo, Le Bègue, Seeley, Mrs. Sears, Stieglitz, Steichen, Strand, White, Watzek, etc., etc.

Also reproductions of the work of Rodin, DeZayas, Matisse, Picasso, Gordon Craig, Marin, Manolo, Cézanne, Van Gogh, Picabia, Walkowitz, etc., etc.

❡ The text contains original articles by :

Maeterlinck, Shaw, De Casseres, Van Noppen, Steichen, Max Weber, Gertrude Stein, Temple Scott, Sadakichi Hartmann, Joseph T. Keiley, Dallett Fuguet, DeZayas, Mabel Dodge, Gabriele Buffet (Mme. Picabia), Maurice Aisen, Oscar Bluemner, John Weichsel, W. D. McColl, J. B. Kerfoot, Mrs. Wm. Sharp, Katharine N. Rhoades, Paul B. Haviland, Torres Palomar, Hutchins Hapgood, Hippolyte Havel, Agnes Ernst Meyer, Picabia, Wm. Murrell Fisher, Charles H. Caffin, etc., etc.

Footnotes to the Introduction

1 "English vs. American Amateurs," *American Amateur Photographer*, Vol. 2, No. 8 (August, 1890), p. 309.

2 "Valedictory," *Camera Notes*, Vol. 6, No. 1 (July, 1902), p. 4.

3 *Camera Notes*, Vol. 1, No. 1 (July, 1897), p. 3.

4 *Ibid.*

5 Robert Doty, *Photo Secession, Photography as a Fine Art*, Rochester, George Eastman House, 1960, p. 19.

6 Alfred Stieglitz, "An Apology," *Camera Work*, No. 1 (January, 1903), p. 16.

7 [Title Page], *Camera Work* No. 1 (January, 1903), p. 1.

8 Paul Rosenfeld, "The Boy in the Dark Room," *America and Alfred Stieglitz*, Waldo Frank, Lewis Mumford, Dorothy Norman, Paul Rosenfeld, Harold Rugg, eds. New York, Doubleday, Doran & Company, Inc., 1934, p. 83.

9 Sidney Allan [Sadakichi Hartmann], "A Visit to Steichen's Studio," *Camera Work*, No. 2 (April, 1903), p. 27 & p. 25.

10 Paul Rosenfeld, "The Boy in the Dark Room," p. 82.

11 [Alfred Stieglitz], "The Editors' Page," *Camera Work*, No. 18 (April, 1907), p. 37.

12 Eduard Steichen, "291," *Camera Work*, No. 47 (dated July, 1914, published January, 1915), p. 66.

13 J. E. Chamberlin, *Camera Work*, No. 22 (July, 1908), p. 11. Reprinted review from the *New York Evening Mail*.

14 W. B. McCormick, *Camera Work*, No. 22 (July, 1908), p. 40. Reprinted review from the *Press*.

15 [Alfred Stieglitz], "Henri Matisse at the Little Galleries," *Camera Work*, No. 23 (July, 1908), p. 10.

16 Charles H. Caffin, "Is Herzog Also Among the Prophets?" *Camera Work*, No. 17 (January, 1907), p. 21 & p. 22.

17 S[adakichi] H[artmann], "Puritanism, Its Grandeur and Shame," *Camera Work*, No. 32 (October, 1910), p. 19.

18 "The Exhibition at the Albright Gallery—Some Facts, Figures, and Notes," *Camera Work*, No. 33 (January, 1911), p. 61.

19 "Unphotographic Paint—The Texture of Impressionism," *Camera Work*, No. 28 (October, 1909), p. 23.

20 "Paintings by Young Americans," *Camera Work*, No. 30 (April, 1910), p. 54.

21 Maurice Aisen, "The Latest Evolution in Art and Picabia," *Camera Work*, Special Number (June, 1913), p. 15.

22 Alfred Stieglitz, Unpublished Letter, April 30, 1914, Stieglitz Archive, Collection of American Literature, Yale University Library, quoted from Doty, p. 63.

23 Alfred Stieglitz, *Camera Work*, No. 47 (dated July, 1914, published January, 1915), p. 4.

24 Eduard Steichen, "291," *Camera Work*, No. 47, p. 66. See Also Edward Steichen, *A Life In Photography*, "World War I and Voulangis," Garden City, New York, Doubleday and Company, 1961.

25 Samuel Green, *American Art, a Historical Survey*, New York, The Ronald Press Company, 1966, p. 622.

26 The distinction is of course between photography as document and record and photography as personal expression. A book of photographs *Paris under the Commune* (1872?) is subtitled "By a Faithful Witness, Photography." Oliver Wendell Holmes called the daguerreotype "the mirror with a memory." See Beaumont Newhall, *The History of Photography*, New York, 1964, p. 71 and p. 22. Samuel F. B. Morse published a letter in the *New York Observer* in March, 1839, in which he calls the daguerreotype "Rembrandt perfected." See Robert Taft, *Photography and the American Scene*, New York, 1938, (Dover Edition, New York, 1964, p. 12).

27 For discussion of similar attitudes in early French photography, see "French Primitive Photography," *Aperture*, Vol. 15, No. 1 (Spring, 1970).

28 Edward Weston, "What Is Photographic Beauty?" *Camera Craft*, Vol. 46 (1939), p. 254.

29 Alfred Stieglitz, "The Joint Exhibition at Philadelphia," *American Amateur Photographer*, Vol. 5, No. 4 (April, 1893), p. 203.

30 Sidney Allan [Sadakichi Hartmann], "A Visit to Steichen's Studio," *Camera Work*, No. 2, p. 28.

31 Marius De Zayas, "Photography and Artistic-Photography," *Camera Work*, No. 42/43 (April–July, 1913), p. 14.

32 See *The Persistence of Vision*, Rochester, New York, George Eastman House, 1967.

33 S[adakichi] H[artmann], "On the Possibility of New Laws of Composition," *Camera Work*, No. 30 (April, 1910), p. 24.

34 "Unphotographic Paint—The Texture of Impressionism," *Camera Work*, No. 28, p. 23.

35 Marius De Zayas, "Photography and Artistic-Photography," *Camera Work*, No. 42/43, p. 14 & p. 13.

36 [Alfred Stieglitz], "Our Illustrations," *Camera Work*, No. 49/50 (June, 1917), p. 36.

37 Paul Strand, "Photography," *Camera Work*, No. 49/50 (June, 1917), p. 3. Reprinted from *Seven Arts*.

38 Frank Eugene Smith, "Extract from a Letter," *Camera Work*, No. 49/50 (June, 1917), p. 36.

Biographies

The following biographies include every artist, author, and photographer who have articles or plates in this Anthology except for those individuals whose writing appears only in number 47. A brief comment on these individuals may be found in the anthologized *Contributors* section of that issue, pages 285–286.

J. Craig Annan was born in 1864 the son of Thomas Annan, professional photographer in Glasgow. Annan was trained in his father's studio and like his father became one of the leading creative photographers in Scotland. Through his efforts the work of Hill and Adamson was rediscovered and presented around the turn of the century. Annan was a member of the Linked Ring and the first president of the International Society of Pictorial Photographers. His best work anticipates the decisive moment esthetic in which an actual event is given formality and meaning by the strength of the visual organization. His work was greatly respected by Stieglitz who published his gravures in *Camera Work* for almost the entire life of the quarterly. Annan died at his home at Lenzie near Glasgow in 1946.

Peyton Boswell was born in Wolf Creek, Illinois, in 1879. His early contact with journalism was as a reporter for the *Springfield State Journal* in 1903 and as police reporter for the *Chicago Chronicle* for the next several years. Boswell came to New York in 1910 and soon became the art critic for the *Herald*. In reviewing the Armory Show of 1913 he made the famous remark that Duchamp's "Nude Descending a Staircase" reminded him of a "cyclone in a shingle factory." In another review of the same year he described the foreground of one of Marin's paintings as being "in the condition of scrambled eggs." Boswell's flippant conservatism was representative of the journalistic level of criticism that pervaded the majority of newspapers at the time. In the early twenties he purchased the *Art News* and the *International Studio* and in 1926 he became the publisher and founder of the *Art Digest*. Boswell operated a large vineyard at his Hopewell home and he is the author of a "Wine Maker's Manual." He died in 1936.

Anne Brigman a member of the Photo-Secession was born in Honolulu, Hawaii, in 1869. By the turn of the century she has settled in the San Francisco area and had won praise and some notoriety for her revolutionary studies of the female nude in natural surroundings. A fervent feminist she separated from her husband to "work out my destiny," and she vigorously championed women's rights and equality. Her nude studies used her friends with whom she would climb in the High Sierras. She was an actress as well as photographer. Anne Brigman was an early member of the Secession but she did not meet Stieglitz until 1909 when she spent eight months in New York. In 1949 she published *Songs of the Pagan*, a group of 35 poems illustrated with an equal number of her photographs. She died in California in 1950.

Charles Henry Caffin was born in Sittingbourne, Kent, England, in 1854. After graduating from Magdalen College, Oxford, he worked in the theater for six years. In 1892 he emigrated to the United States, where he was employed in the decoration department of the Chicago World Columbian Exposition of 1893. He first became acquainted with photography when he wrote a review of the Philadelphia Salon of 1898 for *Harper's Weekly*. After this date he came strongly under the influence of Stieglitz, who in turn greatly admired his criticism. In 1901 he wrote *Photography as a Fine Art*, the first extensive examination of American expressive photography, a book that continues to have relevance into our own time. Together with Sadakichi Hartmann, Caffin was one of the earliest apologists for modernism in America. He wrote articles on art and photography for *Cosmopolitan, St. Nicholas Magazine, the New York Sun, the New York Evening Post* and the *New York American*. He was the American editor of *The Studio*. Among Caffin's other books are *American Masters of Painting, American Masters of Sculpture, How to Study Pictures,* and *The Story of American Painting*. He died in New York City in 1918.

Julia Margaret Cameron was born in Calcutta in 1815 the daughter of an English father and a French mother. In 1838 she married Charles Hay Cameron, a distinguished jurist and member of the Supreme Council of India. When Cameron retired to England in 1848 their house became a center of intellectual society. In 1860 at the age of forty-eight Mrs. Cameron was given a camera. At the Cameron house at Freshwater, Isle of Wight, she taught herself photography and soon was photographing many of her distinguished friends. Many of the most illustrious individuals of the Victorian age sat before her camera: these included Browning, Carlyle, Darwin, Herschel, Longfellow, Tennyson, Dame Ellen Terry, and George Fredrick Watts. Mrs. Cameron gave her calotypes an originality and intensity that often reveals the essence of the individual who sat before her camera. Rarely in the history of art had so much vitality been brought to portraiture. At Tennyson's request she made twenty-four illustrations for *Idylls of the King*. These were published in two volumes in 1874 and 1875. Mrs. Cameron sold her portraits and illustrations at P. & D. Colnaghi, the London printsellers, and though they were not favored by the photographers of her day they were greatly admired by the artists. In 1875 the Camerons went to live on their coffee estate in Ceylon. There Mrs. Cameron continued to photograph the local people. She died at Kalatura, Ceylon, in 1879.

Elizabeth Luther Cary, author and art critic, was born in 1867 of Quaker and New England stock. Her father was editor of the *Brooklyn Union* and later joined the editorial staff of the *New York Times*. Elizabeth was educated at home by her father and began her literary career by translating several French non-fiction works into English. Between 1898 and 1907 she wrote an extensive popular series of books on major figures including Tennyson, Browning, the Rossettis, Emerson, Henry James, Blake, Whistler, and Daumier. In 1905 she began her own art journal, the *Script*. The success of this modest monthly led her to be invited to join the *Times* as the first staff member to be assigned exclusively to art criticism. For a quarter of a century she was a constant contributor to the *Times*. Rather conservative by education and inclination, she nevertheless was receptive to much of the new art. Her criticism tended to steer a middle course and was guided by a deep sense of Victorian spiritual and moral values. She died in 1936 and her obituary in the *Times* called her critical approach one of "unfailing kindliness."

Joseph Edgar Chamberlain, art critic for the *New York Evening Mail* around the turn of the century, tended to see himself as a genial guardian of public taste. He directed his column to the "average Jersey commuter," the "ordinary observer," and the "ordinary mind." His writings acknowledged that something was happening in the art world and he was determined to pave a safe path for his middle-of-the-road readership. Chamberlain early acknowledged the possibilities of expressive photography, yet he was basically opposed to the abstract and the ugly in art. He accepted Rodin but not Matisse—though he eventually changed his mind about the latter. He enjoyed Marin but not Maurer, Hartley or Walkowitz. He cautioned his readers that they would be shocked by Toulouse-Lautrec's subject matter and he decried Weber as being possessed by insane obsessions. His criticism was frequently reprinted in *Camera Work*. More than twenty-five excerpts from his articles were reprinted between 1908 and 1917.

Alvin Langdon Coburn was born in Bos-

ton in 1882. He was introduced to photography by his cousin, the prominent pictorial photographer F. Holland Day, with whom he traveled to Europe in 1900. Coburn first exhibited that year at the London Salon. In 1902 he became a founding member of the Photo-Secession and the next year he was elected to the Linked Ring. In 1904 his first portfolio appeared in *Camera Work* and he went to London where he began a lifelong friendship with George Bernard Shaw. In 1906 he had his first one-man exhibition at the Royal Photographic Society and began a collaboration with Henry James for whom he illustrated *Novels and Tales* in 1909. In 1910 he began a series of books illustrated with hand-pulled photogravures: *New York*, 1910; *London*, 1914; *Men of Mark*, 1913; and *More Men of Mark*, 1922.

Strongly influenced by the Cubists, Coburn began experiments with abstraction in photography. In 1917 he exhibited his Vortographs which were made using three mirrors fastened together which fractured the image in kaleidoscopic fashion. Ezra Pound, whom he had met in 1913, wrote the essay to the catalogue for this exhibition. Coburn later had another Royal Photographic exhibition and was elected Honorary Fellow in the Royal Photographic Society.

In 1919 he began to investigate the mysteries of nature and science through the agencies of Freemasonry, Christianity and Zen Buddhism. In 1932 he became a naturalized British subject. His photographic output was limited until the midfifties when he again made pictures that are notable for their serenity. He died in 1966 in North Wales where he had lived since 1919.

Edward Gordon Craig, English actor, producer, stage designer, and theoretician, was the son of Edward Godwin, an architect, and the actress Ellen Terry. He was born in Hertfordshire in 1872. He began his career as an actor in 1889. By the turn of the century he was designing sets and costumes and producing plays. In 1904 he went to Germany and then in 1906 to Italy where he settled for some time. There he made the copperplate engravings that illustrated his first researches into theatrical ideas. It was from these engravings that Steichen chose the first American showing of Craig's work for 1910. Craig founded and edited his international review, *The Mask*, in 1908. In 1913 he wrote *Towards a New Theatre* which contains forty plates of original scenic designs. In 1929 his work as an engraver reached its peak in the illustrations for the Cranach Press *Hamlet*. Craig aimed to restore to the theater the dignity of an independent art form. His concept of the theater as a unified esthetic experience has profoundly influenced the development of the art of the theater in

the twentieth century. He died in Southern France in 1966.

George Davison, an English civil servant and amateur photographer, was born in 1856. He was strongly influenced by Emerson's naturalistic photography which he carried to an extreme when he founded, in 1890, the impressionistic school of photography. Davison was a founding member of the Linked Ring. In 1898 he became the managing director of Kodak, Ltd., a position he was forced to resign fourteen years later when Kodak learned he was involved in anarchistic activities. His home in Harlech was headquarters of the movement. Davison died at his winter home in Antibes in 1930.

Benjamin De Casseres, a descendant of Spinoza, was born in Philadelphia in 1873. He left school at the age of thirteen to work on Philadelphia newspapers where he began as a proofreader. In 1899 he moved to New York where he slowly moved from proofreader to literary critic for the *New York Herald*. In 1906 he went to Mexico City where he founded and edited *El Diario*. Back in New York he contributed book reviews to the *Sun*, the *Times*, the *Bookman*, Mencken's *American Mercury*, and other publications. From 1922 to 1933 De Casseres was drama critic for *Arts and Decorations* and after 1933 he wrote a column, the "March of Events," for the Hearst papers. De Casseres also contributed drama criticism to several motion picture magazines and served for one year on the staff of Universal Pictures. Over the years he published many volumes of essays, a book of poetry, and several biographies. These were all collected into three volumes in 1939. De Casseres was a brilliant social critic. He felt the lack of true culture in the U.S. and his writings set the groundwork for later systematic criticism of American sensibility. Yet his writings were dated for he saw the world through the eyes of a nineteenth century decadent who relished the irrational and emotional. Stieglitz was strongly drawn to De Casseres' panegyric style which was laced with irony, aphorism, and epigraphs. Almost every issue of *Camera Work* published between 1909 and 1913 contained one, sometimes two, of De Casseres' unbridled pieces. Yet early in 1915 Stieglitz wrote to De Casseres that his theories were becoming anarchic: "You have lost touch with what is really going on at '291' and in *Camera Work*. I have some of your MSS still on hand unused. I know I shall never be able to use them, as they don't fit into what I am doing, or trying to do." De Casseres died in 1945.

Charles De Kay, author and critic, was born in Washington in 1848. He graduated from Yale in 1876 and soon became associated with the *New York Times* where

he became the literature and art editor. In 1894 he left the *Times* for three years to become the American Consul General at Berlin. He later became associate editor of *Art World* and a member of the National Institute of Arts and Letters. His assessments of photography and modern art were very guarded in tone and almost always flippant in style. De Kay was the author of several books of poetry and a study of the life and work of Louis Tiffany. He died in 1935.

Robert Demachy, a Paris banker, amateur painter, and prominent amateur photographer was born in 1859. In his youth he was deeply interested in cars and music, both of which became subjects of his later photography. Demachy, who was elected to the Societe Francais de Photographie in 1882, began to work with gum printing in 1894. By 1896 he had become the foremost exponent of the gum print and had popularized the medium. His work consisted mainly of portraits and landscapes in the impressionist style. In 1905 he was elected to the English Linked Ring and began work on the oil process. By 1911 he had perfected the modern transfer method for oil printing. Demachy was a founder of the Photo-Club de Paris and the leader of the esthetic movement in photography in France. With Alfred Maskell he published *The Photo-Aquatint or the Gum Bichromate Process* in 1897 and with C. Puyo, *Les Procedes d'Art en Photographie* in 1906. He also wrote more than a thousand articles on the esthetics and techniques of the manipulated print. Demachy ceased photographic activity at the outbreak of World War I. He died in 1937.

Baron Adolph De Meyer was born of a Jewish father and a Scottish mother. By the time he was a young man he had amassed a small fortune and had established a considerable circle of connections in English high society which included Edward, Prince of Wales, soon King Edward VII. About 1901 he married Donna Olga Alberta Caraccio, one of the most beautiful and elegant women of her day, the subject of many famous painters and authors including Whistler, Beardsley, Degas, Proust, and James, and the goddaughter (reportedly the illegitimate daughter) of the King. The rank of Baron was conferred upon De Meyer by the King of Saxony in order that he and Olga could attend Edward's coronation. After Edward's death in 1910 the Baron and the Baroness spent a great deal of time in Venice where they had a palace and where Marchesa Casati—the subject of one of De Meyer's finest portraits—reigned over high society. They also followed the Ballet Russe in season, De Meyer making his famous photographs of Nijinsky at this time. Because of his Saxony title, at the outbreak of World War I in

335

1914, De Meyer had to chose between deportation or internment in an English camp. He decided to go to America, where his connections in high society helped him secure photographic work with Conde Nast. He became the first great fashion photographer. His success was based on his familiarity with the fashionable world, his talent as an ornate and exotic interior decorator, and his exquisite taste. His personal flamboyance—he wore outlandish Edwardian costumes, slept under a blanket of mink, and protected his blue-dyed hair with a net while photographing—also heightened his sophisticated image. To be chosen as a model by the man who had photographed all of the most famous European beauties became a certificate of elegance for some American women. After the armistice, De Meyer went back to Paris where he became friends with Jean Cocteau, Rene Crevel and Stravinsky. He continued to go to New York every winter for his work. The Baroness died in 1929 after spending her last days drugged, yet chic, on opium and cocaine. De Meyer then went to live in Hollywood where he died, forgotten and in modest circumstances, in 1946.

Marius De Zayas was born at Vera Cruz, Mexico, of a Spanish family in 1880. His father was a well known Mexican poet. De Zayas settled in New York in 1907 and soon became part of the Stieglitz circle. During this time he worked as a caricaturist for the *New York World* and wrote essays on modern art and African Art for *Camera Work* and other publications. From 1910 through 1914, De Zayas spent long periods in Paris scouting for new art and making contact with the avant-garde painters. Together with Steichen, he helped find material for "291." De Zayas made the selection of works for the Picasso exhibition of 1911 and helped obtain the Braque paintings in 1914. The "291" exhibition of African sculpture was assembled from his own collection. In 1913 he co-authored with Paul Haviland *A Study of the Modern Evolution of Plastic Form*, and in 1916 he wrote *African Negro Art: Its Influence on Modern Art*. In 1914 he also illustrated with caricatures *Vaudeville* a book by Caroline Caffin, Charles Caffin's wife. Between 1915 and 1916 he was one of the editors of the publication *291*. In 1915 De Zayas together with Agnes Ernst Meyer, Paul Haviland, and Francis Picabia established The Modern Gallery, a commercial offshoot of "291." When the gallery closed in 1918, De Zayas opened his own gallery where he continued Stieglitz's tradition of showing West European and primitive art. This, too, was short lived closing in 1921. Throughout the twenties he continued to organize exhibitions for other galleries in New York City and began to build up a substantial private collection. This collection contained

work by the "291" group as well as Whistler, Daumier, Delacroix, Degas, Cezanne, and Braque. It was sold after his death at the Parke-Bernet Gallery. He devoted the remainder of his life to painting, writing, musicology, and film making. He died in 1961.

Frank Eugene was born in New York in 1865. He studied at the City College of New York. After 1886 he attended the Royal Bavarian Academy of Fine Arts in Munich. He moved to Germany in 1906. Here he became a recognized painter and was associated with such artists as Willi Geiger. His style may be related to Jugendstil, the South German and Austrian counterpart of Art Nouveau. Eugene first turned to photography for recreation. Yet as his photography developed he won wide respect as a teacher. About 1913 the Royal Academy of the Graphic Arts at Leipzig created a special chair in photography and appointed him Royal Professor of Pictorial Photography, the first academic recognition of this stature for photography in the world. Eugene died in 1936.

Frederick Henry Evans was born in 1852. He was a bookseller in London until 1898 when he retired to devote his full time to photography. From about 1895 he took portraits of a number of literary and artistic friends including Aubrey Beardsley, whom he launched on his career as an illustrator; William Morris for whom he photographed Kelmscott Manor; and George Bernard Shaw, a close friend, who staged for him a special camera performance of "Mrs. Warren's Profession." Evans was the foremost architectural photographer of his day. He began to photograph English cathedrals in 1896 and he also photographed many of the famous French chateaus and cathedrals. Evans was a member of the Linked Ring and an innovator in exhibition presentation. He was the first Englishman to depart from the floor to ceiling presentation concept and display prints singly in their own environment. He was a vocal defender of pure technique and the "straightest of straight" photography. A master of the platinum print, he gave up photography when platinum paper became unobtainable after World War I. Evans was the first English photographer to become well known in America, exhibiting 120 prints in Boston in 1897, publishing in *Camera Work* in 1903, and exhibiting at the Little Galleries in 1906. Evans died two days before his 91st birthday at his home at Acton, London.

Charles Fitzgerald was one of the three art critics for the *New York Sun*. With Henry McBride and Samuel Swift, he was largely sympathetic to the new art. Fitzgerald was a close friend of Frederick J. Gregg, former editor of the *Sun* and a

prime mover of the Armory Show. Fitzgerald was one of the first to defend the Ashcan painters, though his views on some of the more radical art was at times equivocal. As early as 1904 he was involved in evaluating the methods of pictorial photography. He was one of the first critics to decry the mannerisms of the pictorialists and attempt to describe the nature of a straight approach. Fitzgerald was the first critic to be reprinted in *Camera Work*. In 1904 Stieglitz asked him to review Steichen's paintings at Glaenzer's. Fitzgerald reviewed the show with a great deal of dignity and candor. Uninfluenced by the fact that the review was to appear in *Camera Work*, he announced that he could not find great promise or profound meaning in either Steichen's paintings or photographs. Indeed, Fitzgerald never really became convinced that the camera could become an expressive tool. Stieglitz and Fitzgerald carried on a long and often bitter debate in print about the merits of pictorial photography and the new art. Issue 36 of *Camera Work* reprinted Fitzgerald's stinging yet challenging condemnation of Marius De Zayas' essay on Picasso. Though he could not fully agree with Fitzgerald, Stieglitz admired his writing: "In these degenerate days an art critic who can reason logically is no common bird." More than any other critic outside the "291" group, Fitzgerald helped force the careful definition and articulation of the new esthetic in art and photography.

Dallett Fuguet was associate editor of *Camera Work* throughout all of its publication. He had previously worked with Stieglitz on *Camera Notes*. Very little is known about his personal or professional life. Two of his poems "Blithe Mask" and Silver Linings" were collected in the anthology *Poems of Inspiration* in 1940.

Hutchins Hapgood, the author and critic, was born in Chicago in 1869. He received degrees from Harvard in 1892 and 1897, and later taught English composition at Harvard and Chicago. After serving for a short time as the drama critic for the *Chicago Evening Post*, he came to New York around 1905 where he soon became a leader in liberal literary circles. Hapgood was associate editor of the *New York Globe* and also contributed frequent articles to the *Post* and the *Press*. He was among the first to explore the artistic and literary riches of New York's East Side and he helped generate the Greenwich Village tradition. Hapgood spent his summers in Provincetown where he helped organize the Provincetown Theater and the Provincetown Players. The first plays of this group were given in his cottage in 1915. A man of strong social conscience, and an acquaintance of Stieglitz as well as Dreiser, O'Neill, and Gertrude Stein, he presented his moral and social philosophy in a series of books which included *The Spirit*

of the Ghetto (1902), *The Autobiography of a Thief* (1903), *The Spirit of Labor* (1907), *The Anarchist Woman* (1909), and *Types from City Streets* (1910). In 1939 he published his autobiography, *A Victorian in the Modern World*. Hapgood was a vocal champion of "life forces" and a defender of the "insurgent and the unconventional . . . the unacademic, untraditional, personal." While he did not immediately support all the new artists, he vigorously defended the work of "291" and the concept of the Armory Show. Hapgood took it as his personal task to refute the conservative criticism of Kenyon Cox, one of the most articulate supporters of academic art. Hapgood died in 1944 at his Provincetown home.

Marsden Hartley, the poet and painter, was born in Lewiston, Maine, in 1887. He studied art in Cleveland and New York and then returned to Maine. He met Stieglitz during a visit to New York in 1909, and had his first one-man show at "291" later that year. Influenced by what he saw at "291" and with the financial help of Stieglitz and Arthur B. Davis he was able to leave for Paris, finally settling in Germany to paint in Munich, Berlin and Dresden. He returned to the United States during the war, but soon grew restless and spent the years until 1934 traveling widely in Europe, Mexico, and the States. During this time Stieglitz frequently showed his paintings. In 1934 he came home to his native Maine where he spent the summers of the last nine years of his life. Hartley's early work was greatly influenced by Albert Pinkham Ryder, whose massive clouds stayed for good in Hartley's skies. After his contact with Cubism, his work contained bold patterns which became increasingly linear and massive. After World War I he developed a very personalized representational style to interpret the rugged landscape of New Mexico and New England. Beginning in the 1940's his drawings contained a profound, religious direction. Hartley was the author of *Adventures in the Arts* and *25 Poems* as well as numerous poems and essays. As Dove, Marin and O'Keeffe, he remained close to Stieglitz throughout his life.

Sadakichi Hartmann (Sidney Allan), is one of the most formidable yet obscure figures in the history of twentieth century arts and letters. Hartmann, the son of an affluent German trader and a Japanese mother, was born in Nagasaki about 1867 and received his early education in Hamburg and Kiel. After running away to Paris, his angered father disinherited him, shipping the young boy off to an uncle in America. Here he worked in printing and engraving shops by day and studied art and literature at the Philadelphia Mercantile Library at night. He visited with Walt Whitman at Camden and occasionally translated German correspondence for the aged poet. During the late 1880's Hartmann made four summer trips to Europe where he met many of the leading men of the arts: Liszt, Ibsen, Swinburne, the Rossettis, and Mallarmé. At this time Hartmann began his literary career, writing for various Philadelphia and Boston newspapers, attempting and failing to introduce Ibsen into the States, and producing his symbolist drama *Christ* for which he was arrested in Boston and spent Christmas week in the Charles Street Jail in 1893. That same year Hartmann launched a magazine, *Art Critic*, the first avant-garde publication in the States. But the magazine soon failed, for Hartmann ranged too far ahead of his time. From 1898 to 1902 he worked as a journalist and began writing numerous articles on pictorial photography. Stieglitz recognized Hartmann's perspicuity and encouraged him to contribute first to *Camera Notes* and then to *Camera Work* where he wrote incisive comments on modern art and American society. Throughout his life Hartmann remained involved with art and experimentation. In 1897 he drafted a script for the first psychedelic light show. In 1901 he wrote *The History of American Art* which served as a standard textbook for many years. In 1902 he held the first perfume concert in New York. In 1915 he was hailed as the unchallenged King of Greenwich Village, the archetypal Bohemian. In the 1920's due to steadily deteriorating health, Hartmann moved to California where he became part of John Barrymore's Hollywood circle. Here he was unsuccessful as a motion picture scriptwriter, yet he acted in a bit part in "The Thief of Bagdad" and wrote *The Last Thirty Days of Christ*, a book highly praised by Ezra Pound. In the last six years of his life, hounded by FBI agents inquiring into his Japanese-German background, Hartmann retreated to the Morongo Indian Reservation in Banning, California. He died in 1944.

Paul Burty Haviland was born in Paris in 1880 the son of Charles Haviland of Haviland & Co., china manufacturers of Limoges, France, and Madeleine Burty, daughter of Phillippe Burty, a well-known French art critic. He received a bachelor's degree from the University of Paris in 1898 and an A.B. from Harvard in 1901. After graduating from Harvard, Haviland moved to New York where he became the American representative for Haviland & Co. He first met Stieglitz around 1907. In 1908 when "291" was forced to move across the hall because of increased rent, Haviland guaranteed a three-year lease for the new reduced quarters. By 1909 he had become very active at "291," acting in part as the gallery's secretary, contributing articles on the exhibitions to *Camera Work*, translating statements of the French artists for exhibition catalogues, and working on his own photography. In 1910 he became an associate editor of *Camera Work* and was influential—with the help of his brother, Frank Burty, De Zayas, and Steichen—in obtaining some of the French Post-Impressionist work for the gallery. In 1913 he co-authored with De Zayas *A Study of the Modern Evolution of Plastic Expression*, one of the first extended essays on the new art. In 1915–1916, under Stieglitz's sponsorship, with De Zayas, Agnes Ernst Meyer, and occasional help from Picabia, he edited the new provocative publication *291*. During World War I, Haviland returned to Limoges. Later in life he operated his own farm at Yzeures-Sur-Creuse. He died in 1950.

Hugo Henneberg was born in 1863 and died in 1918. Henneberg worked in Austria along with Kühn and Watzek. In 1891 they organized their first exhibition and called their association the "Viennese Triforium." By 1895 they became affiliated with the Linked Ring. Henneberg's subjects were landscapes and he made his prints largely by the gum-bichromate process.

Felix Benedict Herzog was an inventor and artist. He graduated from Columbia University. He invented numerous electrical devices including improvements for telephone switchboards and police and fire call boxes. He maintained a painter's studio in New York City and was president of the Herzog Telephone Co. He died in 1921.

David Octavius Hill, the son of a stationer and bookseller in Perth, Scotland, was born in 1802. As a youth he learned the new technique of lithography and his *Sketches of Scenery in Perthshire Drawn from Nature and on Stone* of 1821 is one of the earliest British publications in the medium. Hill spent most of his life as a painter. He exhibited his paintings at the Institution for the Encouragement of the Fine Arts in Scotland and at the Royal Scottish Academy—of which he was a founder and secretary for forty years—and at the Royal Academy in London. In 1843 Hill turned to photography as an aid in painting a large portrait study to commemorate the resignation of 474 ministers from the Church of Scotland. Having no previous photographic training he entered into partnership with the calotypist Robert Adamson who had shortly before opened a studio in Edinburgh. At Rock House, Calton Hill, they photographed many distinguished people in addition to the ministers. They also took their camera to seashore villages and photographed fishing boats, sailors, and picturesque fisherman. The enormous painting, "The

Signing of the Deed of Demission," which led Hill into photography was not completed until 1866, four years before his death. Adamson apparently played a great part in their collaboration, for when he died in 1848, Hill ceased to make photographs until he again found a collaborator and his later pictures do not compare with the early work. During Hill and Adamson's collaboration over 1,500 magnificent pictures were produced. However, when Hill died neither newspapers nor art journals referred to his photographic work. It was not until the turn of the century that his work was rescued from oblivion by J. Craig Annan, the leading Scottish photographer, whose father had been a friend of Hill. In his haste to glorify the painter, Annan lost sight of Adamson and it was not until later in the century that the work was acknowledged as a joint effort.

Theodor and **Oskar Hofmeister** were brothers born in the 1860's in Hamburg. Theodor worked as a wholesale merchant in door handles and Oskar as secretary of the county court. In 1895 they became amateur photographers and produced their first exhibition the following year. Their work was soon discovered and encouraged by the Hamburg art patron and collector, Ernst Juhl. In 1896 they exhibited their first carbon pigment prints and from 1897 they worked primarily with the gum-bichromate process. In 1898 Theodor published two booklets on printing technique. Their photographs were of landscapes, fishermen, and seashore scenes. Up until 1914 they were the center of the Hamburg School and Germany's most prominent exhibitors. Oscar died in 1937 and Theodor six years later.

James G. Huneker was born in 1860 in Philadelphia. He studied piano at the Paris Conservatoire and later taught piano at the National Conservatory in New York. He was well known as "critic of the seven arts." He wrote music, drama, art and literature criticism for the *New York Recorder*, the *Sun*, the *Times* and the *World*. In art he was a defender of Henri and the Realists and was generally warm to the experiments of the modernists, though he never thoroughly understood the revolution in art that was taking place. Occasionally a commentator on photography, as early as 1902 he took notice of Eduard Steichen and praised him for his photographic portraiture. Huneker was the author of several critical studies on music and a number of books of essays on art, New York City, and French art, music and literature. He was a member of the American Institute of Arts and Letters. He died in New York in 1921.

Gertrude Käsebier, the photographer, was born of frontier Quaker parents in

Iowa in 1852. After her father's death she moved to New York and in 1874 married a well-to-do importer, Eduard Käsebier. Mrs. Käsebier had been interested in visual arts since childhood and in 1888 she entered Pratt Institute determined to become a portrait painter. During this time she discovered the camera and soon abandoned painting for photography. In 1897 she established her first studio as a professional portrait photographer at a fashionable location on Fifth Avenue. She soon became one of the foremost portrait photographers in New York. It was at this time that she met Stieglitz and had her first exhibitions at the Camera Club of New York. Her exceptional work and her professional status made her a significant force in the pictorial photography movement. She was a founding member of the Photo-Secession, and a member of the English Linked Ring. The first issue of *Camera Work* features her work. Many personalities of the day sat for her camera, including Gelett Burgess, Rodin, Robert Henri, George Luks, and John Sloan. She also made portraits of F. H. Evans, Stieglitz, and Clarence White, and illustrated works of popular fiction for books and magazines. Mrs. Käsebier also made a notable set of portraits of American Indians. After 1910 and the Buffalo Show, Mrs. Käsebier continued to photograph in the soft, pictorial tradition. She broke with Stieglitz and the "291" group, and with White and A. L. Coburn helped organize a rival group: the Pictorial Photographers of America. Mrs. Käsebier's last exhibition was held at the Brooklyn Institute of Arts and Sciences in 1926. She died eight years later at the age of 82 at her home in New York.

Joseph T. Keiley was born July 26, 1869, the eldest of five children born to Mary Helen and Major John D. Keiley. He lived all his adult life with his mother and sister in Brooklyn. Keiley, a Wall Street lawyer, joined the Camera Club in 1899. From that point on he remained close to Stieglitz, writing the foreword to the catalogue of Stieglitz's Camera Club exhibition of 1899, collaborating with Stieglitz on a refinement of the glycerine process for local development of the platinum print, and working as associate editor of *Camera Notes* and then *Camera Work*. Together with Stieglitz, Keiley hung the initial National Arts Club exhibition of the Photo-Secession in 1902. Keiley was the fourth American to be elected to the Linked Ring, the British society of pictorial photographers. (The others were Alfred Stieglitz, Rudolph Eickemeyer, and F. Holand Day). Keiley was a prolific correspondent and the acknowledged historian of the Photo-Secession. Owing to a long stay in England, Keiley was the best known of the Secessionists there. Keiley died on January 21,

1914 of Bright's disease. In Keiley's obituary the English critic R. Child Bayley wrote: "Keiley was a man of very high ideals, quiet, tactful, unselfish to a most uncommon degree, a loyal friend, a doughty and honourable opponent. As a companion he possessed a strange charm, emphasized by his strikingly handsome face and figure."

John Barrett Kerfoot was born in Chicago in 1865. He was educated as a child in Europe. He received his bachelor's degree from Columbia University in 1887 and in 1900 became the literary critic for *Life*. Kerfoot was a member of the New York Camera Club. He first became a part of Stieglitz's circle during Stieglitz's editorship of *Camera Notes*. He contributed humorous pieces to the early issues of *Camera Work* and in 1905 became an associate editor, a position he held until the magazine ceased publication. After 1917 he became well known as an antique collector. He is the author of *Broadway*, 1911; *How to Read*, 1916; and *American Pewter*, 1923. Kerfoot died in 1927.

Heinrich Kühn was born in Dresden in 1866. He studied science and medicine in Dresden until he moved to Innsbruck in 1888 to devote himself to photography. In 1897 he introduced the multiple gum technique for color prints. Kühn worked in Vienna with Herneberg and Watzek as one of the so-called Viennese Triforium. He was a prominent exhibitor of portraits and landscapes and a leader of the Austrian movement in photography. A member of the Linked Ring, he also received an honorary degree from Innsbruck University for developing artistic photographic printing methods. Kühn died in 1944.

John Nilson Laurvik was born in Norway. He studied at the University of Antwerp in Belgium. His critical writings on art and photography first appeared in *Camera Work* in 1907. A photographer as well as a critic, he became a part of Stieglitz's circle and was made a member of the Photo-Secession. An exhibition of his autochromes hung at the Little Galleries in 1909. Laurvik was very involved with the exhibition activity of the Secession. In 1909 he helped hang the International Exhibition of Photography in New York and a year later he was one of the principal lecturers at the Buffalo Show. By the time of the Armory Show he was writing criticism for many periodicals including the *Century* and the *International Studio*. He was among the most informed and least partisan defenders of modernism and his criticism ranks alongside that of Christian Briton, Willard Huntington Wright, and Walter Pach. In 1915 he was made a member of the art commission for the Panama-Pacific International Exposition in San Francisco. There he directed

the Palace of Fine Arts. After the war he continued to write for many New York art journals. He died in 1953.

Mina Loy, an English poet, was a remarkably emancipated woman and one of the major links between the New York avant-garde and the Futurist movement in Europe. Before she came to New York she had known Marinetti and his group in Milan and in Paris she had known Appolinaire. In America she was a member of Alfred Kreymborg's group of the teens. This group included Man Ray, Walter Arensberg, Marcel Duchamp, and Marianne Moore. Her poetry appeared in Kreymborg's magazine *Others* and in his anthology *Lyric America* in 1930. She published several volumes of her own poetry including *Ova* and *Lunar, Baedecker*. Mina Loy was greatly admired by the poet William Carlos Williams, yet she married the English Dada poet Arthur Cravan who disappeared on a sea voyage to Buenos Aires. After his mysterious disappearance she moved to Buenos Aires and then to Paris where she was associated with Gertrude Stein's circle.

William D. MacColl was an art critic who frequently wrote on modern art and photography for the *International Studio* and the *Forum* during the early teens. A supporter of abstraction and a strong defender of the Armory Show, MacColl was one of the sanest, most logical writers of the time.

Maurice Maeterlinck, the chief Belgian poet of the twentieth century, was born in Ghent in 1862. In the eighties he made a significant trip to Paris where he became acquainted with several of the French Symbolists including Villiers de l'Isle-Adam. He began to write about this time. In 1889 he published his first successful drama, *La Princesse Maleine.* In 1891 *Les Aveugles* appeared and during the successive years his chief remaining works: *Pélleas et Mélisande* (1893), *Monna Vanna* (1902), and *L'Oiseau blue* (1908). In 1911 he was awarded the Nobel Prize for Literature. Maeterlinck was approaching the high point of his career when he was photographed by Steichen in 1901. He visited Steichen's first one-man Paris exhibition in 1902, where he discussed the art of photography with Steichen and volunteered to put down some of his thoughts for the new publication *Camera Work.* After the war Maeterlinck's production declined sharply. He traveled and read widely in America, remaining there throughout the Second World War. Returning to France, he died at his villa near Nice in 1949.

John Marin, a painter in oils and watercolor, was born in New Jersey in 1870. Marin belonged to the first generation of avant-garde American painters. He de-

veloped a keenly joyous, individual style, semi-abstract and expressionistic. Marin studied at the Pennsylvania Academy of Fine Arts from 1899 to 1901 and at the Art Students League in New York City in 1904. From 1905–1909 he traveled in Europe, residing mainly in Paris where he became part of the New Society of Younger American Painters which included Weber, Maurer, Brinley, Carles, and Steichen. Steichen arranged for his first American exhibition at "291" in April, 1909. His subsequent development was demonstrated in yearly exhibitions at "291" and at Stieglitz's Intimate Gallery and An American Place. Marin was also represented in the Armory Show of 1913. Marin was given a large one-man exhibition at the Venice Biennale in 1950, the first time such recognition was accorded an American. Over the years Marin remained close to Stieglitz, who helped to financially support his work. He symbolized for Stieglitz the true flowering of American consciousness in art. Marin died in Cape Split, Maine, in 1953. A brilliant letter writer, many of his letters to Stieglitz have been published in *Selected Writings* of John Marin, 1949.

Henri Matisse, French painter and sculptor, was born in 1869 and died in 1954. Until the advent of Cubism, he was the most influential painter in Paris and he remains one of the artistic giants of the century. When Steichen came to Paris, Matisse was already well known to the avant-garde. Steichen arranged through Mrs. Michael Stein for an introduction to the artist and he subsequently secured a group of etchings, drawings, lithographs, and water colors for Matisse's one-man show at "291" in 1908. This was Matisse's first American exhibition. Matisse, the leading spirit of the "Fauves," had a great deal of contact with the Photo-Secession, being photographed by Steichen, interviewed for *Camera Work,* and visited by Charles Caffin in 1909 and Stieglitz in 1911. His opinions on the artistic worth of photography were always guarded. In 1908 he indicated that the role of photography was to document the world and as late as 1942 he stated that his paintings "translate my emotions, my feelings and the reactions of my sensibility into color and design, something that neither the most perfect camera, even in colors, nor the cinema can do."

Henry M. McBride, who had often been called the dean of American art critics, was born in West Chester, Pennsylvania, in 1868 and died 94 years later in 1962. During this long lifetime his writing was enormously important in introducing modern art to the public. From about 1913 until the mid-fifties he wrote perceptive and urbane criticism. During the teens he wrote for the *New York Sun,* the most liberal of the daily papers. In the

twenties he was art critic for the *Dial.* He was also active in educational activities and helped organize the art department of the Educational Alliance. A vocal partisan of modernism, he also favored Dada and a wide range of artistic experimentation. In 1949 an exhibition of his selection in New York showed the artists he had supported early in their career. It included works of Eakins, Stella, Marin and Demuth. His own private collection of painting, mostly gifts from the artists, was sold at the Parke-Bernet Galleries in 1955.

William B. McCormick was born in 1868 in Brooklyn. He began his career as a journalist in 1894. By the turn of the century he was working as literary and art editor and editorial writer for the *New York Press,* a post he held for 20 years. In 1915 he also wrote as art critic for the *New York Evening Mail.* During the war he was associate editor of the *Army and Navy Journal* and after the war he continued to act in an editorial capacity for the *Sun,* the *Herald,* the *International Studio,* and the *New York American.* In 1930 he was made special art critic for the Hearst Newspapers and made two world tours for the syndicate. McCormick represented a thoughtful conservative attitude toward the new art. He found the Cubists competent artists, yet like many of his contemporary critics he was neither very knowledgeable nor sympathetic to their esthetic goals. He died in 1948.

William Murrell (Fisher) was an art critic and poet who was greatly sympathetic to the concerns of modern art and modern American painting. He wrote an article in the *Arts & Decoration* issue on the Armory Show and he was the first critic to deal at length with Georgia O'Keeffe's work. During the twenties and thirties he wrote *A History of American Graphic Humor* as well as several books on American painters for the *Younger Artists Series.* He was born in 1889.

Nietzsche, the German philosopher, lived from 1844 to 1900. His lucid, elegant, yet paradoxical style and his attempt to formulate a philosophy for his age led him to be broadly quoted and interpreted. He is widely referred to in the pages of *Camera Work,* particularly by Benjamin De Casseres, Hartmann and Weischel. They admired his intellectual brilliance and ruthlessness and his loathing of conventional morality and mentality.

Francis Picabia, painter and poet, was born in Paris in 1878. After an early Post-Impressionist phase, he became successively involved with Cubism, Orphism and Futurism, but is most significant as a pioneer of Dada. Working with Marcel Duchamp, whom he met in 1910, he was responsible for bringing Dada to New

York. He first came to New York for the Armory Show of 1913 and was immediately given a one-man exhibition by Stieglitz, in which he showed abstract water colors inspired by the sights and sounds of New York. It was during this time that he conceived one of his most famous works *Udnie*. During his second trip to New York in 1915 he became deeply involved with the "291" circle. With De Zayas, Haviland, and Agnes Ernst Meyer, under Stieglitz's sponsorship, he helped publish the avant-garde magazine *291*. He also helped De Zayas establish the Modern Gallery, the commercial extension of "291." During the summer of 1915, Picabia suddenly started working in his erotic "machinist" style and several of his earliest machinists drawings became the core illustrations for *291*. In 1917, having settled in Barcelona, he began publication of *391*, a journal inspired by and named after the earlier magazine. In 1918 he was invited to collaborate with the Zurich Dadaists and from 1920, in contact with Andre Breton, was active as a Surrealist. Picabia continued his contact with Stieglitz after the War and was shown at the Intimate Gallery in 1928. He died in 1953.

Pablo Picasso, one of the most versatile and influential artists of this century, was born in Malaga, Spain in 1881. Settling in Paris in 1904 he was brought in contact with photography through his early patrons, the Steins, who were acquainted with Steichen, and by Frank Burty Haviland — Paul Haviland's brother — who was a personal friend. The actual selection of Picasso's drawings and water colors for the "291" exhibition of April, 1911, were made by De Zayas, the sculptor Manolo, and Burty. This was Picasso's first one-man exhibition and showed much of his evolution through Cubism. A second exhibition of the work of Picasso and Braque was held at "291" in December, 1914. Stieglitz met Picasso on his last trip to Europe in 1911. In 1915 Picasso contributed a drawing and a circular collage to the publication *291*. Picasso died in April, 1973, at the age of 91.

Auguste Rodin, French sculptor and draftsman, was born in Paris in 1840. His fame was already international in 1901 when he was visited by the young photographer Steichen who was studying in Paris. Rodin and Steichen became quite close. Rodin allowed the photographer not only to take many photographs of himself and his work but also to select drawings for an exhibition at "291" in 1908. A second exhibition at "291" in 1910 resulted in the first publication in *Camera Work* of eight of Rodin's long neglected wash drawings. One of Rodin's last major works, Balzac, was extensively photographed by Steichen in 1908. Rodin's vigorous probing of the moral condition of society and the realities of the

human body exerted great impact on modern art and sculpture. Though he realized that the photograph might not give him the expressive latitude he desired in his own art he was well aware of the value of the information it might contain. In 1887 he was one of the subscribers to Muybridge's photographic study *Animal Locomotion*. By 1908 he could call Steichen "a very great artist," and he saw photography as a worthy medium of artistic expression. He died in Meudon in 1917.

Harry C. Rubicam, a member of the Photo-Secession was born in Camden, New Jersey. In 1897 he moved to Denver and later became the western representative of the Fidelity and Casualty Co. He died in 1941. His brother was Raymond Rubicam, chairman of the board of Young and Rubicam, the advertising firm.

George Seeley, a member of the Photo-Secession, was born in 1880 in Stockbridge, Massachusetts, where he lived all of his life. He studied art at the Massachusetts Normal Art School in Boston. Seeley first received attention as a photographer when he exhibited in the First American Salon of 1904 where Alvin Langdon Coburn, one of the judges, brought him into contact with Stieglitz. Early in his career as a painter and photographer he declined an offer to head the art department at Pratt Institute. Instead, he remained in Stockbridge where for 40 years he was chairman of the ushers at the First Congregational Church. He was also supervisor of art in the Stockbridge public schools and at one time was associated with the *Springfield Republican*. An authority on birds, he was for many years associated with the Biological Survey of Washington for which he maintained a landing station and reported bird migration. Toward the end of his life Seeley achieved recognition as a painter of brasses and coppers in still life canvases. He died in Stockbridge in 1955.

George Bernard Shaw, playwright and critic, was born in Dublin in 1856. He was already well known as a Socialist, orator and cultural critic, yet scarcely recognized as a playwright when he took up photography in 1898, while recuperating from a serious illness. He continued to photograph until a few months before his death in 1950 at the age of 94. He used a variety of equipment over 50 years that included everything from box cameras and 8 x 10 view cameras to Leicas and other hand-held miniatures. One of the most extensively photographed personalities in history, Shaw posed for his friends Alvin Langdon Coburn and Frederick Evans, as well as for many of the Secessionists. He would frequently return the gesture by photographing the photographer. Shaw continued to sit for hundreds of photog-

raphers up till a week before his death. F. E. Loewenstein's book, *Bernard Shaw Through the Camera*, (1948), contains many of these portraits as well as 38 photographs by Shaw himself. An enthusiastic amateur, Shaw loudly championed the new art of photography writing lengthy essays for both British and American photography magazines. Shaw published his first essay on photography in 1901 and continued to write extensively on photography through 1909. Most of these articles appeared in the *English Amateur Photographer* and several were reprinted in *Camera Work*. During this period of his effective polemical essays on photography Shaw was writing *Caesar and Cleopatra* (1898–1907), *Man and Superman* (1903), *The Doctor's Dilemna* (1906), and *Pygmalion* (1912). Just before his death Shaw published a local guide book to Ayot St. Lawrence illustrated with his own photographs.

Eduard Steichen, the acknowledged standard bearer of the Photo-Secession and one of the major figures of twentieth century photography, was born in Luxembourg in 1879. His family came to the United States in 1881, and he was educated in Milwaukee, Wisconsin. There he studied art while working as an apprentice at a lithographic company. In 1897 he won a prize for envelope design and organized and became the first president of the Milwaukee Art Students League. Steichen took his first photograph in 1896 and won his initial recognition at the Second Philadelphia Salon of 1899. His entry to the Chicago Salon the following year evoked a letter of encouragement from Clarence H. White who arranged for his introduction to Stieglitz. Steichen met Stieglitz later that year on his way through New York to Europe. Stieglitz bought three of his prints at this time. While in Europe during 1901–1902, Steichen continued his work in art and photography. He had his first large showing in the New School of American Photography in London in 1901 and his first one-man show at La Maison des Artistes, Paris, 1902. This show included paintings as well as photographs. He was elected a member of the Link Ring in 1901 and in the same year began his friendship with Rodin. Steichen continued to exhibit in the United States during his stay in Europe. In 1902 he contributed 14 prints to the initial Photo-Secession exhibition. He was one of the founders of the Secession and designed the cover and typography for *Camera Work*. In 1902 Steichen returned to New York and took a studio at 291 Fifth Avenue which, with Stieglitz' encouragement, was to become in 1905 "The Little Galleries of the Photo-Secession." There he initiated the idea of showing works of art in all media. On his subsequent trips to Paris he arranged for the "291" exhibitions of modern art. In 1906

he sent back to Stieglitz the works of Rodin, Matisse, Maurer, Marin, Cezanne, Craig, Weber, Picasso, Carles, and Brancusi. In France, Steichen also experimented with the new Lumiere Autochrome and began hybridizing delphinium plants. This became a lifelong concern and resulted in a one-man show of his hybrid flowers at the Museum of Modern Art in 1936. At the outbreak of the war Steichen returned to New York where he remained a peripheral member of the "291" circle until he finally broke with Stieglitz over the war in 1917. Later that year he volunteered for the U.S. Army. He became the commander of the Photographic Division of Aerial Photography in the American Expeditionary Forces. After the war he gave up painting to concentrate on photography. He became the chief photographer for *Vogue* and *Vanity Fair*, taking fashion photographs and portraits of leading personalities. In 1929 he organized with Edward Weston the American Section of Deutsche Werkbund Exhibition, "Film Und Foto." During World War II, Steichen was in command of all Navy combat photography. He retired with the rank of captain in 1946. During this time he directed two exhibitions for the Museum of Modern Art, which established a new concept of photographic presentation: "Road to Victory" in 1942 and "Power in the Pacific" in 1945. In 1947 he was appointed Director of the Department of Photography, Museum of Modern Art. Here he organized numerous exhibitions. The most notable was "The Family of Man" which was prepared with the assistance of Wayne Miller and circulated throughout the world. In honor of his 82nd birthday the museum gave him a large retrospective exhibition in 1961. He became director emeritus of the department in 1962 and retired to continue intensive studies in color film and photography. In 1963 he received the Medal of Freedom from President John F. Kennedy. During his lifetime Steichen was the recipient of many awards and honorary degrees. Through his own photography, the positions he held, and the exhibitions he organized, he undoubtedly did more than any other individual to win popular understanding of the expressive possibilities of photography. His own work was published in four major books: *The Steichen Book*, Supplement to *Camera Work*, 1906; *Steichen the Photographer*, 1949, which included a text by his brother-in-law, Carl Sandburg; *Steichen the Photographer*, 1961, with a foreword by Rene d'Harnoncourt; and *A Life in Photography*, 1963. Steichen died two days before his 94th birthday at his estate in West Redding, Connecticut, in March, 1973.

Mary Steichen was born in 1904 the eldest of two children born to Eduard and Clara Steichen. She graduated from Vassar in 1925 and received her M.D. in 1939. In 1931 and 1932 she collaborated with her father to produce the *First* and *Second Picture Books: Everyday Things for Babies*. In 1941 she married Calderone, her second marriage. Mary Steichen Calderone has been very active in family planning and sex education. From 1953 to 1964 she was the medical director of the Planned Parenthood Federation of America and since 1964 she has been the director of SIECUS, the Sex Information and Education Council of the U.S. She has been the recipient of many national awards for her activities in public health and is the author of numerous articles on abortion, contraception, and family planning. She currently lives in New York.

Gertrude Stein, one of the most influential authors and linguistic experimentalists of our time, was born in 1874 in Allegheny, Pennsylvania, As an undergraduate at Radcliffe she came under the influence of William James and resolved to make psychology her life work. She then went on to study medicine at Johns Hopkins. She settled in Paris in 1903 and her home soon became the focus of avant-garde literary and artistic activity. She encouraged Matisse, Picasso, Braque, and Rousseau when they were virtually unknown during the first decades of the century. In the twenties her salon became the center for the young American expatriates Ezra Pound, Sherwood Anderson, and Ernest Hemingway. Stieglitz met Gertrude Stein during his summer trip to Paris in 1909. He spent many evenings at her salon and in 1912 he brought out a special issue of *Camera Work* in which the text is devoted entirely to her two essays on Matisse and Picasso. These essays represent her first radically experimental work and were her first magazine contributions. In 1914 she wrote a foreword in the form of a play for Marsden Hartley's exhibition at "291," which was reprinted in Camera Work. Her *Portrait of Mabel Dodge* appeared a year later in the second special issue on Modern Art. Gertrude Stein's admiration of Stieglitz remained strong. In 1934 she wrote in *America and Alfred Stieglitz:* "If anything is done and something is done then somebody has to do it. Or somebody has to have done it. That is Stieglitz's way. He has done it." She died in France in 1946.

Alfred Stieglitz was born in Hoboken, New Jersey, in 1864, the son of a German immigrant businessman. He was educated in New York, and studied mechanical engineering and photography at the Berlin Polytechnic from 1882 to 1890. In Germany, he took his first photograph and entered his first competitions. He was awarded a prize by P. H. Emerson in the Amateur Photographer competition of 1887. In 1890 he returned to New York and entered the photo-engraving business in which he worked for the next five years. At this time he joined the Society of Amateur Photographers of New York, began the first extensive use of the hand-camera for creative photography and wrote for the American Amateur Photographer. In 1894 he became the first American to be elected to the Linked Ring. Following the merger of the Society of Amateur Photographers with the New York Camera Club in 1897 he founded and edited the club publication *Camera Notes*. In 1899 he had his first major one-man exhibition at the Camera Club. In 1902 he announced the formation of the Photo-Secession. Its first exhibition was held at the National Arts Club in March of that year. He then resigned from *Camera Notes* and established a new quarterly *Camera Work* which he edited and published from 1903 to 1917. In 1905 he opened, with the help of Eduard Steichen, The Little Galleries of the Photo-Secession at 291 Fifth Avenue. These later became known as "291." The galleries first showed non-photographic art in 1907. With Steichen's help Stieglitz used the galleries to introduce modern art to America. In 1910 with the help of Haviland, Weber and White he organized the triumphant International Exhibition of Pictorial Photography at the Albright Art Gallery in Buffalo. During the Armory Show in 1913 he held his second one-man show at "291." During 1915–1916 he sponsored and helped edit the elegant proto-Dada publication *291*. In 1917 "291" closed and the last number of *Camera Work* was published. It was during this year that he took his first photographs of Georgia O'Keeffe. In 1921 he held a large retrospective exhibition at the Anderson Galleries showing for the first time his portraits of O'Keeffe. In 1923 his first cloud photographs ("equivalents") were exhibited at the Anderson Gallery. In 1924 he received the Progress Medal from the Royal Photographic Society and married Georgia O'Keeffe. From 1925 to 1929 Stieglitz directed the Intimate Gallery where he showed the painters Dove, O'Keeffe, Demuth, Marin, Lachaise, Bluemner, Bacon, Picabia, Hartley and the photographer Paul Strand. From 1929 until his death in 1946 in New York, he directed An American Place, where he continued mainly to show painting; Ansel Adams and Eliot Porter were the only new photographers shown. In 1932 Stieglitz's one-man exhbition at An American Place showed for the first time the series of photographs taken since 1915 from his high city windows. Stieglitz stopped photographing in 1937 at the age of 73 when he could no longer handle his cameras with ease. "I was born in Hoboken. I am an American. Photography is my passion. The search for Truth my obsession," Thus Stieglitz wrote in the catalog to his Anderson Galleries show of 1921. Stieglitz devoted his entire life of

creative effort to photography. His strength of character, his refusal to compromise the integrity of his artistic and personal standards, and his self-assurance led many to see him as almost a mythical presence. His own work and the work of those painters, photographers, and authors he nurtured and supported have become the foundations of twentieth century expression.

Paul Strand, one of the major figures in twentieth-century photography, was born in New York City in 1890, of Bohemian descent. In 1907 at Ethical Culture High School he first studied photography under Lewis Hine who introduced him to Stieglitz and the Little Galleries of the Photo-Secession. After graduating from high school in 1909 Strand set himself up as a commercial photographer, began to visit "291" regularly, and gradually became a member of the "291" group. Strongly influenced by the work shown there, he began his first abstract photography in 1915 and was published in *Camera Work* in 1916, the last issue being entirely devoted to his new work. He also exhibited at "291" in 1916. It was at this time that he began his first close-ups of machine forms and became the first to advocate new realism for photography. From that time on Strand's life has been deeply involved with film and photography. He made the first avant-garde American film, "Manahatta," with Charles Sheeler in 1921; exhibited at Stieglitz's Intimate Gallery in 1929, and An American Place in 1932; was appointed Chief of Photography and Cinematography, Department of Fine Arts, Secretariat of Education of Mexico in 1933–34 (here he photographed and supervised the production of the film "The Wave" for the Mexican government); went to Moscow in 1935 and met Eisenstein and Dovzhenko; on his return made the documentary film "The Plow that Broke the Plains" which was directed by Pare Lorentz; in the late thirties founded Frontier Films and worked with Leo Hurwitz on "Heart of Spain" and "Native Land." Strand had a one-man show at the Museum of Modern Art in 1945; in 1946–47 he traveled in New England working on the book *Time in New England* with Nancy Newhall. In 1950 he went to France to reside and began a succession of projects which resulted in books on France (1951), Italy (1952), Hebrides (1954), Egypt (1959). He photographed in Rumania in 1960, Morocco in 1962 and Ghana 1963–64. In 1967 he supervised the second printing of *The Mexican Portfolio*, which was first issued in 1940; in 1971 he was given a major retrospective exhibition at the Philadelphia Museum of Art and a two-volume monograph of his work from 1915 to 1968 was published by Aperture. Strand lives at Orgeval near Paris and is still working on new book projects.

John Francis Strauss had been associated with Stieglitz at the New York Camera Club and on the editorial board of *Camera Notes*. He was associate editor of *Camera Work* from its inception in 1903 until 1910 when his name was quietly dropped from the masthead and replaced by Paul Haviland's. One of his photographs appears in issue 3 and he was included in all of the early exhibitions of the Photo-Secession of which he was a founding member and fellow. His only signed article in *Camera Work* related the details of Stieglitz's expulsion from the Camera Club.

John Bannister Tabb was born in Virginia in 1845. During the Civil War he was a clerk in the Confederate Navy and was held as a prisoner of war by the North for two years. After the war he studied music and taught in Baltimore. He became a Roman Catholic in 1872 and was ordained as a priest twelve years later. He was the author of many books including: *Poems, An Octave of Mary, Poems: Grave and Gay* and *Rules of English Grammar*. He appears only once in *Camera Work* and his relationship with the Photo-Secession is unknown. He died in Maryland in 1909.

Abraham Walkowitz was born in Tummen, Siberia, in 1880. He came to the United States at about the age of ten. As a young man he studied at the art class of the Educational Alliance and the Art Student's League in New York. He later studied with Walter Shirlaw at the National Academy of Design. Between 1907 and 1914 Walkowitz spent time alternately traveling and studying in Europe and New York. In Paris he studied at the Academy Julian and was influenced by the work of Matisse and Kandinsky. In New York he worked as a sign painter in order to earn enough to support his own work. Walkowitz's first major exhibition in New York was in a group show of East Side subjects at Madison House during the 1911–1912 season. This show attracted Stieglitz, who gave Walkowitz his first one-man show in December, 1912. Walkowitz continued to exhibit at "291" every year until the gallery closed in 1917. Stieglitz and his circle were quite taken with the expressive draftsmanship, simplicity, and intensity of feeling in Walkowitz's work. Stieglitz devoted seven collotype plates to reproductions of his drawings in issue 44. The only other artist honored with such superb reproduction in *Camera Work* was Rodin. Walkowitz also contributed a cover to the publication *291*. He was included in the Armory Show in 1913 and the Forum Exhibition of 1960. Through his contacts with "291" and its artists—Marin, Hartley, Weber, and Dove—Walkowitz began to develop his own semi-abstract style. During the 1920's he dropped from public attention but continued to work on figurative abstractions in which bodies in motion are indi-

cated by broken swirls and rhythmic brushstrokes. He later did abstract scenes of New York buildings. Major books of his work were published in 1925, for which John Weichel and Henry McBride contributed introductions, and in 1945 and in 1948. Walkowitz died in Brooklyn in 1965.

J. C. Warburg, a British photographer, was active in international photographic circles. With Stieglitz, Annan, Hinton, and Demachy he was a member of the advisory committee for the Hamburg International Jubilee Exhibition in 1903. Warburg was a member of the Linked Ring. He was a frequent exhibitor at the salons and did some work using autochrome transparencies.

Max Weber, the painter and sculptor, was born in Bialystok, Russia in 1881. He came to the United States at the age of ten. His formal art education was at Pratt Institute. Weber was in Europe from 1905 to 1908 where he was a member of the New Society of Younger American Painters of Paris. He became a close friend of Henri Rousseau and studied with Matisse in 1907. Steichen introduced Weber's work to Stieglitz. Weber exhibited with the Younger American Painters at "291" in 1910. Weber helped Steichen obtain some of Rousseau's paintings for the gallery that year. The following year Stieglitz gave him his first one-man show. Weber was particulary close to Stieglitz during this time. He designed the installation for the triumphant Buffalo Exhibition of 1910 and he was one of the first to argue Stieglitz into seeing that Stieglitz's early work was much better than his later pictorial work. Together with De Zayas he found among Stieglitz's early works the "Steerage." Weber broke with Stieglitz around 1913. From 1917 on he began to paint less abstractly and to develop his coloristic sense. In the late 1930's he became increasingly concerned with religious subjects and began painting Hasidic themes and subjects. Weber was never reconciled with Stieglitz and to the end of his days Stieglitz never forgot that Weber had once crossed him. Weber died in 1961.

John Weichsel was born in Poland in 1870. In his early years at the gymnasium he showed great aptitude for math and engineering and he completed the University at Heidelberg by the time he was thirteen. At fifteen he went to Berlin to further his engineering studies. Here he became interested in psychology and esthetics and attempted to get a doctorate in psychology. However, he ran out of money before he received his degree. Weichsel then came to New York. He worked as a machinist's helper by day and on his Ph.D. at night. He eventually received his doctorate from New York Uni-

versity. From 1900 until shortly before his death in 1946, Weichsel headed the Department of Mechanical Engineering and Drafting at the Hebrew Technical Institute. He also taught at Brooklyn Polytechnical Institute and City College. An active socialist, Weichsel wanted to take art to the people. He arranged for lectures by Sloan, Bellows, Hartley, Marin, Walkowitz and others at settlement houses around New York. He founded the People's Art Guild which sold fine prints and paintings for two and three dollars. Weichsel helped organize the Forum Exhibition of Modern American Painters. He wrote one of the introductions to Walkowitz's book of painting of 1925.

Herbert George Wells, the English writer, was born in 1866 and died in 1946. He studied to be a chemist but ill health interrupted his scientific work and he turned to science fiction, producing works of great imagination: *The Time Machine* (1895), *The Invisible Man* (1897), *War of the Worlds* (1898), and *The First Men in the Moon* (1901). Wells joined the Fabian society in 1903, though he soon began to criticize the methods of the Fabians and was led to present his own idea of socialism in such works as *New Worlds for Old*, and *First and Last Things*, both of 1908. His faith in political socialism left him as time went by, and by the Second World War he had become very melancholy and pessimistic. Wells helped to influence the breakdown of nineteenth century thought and morality. His quotation in *Camera Work* vividly catches his early optimism and gave the Secessionists another guidepost in their energetic search for release from Victorian conventions.

Clarence Hudson White was born in 1871. For sixteen years, from 1890 to 1906, he was the head bookkeeper in a wholesale grocery firm at Newark, Ohio. In 1894 he began experimental work in photography and two years later was recognized by the Ohio Photographer's Association as being "a man ten years ahead of his time." In 1898 his work was exhibited at the Philadelphia Salon and came to the attention of Stieglitz and Keiley. A year later he was elected as a honorary member in the Camera Club of New York and exhibited in London, New York, and Boston. In 1901 he illustrated Irving Bacheller's *Eben Holden* using Newark, Ohio, people as models. Thus began a series of illustration work which included Clara Morris's *Beneath the Wrinkle* (1904) and *Newport the Maligned* (1908). In 1906, after becoming a founding member of the Photo-Secession, he moved to New York and began an extensive teaching career that ultimately took much of his creative energy, and greatly decreased his own photographic work. He lectured at Columbia from 1907 until his death, and in 1910 he established with

Max Weber his own summer school of photography in Seguinland, Maine. He was also an instructor at the Brooklyn Institute of Arts and Sciences from 1908–1921. In 1910 he and Weber helped Stieglitz and Haviland hang the successful Albright Exhibition in Buffalo. Partly as a result of some differences over this exhibition—the procedure for the returning of prints, and their disagreement about photographic esthetics—White and Stieglitz broke their relationship several years later. White died in Mexico City in 1925 while on tour with students from his school.

Willard Huntington Wright was born in Charlottesville, Virginia, in 1888. After graduating from Harvard in 1906 he had an extremely varied career. He wrote criticism of art and literature for such publications as the *Los Angeles Times*, the *Forum*, *International Studio*, and the *San Francisco Bulletin;* he collaborated on *Europe after 8: 15* with H. L. Mencken; wrote nine books on painting and literature; became police commisioner for Bradley Beach, New Jersey; and wrote a dozen murder mysteries under the name of S. S. Van Dine. Wright, brother of Synchromist painter Stanton Macdonald-Wright, was one of the most articulate and sophisticated defenders of modernism. His critical writings contain astute comments on American taste and civilization. He immediately recognized the work of Maurer, Walkowitz, Marin, and Dove. He did not especially care for the other painters in Stieglitz's circle, though he reviewed their work with thoroughness and intelligence. He died in 1939.

Bibliography

The Text

Camera Work, An Illustrated Quarterly Magazine Devoted to Photography, edited and published by Alfred Stieglitz, New York, 1903–1917. Issued in fifty numbers with three special issues: Special Steichen Supplement (April, 1906); Special Number (August, 1912); Special Number (June, 1913). Reprinted in full by Kraus Reprint, Nendeln/Lichtenstein, 1969.

Major Sources

The following periodicals, annuals, and catalogue are the principal sources of material relating to *Camera Work*, the Photo-Secession, and photographic aesthetics. The most important articles from these sources are listed in the dated bibliography below.

Amateur Photographer and Cinematographer, London, 1888 to date. Vol. 1–25, 1888–1908 known as *Photography*. Vol. 26–45, 1908–1918 known as *Photography and Focus*. Vol. 46–64, 1918–1927 known as *Amateur Photographer and Photography*. After 1927 known by its present name.

American Amateur Photographer, W. H. Burbank, F. C. Beach, W. G. Chase, Brunswick, Maine, 1889–1892. Outing Co., Ltd., New York, 1893–1907.

American Annual of Photography, Boston and New York, 1887–1953. 1887–1903 in Scoville photo series. 1903 absorbed the *International Annual* of *Anthony's Photo Bulletin*.

The Blind Man, edited by Marcel Duchamp, April–May, 1917. Two issues.

British Journal of Photography, Liverpool, 1854–1863. London, 1864–1935.

Camera Notes, The Camera Club of New York, 1897–1903. Published quarterly under Stieglitz's direction, 1897–1902. Edited by Juan C. Abel, 1903.

Catalogue of the Photographic Library of the Camera Club, N.Y., compiled and edited by Juan C. Abel. Bound in with *Camera Notes*, Vol. 6 (July, 1902).

International Studio, New York, 1897 to date. 1897–1921 forms the American edition of *Studio*, London. Vol. 1 of *International Studio* corresponds to Vol. 10 of *Studio*.

MSS [Manuscripts], edited by Paul Rosenfeld, 1922–1923. Six issues. Portfolio and cover designed by Georgia O'Keeffe.

New York Dada, edited by Marcel Duchamp, April, 1921. One issue.

Photo-Era Magazine, Boston, 1898–1920. Merged into *American Photography*, 1920.

Photograms of the Year, Photogram Ltd., London, 1895 to date.

The Photographic Journal, including *Transactions of the Royal Photographic Society of Great Britain*, London, 1853 to date.

Photographic Journal of America, Philadelphia, 1864–1923. Vol. 1–25, 1864–1888 known as *Philadelphia Photographer*. Vol. 26–51, 1889–1914 known as *Wilson's Photographic Magazine*. Merged into *Camera*.

Photographic Times, New York, 1871–1915. Merged into *Popular Photography*.

Photo-Minature, Tennant and Ward, New York, 1899–1932.

Rongwrong, edited by Marcel Duchamp, New York, 1917. One issue.

Seven Arts, New York, November 1916–October 1917. Complete in 12 numbers. Merged into *Dial*.

391, edited by Francis Picabia, January, 1917–October, 1924. 19 issues. Published in Barcelona, New York, and Paris. Numbers 5 (June, 1917), 6 (July, 1917), and 7 (August, 1917) were published in New York.

291, edited by Marius De Zayas Paul Haviland and Agnes Ernst Meyer, published at 291, New York, March, 1915–February, 1916. 12 issues. Reprinted in full with an introduction by Dorothy Norman by Arno Press, Contemporary Art Series, New York, 1971.

Before 1903

Allen, Sidney [Sadakichi Hartmann], "Eduard J. Steichen, Painter-Photographer," *Camera Notes*, 6:1 (1902).

"American Photography," *Photograms of the Year, 1901*, London, Photogram, Ltd., 1901, pp. 71–86.

Black, Alexander, "The Artist and the Camera," *The Century Magazine*, 64:813–822 (October, 1902).

_____, "The New Photography," *The Century Magazine* October, 1902.

Caffin, Charles H., "Modern Photographic Art," *The New York Evening Post*, October 24, 1898, p. 7.

_____, "The New Photography," *Munsey's Magazine*, 27: 729–737 (August, 1902).

_____, "Photography as a Fine Art," *Everybody's Magazine* (New York). Ten Essays beginning March, 1901.

_____, *Photography as a Fine Art*, New York, Doubleday, Page and Co., 1901. Reprinted by Morgan and Morgan, Hastings-on-Hudson, New York, 1972

Carrington, James B., "Night Photography," *Scribner's*, November, 1897.

Carter, A. C. R., "The Photographic Salon," *Photograms of the Year 1899*, London, Photogram, Ltd., 1899, pp. 83–112.

_____, "The Photographic Salon," *Photograms of the Year 1900*, London, Photogram, Ltd., 1900, pp. 109–148.

_____, "The Photographic Salon," *Photograms of the Year 1901*, London, Photogram, Ltd., 1901, pp. 87–126.

Catalogue of an Exhibition of American Pictorial Photography Arranged by the Photo-Secession, 1902, National Arts Club, New York, 1902.

Catalogue of Retrospective Exhibition of Eighty-Seven Stieglitz Photographs, The Camera Club, New York, May, 1899. Introduction by Joseph T. Keiley.

"Clarence White Exhibit," *Photo-Era*, 4: 23 – 24 (January, 1900).

Coburn, Alvin Langdon, "American Photographs in London," *Photo-Era*, 6: 209 – 214 (January, 1901).

Davidson, George, "The Photographic Salon," *American Amateur Photographer*, 5: 495 – 498 (November, 1893).

Demachy, Robert, "The American New School of Photography in Paris," *Camera Notes*, 5: 1 (1901 – 2).

——————, "A Few Notes on the Gum Bichromate Process," *Photographic Times*, 30: 4 (1898).

——————, "Gum Bichromate Prints at the Salon," *Photographic Times*, 30: 8 (1898).

——————, "The Training of the Photographer in View of Pictorial Results," *American Annual of Photography and Photographic Times Almanac for 1901*, 1901.

——————, "What Difference is there Between a Good Photograph and an Artistic Photograph?" *Camera Notes*, 3: 2 (1899).

Dreiser, Theodore, "The Camera Club of New York," *Ainslee's* (New York) September, 1899.

——————, "A Master of Photography," *Success*, June 10, 1899.

——————, "A Remarkable Art, The New Pictorial Photography," *The Great Round World*, May 3, 1902.

Eastlake, Lady Elizabeth, "Photography," *London Quarterly Review* (American Edition), 101: 241 – 255, (1857).

Emerson, Peter Henry, *The Death of Naturalistic Photography*, London, 1891. Reproduced in facsimile in *On Photography*, Beaumont Newhall, ed. Watkins Glen, New York; Century House, 1956, pp. 124 – 132.

——————, *Naturalistic Photography*, London, Sampson Low, Marston, Searle, and Revington, 1889.

——————, *Naturalistic Photography*, New York, Scovill and Adams Company, 1899.

——————, *Pictures of East Anglian Life*, London, Sampson Low, Marston, Searle, and Revington, 1888.

——————, and T. F. Goodall, *Life and Landscape on the Norfolk Broads*, London, Sampson Low, Marston, Searle, and Revington, 1886.

Exhibition of Photographs by Clarence H. White of Newark, Ohio, Boston, Boston Camera Club, 1899. Introductory Notes by Erna Spencer.

Genre Photography, *Photo-Miniature*, 4: 253 – 254 (September, 1902).

Hartmann, Sadakichi, "Clarence F. [sic] White," *The Photographic Times*, 32: 18 – 23 (July, 1900).

——————, "Gertrude Käsebier," *The Photographic Times*, 32: 195 – 99 (May, 1900).

——————, *History of American Art*, Boston, Page and Co., 1902. See Volume 2, pp. 151 – 159.

——————, "Rudolph Eickemeyer, Jr.," *The Photographic Times*, 32: 161 – 66 (April, 1900).

Hoge, F. Huber, "King of the Camera," *Illustrated Buffalo Express*, January 22, 1899.

Käsebier, Gertrude, "Studies in Photography," *The Photographic Times*, 30: 269 – 272 (June, 1898)

Keiley, Joseph T., "The Philadelphia Salon – Its Origin and Influence," *Camera Notes*, 2: 113 – 132 (January, 1899).

——————, "Photography and Progress," *American Annual of Photography and Photographic Times Almanac*, 1901, pp. 20 – 67.

Moore, Clarence B., "Leading Amateurs in Photography," *Cosmopolitan* (February, 1892).

Pennel, Joseph, "Is Photography Among the Fine Arts?" *Contemporary Review*, 72: 824 – 836 (1897).

"Progress in the United States," *Photograms of the Year, 1898*, London, Photogram, Ltd., 1898, pp. 37 – 46.

Robinson, Henry Peach, *Pictorial Effect in Photography*, London, Piper and Carter, 1869.

Spencer, Erna, "The White School," *Camera Craft*, 3: 85 – 92 (July, 1901).

Steichen, Eduard, "The American School," *The Photogram*, 8: 4 – 9 (January, 1901).

——————, "British Photography from an American Point of View," *Amateur Photographer*, 32: 839 (1900). Repeated in *Camera Notes*, 4: 3 (1901).

Stieglitz, Alfred, "The Hand Camera," *The American Annual of Photography*, Vol. 10 (1897).

——————, "The Joint Exhibition at Philadelphia," *American Amateur Photographer*, 5: 201 – 208 (May, 1893).

——————, "Modern Pictorial Photography," *The Century Magazine*, 64: 822 – 826 (October, 1902).

——————, "A Natural Background for Out-of-Door Portraiture," *American Annual of Photography and Photographic Times Almanac for 1898*, New York, 1897.

——————, "Night Photography with the Introduction of Life," *American Annual of Photography and Photographic Times Almanac for 1898*, New York, 1897.

——————, "Pictorial Photography," *Scribner's Magazine*, 26: 528 – 537 (November, 1899).

——————, *Picturesque Bits of New York and Other Studies*, New York, 1898. Portfolio of twelve photogravures by Alfred Stieglitz. Introduction by Walter E. Woodbury.

_____, "A Plea for a Photographic Art Exhibition," *The American Annual of Photography and Photographic Times Almanac*, 1895, pp. 27–28.

_____, "The Progress of Pictorial Photography in the United States," *The American Annual of Photography and Photographic Times Almanac*, 1899, pp. 158–159.

[Stieglitz, Alfred], [Untitled statement of editorial policy], *Camera Notes*, 1:3 (July, 1897).

Strauss, John Francis, "The Club and Its Official Organ," *Camera Notes*, 4: 153–158 (January, 1901).

_____, "The 'Photo-Secession' at the Arts Club," *Camera Notes*, 6: 33–49 (July, 1902). Catalogue of Exhibition, pp. 40–46. Illustrations of Exhibition, pp. 47–49.

"Valedictory," *Camera Notes*, 6: 4–6 (July, 1902).

Woodbury, W. E., "Alfred Stieglitz and His Latest Work," *The Photographic Times*, April, 1896.

Yellott, Osborne I., "The Rule or Ruin School of Photography," *Photo-Era*, November, 1901.

1903–1917

"Alfred Stieglitz, Artist and His Search for the Human Soul," *New York Herald,* March 8, 1908, p. 5.

Allan, Sidney [Sadakichi Hartmann], "The Exhibition of the Photo-Secession," *The Photographic Times-Bulletin* (New York), 36:97–105 (March, 1904).

_____, "A New Departure in Photography," *The Lamp*, 28:18–25 (1904).

_____, "Photography a Fine Art," *The New York Evening Post*, November 9, 1910, p. 9.

_____, "Portraiture at the Buffalo Exhibition," *Wilson's Photographic Magazine*, 47: 530–532 (December, 1910).

Anderson, P. L., *Pictorial Photography; It's Principles and Practice*, Philadelphia, 1917.

"Artistic Side of Photography," *New York Times*, Part 7, p. 7, October 13, 1912.

Barnes, Djuna, "Giving Advice on Life and Pictures . . .," *Morning Telegraph*, February 25, 1917.

Bayley, R. Child, *The Complete Photographer*, Second Edition, New York, McClure, Phillips and Co., 1907.

Beck, Otto Walter, *Art Principles in Portrait Photography*, New York, Baker and Taylor and Co., 1907.

Bicknell, George, "The New Art in Photography: The Work of Clarence H. White," *The Craftsman*, 19: 495–510 (January, 1906).

Brinton, Christian, "Four Portrait-Photographs by Eduard Steichen," *The Critic*, Vol. 42 (1903).

Cadby, Carene and Will A., "London Letter," *Photo-Era*, 35: 263–264 (November, 1915).

Caffin, Charles H., "The Development of Photography in the United States," *The Studio* (London), Special Summer Number devoted to Art in Photography, 1905, pp. 1–7.

_____, "Progress in Photography, with special reference to the art of Eduard J. Steichen," *The Century Magazine*, 64: 483–498 (February, 1908).

"Camera Club Ousts Alfred Stieglitz ," *New York Times*, February 14, 1908, p. 1.

Carter, Huntley, "Two-Ninety-One," *The Egoist,* 3: 3 (March, 1916).

Catalogue of the International Exhibition of Pictorial Photography. Organized by Alfred Stieglitz and the Photo-Secession, Buffalo Fine Arts Academy, Albright Art Gallery, Buffalo, New York, 1910.

"Clarence H. White School of Photography," *The Outlook*, 114: 97–99 (September, 1916).

Coburn, Alvin Langdon, "Modern Photography at the English Art Club," *Photographic News*, Vol. 51 (1907).

A Collection of American Pictorial Photographs, Catalogue arranged by Alfred Stieglitz, Cover designed by Eduard Steichen, Carnegie Institute, Pittsburgh, 1904.

De Zayas, Marius, "The Steerage: Stieglitz, Photography, and Modern Art," *291*, No. 7/8 (September, 1915).

_____, and Paul Haviland, *A Study of the Modern Evolution of Plastic Expression*, New York, 291 Gallery, 1913.

Edgerton, Giles, "The Lyric Quality in the Photo-Secession Art of George H. Seeley," *The Craftsman*, 13: 298–303 (December, 1907).

_____, "Photography as One of the Fine Arts; the Camera Pictures of Alvin Langdon Coburn as a Vindication of This Statement," *The Craftsman*, 12: 394–403 (1907).

Ernst, Agnes, "New School of the Camera," *New York Sun*, April 26, 1908.

An Exhibition Illustrating the Progress of the Art of Photography in America, New York, Montross Art Galleries, 1912. Foreword by Temple Scott.

Guest, Anthony, "Mr. A. L. Coburn's Vortographs at the Camera Club," *Amateur Photographer*, Vol. 60 (1917).

Gillies, John Wallace, "Amateurs I Have Known," *American Photography*, 9: 424–426 (July, 1915).

Hartmann, Sadakichi, "Aesthetic Activity in Photography," *Brush and Pencil*, 14: 24–40 (April, 1904).

_____, "Gessler's Hat," *The Camera*, November, 1904. Written under the pseudonym: Caliban.

_____, "The Photo-Secession, A New Pictorial Movement," *The Craftsman*, 6: 30–37 (April, 1904).

Haviland, Paul B., "Accomplishments of Photography

and Contributions of the Medium to the Arts," *Academy Notes* (Journal of the Albright Art Gallery, Buffalo Fine Arts Academy, Buffalo, New York), 6:13–26 (January, 1911). Reprinted in *Camera Work*, 33: 65–67 (January, 1911).

——————, "Man, the Machine and Their Product, the Photographic Print," *291*, No. 7/8 (September, 1915).

Hinton, A. Horsley, "The Work and Attitude of the Photo-Secession of America," *Amateur Photographer*, London, June 2, 1904.

Holme, Charles, ed. "Art in Photography," *The Studio*, Special Summer Number, London, 1905.

Laurvik, J. Nilsen, "Alfred Stieglitz, Pictorial Photographer," *International Studio*, August, 1911.

——————, "New Color Photography," *Century*, January, 1908.

Lidbury, F. A., "Some Impressions of the Buffalo Exhibition," *American Photography*, 4: 676–681 (December, 1910). Reprinted in *Camera Work*, 33: 65–71 (January, 1911).

MacColl, W. D., "International Exhibition of Pictorial Photography at Buffalo," *The International Studio*, 43: 11–14 (March, 1911).

[McBride, Henry and Swift?], "Art Photographs and Cubist Painting," *Sun*, March 3, 1913.

Minuit, Peter [Paul Rosenfeld], "291," *The Seven Arts*, 1: 61–65 (November, 1916).

Moore, Henry Hoyt, "The New Photography," *The Outlook*, 83:454–463 (June 23, 1906).

——————, "Photography with a Difference," *The Outlook*, 114: 97–99 (September 13, 1916).

Muir, Ward, "Alfred Stieglitz. An Impression," *Amateur Photographer and Photographic News*, March 24, 1913.

Oliver, Maude I. G., "The Photo-Secession in America," *The International Studio*, 32: 199–215 (September, 1907).

"Photographs by Clarence H. White," *The International Studio*, 40: 102–104 (June, 1910).

Poore, H. R., "The Photo-Secession," *The Camera*, Philadelphia, 1903.

Rood, Roland, "Eduard J. Steichen . . .," *American Amateur Photographer*, 18: 4 (1906).

——————, "The Exhibitions of Käsebier, White, Annan, Hill and Evans at the Photo-Secession," *American Amateur Photographer*, 18: 99–102 (March, 1906).

——————, "The Three Factors in American Pictorial Photography," *American Amateur Photographer*, New York, 1905.

Savery, James C., "Photo-Secession," *Burr McIntosh Monthly*, 12: 36–43 (April, 1907).

Shaw, George Bernard, "Alvin Langdon Coburn," *Wilson's Photographic Magazine*, 43: 107–109 (March, 1906).

Smith, Pamela Colman, [Porfolio of Prints], New York, The Photo-Secession, 1907. 22 platinum prints. Only seven regular and one special porfolio issued.

Steichen, Eduard J., [The Steichen Book], New York, Alfred Stieglitz, 1906. Selected proofs by Steichen from *Camera Work*, with a preface by Maurice Maeterlinck.

Stieglitz, Alfred, "Exhibition of Pictorial Photography," *Academy Notes*, (Journal of the Albright Art Gallery, Buffalo Fine Arts Academy, Buffalo, New York), 6: 11–13 (January, 1911).

——————, "The Fiasco at St. Louis," *Photographer*, August 20, 1904.

——————, "The First Great Clinic to Revitalize Art," *New York American*, 5-ce, Sunday, January 26, 1913.

——————, "The Photo-Secession," *The American Annual Photography and Photographic Times-Bulletin Almanac 1904*, New York, 1904, pp. 41–44.

——————, *Photo-Secessionism and Its Opponents. Five Letters by Alfred Stieglitz. A Sixth Letter by Alfred Stieglitz*, New York, August, 1910, October, 1910.

——————, "The Photo-Secession—Its Objects," *Camera Craft*, 7: 81–83 (August, 1903).

——————, "Simplicity in Composition," *The Modern Way in Picture Making*, 1905.

Strand, Paul, "Photography," *Seven Arts*, August, 1917, pp. 524–26. Reprinted in *Camera Work*, 49/50: 3–4 (June, 1917), and in *Photographers on Photography*, Nathan Lyons, ed. Englewood Cliffs, New Jersey, Prentice-Hall, Inc., 1966, pp. 136–137.

Traubel, Horace, *Optimos*, New York, B. W. Heubsch, 1910.

——————, "Stieglitz," *Conservator*, New York, December, 1916.

291 [The Little Galleries of the Photo-Secession], New York. Exhibition catalogues, 1905–1917, assembled and bound by Stieglitz. One copy is in the Alfred Stieglitz Archive in Yale University's Collection of American Literature.

"'291' the Mecca and the Mystery of Art in a Fifth Avenue Attic," *New York Sun*, Sunday, October 24, 1915.

Vortographs and Paintings by Alvin Langdon Coburn, Catalogue essay by Ezra Pound, London, 1917.

Weber, Max, *Essays on Art*, New York, Gomme, 1916.

White, Clarence H., "Old Masters in Photography," *Platinum Print*, 1: 4, No. 7 (1915).

——————, [The White Book], New York, Alfred Stieglitz, 1909. Selected proofs of White's photographic work from *Camera Work* together with one new plate. 23 plates. No known copy.

Yellot, Osborne I., "The Outlook for 1903," *Photo-Era*, 10: 25–26 (January, 1903).

—————, "Pictorial Photography in the United States," *Photograms of the Year, 1903*, London, Photogram, Ltd., 1903, pp. 27–50.

After 1917
"Alfred Stieglitz and Exhibitions," *Image*, 14:15, No. 3 (June, 1971). Contains reproduction of May, 1917 cover of *The Blind Man*.

Alvin Langdon Coburn, "Frederick H. Evans," *Image*, Vol. 2 (1953).

Anderson, Paul L., "The Fine Art of Photography," Philadelphia, J. B. Lippincott and Co., 1919.

—————, "Some Pictorial History," *American Photography*, 29: 199–214 (April, 1935).

Anderson, Sherwood, "Alfred Stieglitz," *New Republic*, October 25, 1922.

—————, *Sherwood Anderson's Notebook*, New York, Boni and Liveright, 1926.

Arens, Egmont, "Alfred Stieglitz: His Cloud Pictures," *Playboy*, 9: 15 (July, 1924).

Arnold, Rus, "The Doodler Makes a Date—How to Recognize a Dated Photograph," *Minicam Photography*, 7: 56–65 (August, 1944).

Bauer, Catherine, "Photography: Man Ray and Paul Strand," *Arts Weekly*, 1: 193, 198 (May 7, 1932).

Baur, John I. H., *Revolution and Tradition in Modern American Art*, Cambridge, Massachusetts, Harvard University Press, 1951.

Benson, M., "Alfred Stieglitz, The Man and the Book," *American Magazine of Art*, 28: 36–42 (January, 1935).

Benton, Thomas Hart, "America and/or Alfred Stieglitz," *Common Sense*, No. 4 (January, 1935).

Brown, Milton W., *The Story of the Armory Show*, New York, Joseph H. Hirshhorn Foundation, 1963.

Bruno, Guido, "The Passing of "291," *Pearson's Magazine*, March, 1918.

Bry, Doris, *Alfred Stieglitz: Photographer*, Boston, The Museum of Fine Arts, 1965.

—————, *An Exhibition of Photographs by Alfred Stieglitz*, National Gallery of Art Exhibition Catalogue, Washington, 1958.

—————, "The Stieglitz Archive at Yale University," *Yale University Library Gazette*, April, 1951.

Bryan, W. B, "Stieglitz," *Twice a Year* No 5/6: 132–133 (1942).

Bunnell, Peter C., "Alfred Stieglitz and 'Camera Work,'" *Camera* (Lucerne), 48:8, No. 12 (December, 1969).

—————, "The 1907 Photographic Collaboration of Clarence H. White and Alfred Stieglitz." Unpublished manuscript of paper read at the Symposium on the History of Photography, George Eastman House, November 27, 1964.

—————, "The Significance of the Photography of Clarence Hudson White (1871–1925) in the Development of Expressive Photography." Unpublished Master's Thesis, Ohio University, Athens, 1961.

"Camera Work," *Camera* (Lucerne), Allan Porter, ed. 48:5–57, No. 12, (December, 1969). Issue reproduces 41 plates from *Camera Work* and reprints selected texts from *Camera Work* and *America and Alfred Stieglitz*, Waldo Frank et al., eds. New York, 1934. Also contains article by Peter Bunnell," Alfred Stieglitz and 'Camera Work.'"

Cameron, Julia Margaret, "The Annals of My Glass House," *Photographic Journal* (London), 67:296–301 (July, 1927). Reproduced in Helmut Gernsheim's *Julia Margaret Cameron*, London, Fountain Press, 1948, pp. 67–72.

Carey, Elizabeth Luther, "Recent Pictorial Photography at the Camera Club Exhibition," *New York Times Book Review and Magazine*, September 10, 1922, p. 10.

Catalogue of the John Marin Memorial Exhibition, contributions by Duncan Phillips, William Carlos Williams, Dorothy Norman, MacKinley Helm, and Frederick S. Wight, Art Galleries, University of California, Los Angeles, 1955.

Catalogues of four exhibitions organized by Alfred Stieglitz, with statements by him, Anderson Galleries, New York, 1921, 1923, 1924, 1925.

Clurman. Harold, "Photographs by Paul Strand," *Creative Art*, 5: 735–738 (October, 1929).

Coates, R. M., "Alfred Stieglitz," *The New Yorker*, 23: 43–45 (June 21, 1947).

Coburn, Alvin Langdon, *Alvin Langdon Coburn, Photographer*, an autobiography, Helmut and Alison Gernsheim, eds. Frederick A. Praeger, New York, 1966.

—————, "Bernard Shaw, Photographer," *Photoguide Magazine* (December, 1950).

—————, "Retrospect," *The Photographic Journal*, 98: 36–40, London, February, 1958).

Coomaraswamy, Ananda, "A Gift from Mr. Alfred Stieglitz," *Museum of Fine Arts Bulletin*, Boston, April, 1924.

Craven Thomas, "Art and the Camera," *Nation* 118: 456–57 (April 16, 1924).

—————, *Modern Art*, New York, Simon and Schuster, 1934.

—————, "Stieglitz, Old Master of the Camera," *Saturday Evening Post*, 216: 14–15 (January 8, 1944).

Dahlberg, Edward, *Alms for Oblivion*, Minneapolis, University of Minnesota Press, 1964.

Davidson, M., "Beginnings and Landmarks of a Pioneer Gallery: 291 and An American Place," *Art News*, 36: 13, No. 27 (1937).

Dijkstra, Bram, *The Hieroglyphics of a New Speech, Cubism, Stieglitz, and the Early Poetry of William Carlos Williams*, Princeton University Press, 1969.

Doty, Robert, *Photo-Secession: Photography As a Fine Art*, Rochester, New York, George Eastman House, 1960. Contains selected bibliography, pp. 99–100, and 56 illustrations taken from *Camera Notes, Camera Work*, and Stieglitz's work.

——————, "What Was the Photo-Secession?" *Photography* (London), 17: 18–29 (January, 1962).

Eder, Joseph Maria, *History of Photography*, New York, Columbia University Press, 1945.

Eglington, Guy, "Art and Other Things," *International Studio*, 79: 148–151 (May, 1924).

Engelhard, Georgia, "Alfred Stieglitz, Master Photographer," *American Photography*, 39: 8–12 (April, 1945).

——————, "The Face of Alfred Stieglitz," *Popular Photography* (September, 1946).

——————, "Grand Old Man," *American Photography*, 44: 18–19, (May, 1950).

——————, "Master Photographer," *American Photography*, Vol. 39 (April, 1945).

Evans, Walker, "Photography," *Quality*, Louis Kronenberger, ed. New York, Atheneum, 1969, pp. 178–179.

Firebaugh, Joseph J., "Coburn: Henry James's Photographer," *American Quarterly*, 7: 215–233 (Fall, 1955).

Flint, R., "What is 291? Alfred Stieglitz and Modern Art in the United States," *Christian Science Monitor Weekly Magazine*, Section 5, November 17, 1937.

Frank, Waldo, "Alfred Stieglitz," *McCall's Magazine*, May, 1927, pp. 24, 107–108.

——————, *Our America*, New York, Boni and Liveright, 1919, pp. 180–187.

——————, *The Rediscovery of America*, New York, 1929.

——————, Lewis Mumford, Dorothy Norman, Paul Rosenfeld and Harold Rugg, eds. *America and Alfred Stieglitz: A Collective Portrait*, New York, Doubleday Doran and Co., Inc., 1934. Contains 120 illustrations of work shown at 291, The Intimate Gallery, An American Place, and in *Camera Work*. Also includes selected bibliography of material relating to Stieglitz's life and work. pp. 319–322.

Freed, Clarence I., "Alfred Stieglitz: Genius of the Camera," *The American Hebrew*, January 18, 1924.

Friedlander, Max J., *Landscape Portrait Still-Life*, Schocken Books, 1963

Garfield, George, and Frances O'Brien, "Stieglitz, Apostle of American Culture," *Reflex Magazine*, New York, September, 1928.

Geldzahler, Henry, *American Painting in the Twentieth Century*, New York, The Metropolitan Museum of Art, 1965.

Gernsheim, Helmut, *Creative Photography: Aesthetic Trends 1839–1960*, London and New York, 1962.

——————, with Alison Gernsheim, *The History of Photography*, London and New York, 1955.

Goodrich, Lloyd, *Pioneers of Modern Art in America, The Decade of the Armory Show, 1910–1920*, New York, 1963.

Green, Samuel M., *American Art: A Historical Survey*, New York, The Ronald Press Company, 1966.

Haines, Robert E., "Alfred Stieglitz and the New Order of Consciousness in American Literature," *Pacific Coast Philology*, 6: 26–34 (April, 1971).

Hartley, Marsden, *Adventures in the Arts*, New York, Boni and Liveright, 1921. See "The Appeal of Photography," pp. 102–111.

Haz, Nicholas, "Alfred Stieglitz, Photographer," *American Annual of Photography*, Boston, 1936.

Helm, MacKinley, "John Marin," *Atlantic Monthly*, 179: 76–81 (February, 1947).

——————, *John Marin*, Boston, 1948.

Ivins, William M. Jr., "Photography by Alfred Stieglitz," *Bulletin of the Metropolitan Museum of Art*, New York, 24: 44–45, No. 2 (February, 1929).

——————, *Prints and Visual Communication*, Cambridge, Massachusetts, 1953.

[Jewell, Edward Alden], "Alfred Stieglitz" [Editorial], *New York Times*, July 14, 1946.

——————, "Hail and Farewell," *New York Times*, June 15, 1947.

Johnson, Dorothy Rylander, *Arthur Dove: The Years of Collage*, University of Maryland Art Gallery Exhibition Catalogue, College Park, Maryland, 1967.

Johnston, J. Dudley, "Phases in the Development of Pictorial Photography in Britain and America," *The Photographic Journal* (London), 63: 568–582 (1923).

Kreymborg, Alfred, *Troubadour*, New York, 1925.

Lacey, Peter and A. La Rotonda, *The History of the Nude in Photography*, New York, Bantam, 1964.

Larkin, Oliver W., "Alfred Stieglitz and 291," *Magazine of Art*, 40: 179–183 (May, 1947).

——————, *Art and Life in America*, New York, Holt, Rinehart and Winston, 1960, pp. 326–328, 354.

Leonard, N., "Alfred Stieglitz and Realism," *Illustrated Arts Quarterly*, 29: 277–286, No. 3/4 (1966).

Life Library of Photography, Robert G. Mason, ed. (1970), Richard L. Williams, ed. (1971). See especially *The Print:* "The Artist as Photographer" and "Photography's Lavish Showcase," pp. 11–50, reproduces 24 full pages from *Camera Work*, including 19 plates. *The Camera:* "The Many Levels of Photography," "A Search for Beauty," pp. 12–17 and pp. 34–45. *Great Photographers:* "1900–1920," and "1920–1940," pp. 113–190, notes on and reproductions of work by Robert Demachy, Clarence White, Alvin Langdon Coburn, Alfred Stieglitz, Edward Steichen, and Paul Strand among others. *Photographing Children:* "The Ideal, the Real, and the Surreal", "The Model Child," pp. 37–63, reproductions of work by Edward Steichen, Clarence White, De Meyer, among others. *The Studio:* "De Meyer: Mannered Chic," "Steichen: Master of Lighting," pp. 105–111. *Color:* "The Search for a Color Process," pp. 53–76, reproduces eight Lumiere Autochrome Transparencies. *The Great Themes* "Changing Views of the Human Form," pp. 129–133, reproductions of work by Frank Eugene, Alvin Langdon Coburn, and Edward Steichen.

Longwell, Dennis, "Alfred Stieglitz vs the Camera Club of New York," *Image*, 14: 21–23, No. 5/6 (December, 1971).

Lyons, Nathan, *Photography in the Twentieth Century*, Rochester, George Eastman House, Horizon Press, 1967. A visual anthology or photographs.

_____, ed. *Photographers on Photography, A Critical Anthology*, Englewood Cliffs, New Jersey, Prentice-Hall, Inc., 1966. A critical source book with thirty-nine reprinted essays by leading photographers from 1892 to 1963.

Marin, John, *Letters*, edited by Herbert J. Seligman, New York, An American Place, 1931.

_____, *Selected Writings*, edited with an introduction by Dorothy Norman, New York, 1949.

Marks, Robert W., "Man With a Cause," *Coronet*, September, 1938.

_____, "Peaceful Warrior," *Coronet*, 4: 161–171 (October, 1938).

_____, "The Photography of Clarence H. White," *Gentry*, 9: 134–139 (Winter, 1953–54).

Mather, F. J., "Photographer and Champion of Art," *Saturday Review*, 11: 337 (December 8, 1934).

McBride, Henry, "Modern Art," *The Dial*, April, 1921.

_____, "The Paul Strand Photographs," *New York Sun*, March 23, 1929, p. 34.

McCausland, Elizabeth, *Marsden Hartley*, Amsterdam, Amsterdam Stedelijk Museum Catalogue, 1961.

[McCausland, Elizabeth], "Stieglitz's 50-year Fight for Photography Triumphant," *Springfield Sunday Union and Republican*, May 14, 1933.

Mees, C. E. Kenneth, *From Dry Plates to Ektachrome Film*, New York, Ziff-Davis, 1961.

Mellquist, Jerome and Lucie Wiese, *Paul Rosenfeld: Voyager in the Arts*, New York, 1948.

Millard III, Charles W., "Charles Sheeler: American Photographer," *Contemporary Photographer*, Vol. 6, No. 1 (1967).

Miller, Henry, "Stieglitz and John Marin," *Twice a Year*, No. 8/9: 146–155 (Spring-Summer 1942). Reprinted in *Civil Liberties and the Arts*, William Wasserstrom, ed. Syracuse, New York, Syracuse University Press, 1964.

Muir, Ward, "'Camera Work' and its Creator," *The Amateur Photographer and Photography*, 56:465–66 (November 28, 1923).

_____, "Photographic Days," *The Amateur Photographer and Photography*, August 14, 1918.

Mumford, Lewis, "A Camera and Alfred Stieglitz," *New Yorker*, December 22, 1934.

Munson, Gorham, "291: A Creative Source of the Twenties," *Forum*, 3: 4–9 (Fall-Winter, 1960).

Newhall, Beaumont, *Frederick H. Evans*, Rochester, New York, George Eastman House, 1964.

_____, *The History of Photography from 1839 to the Present Day*, New York, The Museum of Modern Art, 1964. See also earlier editions.

_____, *On Photography*, Watkins Glen, New York, Century House, 1956. Reproductions of Classic Documents.

_____, "Photography As Art in America," *Perspectives, USA*, 15: 122–133 (1956).

_____, "Stieglitz and 291," *Art in America*, 51: 49–51 (February 1963).

Newhall, Nancy, "Emerson's Bombshell," *Photography* (Quarterly), 1:50–52, 114, No. 2 (Winter, 1947).

_____, *Paul Strand: Photographs 1915–1945*, New York, The Museum of Modern Art, 1945.

_____, "What Is Pictorialism?" *Camera Craft*, 48: 653–663 (November, 1941).

Norman, Dorothy, "Alfred Stieglitz," *Aperture*, 8: 1–66, No. 1 (1960).

_____, *Alfred Stieglitz: An American Seer*, New York, Random House, 1973. Contains extensive bibliography on Stieglitz.

_____, "Alfred Stieglitz on Photography," *The Magazine of Art*, 43: 298–301 (December, 1950).

_____, "Alfred Stieglitz—Seer," *Aperture*, 3: 3–24, No. 4 (1955).

_____, "Marin Speaks, and Stieglitz," *Magazine of Art*, 30: 151 (March, 1937).

——————, "Stieglitz and Cartier-Bresson," *Saturday Review*, 45: 52–56 (September 22, 1962).

——————, "Stieglitz's Experiments in Life," *New York Times Magazine*, December 29, 1963, p. 12–13.

——————, ed. *Twice a Year*, New York, 1938–1948. See especially issues 1, 5/6, 8/9, 10/11, 14/15. "Alfred Stieglitz: Four Happenings" from issue 8/9 reprinted in *Photographers on Photography*, Nathan Lyons, ed. Englewood Cliffs, New Jersey, Prentice-Hall, Inc., 1966. Selections also reprinted in *Civil Liberties and the Arts*, William Wasserstrom, ed. Syracuse, New York, Syracuse University Press, 1964.

——————, "Was Stieglitz a Dealer?" *Atlantic Monthly*, 179: 22–23 (May, 1947).

O'Keeffe, Georgia, "Stieglitz: His Pictures Collected Him," *New York Times Magazine*, December 11, 1949, pp. 24–26.

Parker, Robert Allerton, "The Art of the Camera: An Experimental Movie [Manahatta]", *Arts and Decoration*, 15: 369, 414–415 (October, 1921).

"Pictorialism 1890–1914," *Camera* (Lucerne), Allan Porter, ed. 49: 5–52, No. 12 (December, 1970). Issue devoted to early pictorial photography. Includes 38 plates and introductory text and biographies.

Pictorial Photography in America, 1926, New York, Tennant and Ward, 1926.

Pollack, Peter, *The Picture History of Photography*, New York, Harry N. Abrams, Inc., 1969. See also earlier editions.

Porterfield, W. H., "Pictorial Photography in America," *Photograms of the Year, 1917–1918*, London, Photograms, Ltd., 1918, pp. 27–28.

Rich, Daniel Catton, *Georgia O'Keeffe*, Chicago, 1943.

Richie, Andrew Carnduff, *Charles Demuth*, New York, 1959.

Rose, Barbara, *American Art Since 1900*, New York, Frederick A. Praeger, Inc., 1967.

——————, *Readings in American Art Since 1900*, New York, Frederick A. Praeger, 1968.

Rosenfeld, Paul, "Alfred Stieglitz," *Twice a Year*, 14/15: 203–205 (Fall Winter 1946–1947). Reprinted from *The Commonweal*, 44:380–1 (August 2, 1946).

——————, "American Painting," *The Dial*, 71:649–670, No. 6 (December, 1921).

——————, "The Paintings of Georgia O'Keeffe," *Vanity Fair*, 19: 56, 112, 114 (October, 1922).

——————, "The Paintings of Marsden Hartley," *Vanity Fair*, 18: 47, 84 94, 96 (August, 1922).

——————, "Photography of Alfred Stieglitz," *The Nation*, New York, March 23, 1932.

——————, *Port of New York*, New York, Harcourt, 1924.

——————, "Stieglitz," *The Dial*, April, 1921, pp. 397–409.

——————, "The Watercolors of John Marin," *Vanity Fair*, 18: 48, 88, 92, 110 (April, 1922).

Rugg, Harold Ordway, *Culture and Education in America*, New York, Harcourt Brace, 1931.

Sandburg, Carl, *Steichen the Photographer*, Harcourt Brace, 1929.

Scharf, Aaron, *Art and Photography*, Baltimore, Penguin Books, 1969.

——————, *Creative Photography*, Reinhold, 1965.

Seligmann, Herbert J., "Alfred Stieglitz and His Work at 291," *American Mercury*, May, 1924, pp. 83–84.

——————, *Alfred Stieglitz Talking 1925–1931*, New Haven, Yale University Press, 1966.

——————, "A Photographer Challenges," *The Nation*, February 16, 1921.

Sheeler, Charles, "Recent Photographs by Alfred Stieglitz," *The Arts*, 3: 345 (May, 1923).

Sobieszek, Robert A., "Heinrich Kuhn," *Image*, 14: 16–18, No. 5/6 (December, 1971).

Steichen, Eduard, "The Fighting Photo-Secession," *Vogue*, June 15, 1941, pp. 22, 74.

——————, Edward, *A Life in Photography*, Garden City, New York, Doubleday and Company, 1963.

——————, "The Lusha Nelson Photographs of Alfred Stieglitz," *U.S. Camera*, February/March 1940.

Steichen the Photographer, New York, The Museum of Modern Art, Doubleday, 1961.

Stein, Gertrude, *The Autobiography of Alice B. Toklas*, New York, Modern Library, 1933.

Stettner, Louis, *History of the Nude in American Photography*, Whitestone, 1966.

Stieglitz, Alfred, "Foreword to Exhibition of Photography," Anderson Galleries, New York, February, 1921.

——————, "From the Writings and Conversations of Alfred Stieglitz as told to Dorothy Norman," *Twice a Year*, 1:77–110; 5/6: 135–163; 8/9: 105–136; 10/11: 245–264; 14/15: 188–202, 1938–1948. "Alfred Stieglitz: Four Happenings," from issue 8/9, reprinted in *Photographers on Photography*, Nathan Lyons, ed. Englewood Cliffs, New Jersey, Prentice-Hall, Inc., 1966. "The Origin of the Photo-Secession and How It Became 291," from issue 8/9, reprinted in *Civil Liberties and the Arts*, William Wasserstrom, ed. Syracuse, New York, Syracuse University Press, 1964.

Stieglitz Memorial Portfolio, Dorothy Norman, ed. New York, Twice a Year Press, 1947.

Stone, Gray, "The Influence of Alfred Stieglitz on Modern Photographic Illustration," *American Photography*, 30:199–206 (April, 1936).

Strand, Paul, "Aesthetic Criteria," *The Freeman*, 2:426–427 (January 12, 1921). Letter to the Editor.

_____, "Alfred Stieglitz and a Machine," *MSS*, 2: 6–7 (March, 1922).

_____, "Alfred Stieglitz 1864–1946," *New Masses*, 60:6–7 (August 6, 1945). Reprinted in *Stieglitz Memorial Portfolio*, Dorothy Norman, ed. New York, Twice a Year Press, 1947, pp. 12–13.

_____, "American Watercolors at the Brooklyn Museum," *The Arts*, 2: 158–152 (December 1921). Excerpt reprinted in *John Marin*, Sheldon Reich, Tucson, University of Arizona Press, 1970, p. 136.

_____, "The Art Motive in Photography," *British Journal of Photography*, 70: 613–615 (October, 1923). Reprinted in *On Photography*, Beaumont Newhall, ed. Watkins Glen, New York, Century House, 1956. Reprinted in *Photographers on Photography*, Nathan Lyons, ed. Englewood Cliffs, New Jersey, Prentice-Hall, Inc., 1966.

_____, "The Forum," *The Arts*, 2: 332–333 (February 1922). Letter to the Editor in reply to response to Strand's article "American Watercolors at the Brooklyn Museum".

_____, "Georgia O'Keeffe," *Playboy*, 9: 16–20 (July, 1924).

_____, "Painting and Photography," *Photographic Journal* (London), 103:7 (1963). Letter to the Editor.

_____, "Photographers Criticized, *New York Sun*, June 27, 1923, p. 20. Letters to the Editor in response to Arthur Boughton's letter entitled "Photography as an Art," *New York Sun*, June 20 1923, p. 22. The latter letter was in response to an article by Charles Sheeler entitled "Recent Photographs by Alfred Stieglitz," *The Arts*, 3:345 (May, 1923).

_____, "Photography and the New God," *Broom*, 3: 252–58 (November, 1922). Reprinted in *Photographers on Photography*, Nathan Lyons, ed. Englewood Cliffs, New Jersey, Prentice-Hall, Inc., 1966.

_____, "Photography to Me," *Minicam Photography*, 8: 42 (1945).

_____, *A Retrospective Monograph, 1915–1968*, Two Volumes, Millerton, New York, Aperture, 1971. Contains selected bibliography on Strand by Peter Bunnell.

_____, "Steichen and Commercial Art," *New Republic*, 62:21 (February 19, 1930). Letter to the Editor in reference to Paul Rosenfeld's "Carl Sandburg and Photography," *The New Republic*, 62:251–253 (January 22, 1930).

_____, "Stieglitz: An Appraisal, *Popular Photography*, 21: 62 (July, 1947).

Strasser, Alex, *Immortal Portraits*, London, The Focal Press, 1941.

_____, *Victorian Photography*, London, The Focal Press, 1942.

Sweeney, James Johnson, "Rebel With a Camera," *New York Times Magazine*, June 8, 1947, p. 20.

Szarkowski, John, *The Photographer and the American Landscape*, New York, The Museum of Modern Art, Doubleday, 1963.

_____, *The Photographer's Eye*, New York, The Museum of Modern Art, Doubleday, 1966.

Taylor, Francis Henry, "American and Alfred Stieglitz," *The Atlantic Monthly*, 155: 8, 10 (January, 1935). Book review.

Tennant, John A., ed. "Soft Focus Effects in Photography," *Photo-Miniature*, 16: 189–190 (December, 1921).

Tilney, F. C., "What Pictorialism Is," *Photo-Miniature*, 16: 565–592 (January, 1924).

Ward, John L., *The Criticism of Photography as Art, The Photographs of Jerry Uelsmann*, Gainesville, University of Florida Press, 1970.

Wasserstrom, William, ed. *Civil Liberties and the Arts: Selections from 'Twice a Year' 1938–1948*, Syracuse, New York, Syracuse University Press, 1964. Anthology includes "The Origin of the Photo-Secession and How It Became 291," from *Twice a Year*, issue 8/9.

Weston, Edward, *The Daybooks of Edward Weston*, Vol. 1, Mexico; Vol. II, California. Nancy Newhall, ed. Vol. I, Rochester, New York, George Eastman House, 1961. Vol. II, New York, Horizon Press, 1966.

White, Clarence H., "The Progress of Pictorial Photography," *Pictorial Photographers of America 1918*, New York, The Pictorial Photographers of America, 1918, pp. 5–16.

White, Clarence H., Jr., "The Art of Clarence Hudson White," *The Ohio University Review* (Athens, Ohio), 7: 40–65 (1965). Contains extensive bibliography by Peter C. Bunnell, pp. 55–65. Illustrations by Clarence H. White, pp. 43–54.

_____, *Photographs of Clarence H. White*, University of Nebraska Art Galleries, 1968.

White, Minor, "On the Strength of a Mirage," *Art in America*, 46: 52–55 (Spring, 1958).

_____, "What Is Meant by 'Reading' Photographs," *Aperture*, 5: 9–10, No. 2 (1957). See also "Some Methods for Experiencing Photographs," *Aperture*, 5: 156–171, No. 4 (1957).

Wight, Frederick S., *Arthur G. Dove*, Berkeley, 1958.

Wilson, Edmund, *The American Earthquake*, Garden City, N.Y., Doubleday, 1958.

Zigrosser, Carl, "Alfred Stieglitz," *Twice a Year*, 8/9: 137–145 (Fall-Winter, 1942).

Indices

These indices simultaneously index this Anthology and the complete edition of CAMERA WORK. A **bold** entry indicates an item that is included in the Anthology. This item will appear on the page indicated by the **bold** numeral adjacent to the index column.

Certain pages in the original edition of CAMERA WORK were left blank, but paginated; incorrectly paginated; or included as unpaginated supplements. These indices use the page numbers and supplement and plate positions as they appear in the Kraus Reprint edition. Other collections of CAMERA WORK may have slightly differing sequencing. Supplements, in particular, may be found in an issue preceding or following the one indicated.

An *S* indicates that the article appears on supplemental sheets added to an issue. An *A* indicates that the article or plate appears among the unpaginated advertisements. *S1* refers to the Special Steichen Supplement, April, 1906. *S2* refers to the Special Number, August, 1912; *S3* to the Special Number, June, 1913. The publication date of each issue is indicated in the Chronological Article Index.

In the following index, non-bracketed items are references to individuals. Bracketed items [] are articles or statements by individuals. If an item of more than one page is anthologized, only its beginning page will be indicated.

Index of Selected Names and Subjects

356

Chronological Article Index

(Error in original pagination of this issue. Page 47 on which Photo-Secession Notes appears should have read 49; the number of all additional pages following 49 should also be increased by two.)

Photographers and Artists Index

This index indicates the issues of CAMERA WORK in which plates by each photographer and artist occur. A bold **name** indicates that the Anthology contains plates by that individual reproduced from the **issues** denoted in bold. To find a specific plate and the page on which it appears, consult the Chronological Plate Index.

Chronological Plate Index